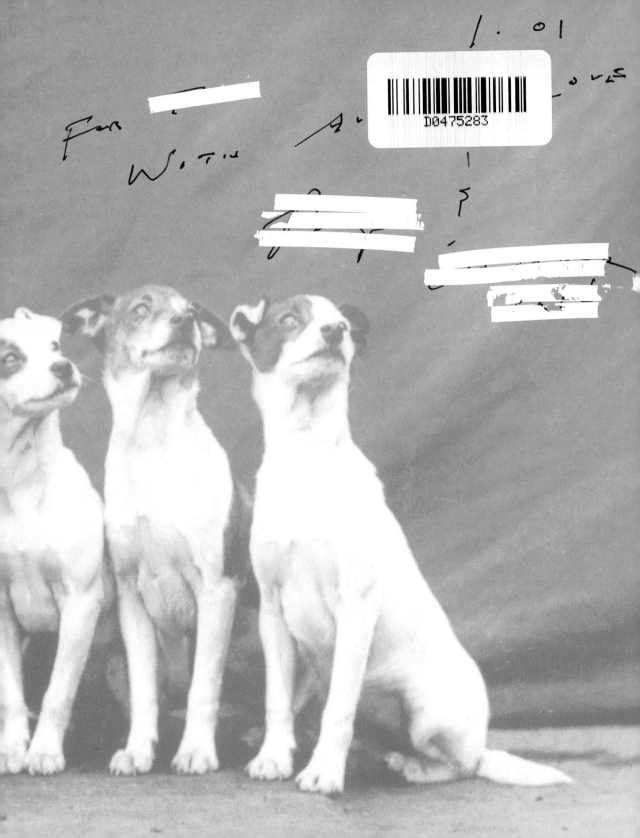

A Thousand Hounds

The Presence of the Dog
in the History of Photography
1839 to Today

Tausend Hunde

Hunde in der Geschichte der Fotografie
von 1839 bis zur Gegenwart

Un millier de chiens

Le chien dans l'histoire de la photographie
de 1839 à nos jours

RAYMOND MERRITT & MILES BARTH

A THOUSAN

TAUSEND HUNDE

RAYMOND MERRITT & MILES BARTH

D HOUNDS

UN MILLIER DE CHIENS

TASCHEN

KÖLN LONDON MADRID NEW YORK PARIS TOKYO

Contents
Inhalt
Sommaire

1839·1890

1890·1930

 1930·1950

 1950·1980

 1980·2000

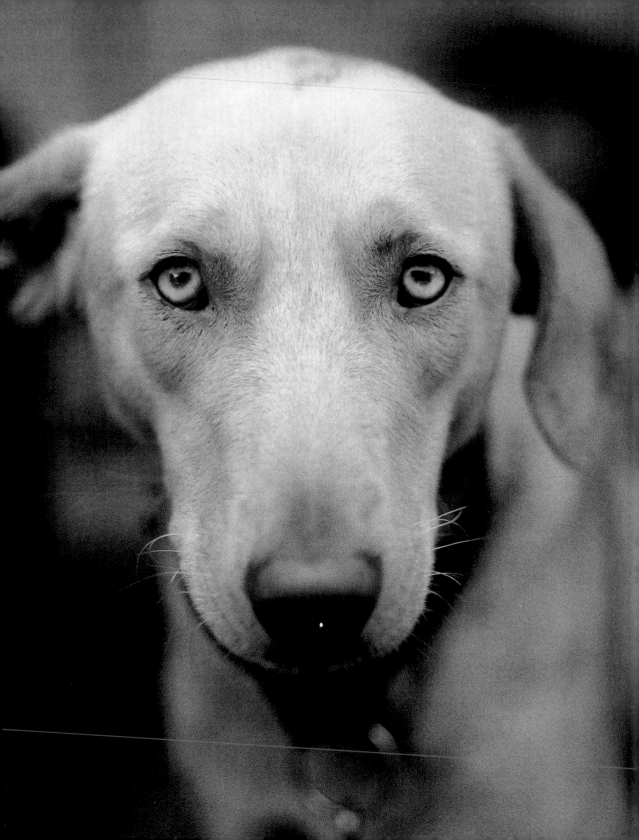

In the beginning,
God created man,
but seeing him so feeble,
He gave him the dog.

TOUSSENEL

Keith Carter, 1994

Introduction

Toussenel's view may well be hyperbole. Yet no creature in the history of the world has been so inextricably linked to man, transformed physically, emotionally, and socially by a bond that began at the birth of human civilization. Ferdinand Mery was not exaggerating when he noted: "The dog, our friend, seems to have been waiting, since the dawn of time, for the arrival on earth of homo sapiens, waiting for the moment when it could sever forever its links with all other creatures and give itself up to man." Trust, confidence, loyalty, dependency, and sympathy appear to be the principal articles of the canine-human partnership. Whether as hero, helper, symbol, or soulmate, this creature has experienced the best and worst of man. Nevertheless, this union has been the longest running co-beneficial relationship each has had with another species.

Affection for canines begins at birth. No child fails to be drawn to a dog because the dog sees with the eyes of its heart. Dogs stay in our lives forever. They are at once the children that never grow up, the savants whose innate wisdom helps part the shadows that all too often fall over our everyday lives. Our affection for them is always reciprocated, fulfilling, and manageable. Consequently, it is not surprising that, in our impersonal digital age, we have enhanced our bonds of friendship with animals, particularly dogs, so as not to lose completely our affinity with the other creatures of the earth.

As the arts elucidate the fine lines and fault lines of our lives, they also inform us of the relationship between man and dog. Drawn in French caves, entombed in Egypt, enshrined in China, dogs have always served art as subject and symbol. Early painters such as Velázquez and Titian included dogs in their paintings. It was not until the nineteenth century, however, that the great portrait painters began to express man's love for dogs and at the same time to capture their nobility. Hogarth, Gainsborough and Landseer majestically rendered canine presence in the family of man. The tradition, once started, continues. Today, we see the dog as an important element in the works of our leading artists, from Picasso to Salle, from Monet to Fischl.

The early photographers worked hard to include dogs, having them embraced by adult and child alike in the early daguerreotypes. As the camera improved, dogs photographically took their place at man's side forever. The advent of the camera happened to coincide with the emancipation of the dog from feudal servitude, and, from the middle of the nineteenth century, both *canis familiaris* and *camera obscura* experienced rapid absorption into the very fabric of human life.

Photography became and remains the principal prism through which we see our world. Through the latter part of the nineteenth century and for the duration of the twentieth century, the camera has been the key witness to our abiding affection for dogs. Manuel Alvarez Bravo, Mexico's leading photographic light, once commented that if all he ever did was to photograph a thousand hounds he would die a happy man. Why this photographic obsession? No one is quite sure. Perhaps it is the dog's innate sense of beauty, lack of self-consciousness, and abiding spirit of joy that continue to lead one to the other.

The images that follow speak as much about the history of the times and concerns of photography as they do about man's and dog's evolving relationships. No attempt was made to cull only the best. Rather, we have attempted to include the kitsch with the aesthetic to better capture the depth and breadth of man's addiction to the dog. Without a common vocal language with which to communicate, man and dog are forced to relate through their emotional responses to each other, and relate they do. Capable of reflection, the dog communicates pride, joy, sagacity, courage, and gentleness. In part, it is precisely these emotions and attributes that it is hoped these photographs capture. It was once said that some of our greatest treasures hang on the walls of museums, while others are taken for walks. Here you might see both. Yet we caution you to heed the caveat of Gary Winogrand to his students: "Beware of pictures of dogs and children, they are not as good as you think they are." If you still wish to proceed, enjoy and let these dogs make your day.

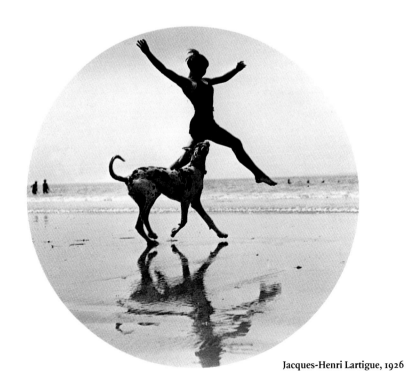

Jacques-Henri Lartigue, 1926

Am Anfang
schuf Gott den Menschen,
doch als er sah, wie schwach er war,
gab er ihm den Hund.

TOUSSENEL

Einführung

Toussenels Sicht der Dinge mag etwas übertrieben sein. Und doch war in der Geschichte der Menschheit keine Kreatur jemals so untrennbar mit dem Menschen verbunden wie der Hund – eine Verbindung, die zu Beginn der Zivilisation geknüpft wurde und das Tier in körperlicher, emotionaler und sozialer Hinsicht veränderte. Ferdinand Mery übertrieb nicht, als er feststellte: „Der Hund, unser Freund, scheint von Anbeginn der Zeit auf das Erscheinen des *Homo sapiens* auf der Erde gewartet zu haben, auf den Augenblick, wo er seine Verbindungen zu sämtlichen anderen Kreaturen abbrechen und sich ganz dem Menschen hingeben konnte." Vertrauen, Zutrauen, Loyalität, Abhängigkeit und Zuneigung scheinen die wichtigsten Punkte in der Partnerschaft zwischen Hund und Mensch zu sein. Ob als Held, Helfer, Symbol oder Kamerad, dieses Tier hat die besten und die schlechtesten Seiten des Menschen kennen gelernt. Dennoch ist keiner von beiden mit einer anderen Spezies eine länger andauernde, für beide Seiten vorteilhaftere Beziehung eingegangen.

Die Liebe zu Hunden beginnt mit der Geburt. Es gibt kein Kind, das sich nicht zu einem Hund hingezogen fühlt, weil Hunde mit dem Herzen sehen. Hunde sind für immer Teil unseres Lebens. Sie sind die Kinder, die nie erwachsen werden, und zugleich die Weisen, deren angeborenes Wissen hilft, die dunklen Schatten zu vertreiben, die nur zu oft auf unser tägliches Leben fallen. Diese Zuneigung wird immer erwidert, sie ist befriedigend und lässt sich kontrollieren. Folglich überrascht es nicht, dass wir in unserem unpersönlichen digitalen Zeitalter die Bande der Freundschaft mit Tieren und besonders mit Hunden noch enger geknüpft haben, um unsere Verbundenheit mit den anderen Kreaturen dieser Erde nicht gänzlich zu verlieren.

Wie die Künste die guten und die schlechten Seiten unseres Lebens darstellen, so zeigen sie uns auch die Beziehung zwischen Mensch und Hund auf. Ob in Frankreich auf Höhlenwände gemalt, im alten Ägypten in Grabkammern oder in China in Schreinen beigesetzt, seit Menschengedenken ist der Hund Motiv und Symbol in der Kunst. Auf den Bildern früher Maler wie Velázquez und Tizian sind Hunde abgebildet. Doch erst im 19. Jahrhundert begannen die großen Porträtmaler die Liebe des Menschen zu Hunden zum Ausdruck zu bringen und gleichzeitig deren vornehme Würde einzufangen. Hogarth, Gainsborough und Landseer stellten Hunde majestätisch im Kreis der Menschen dar. Diese von ihnen begründete Tradition wird fortgesetzt. Heute sehen wir den Hund als wichtiges Element in den Werken unserer bedeutendsten Künstler, von Picasso bis Salle und von Monet bis Fischl.

Für die frühen Fotografen war es harte Arbeit, Hunde einzubeziehen. Erwachsene wie Kinder hielten sie auf den ersten Daguerreotypien im Arm. Mit der Weiterentwicklung der Kamera eroberten sich Hunde auf Fotos für alle Ewigkeit ihren Platz an der Seite des Menschen. Die Erfindung der Kamera fiel zufällig mit der Befreiung des Hundes aus feudalistischer Knechtschaft zusammen, und von der Mitte des 19. Jahrhunderts an wurden sowohl *Canis familiaris* als auch die *Camera obscura* rasch zum festen Bestandteil unseres Lebens. Die Fotografie wurde und

bleibt das Hauptprisma, durch das wir unsere Welt sehen. Vom Ende des 19. Jahrhunderts an und durch das gesamte 20. Jahrhundert hindurch ist die Kamera Hauptzeuge unserer anhaltenden Zuneigung für Hunde. Manuel Alvarez Bravo, der bedeutendste mexikanische Fotograf, meinte einmal, wenn er sein Leben lang nichts anderes täte, als tausend Hunde zu fotografieren, würde er als glücklicher Mann sterben. Woher diese fotografische Obsession kommt, weiß niemand so genau zu sagen. Vielleicht sind es die dem Hund angeborene Schönheit, sein Selbstbewusstsein oder seine unbegrenzte Fähigkeit sich zu freuen.

Die folgenden Bilder erzählen genauso viel über Geschichte und Anliegen der Fotografie wie über die Beziehung zwischen Mensch und Hund. Es wurde nicht versucht, nur die besten Fotos auszusuchen – im Gegenteil, wir haben uns bemüht, neben dem Ästhetischen auch den Kitsch nicht zu vergessen, um das gesamte Spektrum der Zuneigung des Menschen zum Hund einzufangen. Ohne gemeinsame Sprache sind Mensch und Hund gezwungen, auf der Gefühlsebene eine Verbindung aufzubauen, und das tun sie auch. Der Hund ist in der Lage, eigenständig zu denken, und drückt Stolz, Freude, Klugheit, Mut und Freundlichkeit aus. Zu einem gewissen Grad sollen die hier gezeigten Fotografien genau diese Gefühle und Eigenschaften wiedergeben. Irgendjemand sagte einmal, einige unserer größten Schätze hingen in Museen, mit den anderen ginge man Gassi. Im vorliegenden Band wird von beidem etwas gezeigt. Wir raten dem Leser jedoch, die Warnung Gary Winogrands an seine Studenten ernst zu nehmen: „Hütet euch vor Bildern von Hunden und Kindern, sie sind nie so gut, wie ihr denkt." Falls Sie trotzdem weiter blättern wollen: viel Spaß an den Fotos und den Hunden!

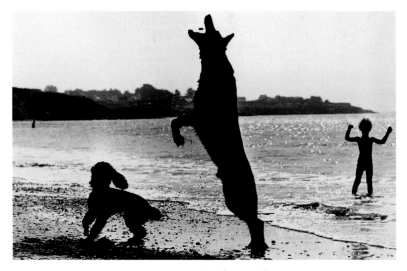

Jacques-Henri Lartigue, 1976

Au début,
Dieu créa l'homme.
Mais en le voyant si faible,
il lui fit don du chien.

TOUSSENEL

Timothy Greenfield-Sanders, 1994

Introduction

Ce point de vue de Toussenel peut sembler excessif. Pourtant, dans l'histoire du monde, il n'est point de créature dont l'histoire soit aussi intimement liée à celle de l'homme, sur le plan physique, émotionnel et social, car leur lien remonte à l'aube de la civilisation. Ferdinand Mery n'exagérait pas en remarquant : « Notre ami le chien semble avoir attendu, depuis le premier jour, l'arrivée sur terre de l'*homo sapiens* et le moment où il pourrait, à tout jamais, rompre ses liens avec les autres animaux pour se consacrer uniquement à l'homme. » Confiance, fidélité, loyauté, soumission et sympathie, telles sont les caractéristiques de l'union entre le chien et l'homme. Héros, auxiliaire, symbole ou compagnon, le chien trouve chez l'homme ce qu'il a de meilleur et de pire. Pourtant leur histoire est la plus longue et la plus riche de toutes les espèces.

L'amour des chiens commence à la naissance. Il n'est de bambin qui ne soit attiré par le chien, lui qui sait voir avec les yeux du cœur. Le chien, c'est le compagnon de toujours. C'est l'enfant qui ne grandit jamais, le sage qui nous apprend à chasser les ombres qui envahissent souvent notre vie quotidienne. C'est une affection toujours partagée, satisfaisante, sans complications. Alors, dans cette ère technologique qui est la nôtre, il n'est pas surprenant que l'accent soit mis sur nos liens affectifs avec les animaux, en particulier les chiens, afin que ne disparaissent pas complètement nos affinités avec les autres créatures.

De même que l'art sait mettre en lumière la beauté ou la laideur de nos vies, il nous informe aussi sur la relation entre l'homme et le chien. Sculpté dans les grottes françaises, descendu au tombeau en Egypte, enseveli sous la terre de Chine, de tous temps, le chien a servi de sujet et de symbole dans le domaine des arts. Déjà des peintres comme Velázquez ou Le Titien le faisaient figurer dans leurs tableaux. Il faudra toutefois attendre le XIXᵉ siècle et les peintres de portraits, pour que s'exprime enfin l'amour de l'homme pour le chien, ainsi que la noblesse de cet animal. Hogarth, Gainsborough et Landseer montrèrent magistralement sa présence au sein de la famille. Une fois établie, la tradition n'avait plus qu'à continuer. Aujourd'hui, le chien apparaît comme un élément central dans les œuvres de nos plus grands artistes, de Picasso à Salle, de Monet à Fischl.

Les premiers photographes se donnèrent beaucoup de mal pour montrer le chien. Sur les premiers daguerréotypes, il apparaît dans les bras d'un adulte ou d'un enfant, par nécessité autant que par affection. A mesure que la technique progresse, le chien trouve enfin sa place aux côtés de l'homme. Par bonheur, la propagation de la photographie se trouva coïncider avec l'émancipation du chien et la fin de sa servitude féodale. Dès la moitié du XIXᵉ siècle, le *canis familiaris* et la *camera obscura* s'installèrent au sein du tissu familial. La photographie devint et demeura le prisme au travers duquel nous percevons notre monde. Dans la dernière partie du XIXᵉ siècle et tout au long du XXᵉ, l'appareil photo devient le témoin principal de notre affection sans borne pour le chien. Manuel Alvarez Bravo, un des meilleurs photographes mexicains, déclara un jour que, si toute sa vie se résumait à avoir pris en photo un millier de chiens, alors, il pourrait

mourir heureux. Pourquoi cet intérêt photographique ? Peut-être à cause de ce sens inné du chien pour la beauté, pour son absence d'affectation, et pour ce goût du bonheur qui continue de les lier l'un à l'autre.

Les images qui suivent nous racontent non seulement l'histoire de la photo, mais aussi l'évolution de la relation entre l'homme et le chien. D'ailleurs, nous n'avons pas sélectionné que le meilleur. Au contraire, nous avons tenté d'inclure le kitsch comme le beau, afin de mieux saisir la profondeur et l'ampleur de cette passion. Sans langue commune pour communiquer, l'homme et le chien sont forcés de se comprendre à travers les sentiments qu'ils entretiennent l'un pour l'autre. Et il y réussissent. Capable de réfléchir, le chien sait exprimer fierté, joie, sagesse, courage ou affection. Or, ce sont précisément ces émotions et ces qualités que ces photos, nous semble-t-il, ont réussi à immortaliser. On a dit autrefois que nos plus grands trésors étaient accrochés aux murs de nos musées, alors que d'autres se promenaient en toute liberté. Ici, vous verrez les deux. Il convient cependant de vous mettre en garde, comme le fit Gary Winogrand avec ses étudiants : « Méfiez-vous des tableaux de chiens et d'enfants, ils ne sont pas aussi fidèles que vous le croyez. » Alors, si malgré cela vous décidez de poursuivre, allez-y et profitez de ces beaux chiens !

Ylla, n.d.

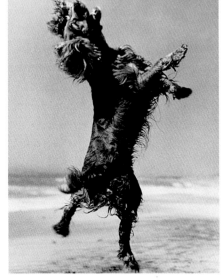

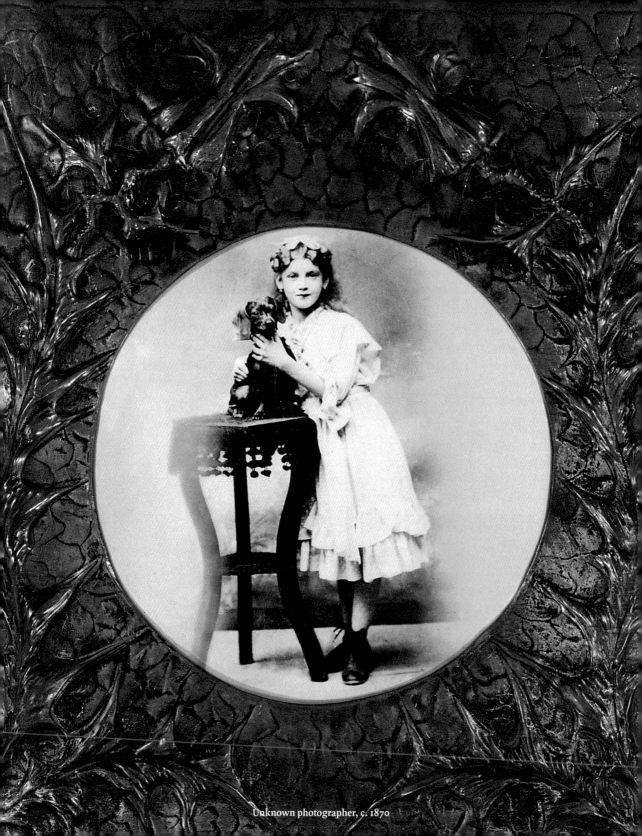

Unknown photographer, c. 1870

Catching the Sun – Seeing the Light
From Portraiture to Pictorialism

Der Sonne folgen – das Licht sehen
Vom Porträt zum Piktoralismus

Saisir le soleil – voir la lumière
Du portrait au pictorialisme

1839·1890

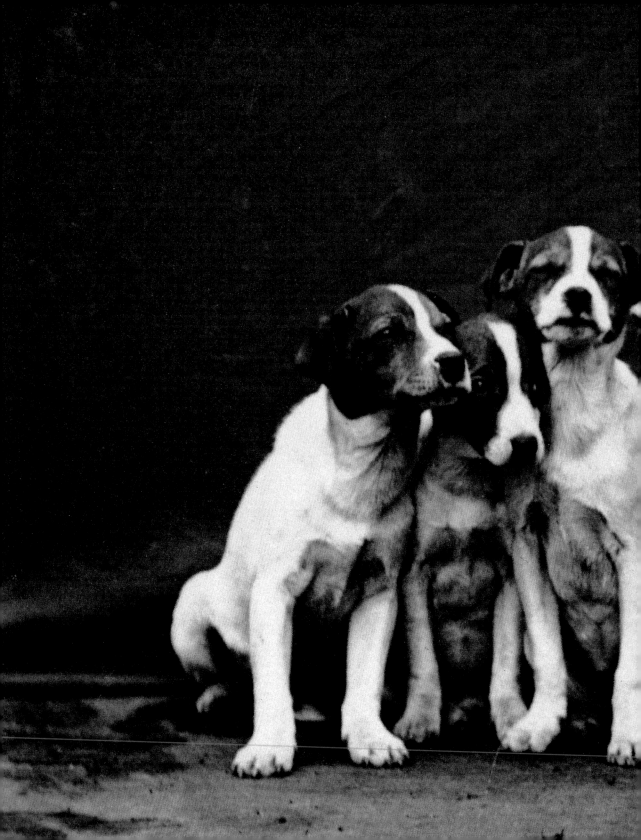

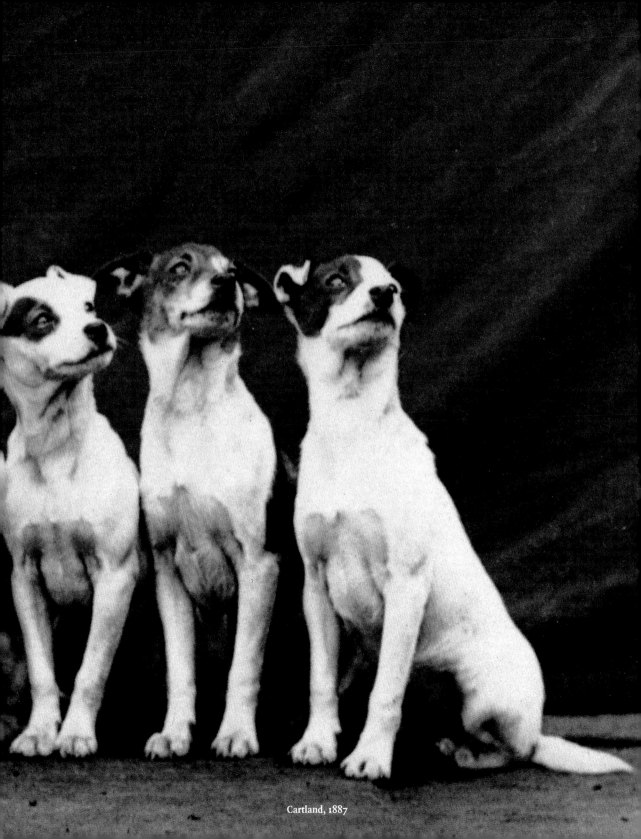

Cartland, 1887

W. Kurtz, c. 1870

Catching the Sun – Seeing the Light
From Portraiture to Pictorialism

The last half of the nineteenth century served as the gateway to the world we know today. Britain reigned as the most powerful nation in the world. At her helm stood a queen who, for the rest of the century, would guide her country to new heights of industrial power and colonial influence. Victoria set the standards that the world would follow, embracing the progress that would lead the world into the twentieth century. Her enthusiastic support of photography, combined with her love of dogs and advocacy of canine protection, earned her the title of patroness monarch of photography and dogs.

Political, technological, cultural, and humanitarian advances dominated the period. Progress was indeed in the air, and the advent of photography may well have been its single most significant catalyst. From the time of Aristotle, many had known that an image could be projected with the aid of the sun, but it took over two thousand years for anyone to be able to make that image permanent. In 1839, dual discoveries changed the world. The collaborative work of two Frenchmen, an artist, Louis-Jacques Mandé Daguerre, and a chemist, Joseph Nicéphore Niepce, culminated in the invention of a process by which light-induced images were fixed permanently on a plate – the "daguerreotype." At the same time, an Englishman, William Henry Fox Talbot, utilizing a different approach, was able, with the aid of light, to make unlimited paper positives from a single paper negative. These salt paper prints came to be called "talbotypes" or "calotypes." Talbot's process would prove to be the progenitor of modern photography. Despite the limitations of this new technology, photo graphia (light writing), was now possible. Thousands of artisans, calling themselves "daguerreotypists," began plying their trade at a point in history when communication was essentially limited to speech, letters, and art. Now, for the very first time in history, one's image could be captured inexpensively and held for others to see. "Catching the shadow 'ere the substance fade" became the photographer's motto. This apt phrase had its origin in Aesop's fable, *The Dog and His Shadow,* which recounts the story of a dog who, while bounding home with a choice bone, stops when he sees his reflection in a stream. Bending down greedily, he reaches for the reflected bone only to lose the real one – the shadow and the substance both vanish. At first, photography was a bit like Samuel Johnson's dog walking on its hind legs – astonishing not because it was done well, but because it was done at all.

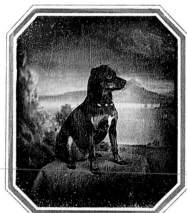

Carl Ferdinand Stelzner, c. 1850

Calotypes were gauzy and unclear and daguerreotypes, although quite precise, were exceedingly fragile. Each process required its subjects to remain still for uncomfortably long periods of time. Nevertheless, the photographic phenomenon captivated the world, filling a social vacuum. By 1850, an emerging middle class found at last the ability to obtain what theretofore had been available only to the aristocracy and the landed gentry. For the first time, ordinary people could obtain a visual record of themselves and their loved ones. Being memorialized on film involved more than vanity. It established an aura of wealth and social rank as well.

People now clamored to see things for themselves rather than envision them through other's words. Photography became the standard-bearer of truth and accuracy, enthralling even the most aesthetically sophisticated. Elizabeth Barrett Browning wrote in a letter to a friend, "the invention of the day, the daguerreotype … is the very sanctification of portraits. I would rather have such a memorial of one I dearly loved than the noblest artist's work ever produced."

Photography's popularity arrived at a propitious moment. The new process, requiring only a small outlay of money and very little training, attracted men hungry for opportunity. For the next three dec-

ades, in studios throughout the world, copper plates were burnished bright, plated with silver, exposed to iodine, chlorine, and bromine fumes and developed over molten mercury until an image emerged. Millions of rich and poor, exalted and humble, young and old faced a bulky wooden box camera, exchanging forty seconds of immobility for visual immortality. Well-adorned husband, wife, child, watch fob, pipe – and the family dog – became the photographic symbols of prosperity.

The daguerreotype process of image making eventually waned because of its limitations. It was a one-of-a-kind process, best suited for portraiture, and had only limited utility outside the studio. Daguerreotypes were easily marred, a defect which led to the need for, and the popularity of, embossed cases. Since daguerreotypes were, in most instances, produced by skilled technicians rather than artists, their variations and aesthetics were limited.

In 1850, albumen paper was introduced. The binding material, essentially egg whites mixed with salt, created a shiny paper with a surface that made possible significantly greater contrast. Additionally, new applications were developed. The most popular were "cartes-de-visites" and cabinet cards. These small, inexpensive, and easily duplicated images, originally

Mosely & Stoddard, Co., c. 1880

printed on gold-toned albumen paper from wet collodion negatives and later using a dry plate process, became the most plentifully surviving forms of nineteenth-century photography. Initially, they were exchanged among friends. Later, in a somewhat larger format, they were dubbed "cabinet cards," assembled into albums, and proudly displayed in homes. Another form of photography to gain popularity was the "tintype" (or ferrotype), a distinctively American invention, in which images were printed on sheet iron. Some credit the popularity of these metal imprints to the American Civil War, where soldiers found that they proved more durable than paper for mailing home before or after battle and that the sitting time was reduced to a few seconds. Finally came the stereograph – paired photographs taken with a twin-lens camera. Seen through a stereoscope, they introduced the user to a three-dimensional view of the world. Stereography viewing became a significant learning tool, exposing the masses to a new world beyond their personal realm, and a vastly popular form of home entertainment – the nineteenth-century prequel to television.

Because of the slow response of light-sensitive materials in the 1840s, animals, particularly dogs, were not preferred subjects of photographers. A wag of the tail, a turn of the head, and the image was ruined. Talbot's 1845 image of a canine gravemarker is believed to be the first dog-related photograph. His brother-in-law, Nicolas Henneman, captured Elizabeth Barrett Browning's dog sleeping in what may be the earliest live canine photograph. Public pressure to memorialize pets forced photographers to keep experimenting until finally, in the last quarter of the century, the photographic process advanced sufficiently to meet customer demand. Dogs joined their mistresses and masters before the camera, and often got to pose by themselves, perched on stools or seated on luxurious pillows, frequently with fanciful human props. The well-groomed and well-bred dog signified prosperity, underscored status, and epitomized good taste. Those images that have survived serve as unique testaments to the customs and mores of the times.

During this same period, the status of the dog was marked by a stark dichotomy. The domestication of dogs was considered man's most useful animal conquest, consistent with the Victorian tenet that a good creature was one that could be induced to serve or amuse man. And serve they did. For the working class, canines proved to be their most efficient helpers. Small dogs were trained to turn spits, churn butter, and press cider, while larger dogs hauled wagons, transporting both cargo and people. They were the perfect serfs, working tirelessly without pay and without complaint, sustained only by the leftovers of human consumption. The problem,

however, was exploitation. Kept toiling without adequate sustenance or water, turnspits and trek-hounds often died prematurely – overworked, under-fed and abused.

At the other end of the spectrum was the *chien de fantaisie*. Following the lead of the aristocracy, the bourgeoisie made the family dog a cliché of modern life. Middle-class aspirations of affluence fueled demand for "aristocratic" animal companions to help compensate for a human lack of "good breed-ing." The well-bred dog was also there to amuse. Relieving the monotony, and perhaps the pressures of everyday living, the family dog, particularly throughout Europe, permitted middle-class families to emulate the rich. They imbued their pets with human and toy-like qualities, often adorning them with elaborate coiffures and clothing – silk skirts, embroidered cloaks, and elaborate collars – leading some to consider this period the "Golden Age of Lap Dogs."

This contradiction in treatment had to be brought to an end. Victoria made her advocacy of canine-protection organizations wellknown, and she devoted her energy

and prestige to these efforts. Turnspits and trek-hounds, a canine slave class, found their artistic champion in the Queen's close friend, Sir Edwin Landseer, who, along with Hogarth, became one of the most prominent dog painters in history. Land-seer's art breathed life into his subjects, showing canine emotions that tugged at the viewer's heart and conscience. It underscored the differences between working dogs and house pets, and its popu-larity helped make exploitation of, and cruelty to, animals unacceptable human behavior. Eighteen thirty-nine not only welcomed the *camera obscura* but also saw the passage of England's first Dog Cart Nuisance Law, which over the next quarter-century was progressively strengthened until it included a nationwide banning of dog carts. Inspired by the British ban, America, with considerable reluc-tance, and continental Europe followed suit. By the end of the century, aided principally by the example and efforts of Queen Victoria as well as by the increasing availability of mechanized equipment, the "underdog" was finally eman-cipated. Mankind had taken a major step in broadening the embrace of humanity.

Moore Bros., 1862

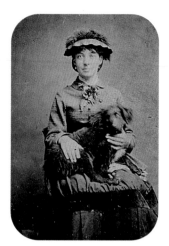

Matthew Brady Studio, c. 1870

1839·1890
Der Sonne folgen – das Licht sehen
Vom Porträt zum Piktoralismus

In der zweiten Hälfte des 19. Jahrhunderts vollzog sich der Übergang zu unserer modernen Welt. Großbritannien war die größte Weltmacht, regiert von einer Königin, die ihr Land bis zur Jahrhundertwende als Industrie- und Kolonialmacht zu noch größerer Blüte führen sollte. Die Maßstäbe denen die Welt folgte, legte Viktoria fest, indem sie sich dem Fortschritt öffnete, der die Welt ins 20. Jahrhundert führte. Ihre begeisterte Förderung der Fotografie sowie ihre Liebe zu Hunden und ihr Eintreten für den Hundeschutz brachten ihr den Beinamen „Königliche Schirmherrin der Fotografie und der Hunde" ein.

Die Zeit stand im Zeichen politischer, technologischer, kultureller und humanitärer Fortschritte. Der Fortschritt lag in der Luft, und möglicherweise war die Erfindung der Fotografie sein wichtigster Katalysator. Seit Aristoteles wusste man, dass ein Bild mit Hilfe des Lichts projiziert werden kann, doch es dauerte über zweitausend Jahre, bis es gelang, dieses Bild dauerhaft festzuhalten. 1839 veränderten zwei Erfindungen die Welt. Die Gemeinschaftsarbeit zweier Franzosen – von Louis-Jacques Mandé Daguerre, einem Künstler, und Joseph Nicéphore Niépce, einem Chemiker – gipfelte in der Erfindung eines Verfahrens, durch das mit Licht erzeugte Bilder dauerhaft auf einer Platte festgehalten werden konnten – die Daguerreotypie war geboren. Zur selben Zeit gelang es einem Engländer, William Fox Talbot, mittels einer anderen Methode von einem einzigen Papiernegativ mit Hilfe des Lichts unbegrenzt viele Papierpositive herzustellen. Diese Papierabzüge wurden „Talbotypien" oder „Kalotypien" genannt. Das Verfahren Talbots sollte zum Vorläufer der modernen Fotografie werden. Trotz der Beschränkungen dieser neuen Technologie war die *photo graphia*, das Schreiben mit Licht, jetzt möglich. Tausende so genannter Daguerreotypisten übten ihr Gewerbe zu einer Zeit aus, als sich die Kommunikation im Wesentlichen auf Sprechen, Lesen und künstlerische Darstellung beschränkte. Zum ersten Mal in der Geschichte war es nun möglich, für wenig Geld ein Bild von sich selbst erstellen zu lassen, das alle sehen konnten. „Das Spiegelbild einfangen, bevor der Gegenstand verschwindet", wurde zum Motto der Fotografen. Dieser treffende Satz hatte seinen Ursprung in der Äsopschen Fabel *Der Hund und sein Spiegelbild*. Sie erzählt die Geschichte eines Hundes, der mit einem Knochen auf dem Heimweg ist und innehält, als er sein Spiegelbild in einem Fluss sieht. Gierig beugt er

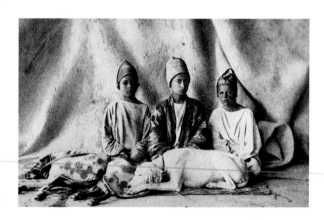

A. S. Murenko, 1858

J. C. Brown, 1865

sich hinunter, um sich den gespiegelten Knochen zu holen, und verliert dabei den echten – beide, das Objekt und sein Abbild, verschwinden.

Zu Anfang glich die Fotografie Samuel Johnsons Hund, der auf den Hinterbeinen ging: Er wurde bewundert, nicht weil er es gut machte, sondern weil er es überhaupt tat. Kalotypien waren wenig brillant und unscharf, Daguerreotypien waren zwar recht scharf, aber äußerst empfindlich. Bei beiden Verfahren mussten die „Motive" eine unangenehm lange Zeit still halten. Dennoch eroberte das Phänomen Fotografie die Welt, füllte es doch ein soziales Vakuum. 1850 hatte eine aufstrebende Mittelschicht die Möglichkeit, etwas zu bekommen, das sich bislang nur der Hoch- und Landadel hatten leisten können: Zum ersten Mal war es gewöhnlichen Leuten möglich, ein Abbild ihrer selbst und ihrer Lieben zu erwerben. Für die Nachwelt auf Film festgehalten zu sein, war mehr als bloße Befriedigung der Eitelkeit, sondern zeugte von Wohlstand und sozialem Ansehen.

Alle wollten die Dinge jetzt mit eigenen Augen sehen, anstatt sich nach den Worten anderer ein Bild davon machen zu müssen. Die Fotografie wurde zum Fahnenträger von Wahrheit und Genauigkeit und erfüllte selbst höchste ästhetische Ansprüche. Elizabeth Barrett Browning schrieb in einem Brief an einen Freund: „... die größte Erfindung der letzten Zeit, die Daguerreotypie, ... ist die hohe Schule der Porträtkunst. Eine solche Erinnerung an einen geliebten Menschen ist mir lieber als das edelste Kunstwerk, das je geschaffen wurde."

Die Popularität der Fotografie stellte sich zu einem günstigen Zeitpunkt ein. Das neue Verfahren, das nur geringe Kosten verursachte und kaum Übung erforderte, zog Menschen an, die nur auf ihre Chance gewartet hatten. In den folgenden drei Jahrzehnten wurden in Studios auf der ganzen Welt Kupferplatten blank poliert, versilbert, Jod-, Chlor- und Bromdämpfen ausgesetzt und unter verdampfendem Quecksilber entwickelt, bis ein Bild erschien. Millionen von Menschen, arme wie reiche, stolze wie bescheidene, junge wie alte, schauten in die Linse einer sperrigen Holzkiste und tauschten vierzig Sekunden Reglosigkeit gegen bildliche Unsterblichkeit ein. Geliebte Ehemänner und -frauen, Kinder, Taschenuhren und Pfeifen – und der Familienhund – wurden zu fotografischen Symbolen des Wohlstands.

Das Verfahren der Daguerreotypie zur Bilderstellung war aufgrund seiner Beschränkung bald

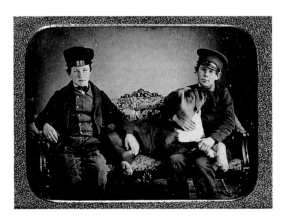

Unknown photographer, 1845

S. Prince, c. 1860

überholt. Es lieferte nicht repro-
duzierbare Einzelaufnahmen und
eignete sich zwar bestens für
Porträts, war außerhalb des Stu-
dios jedoch nur beschränkt ein-
setzbar. Daguerreotypien bekamen leicht Kratzer,
ein Nachteil, der gefütterte Klappetuis notwendig
und beliebt machte. Da die Daguerreotypien in den
meisten Fällen von erfahrenen Technikern und we-
niger von Künstlern angefertigt wurden, variierten
sie kaum, und auch die ästhetischen Möglichkeiten
waren begrenzt.

1850 wurde Albuminpapier eingeführt. Das
Bindemittel, in erster Linie Hühnereiweiß, ver-
mischt mit Jod-, Chlor- oder Bromsalzen, ließ ein
glänzendes Papier entstehen, dessen Oberfläche
bedeutend größere Kontraste möglich machte.
Außerdem entdeckte man neue Anwendungsgebiete
der Fotografie. Die populärsten waren die Visiten-
kartenfotos, „cartes-de-visites", und Kabinettfotos,
„cabinet cards". Die kleinen, billigen und leicht zu
vervielfältigenden Visitenkartenfotos, ursprünglich
vom nassen Kollodium-Negativ auf goldgetöntes
Albuminpapier abgezogen (später ging man auf ein
Verfahren mit Trockenplatten über), sind die in

größter Zahl erhaltenen Zeug-
nisse der Fotografie des 19. Jahr-
hunderts. Anfangs tauschte man
sie unter Freunden aus. Später
gab es die etwas größeren Kabi-
nettkarten, die in Alben gesteckt oder stolz zu Hause
zur Schau gestellt wurden. Ein anderes fotografi-
sches Verfahren, das es zu Popularität brachte, war
die Ferrotypie, eine unverkennbar amerikanische
Erfindung, bei der die Bilder auf beschichtete Weiß-
blechstücke abgezogen wurden. Die Popularität
dieser Metallbilder wird gelegentlich dem Amerika-
nischen Bürgerkrieg zugeschrieben, da die Soldaten
feststellten, dass sie, wenn sie sie vor oder nach
einer Schlacht nach Hause schickten, nicht so leicht
beschädigt wurden wie Papierbilder, und dass die
Aufnahme selbst nur noch wenige Sekunden dauer-
te. Schließlich kam die Stereofotografie – Bildpaare,
die mit einer Kamera mit zwei Objektiven aufgenom-
men wurden. Betrachtete man die im Augenabstand
aufgenommenen Fotos durch ein Stereoskop, boten
sie dem Beschauer ein dreidimensionales Bild. Sol-
che Stereokarten wurden zu einem wichtigen Lern-
instrument, das den Massen eine neue Welt außer-
halb ihrer direkten Umgebung eröffnete, und eine
äußerst beliebte Form der Unterhaltung in den eige-
nen vier Wänden – im 19. Jahrhundert das Pendant
zum Fernseher.

Da in den 1840er Jahren das lichtempfindliche
Material noch sehr langsam reagierte, zählten Tiere,
und besonders Hunde, nicht gerade zu den Lieb-

John P. Soule, c. 1880

lingsmotiven der Fotografen.
Ein Schwanzwedeln oder eine
Drehung des Kopfes und man konnte
das Bild vergessen. Man geht davon aus, dass
Talbots Aufnahme aus dem Jahr 1845 von einem
Hundegrabstein die erste Fotografie im Zusammen-
hang mit einem Hund ist. Sein Schwager, Nicolas
Henneman, machte eine Aufnahme von Elizabeth
Barrett Brownings schlafendem Hund, möglicher-
weise die erste, auf der ein lebendiger Hund zu
sehen ist. Der Druck der Öffentlichkeit, die auch
Haustiere verewigt haben wollte, zwang die Fotogra-
fen zum permanenten Experimentieren, bis schließ-
lich im letzten Viertel des Jahrhunderts die Fotogra-
fie so weit fortgeschritten war, dass dem Wunsch der
Kunden entsprochen werden konnte. Hunde beglei-
teten ihre Besitzer vor die Kamera, posierten aber oft
auch allein, auf Hockern oder kostbaren Kissen, und
häufig umgeben von abstrusen Requisiten ihrer
Besitzer. Ein gut gepflegter und gut erzogener Hund
bedeutete Wohlstand, unterstrich den gesellschaftli-
chen Status und verkörperte guten Geschmack.
Bilder, die uns aus dieser Zeit erhalten sind, spiegeln
auf einzigartige Weise die damals herrschenden
Sitten und Gebräuche wider.

Der Status des Hundes zu jener Zeit war von
krassen Gegensätzen gekennzeichnet. Seine Domes-
tikation wurde als die für den Menschen nützlichste
Zähmung eines Tieres angesehen, entsprechend der
viktorianischen Doktrin, dass ein gutes Tier eines
sei, das man dazu bringen könne, dem Menschen zu
dienen oder ihn zu erfreuen. Sie
dienten ihm fraglos. Hunde stell-
ten sich als die effizientesten Helfer
der arbeitenden Bevölkerung heraus: Kleine
Hunde wurden darauf dressiert, Bratenspieße zu
drehen, Butter zu machen und Most zu pressen,
während größere Hunde Wagen zogen und Güter
wie Menschen transportierten. Sie waren perfekte
Bedienstete, arbeiteten unermüdlich ohne Lohn und
ohne zu klagen und ernährten sich lediglich von
dem, was vom Tisch ihrer Herren abfiel. Ohne ange-
messenes Futter oder ausreichend Wasser starben
Bratenspießdreher und Wagenzieher oft vor der Zeit,
überarbeitet, unterernährt und misshandelt.

Am anderen Ende des Spektrums stand der
chien de fantaisie, das Schoßhündchen. Nach dem
Vorbild der Aristokratie machte die Bourgeoisie den
Haushund zum Sinnbild des modernen Lebens.
Das Streben des Mittelstandes nach Reichtum nährte
den Wunsch nach „aristokratischen" Tiergefährten
als Ausgleich für den eigenen Mangel an „guter
Erziehung". Der gut erzogene Hund war auch

Unknown photographers, c. 1880

29

zur Unterhaltung da. Vor allem in Europa linderte der Haushund die Monotonie und vielleicht auch den Druck des Alltags und erlaubte es den Familien der Mittelschicht, den Reichen nachzueifern. Sie sprachen ihren Haustieren menschliche Eigenschaften zu oder behandelten sie als Spielzeug, trimmten sie kunstvoll und putzten sie mit seidenen Röckchen, bestickten Umhängen und kunstvollen Kragen heraus, was dazu führte, dass einige diese Zeit als das goldene Zeitalter der Schoßhunde ansehen.

Die extrem unterschiedliche Behandlung der Hunde musste ein Ende haben. Königin Viktoria ließ der Allgemeinheit bekannt werden, dass sie die Hundeschutzorganisationen unterstützte, und sie setzte ihre Energie und ihr Ansehen für deren Bemühungen ein. Arbeitshunde, die Sklaven unter den Hunden, fanden ihren künstlerischen Meister in einem engen Freund der Königin, Sir Edwin Landseer, neben Hogarth einer der berühmtesten Hundemaler der Geschichte. Landseers Kunst ließ seine Modelle lebendig erscheinen und zeigte Emotionen der Tiere,

die dem Betrachter an Herz und Gewissen rührten. Er strich den Unterschied zwischen Arbeitshunden und Familienhunden heraus, und seine Popularität trug dazu bei, dass Ausbeutung und Misshandlung von Tieren bald als inakzeptables menschliches Verhalten angesehen wurden. Das Jahr 1839 begrüßte nicht nur die *Camera obscura*, sondern auch die Verabschiedung von Englands erstem *Dog Cart Nuisance Law*, einem Gesetz zum Schutz der Wagenhunde, das in den folgenden fünfundzwanzig Jahren schrittweise verschärft wurde, bis ein landesweites Verbot von Hundewagen erlassen wurde. Das britische Verbot machte in Amerika – gegen beträchtlichen Widerstand – und im kontinentalen Europa Schule. Bis zum Ende des Jahrhunderts war der „Underdog", in erster Linie dank des guten Beispiels und der Bemühungen von Königin Viktoria wie auch der wachsenden Verfügbarkeit von Maschinen, schließlich frei. Die Menschheit war in Sachen Menschlichkeit einen großen Schritt vorangekommen.

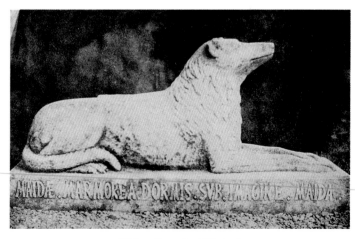

William Henry Fox Talbot, 1845

1839·1890
Saisir le soleil – voir la lumière
Du portrait au pictorialisme

Unknown photographer, c. 1863

La seconde moitié du XIX^e siècle a ouvert la voie sur notre monde actuel. L'Angleterre règne. C'est la nation la plus puissante du monde. A la barre, navigue une souveraine qui allait, jusqu'à la fin du siècle, mener son pays vers les sommets de la puissance industrielle et coloniale. Victoria créa les modèles que le monde allait imiter, intégrant les progrès qui allaient engager notre monde dans le XX^e siècle. Son enthousiasme pour la photographie et son amour des chiens, lui valurent le titre de patronne de la photographie et des chiens.

Ce fut l'époque des avancées politiques, technologiques, culturelles et humanitaires. Le progrès était partout dans l'air et l'avènement de la photographie pourrait bien s'inscrire comme son catalyseur le plus significatif. On savait depuis Aristote que l'image pouvait être projetée par le soleil. Mais il fallut plus de deux mille ans pour réussir à ce que cette image devienne permanente. En 1839, deux découvertes vinrent changer le monde. Les recherches de deux Français, Louis-Jacques Mandé Daguerre et Joseph Nicéphore Niepce, aboutirent à l'invention d'un procédé par lequel des images produites par la lumière sont fixées sur une plaque et de manière permanente. Le « daguerréotype » vient d'être découvert. Au même moment, et par une approche différente, l'Anglais William Henry Fox Talbot, parvient, à l'aide de la lumière, à reproduire sur papier et à

partir d'un seul négatif, des positifs en nombre illimité. Ces tirages seront désormais désignés sous le nom de « talbotypes » ou « calotypes. » C'est le procédé de Talbot qui donnera naissance à la photographie moderne. Malgré les limites de cette nouvelle technique, la « photo graphia » (graphie par la lumière) venait d'être inventée. Des milliers d'artisans, se nommant « daguerréotypistes, » se mirent à exercer cet art à une époque où la communication se limitait essentiellement à la parole, aux arts et aux lettres. Ainsi, pour la première fois dans l'histoire, une image pouvait être immortalisée à peu de frais et montrée à tous. « Saisir l'ombre avant que sa substance ne s'efface », telle fut la devise des photographes. Cette heureuse expression se réfère à la fable d'Esope : *Le chien et son ombre*. C'est l'histoire d'un chien qui, alors qu'il rentre au logis en gambadant, avec un os bien garni, s'immobilise en voyant son reflet dans un ruisseau. Il se penche, alléché, et tente de s'emparer du reflet de son os. Alors il perd le vrai, donc l'ombre et sa substance, toutes deux disparaissent. A ses débuts, la photographie ressemblait au chien de Samuel Johnson avançant sur ses pattes arrière. L'étonnant n'étant pas qu'il le fît bien, mais qu'il le fît, tout simplement. Les calotypes étaient flous et imprécis,

Unknown photographer, c. 1861

31

tandis que les daguerréotypes, plus nets, étaient extraordinairement fragiles. Chacun des procédés exigeait que le sujet reste immobile pendant un temps interminable. Pourtant le phénomène photographique s'empara du monde, et remplit un vide social. Aux environs de 1850, la classe moyenne, en pleine émergence, put enfin disposer de ce qui, jusque-là, avait été réservé à l'aristocratie de cour et la bourgeoisie de terre. Pour la première fois, des gens du commun pouvaient s'offrir une représentation visuelle de leur personne et de leur famille. Etre immortalisé sur pellicule, c'était bien davantage que simple vanité. C'était obtenir à la fois une auréole de richesse et une place dans la société.

Alors les gens exigèrent de voir par eux-mêmes au lieu de percevoir à travers les paroles d'autrui. La photographie devint le « porte-drapeau » même de la vérité et de la précision. Dans une lettre, Elizabeth Barrett Browning écrit : « L'invention du jour, le daguerréotype... c'est la sanctification même du portrait. Je préférerais, quant à moi, posséder ce type de souvenir d'une personne chère, plutôt que la plus noble des œuvres d'art produite par un artiste. »

La popularité de la photographie prit son essor à un moment propice. Le nouveau procédé ne nécessitant qu'une petite mise de fonds et très peu d'apprentissage, il attira les esprits entreprenants. Pendant les trente années qui suivirent, dans tous les studios du monde, des plaques de cuivre furent noircies par la lumière, recouvertes d'argent, exposées à l'iodine, au chlore et aux fumées de bromure, puis développées au mercure fondu, jusqu'à ce que l'image apparaisse. Des millions d'hommes, riches ou pauvres, humbles ou exaltés, jeunes ou vieux, s'installèrent face à une grosse boîte en bois, troquant quarante secondes d'immobilité contre une image immortelle. Maris avec épouses et enfants, sur leur trente et un, affublés de leur pipe et de la montre de leur gousset, sans oublier le chien de la famille, devinrent, en photo, le symbole de la prospérité.

Le daguerréotype finit par disparaître à cause de ses propres limites. Ce procédé à fonction unique, convenant surtout au portrait, avait une utilité restreinte hors studio. Se dégradant facilement, il devait être protégé dans des coffrets gravés qui connurent une certaine popularité. Davantage produit par des techniciens qualifiés que par des artistes, il n'offrait que peu de possibilités d'évolution et de recherche esthétique.

En 1850, on vit apparaître le papier albuminé. Le produit liant, essentiellement du blanc d'œuf mélangé à du sel, produisait un papier brillant dont la surface permettait des contrastes nettement plus

Giorgio Sommer, 1870

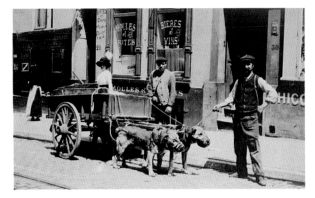

Alphonse J. Liebert, c. 1870

marqués. Parallèlement, on vit se développer de nouvelles applications dont les plus connues furent les « cartes-de-visite » et les « cartes de cabinet ». Ces images de petit format, peu coûteuses et facilement reproduites, étaient à l'origine imprimées sur du papier albuminé, en tons dorés, à partir de négatifs au collodion humide. Plus tard, par un procédé de plaques sèches, elles prirent les formes connues de la photographie du XIXe siècle. Au début, on se les échangeait entre amis. Plus tard, dans un format quelque peu agrandi, elles prirent le nom de « carte de cabinet », furent rassemblées en albums et fièrement montrées chez soi. Autre forme de photographie à connaître le succès : le ferrotype, invention typiquement américaine dont les images étaient imprimées sur plaques de fer. Pour certains, le succès de ces impressions sur métal remonterait à la Guerre de Sécession, quand les soldats découvrirent qu'elles étaient plus résistantes que le papier pour les envoyer à leur famille, avant ou après la bataille, et ne nécessitaient qu'un temps de pose de quelques secondes. Enfin vint le stéréogramme, photos doubles, prises avec un double objectif. Vues au stéréoscope, elles offraient au spectateur une vision du monde en trois dimensions. Ce procédé devint un important moyen éducatif, proposant à tous un univers au-delà du quotidien, et une forme de divertissement familial très répandue, l'ancêtre de notre télévision.

Vers 1840, compte tenu de la lenteur de réaction à la lumière des matériaux sensibles, les animaux, et en particulier les chiens, ne constituaient guère le sujet favori des photographes. Une queue qui frétille, une tête qui bouge, et la prise était fichue. L'image de Talbot montrant un canin et datant de 1845, semble être la première de ce type. Son beau-frère, Nicolas Henneman, fixa le chien d'Elizabeth Barrett Browning pendant son sommeil, en ce qui pourrait bien être la première photographie de chien vivant. La demande du public pour immortaliser les animaux familiers, força les photographes à poursuivre leurs expérimentations jusqu'à ce qu'enfin, dans le dernier quart du siècle, le processus photographique ait suffisamment progressé pour répondre à ce besoin. Les chiens furent placés aux côtés de leur maître ou de leur maîtresse, face à l'objectif, ou même tout seuls, perchés sur un tabouret ou installés sur de luxueux coussins, souvent avec des accessoires de fantaisie. Le chien, soigneusement peigné et attifé, devint signe de prospérité, de rang social élevé et de bon goût. Ces images demeurent un témoignage unique des us et coutumes de l'époque.

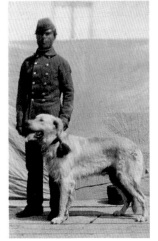

Au cours de cette même période, le statut du chien fut marqué par une forte dichotomie. La domestication était considérée

Pascal Sébah, c. 1870

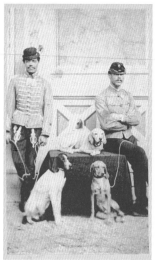

comme la conquête animale la plus utile, en accord avec la croyance victorienne selon lequel un bon animal était celui que l'on pouvait amener à servir ou à amuser l'homme. Servir, c'était peu dire. Pour la classe ouvrière, le chien s'avéra être une aide formidable. On entraîna les petites races à tourner la broche, à battre le beurre et à presser le cidre. Pour les plus gros, on les força à tirer les charrettes, à transporter gens et marchandises. Ils furent des serfs parfaits, travaillant sans relâche, sans être payés et sans jamais se plaindre, se contentant pour survivre des restes alimentaires de l'homme. Toutefois, ils furent pour le moins surexploités. Astreints au travail sans nourriture ni eau suffisantes, ces tourneurs de broches et ces traîneurs de charrettes mourraient souvent de façon prématurée – à bout de force, maltraités et sous-alimentés.

A l'autre bout de la chaîne, il y avait le chien de fantaisie. A l'exemple de l'aristocratie, la bourgeoisie érigea son chien de famille en symbole de modernisme. Alors la classe moyenne montante afficha son désir d'animaux de compagnie « aristocratiques », pour compenser le manque de « bonne éducation » chez les humains. Le chien bien élevé avait aussi pour mission d'amuser. Contre la monotonie et les contraintes du quotidien, rien de tel que le chien de famille, surtout en Europe, pour permettre à la petite-bourgeoisie d'imiter les riches. Ils dotèrent leur petites bêtes de qualités humaines, les transformant en jouets, les affublèrent souvent de coiffures et de vêtements élaborés – jupes de soie, manteaux brodés, cols empesés – ce qui fit que certains décrivirent cette période comme « l'âge d'or du chien d'appartement ».

Il fallait que fin soit mise à une telle inégalité de traitements. La reine Victoria soutint ouvertement des organisations de protection canine. Elle y consacra son énergie et son prestige. Dans le domaine des arts, les tourneurs de broche et les tireurs de charrettes, véritables esclaves canins, trouvèrent un éloquent défenseur en la personne de Sir Edwin Landseer, proche ami de la reine. De même que Hogarth, il s'imposa comme l'un des peintres de chiens les plus remarquables de tous les temps. Il sut insuffler la vie à ses sujets, montrer chez les chiens leurs émotions, toucher le cœur et la conscience du spectateur. Landseer souligna les différences entre chiens de labeur et chiens d'appartement, et se servit de son art pour dénoncer l'exploitation et la cruauté dont ils étaient victimes. L'année 1839 fut non seulement celle de la *camera obscura*, mais aussi celle de la première loi anglaise contre l'utilisation des chiens de trait. Au cours des vingt-cinq années suivantes, cette loi allait être renforcée, pour aboutir à une interdiction totale dans le pays. S'inspirant de l'exemple anglais, l'Amérique, non sans réticences, puis l'Europe entière, suivirent. A la fin du siècle, essentiellement grâce aux efforts de la Reine et aux progrès de la mécanisation, le prolétariat canin finit par s'émanciper. Le genre humain franchissait ainsi un pas décisif dans l'élargissement de l'humanisme.

The most transitory of things, a shadow, the proverbial emblem of all that is fleeting and momentary, may be fettered by the spells of our "natural magic" and may be fixed forever in the position which it seemed only destined for a single instant to occupy.

Das Vergänglichste aller Dinge, der Schatten, das sprichwörtliche Symbol alles Flüchtigen und Vorübergehenden, kann durch unsere „natürliche Magie" in den Bann geschlagen und für immer in der Position festgehalten werden, die einzunehmen ihm doch nur einen einzigen Augenblick lang bestimmt war.

L'ombre, ce qu'il y a de plus fugitif, emblème proverbial de tout ce qui est insaisissable et passager, peut être entravée par les charmes de notre « magie naturelle » et fixée à tout jamais dans la position qu'elle semblait destinée à n'occuper qu'un bref instant.

WILLIAM HENRY FOX TALBOT

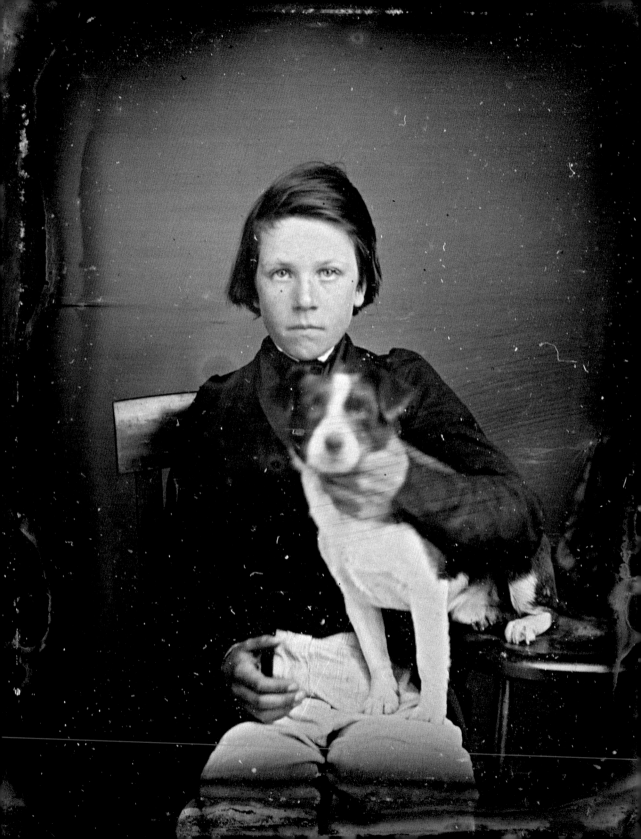

Albert Sands Southworth and Josiah J. Hawes, 1852

Unknown photographer, 1860

Charles D. Frederick, 1860

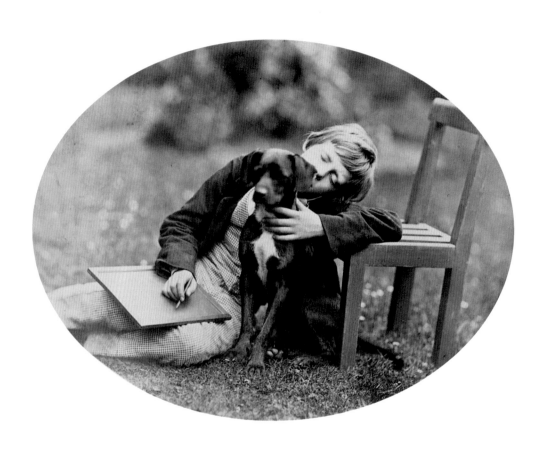

Lewis Carroll (Charles Dodgson), 1857

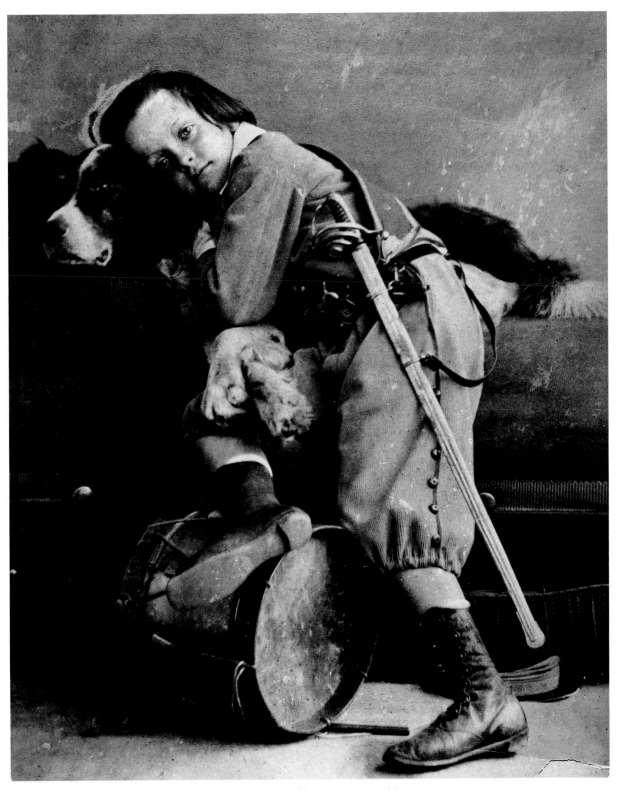

I think I could turn and live with animals,
they are so placid and self-contained.
Not one is dissatisfied, not one is demented
with the mania of owning things.

Ich glaube, ich könnte auch mit Tieren leben,
sie sind so gelassen und in sich ruhend.
Keines ist unzufrieden,
keines ist beherrscht von dem Drang,
Dinge zu besitzen.

Je pense que je pourrais vivre complètement
avec les animaux.
Ils sont si placides et réservés.
Pas un n'est insatisfait, pas un n'est dérangé
par cette obsession à posséder les choses.

WALT WHITMAN

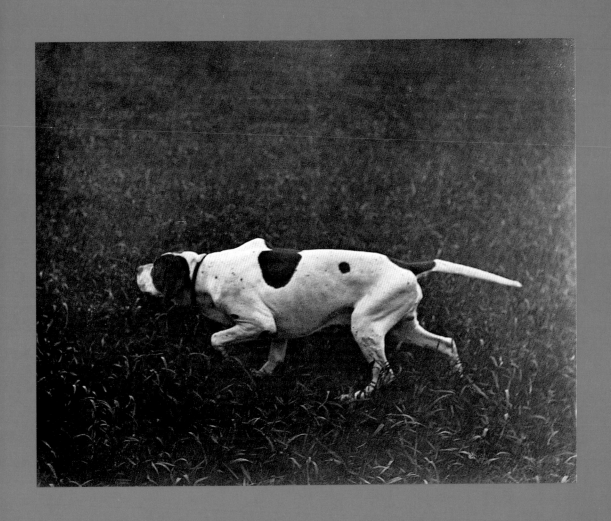

Adolphe Braun, c. 1870

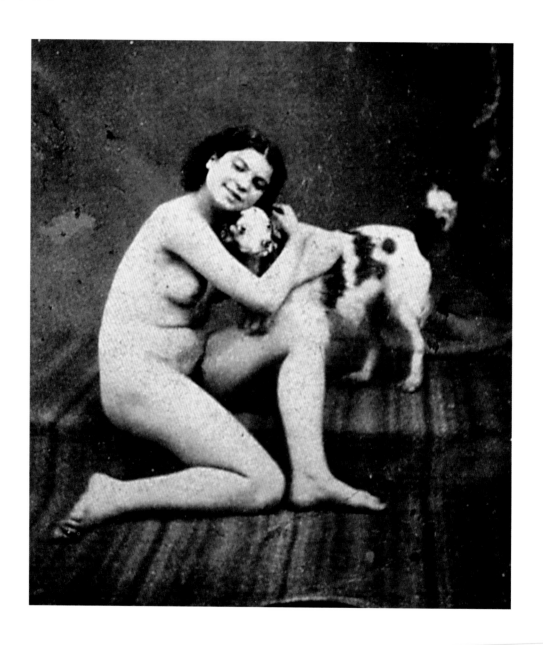

Louis-Camille d'Olivier, 1857

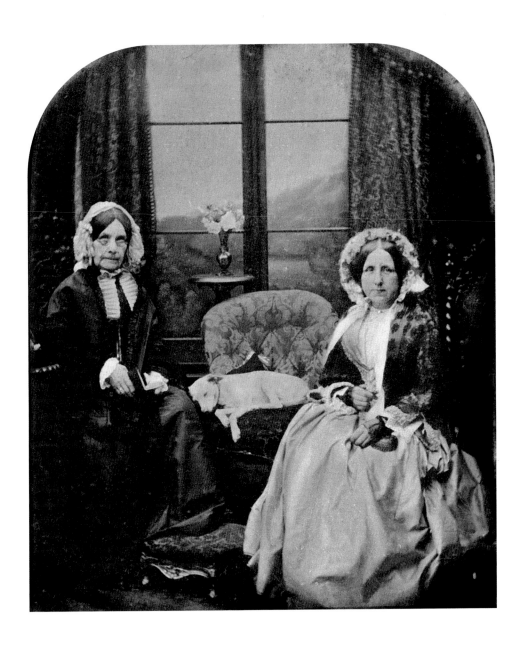

André-Adolphe-Eugène Disdéri, c. 1845

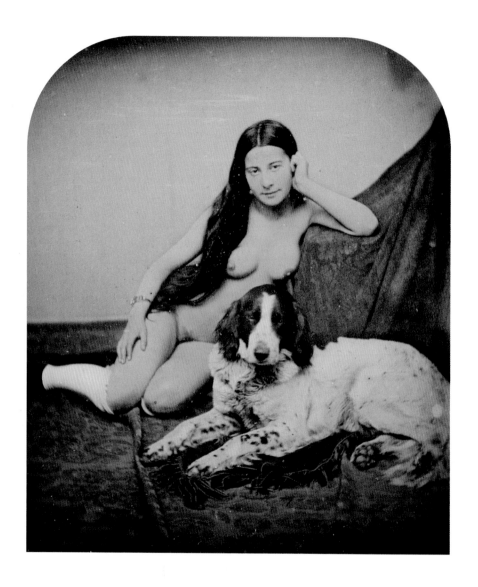

Antoine Claudet, c. 1845

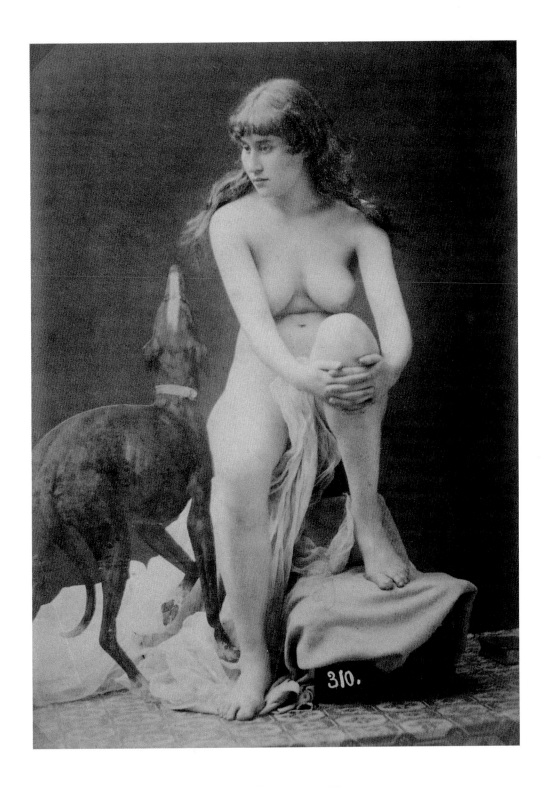

Unknown photographer, c. 1860

47

My little dog –
a heartbeat at my feet.

Mein kleiner Hund –
ein Herzschlag zu meinen Füßen.

Mon petit chien –
un battement de cœur
à mes pieds.

EDITH WHARTON

Unknown photographer, 1870

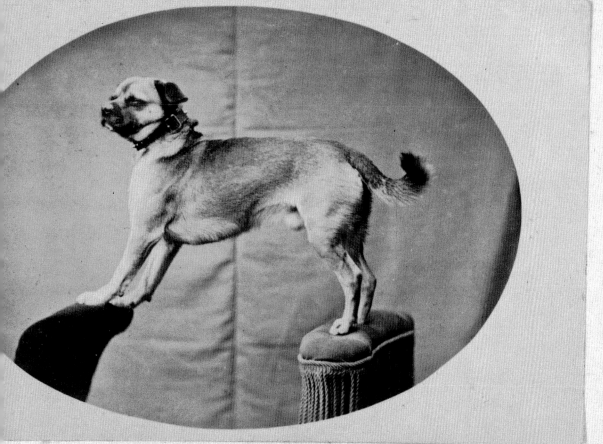

Bijou.

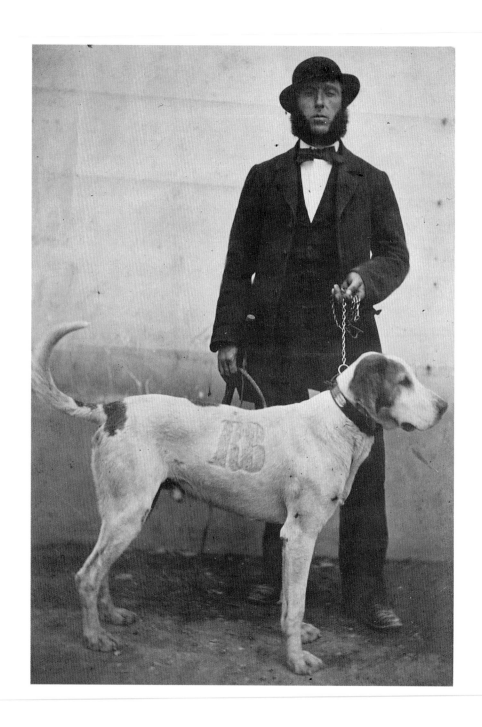

Henry Tournier, 1863

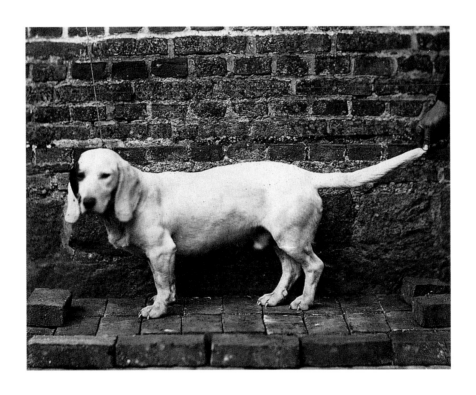

Henry Tournier, 1865

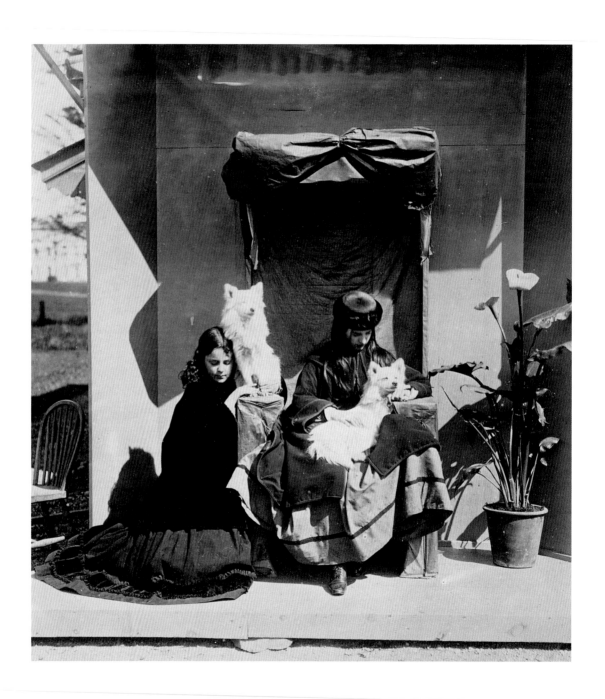

Clementina, Lady Hawarden, c. 1859

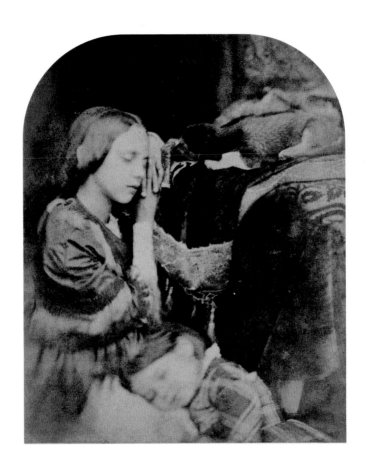

David Octavius Hill and Robert Adamson, c. 1845

No civilization is complete when it does not include
the dumb and the defenseless of God's creatures
within the sphere of charity and mercy.

QUEEN VICTORIA

Eine Zivilisation wird ihrem Namen nicht gerecht, wenn sie nicht
die stummen und die schutzlosen unter Gottes Kreaturen
in Güte und Barmherzigkeit einschließt.

KÖNIGIN VIKTORIA

Une civilisation ne peut être digne de ce nom si,
parmi les créatures de Dieu, elle n'inclut pas le faible
et l'imbécile dans sa sphère de charité et de miséricorde.

LA REINE VICTORIA

Hills & Saunders, c. 1870

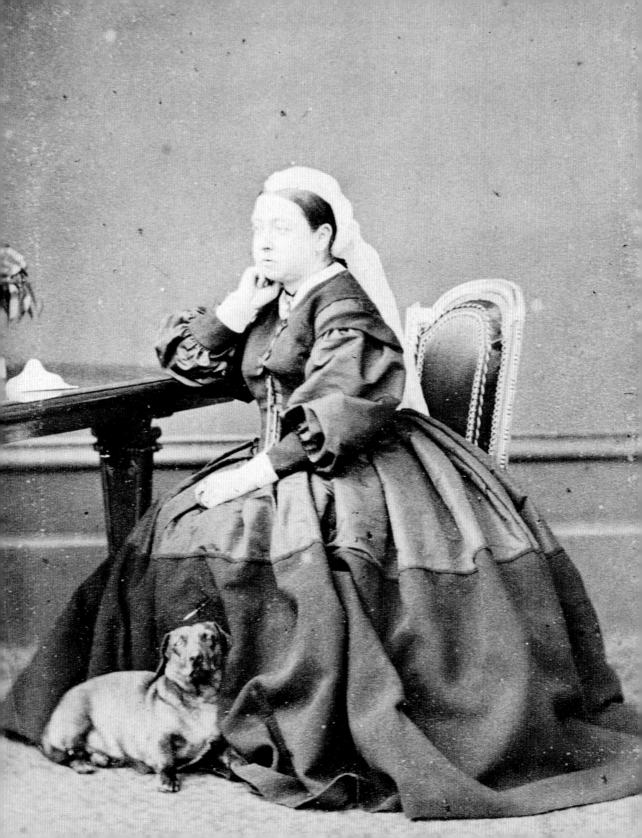

The Power of a Dog

There is sorrow enough in the natural way
From men and women to fill our day;
And when we are certain of sorrow in store,
Why do we always arrange for more?
Brothers and Sisters, I bid you beware
Of giving your heart to a dog to tear.

Buy a pup and your money will buy
Love unflinching that cannot lie –
Perfect passion and worship fed
By a kick in the ribs or a pat on the head.
Nevertheless it is hardly fair
To risk your heart for a dog to tear.

When the fourteen years which Nature permits
Are closing in asthma, or tumour, or fits,
And the vet's unspoken prescription runs
To lethal chambers or loaded guns,
Then you will find – it's your own affair –
But...you've given your heart to a dog to tear.

When the body that lived at your single will
With its whimper of welcome, is stilled (how still);
When the spirit that answered your every mood
Is gone – wherever it goes – for good,
You will discover how much you care,
And will give your heart to a dog to tear.

We've sorrow enough in the natural way,
When it comes to burying Christian clay.
Our loves are not given, but only lent,
At compound interest of cent per cent.
Though it is not always the case, I believe,
That the longer we've kept 'em, the more do we grieve;
For, when debts are payable, right or wrong,
A short-time loan is as bad as long –
So why in Heaven (before we are there)
Should we give our hearts to a dog to tear.

RUDYARD KIPLING

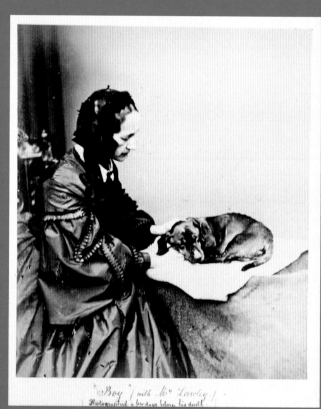

Blanford Caldesi & Co., 1867

Die Macht des Hundes

Es gibt schon Sorgen, Mühen und Plage
Durch Männer und Frauen, sie füllen die Tage;
Und da wir wissen, die Sorgen sind schwer,
Warum nur schaffen wir uns dann mehr?
Brüder und Schwestern, gebt acht, was es heißt
Wenn Euch ein Hund das Herz zerreißt.

Kauf Dir ein Hündchen, und Dein Geld bringt dir ein
Unendliche Liebe ohne Trug und Schein –
Leidenschaft und Treue bekommt man sehr schnell,
Gleich ob Du ihn trittst oder streichelst sein Fell.
Und doch bleibt es unfair, dass Du's nur weißt,
Weil Dir der Hund das Herz zerreißt.

Nach einer vierzehnjährigen Reise,
Kommt das Leben zu Ende, so ist es die Weise,
Und das Rezept des Tierarztes lautet nur mehr
Tödliche Spritze oder geladenes Gewehr,
Dann wirst Du genau wissen, was es heißt,
Wenn Dir der Hund das Herz zerreißt.

Und ist der Leib, der nur für dich lebt,
Und freudig bellt, endgültig erbebt,
Ist die Seele, die jede Stimmung gleich wusste,
Gegangen – wohin sie nun mal geht – weil sie musste,
Der Schmerz, der dann eintritt, allein er beweist,
Daß Dir der Hund das Herz zerreißt.

Es gibt genug Sorgen, Mühen und Plage,
Kommen für den Christen die letzten Tage.
Unsere Liebe ist geborgt, sie gehört uns nicht,
Mit Zins und Zinseszins zahlen wir, so ist die Pflicht.
Es stimmt auch nicht immer, denk ich manchmal
Je länger die Leihfrist, desto grösser die Qual;
Denn sind Schulden fällig, ob recht oder nicht,
Ob Kurzzeit geliehen oder lang, es ist Pflicht –
Dann weißt Du – oh Himmel (bevor Du dorthin reist)
Dass Dir der Hund nur das Herz zerreißt.

RUDYARD KIPLING

Le pouvoir du chien

Nous avons chaque jour assez de chagrin
Causé par les hommes, et par notre prochain ;
Alors pourquoi, malgré cette attitude
Cherchons-nous à forcer sur notre servitude ?
Mes amis, croyez-moi, cela ne mène à rien
De laisser son cœur s'attacher à un chien.

Vous achetez un chiot pour être propriétaire,
D'un amour absolu, parfaitement sincère.
Une passion totale et vous paierez cette dette
D'un coup de pied dans les côtes, d'une tape sur la tête.
Pourtant, cela n'a rien de bien
De laisser son cœur s'attacher à un chien.

Quand les quatorze ans qu'accorde la nature
Sur asthme, tumeur ou crise se clôturent,
Que le vétérinaire sans un mot vous prescrit
La piqûre mortelle ou le coup de fusil,
Alors vous comprenez la force de ces liens
Qui toutes ces années vous liaient à ce chien.

Quand le corps de celui qui jadis obéit
Celui qui aboyait, se tait, à tout jamais,
Celui qui répondait à l'humeur du moment
Désormais vous laisse définitivement,
Vous savez alors, que vous recommencerez
A laisser votre cœur à un chien s'attacher.

Nous avons bien sûr notre part de chagrin
Lorsque l'on met en terre le corps de son prochain,
L'amour n'est pas donné, mais prêté seulement
Avec un intérêt qui grimpe à cent pour cent.
Toutefois il n'est pas, selon moi, assuré
Qu'à plus les garder, nous serions affligés ;
Car si dette faut payer, fausse ou justifiée,
La durée de l'emprunt doit être considérée.
Alors, Juste Ciel, (avant d'y arriver)
Allons-nous au chien devoir renoncer ?

RUDYARD KIPLING

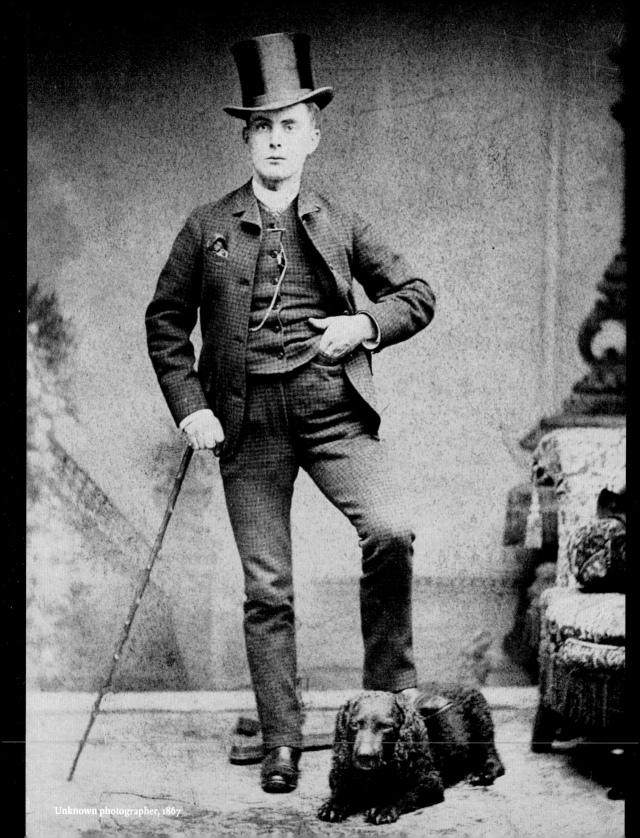

Unknown photographer, 1867

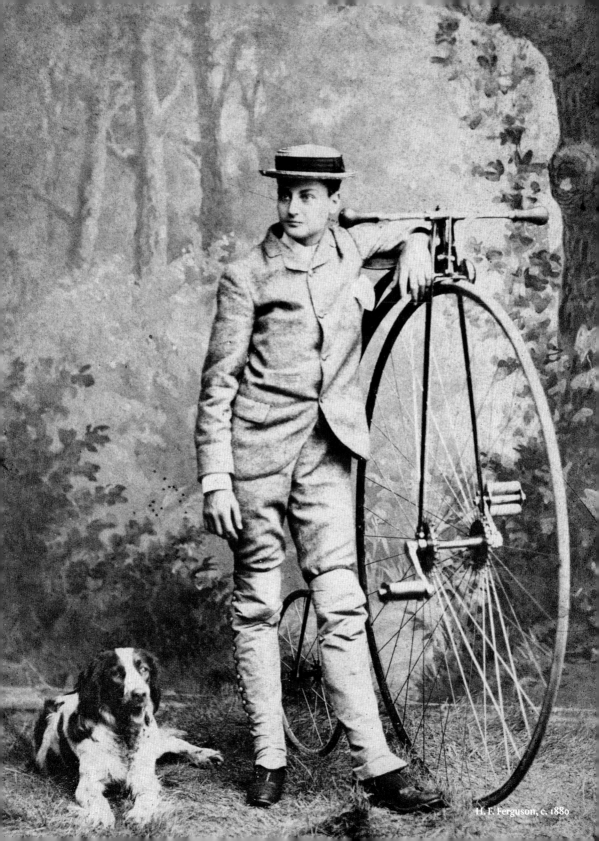

H. F. Ferguson, c. 1880

The behavior of men to the lower animals,
and their behavior to each other,
bear a constant relationship.

Das Verhalten eines Menschen gegenüber den Tieren
und sein Verhalten gegenüber anderen Menschen
stehen immer in einer Beziehung zueinander.

L'attitude des hommes au regard des animaux inférieurs
et leur comportement envers autrui
sont en constante relation.

HERBERT SPENCER

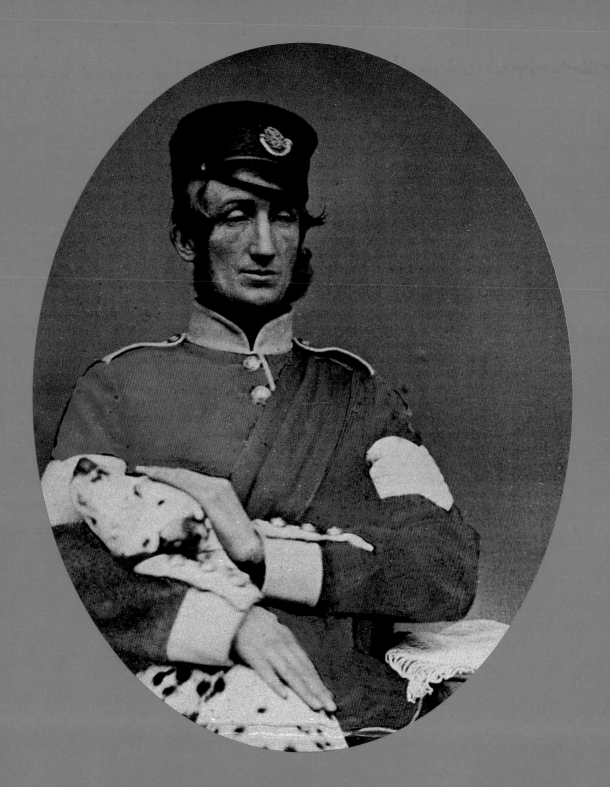

Unknown photographer, 1871

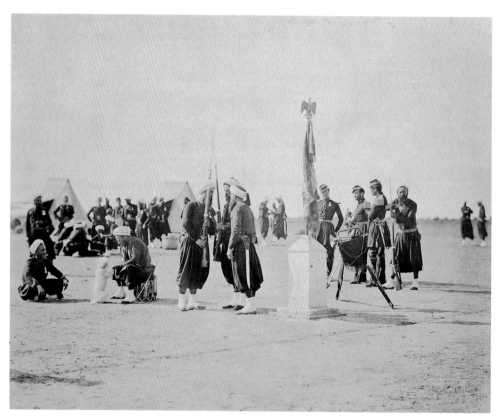

Gustave Le Gray, 1856

Roger Fenton, 1856

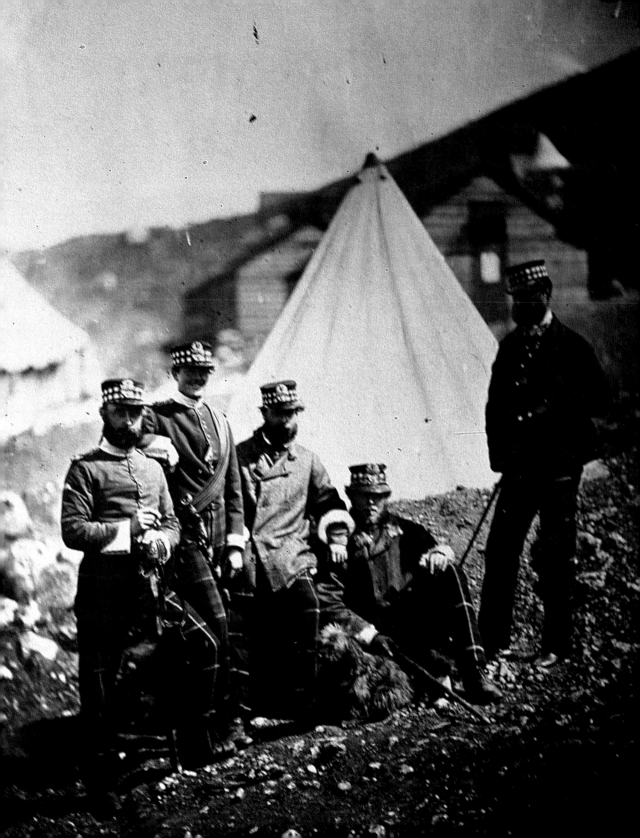

PHOTOGRAPHIC HISTORY

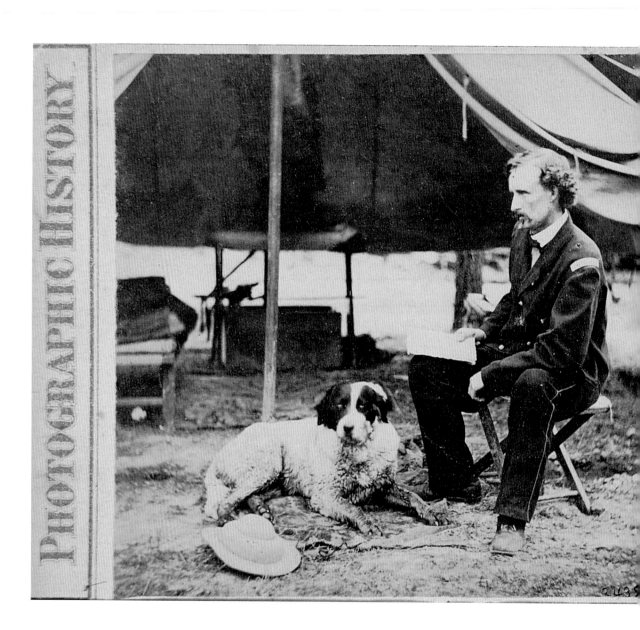

2435

PHOTOGRAPHIC HISTORY

Matthew Brady Studio, 1868

Unknown photographer, c. 1860

There is implanted by Nature in the heart of man a noble and excellent affection of mercy, extending even to the brute animals which by Divine appointment are subjected to his dominion. The more noble the mind, the more enlarged is this affection. Narrow and degenerate minds think that such things do not pertain to them, but the nobler part of mankind is affected by sympathy.

Die Natur hat dem Herzen des Menschen ein edles und vortreffliches Gefühl der Barmherzigkeit verliehen, das sich selbst auf die wilden Tiere erstreckt, die durch göttliche Bestimmung seiner Herrschaft unterworfen sind. Je edler der Geist, umso mächtiger dieses Gefühl. Engstirnige und degenerierte Menschen glauben, dass ihnen so etwas nicht gut anstünde, doch der edlere Teil der Menschheit empfindet Mitgefühl.

La Nature a implanté dans le cœur de l'homme une remarquable capacité de noblesse et de miséricorde s'étendant même aux animaux les plus brutes, lesquels, par décision divine, sont assujettis à sa domination. Plus l'âme est noble, plus grande sera sa tendresse. Les esprits étroits et dégénérés pensent que de telles choses ne les concernent pas. Mais la partie la plus noble de l'humanité en est touchée de sympathie.

LORD BACON

Unknown photographer, 1852

Unknown photographer, c. 1867

Léon Crémière, c. 1880

Léon Crémière, 1882

André-Adolphe-Eugène Disdéri, 1875

With eye upraised, his master's look to scan,
The joy, the solace, and the aid of man;
The rich man's guardian, and the poor man's friend,
The only creature faithful to the end.

Die Augen erhoben, suchend in des Herrn Blick,
der Trost, die Hilfe und des Menschen Glück,
des Reichen Wächter und des Armen Freund in Not,
das einz'ge Wesen treu bis in den Tod.

L'œil levé, observant le regard de son maître,
la joie, la consolation, et le soutien de l'homme;
gardien du riche, ami du pauvre
seule créature fidèle jusqu'à la fin.

GEORGE CRABBE

IN REMEMBRANCE OF SIR EDWIN LANDSEER.

H. S. Mendelsohn, 1873

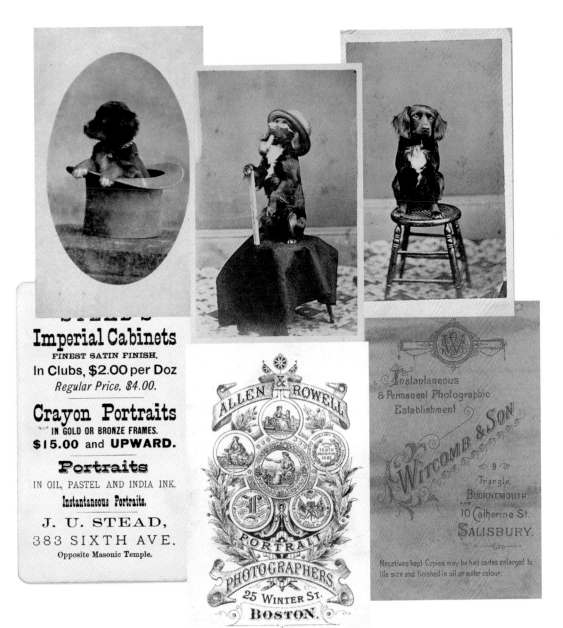

Imperial Cabinets

FINEST SATIN FINISH.

In Clubs, $2.00 per Doz

Regular Price, $4.00.

Crayon Portraits

IN GOLD OR BRONZE FRAMES.

$15.00 and UPWARD.

Portraits

IN OIL, PASTEL AND INDIA INK.

Instantaneous Portraits.

J. U. STEAD,

383 SIXTH AVE.

Opposite Masonic Temple.

ALLEN & ROWELL

PORTRAIT

PHOTOGRAPHERS

25 WINTER ST.

BOSTON.

Instantaneous
& Permanent Photographic
Establishment

Witcomb & Son

9

Triangle,

BOURNEMOUTH.

AND

10 Catherine St.

SALISBURY.

Negatives kept Copies may be had cartes enlarged to
life size and finished in oil or water colour.

J. U. Stead, Allen & Rowell, Witcomb & Son, c. 1875–1880

Let your boat of life be light,
packed with only what you need –
someone to love, a dog and a pipe or two,
enough to eat …
and a little more than enough to drink,
for thirst is a dangerous thing.

Pack das Boot deines Lebens nicht zu voll,
nimm nur mit, was du brauchst:
jemanden zum Liebhaben, einen Hund und
eine Pfeife oder zwei, genug zu essen …
und etwas mehr als genug zu trinken,
denn Durst ist etwas Gefährliches.

Que le bateau de votre vie soit léger,
seulement chargé des simples nécessités,
l'être aimé, un chien,
une pipe ou deux, de quoi manger
un peu plus à boire, un rien,
car la soif pourrait être le véritable danger.

JEROME K. JEROME

Wilhelm Breiner, c. 1880

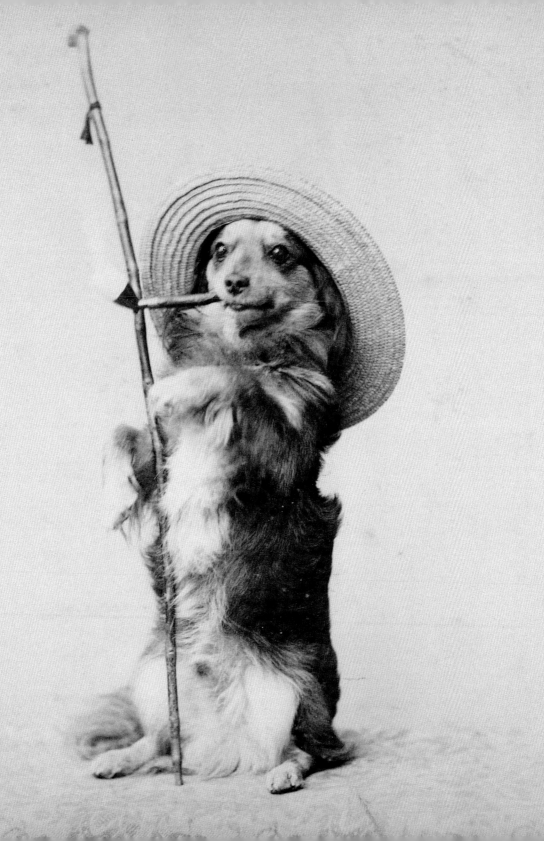

Ottomar Anschütz, Lissa (Posen) 1887.

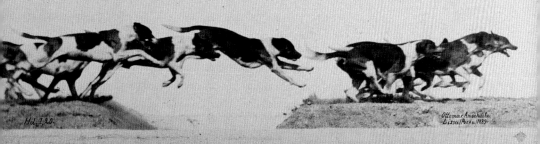

Unknown photographer, c. 1870

Napoleon Sarony, 1890

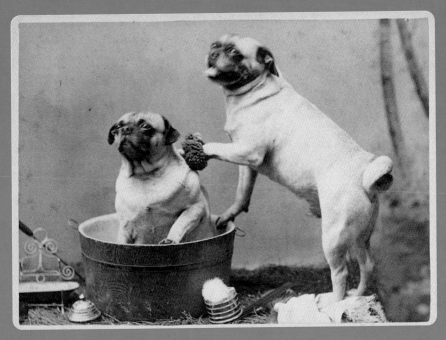

Richardson Brothers, 1890

Animals are such agreeable friends –
they ask no questions, they pass no criticisms.

Tiere sind so angenehme Freunde –
sie stellen keine Fragen, üben keine Kritik.

Les animaux sont des amis si doux : ils ne posent point de
questions, ils ne font point de critiques.

GEORGE ELIOT

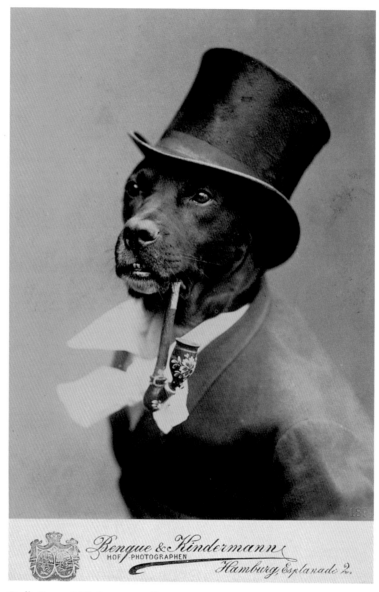

Studio Bengue & Kindermann, c. 1890

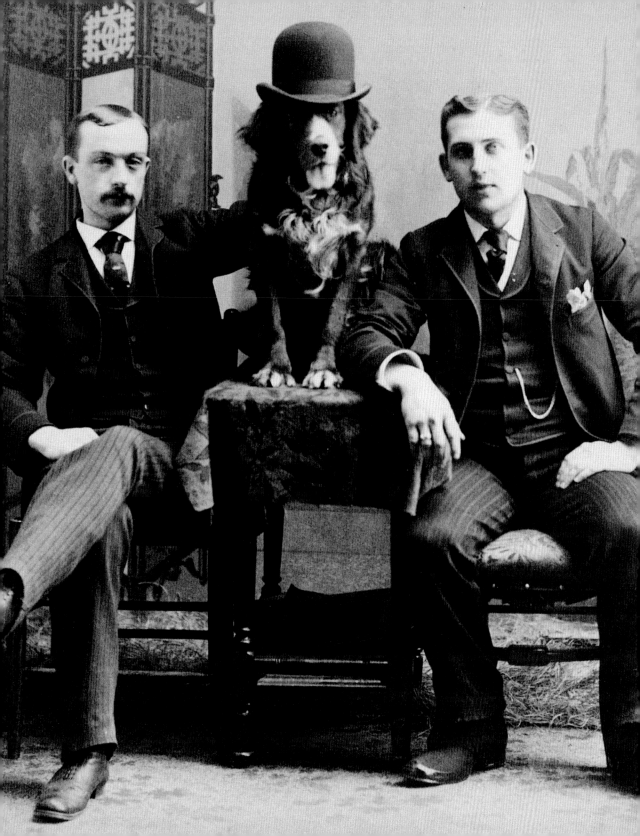

The dog was created especially for children.
He is the god of frolic.

Der Hund wurde vor allem für Kinder erschaffen.
Er ist der Gott der Ausgelassenheit.

Le chien fut créé surtout pour les enfants.
C'est le dieu des gambades.

HENRY WARD BEECHER

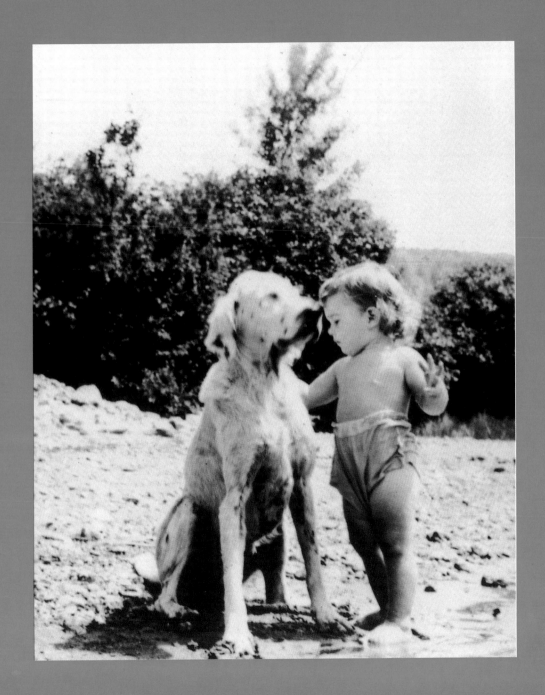

Unknown photographer, c. 1880

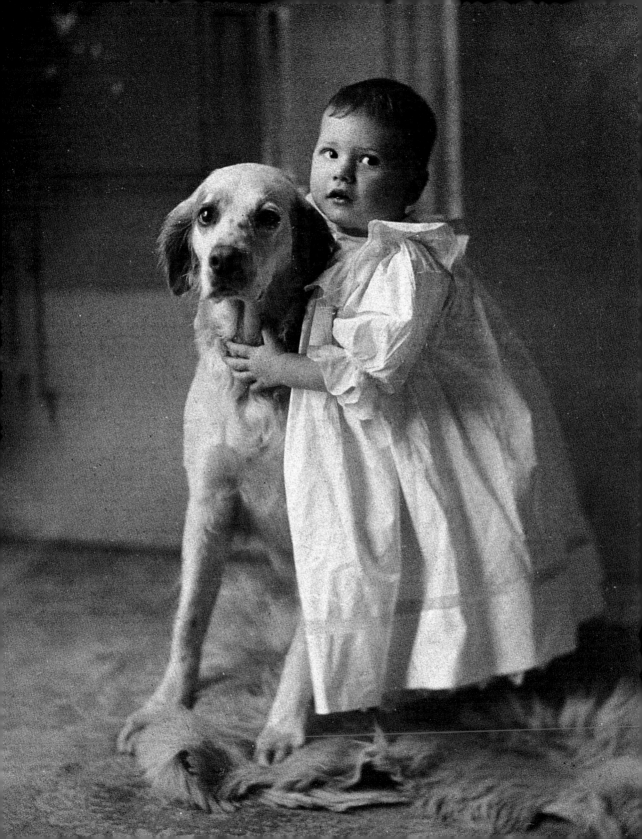

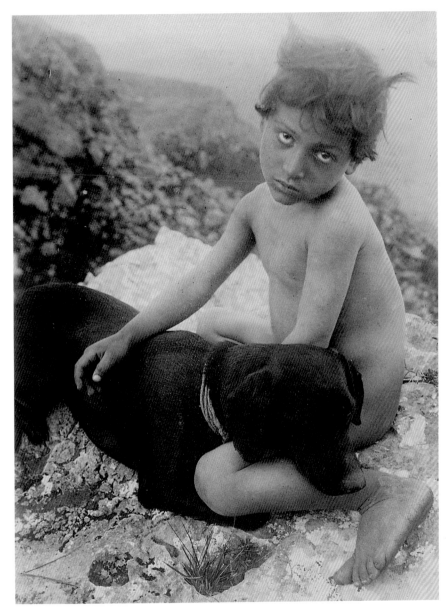

Wilhelm von Gloeden, c. 1890

There is no faith which has never yet been broken,
except that of a truly faithful dog.

Es gibt keine Treue, die nicht gebrochen worden wäre,
außer der eines wahrhaft treuen Hundes.

Il n'est de credo qui n'ait été brisé,
mais jamais par un chien fidèle et aimé.

KONRAD LORENZ

President Franklin D. Roosevelt, Aged 6 · Frederic Lewis, 1885

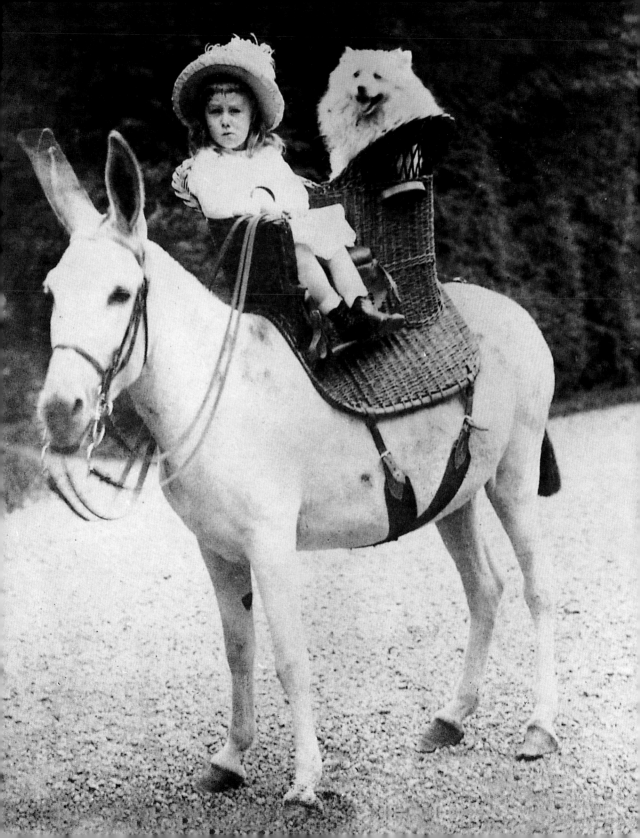

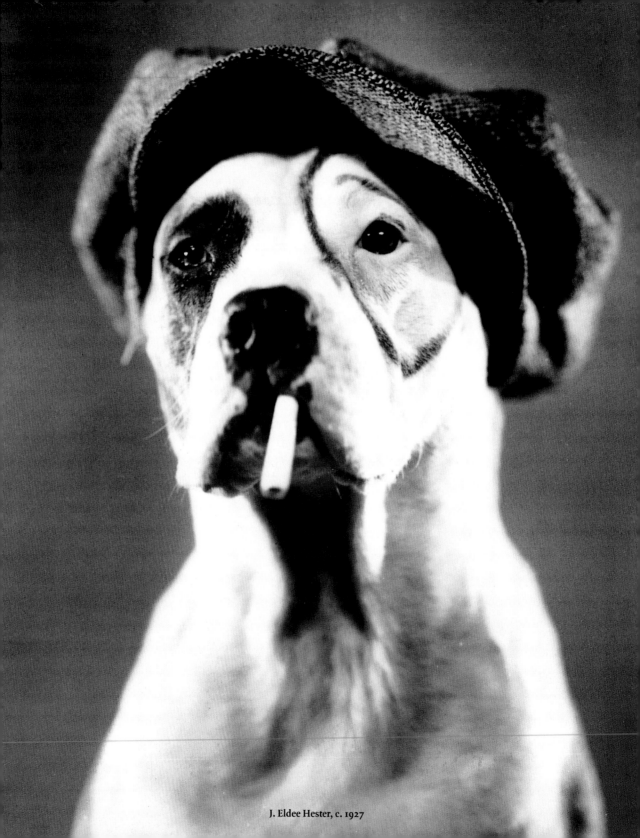

J. Eldee Hester, c. 1927

Embracing Uncertain Verities

From Pictorialism to Modernism

Einige zweifelhafte Wahrheiten

Vom Piktoralismus zum Modernismus

Quelques vérités douteuses

Du pictorialisme au modernisme

1890·1930

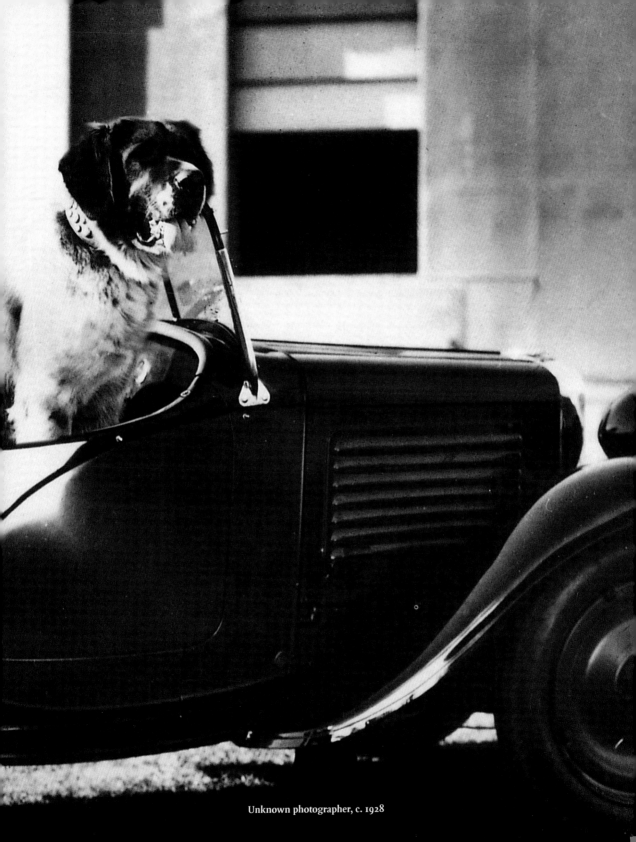

Unknown photographer, c. 1928

1890·1930
Embracing Uncertain Verities
From Pictorialism to Modernism

For many, the advent of the new century was welcomed with confidence – new hopes, ideas and plans. A world with burgeoning prosperity and virtually at peace fed this confidence. Societal changes at the end of the nineteenth century, fueled by the remarkable technological advances of the preceding four decades, substantially altered the way man and his canine companions lived. Mechanization alleviated a large portion of the drudgery of farm life and freed large numbers of people to relocate in urban centers, creating a large new middleclass impatient in their wait for the baton of power. Queen Victoria died and with her death, the honored tenets of her era began to give way to uncertain verities, creating inevitable trepidation and tension. As the century closed, Europe stood at the center of the civilized world. Its cultural influence and imperialism spread its mark across the globe.

During this period, a kaleidoscope of events quickly transformed people's lives, some the most sublime, others the most abject of the century. Electricity entered the home as did the recorded music of the gramophone. Pictures were made to move through animation; the Pathé brothers began to film the news for all to see. The

Wright brothers soared, while the Titanic sank. Chanel gave the world fashion and fragrance; Gandhi and Collins gave it substance and sacrifice. During this same period, the first global war consumed humanity. Perhaps the most inhumane of all global conflicts, the war destroyed the old Europe, and, in the process, ten million of Europe's youth died in the trenches from the horrors of war – gas, rats, and lice as well as enemy fire. Peace was finally achieved but at an untenable price. A war-weary world then passionately embraced the balm of enjoyment. In the arts, *le moderne* arrived. Picasso, Léger, Brancusi, Matisse, and Duchamp introduced the world to the abstract. Eliot, Joyce, and Stein took their cue from Shaw, Ibsen, and Nietzsche and presented the world with an avant-garde. Paris became the City of Lights, the epitome of civilization, giving an outlet to a creativity that had been stifled during the war.

A new leisure industry sprouted, encouraging a more free and daring lifestyle. Skirts got shorter; dances got longer. Sounds syncopated and their rhythms permeated the clubs of New York, London, Paris, and Berlin, until the roar finally overwhelmed and crippled the world's economy.

Burr McIntosh, 1905

Eugène Atget, 1912

1890·1930
Einige zweifelhafte Wahrheiten
Vom Piktoralismus zum Modernismus

Viele begrüßten das neue Jahrhundert mit Zuversicht – neue Hoffnungen, Ideen und Pläne. Anlass für diese Zuversicht gab eine Welt, in der Wohlstand und de facto Frieden herrschten. Im Gefolge der beachtlichen technologischen Fortschritte der vorangegangenen vier Jahrzehnte hatte sich am Ende des 19. Jahrhunderts ein gesellschaftlicher Wandel vollzogen, der auch die Lebensweise des Menschen und seines Gefährten, des Hundes, grundlegend veränderte. Die Mechanisierung erleichterte das bäuerliche Leben entscheidend und ermöglichte es vielen Menschen, in die Städte zu ziehen. Eine neue, breite Mittelschicht entstand, die ungeduldig auf ihren Anteil an der Macht wartete. Königin Viktoria starb,

und mit ihrem Tod gerieten die Grundwahrheiten ihrer Ära ins Wanken. Unsicherheit breitete sich aus, was unvermeidlich zu Unruhe und Spannungen führte. Als das Jahrhundert zu Ende ging, war Europa Mittelpunkt der zivilisierten Welt. Sein kultureller Einfluss und die imperialistischen Bestrebungen drückten dem Globus den Stempel auf.

In dieser Zeit veränderten die unterschiedlichsten Ereignisse – einige gehörten zu den großartigsten des Jahrhunderts, andere zu den entsetzlichsten – rasch das Leben der Menschen. Die Elektrizität kam in die Häuser, ebenso wie das Grammofon. Filmtechnische Animation ließ bewegte Bilder entstehen. Die Brüder Pathé drehten die ersten Nach-

Detroit Publishing Co., c. 1905

richtenfilme, die Gebrüder Wright stiegen in die Luft, und die Titanic ging unter. Coco Chanel brachte der Welt Mode und Parfüm, Gandhi und Collins brachten ihr Inhalt und Opfer. Gleichzeitig rieb der Erste Weltkrieg die Menschheit auf. Dieser Krieg, vielleicht der unmenschlichste aller globalen Auseinandersetzungen, vernichtete das alte Europa. Zehn Millionen junge Menschen starben in den Schützengräben an den Schrecken des Krieges, zu denen nicht nur feindliches Feuer zählte, sondern auch Gas, Ratten und Läuse. Schließlich wurde wieder Frieden geschlossen, doch zu einem unhaltbaren Preis. Eine kriegsmüde Welt begrüßte enthusiastisch alles, was Freude machte. In der Kunst brach die

Moderne an. Picasso, Léger, Brancusi, Matisse und Duchamp konfrontierten die Welt mit ihren Abstraktionen. Eliot, Joyce und Stein orientierten sich an Shaw, Ibsen und Nietzsche und präsentierten sich der Welt als Avantgarde. Paris wurde zur „Stadt der Lichter", zum Inbegriff der Zivilisation, und bot ein Ventil für eine Kreativität, die während des Krieges unterdrückt worden war. Eine neue Freizeitindustrie boomte und propagierte eine freiere und gewagtere Lebensweise. Die Röcke wurden kürzer, die Partys länger. Synkopen beherrschten die Musik, und ihre Rhythmen füllten die Clubs in New York, London, Paris und Berlin, bis ihr Dröhnen schließlich die Weltwirtschaft zusammenbrechen ließ.

1890·1930
Quelques vérités douteuses
Du pictorialisme au modernisme

Pour beaucoup, le siècle nouveau fut accueilli avec confiance, avec l'espoir d'idées neuves et de grands projets grandioses. Le monde s'annonçait prospère et pacifique. Grâce aux immenses progrès technologiques des quarante dernières années, la société du XIXe siècle avait évolué. La relation de l'homme avec son compagnon canin en avait été considérablement modifiée. La mécanisation avait allégé la plupart des travaux de ferme, libérant un grand nombre de gens. Ceux-ci partirent s'installer dans les centres urbains, créant une classe moyenne importante, impatiente de s'approprier les rênes du pouvoir. Quand la Reine Victoria s'éteignit, les credos de l'époque vacillèrent

et on se prit à douter de certaines vérités, d'où trépidations et tensions inévitables. Au tournant du siècle, l'Europe était au centre du monde civilisé. Son influence culturelle et son impérialisme régnaient sur la planète toute entière.

Au cours de cette période, la vie des gens se trouva vite transformée en un kaléidoscope d'événements, les plus sublimes et les plus abjects du siècle. L'électricité s'installa dans les foyers, en même temps que la musique enregistrée et les gramophones. Les images commencèrent à s'animer. Les frères Pathé se mirent à filmer des actualités, auxquelles tous pouvaient assister. Les frères Wright

Unknown photographer, c. 1915

s'envolèrent. Le Titanic sombra. Chanel offrit au monde sa mode et ses parfums. Gandhi et Collins lui apportèrent substance et esprit de sacrifice. Pendant cette même période, la Première Guerre mondiale embrasa l'humanité. Sans doute le plus inhumain de tous, ce conflit détruisit la vieille Europe. Dix millions de jeunes Européens trouvèrent la mort dans les tranchées, face aux horreurs de la guerre, les gaz, les rats et les poux, sous les feux de l'ennemi. La paix finit par s'imposer, mais à un prix exorbitant. Alors ce monde épuisé saisit à pleines mains les plaisirs retrouvés. Dans le domaine des arts, ce fut l'arrivée du moderne. Picasso, Léger, Brancusi, Matisse et Duchamp introduisirent le monde à l'art abstrait. Eliot, Joyce et Stein à la suite de Shaw, Ibsen et Nietzsche, aux yeux du monde, se constituèrent en avant-garde. Paris devint la Ville lumière, l'excellence de la civilisation, de l'épanouissement de toute une créativité étouffée pendant la guerre. On vit poindre une nouvelle industrie, celle des loisirs, encourageant un style de vie plus libre et plus audacieux. Les jupes se raccourcirent, les danses s'allongèrent. Des sons rythmés, syncopés, envahirent les clubs de New York, Londres, Paris et Berlin, jusqu'à ce qu'un horrible rugissement finisse par retentir : le monde était à nouveau malade de son économie.

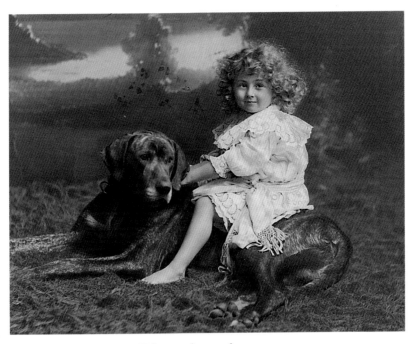

Unknown photographer, c. 1920

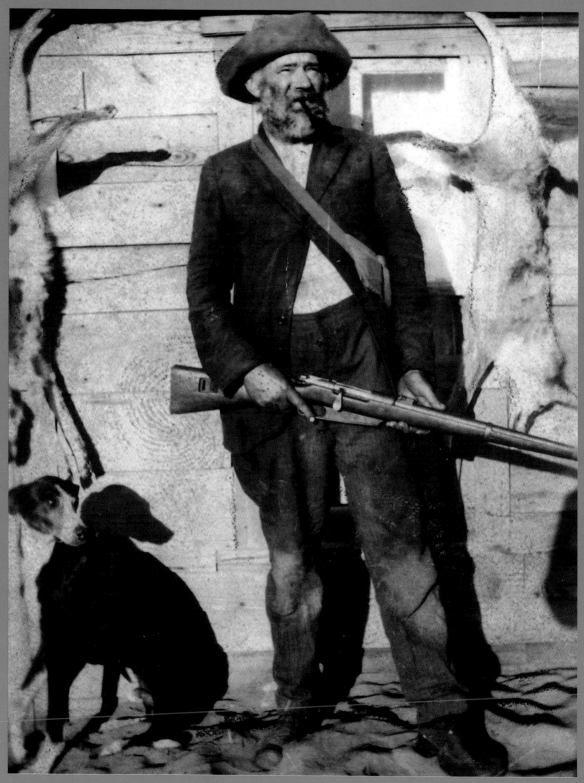

Unknown photographer, c. 1908

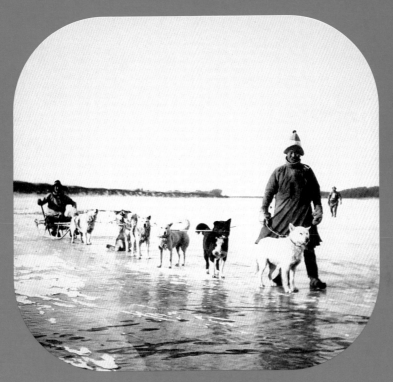

William Henry Jackson, 1895

No man can be condemned for owning a dog.
As long as he has a dog, he has a friend;
and the poorer he gets, the better friend he is.

Man kann keinen Menschen verdammen, weil er einen Hund besitzt.
Solange er einen Hund hat, hat er einen Freund;
und je ärmer er wird, desto enger wird die Freundschaft.

Aucun homme ne peut être accusé, parce qu'il possède un chien.
Tant qu'il a un chien, il a un ami ; et plus il deviendra pauvre,
plus fidèle sera son ami.

WILL ROGERS

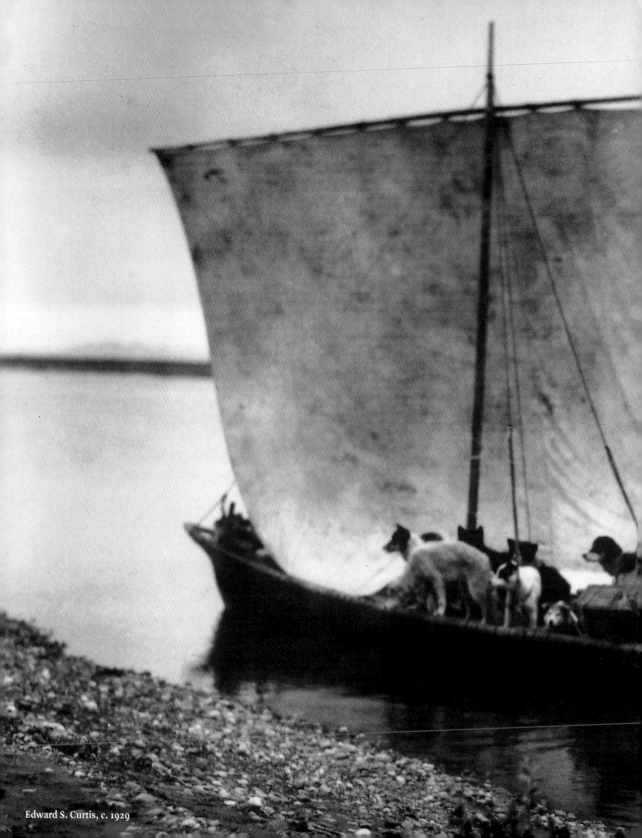

Edward S. Curtis, c. 1929

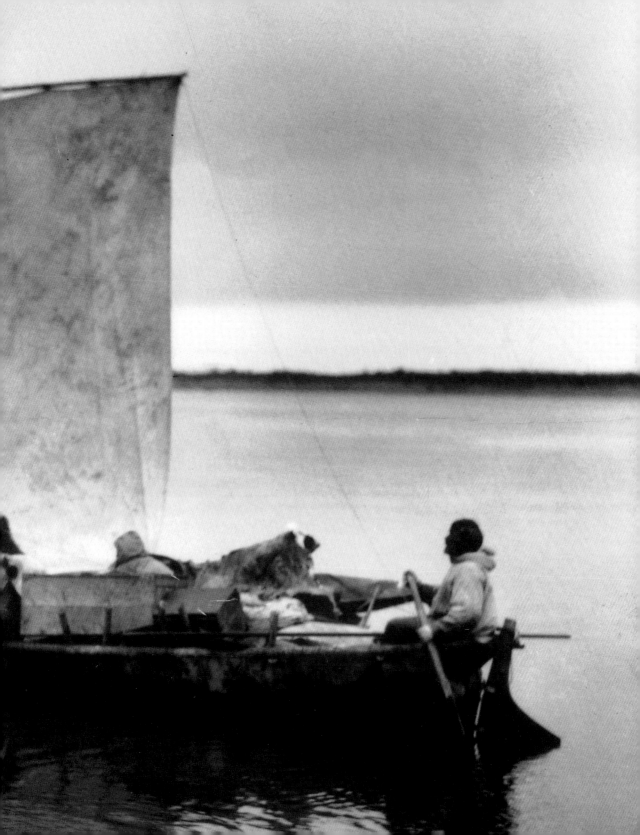

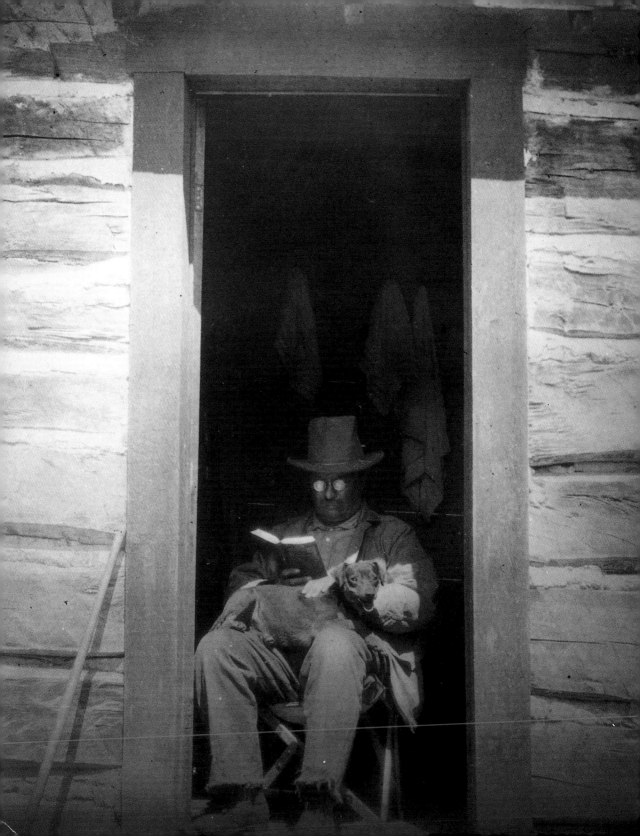

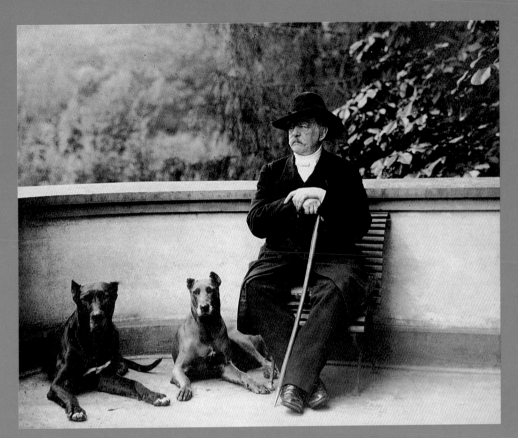

Otto von Bismarck · Strumper & Co., 1891

Great men
have great dogs.

Großartige Menschen
haben großartige Hunde.

Les hommes géniaux
ont des chiens géniaux.

OTTO VON BISMARCK

Theodore Roosevelt · Unknown photographer, c. 1905

Queen Alexandra
Unknown photographer, c. 1908

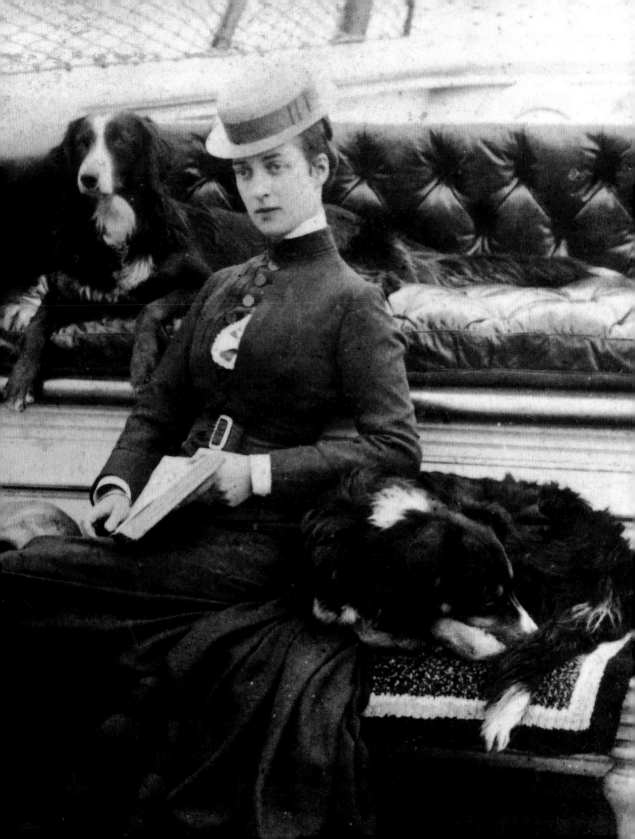

Command: he thee obeys most readily.
Strike him: he whines and falls down at thy feet.
Call him: he leaves his game and comes to thee
With wagging tail, offering his service meek.
If so thou wilt, a Collar he will wear;
And when thou wish to take it off again,
Unto thy feet he crouchest down most fair,
As if thy will were all his good and gain.

Befiehl, und er gehorcht dir voller Eifer.
Schlag ihn, und er winselt und legt sich dir zu Füßen.
Ruf ihn, und er lässt von seinem Spiel ab und eilt zu dir,
um dir schwanzwedelnd zu Diensten zu sein.
Wenn du es willst, trägt er ein Halsband,
Und wenn es dein Wunsch ist, es ihm wieder abzunehmen,
kauert er sich glücklich zu deinen Füßen nieder,
als sei dein Wille das Himmelreich für ihn.

Commande-le ; il t'obéit sans tarder.
Bats-le, il gémit et se blottit à tes pieds.
Appelle-le ; il abandonne son jeu et vient vers toi,
La queue frétillante, t'offrir sa douce obéissance.
Si tu le souhaites, un manteau il portera
Et quand tu décideras de le lui ôter à nouveau,
A tes pieds il se tapira, obligeamment,
Comme si tu étais son seigneur et maître.

J. MOLLE

William Henry Jackson, c. 1902

Jacob A. Riis, c. 1890

Lewis W. Hine, c. 1910

George A. M. Morris, c. 1910

Unknown photographer, c. 1900

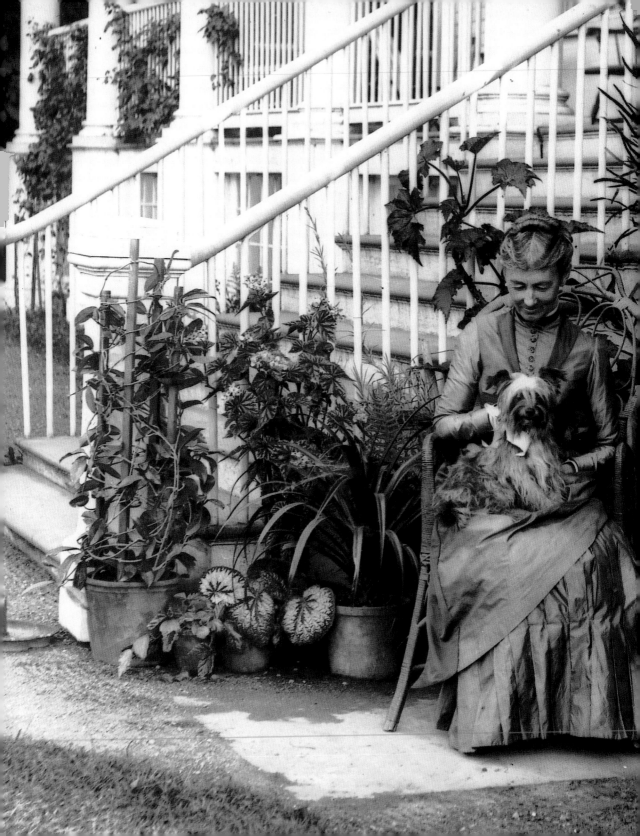

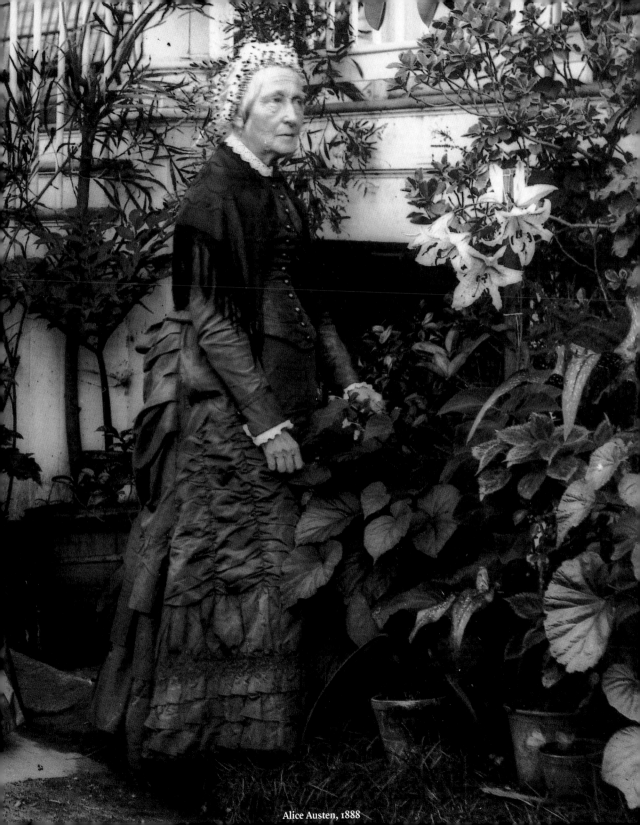

Alice Austen, 1888

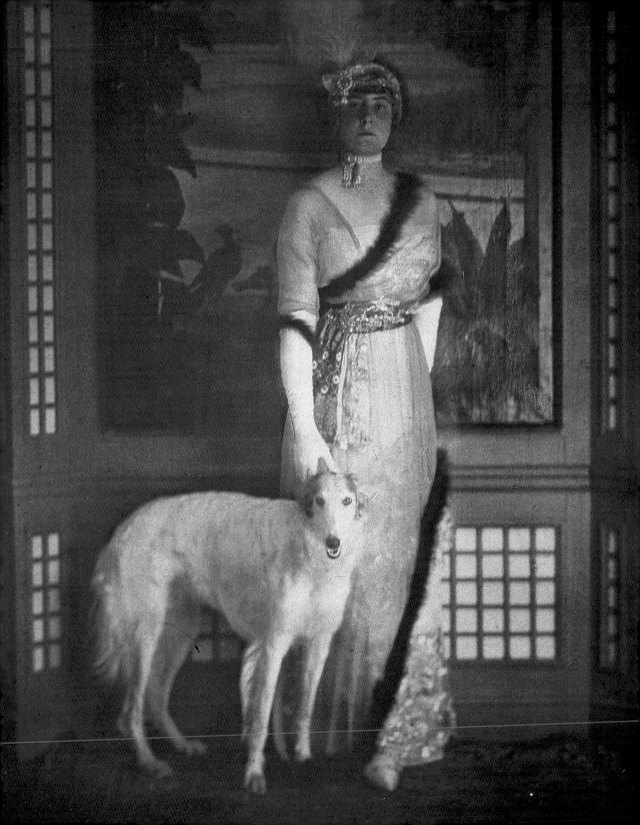

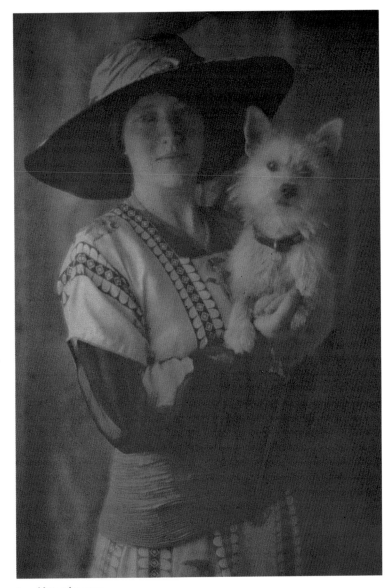

Arnold Genthe, 1913

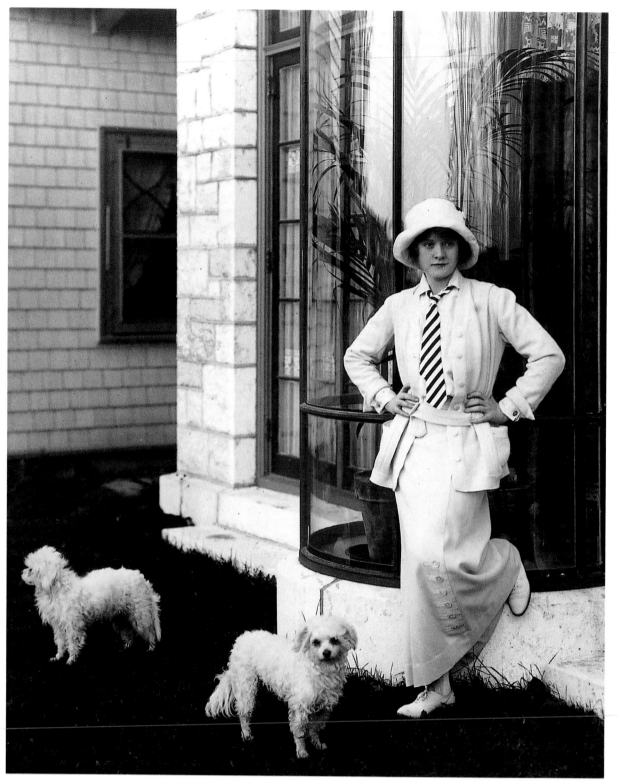

Byron Studio, 1912

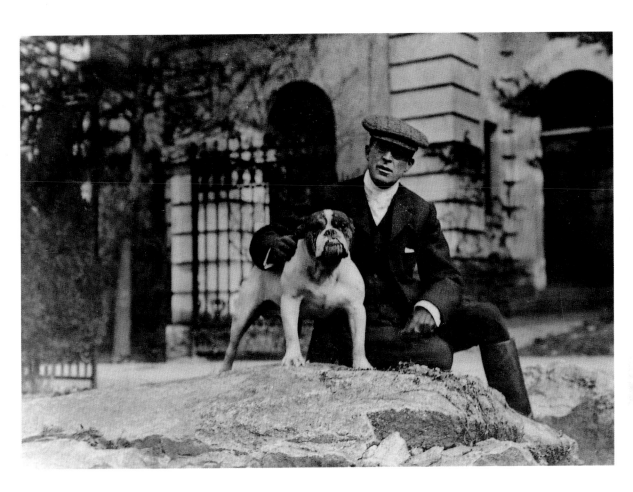

Unknown photographer, c. 1900

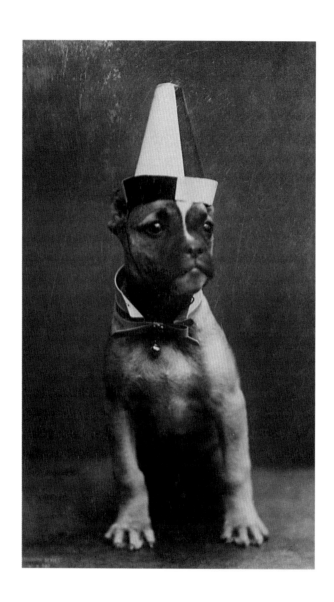

Unknown photographer, c. 1910

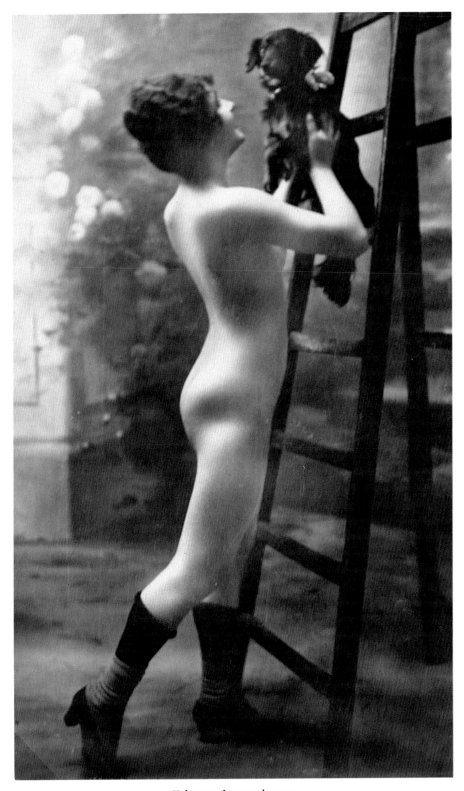

Unknown photographer, 1911

He seemed neither old nor young.
His strength lay in his eyes.
They looked as old as the hills, and as young and as wild.
I never tired looking into them.

Er schien weder alt noch jung.
Seine Kraft lag in seinen Augen.
Sie sahen genauso alt aus wie die Berge und genauso jung und wild.
Ich wurde nie müde ihm in die Augen zu schauen.

Il ne semblait ni vieux, ni jeune.
Sa force, c'était son regard.
Il avait l'air aussi vieux que les montagnes et aussi jeune et aussi sauvage.
Jamais je ne me lassais d'y plonger le mien.

JOHN MUIR

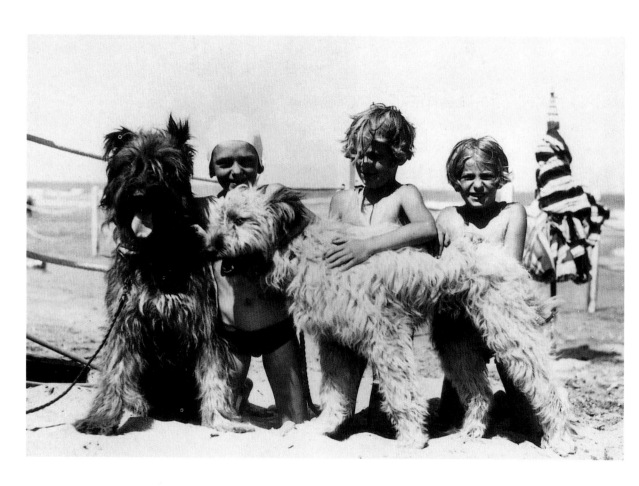

Unknown photographer, c. 1920

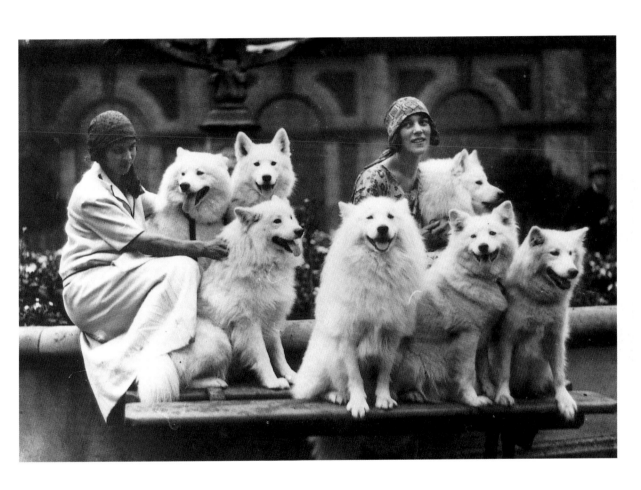

Unknown photographer, c. 1920

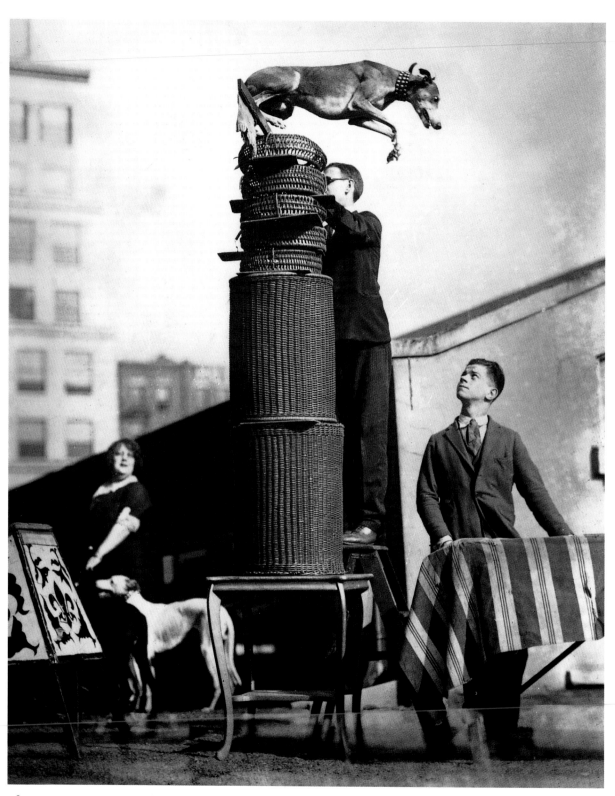

Unknown photographer, 1925

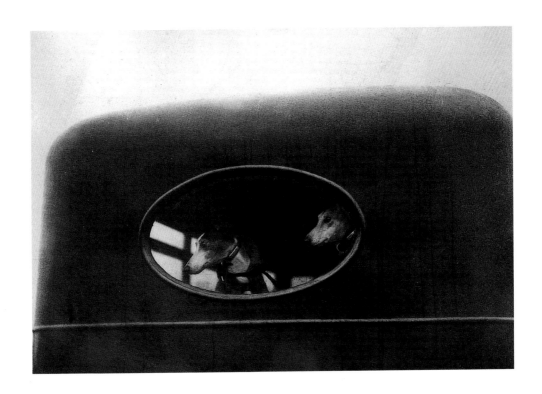

Unknown photographer, 1922

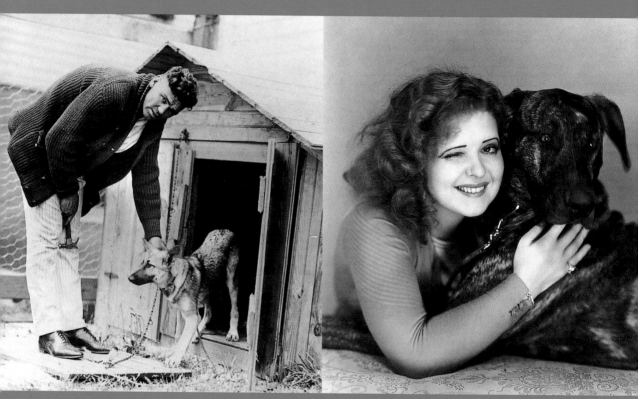

Jack Dempsey, c. 1925

Clara Bow, c. 1927

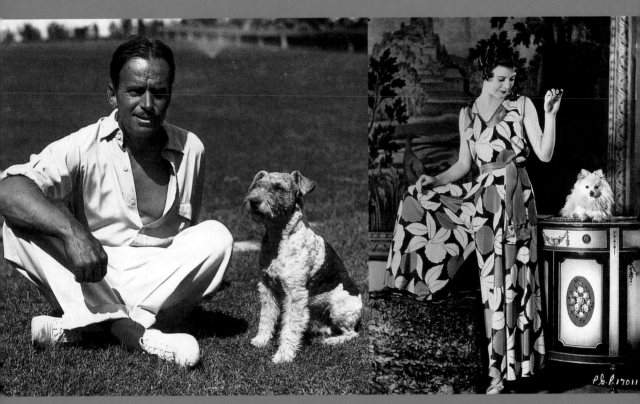

Douglas Fairbanks, c. 1925

Ginger Rogers, 1930

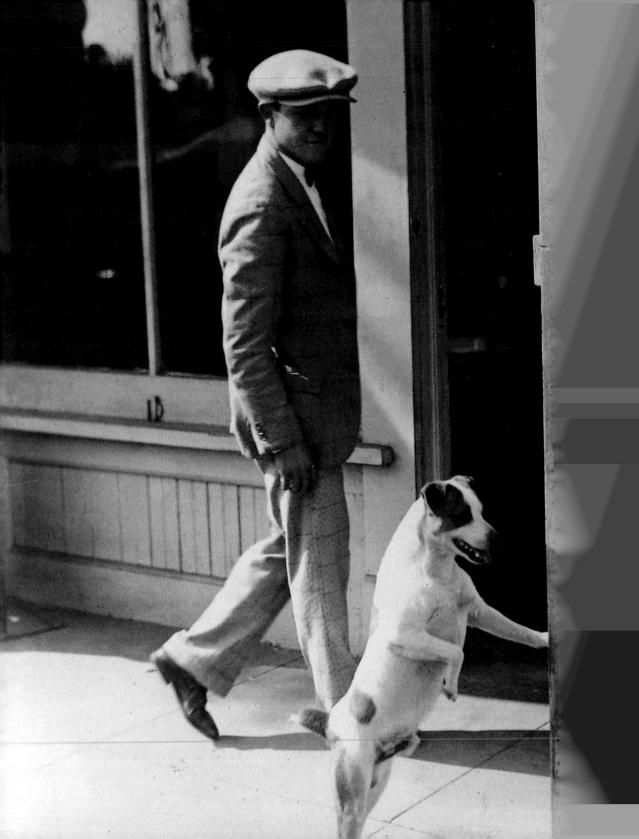

The good Lord in his ultimate wisdom gave us
three things to make life bearable, hope, jokes and
dogs, but the greatest of these was dogs.

Der liebe Gott in seiner unendlichen Weisheit
gab uns drei Dinge, um das Leben erträglich zu machen:
Hoffnung, Humor und Hunde,
das Wichtigste aber waren die Hunde.

Notre Seigneur, dans sa grand sagesse,
nous légua trois choses pour rendre la vie supportable :
l'espérance, la plaisanterie et le chien. Mais le plus
important, ce fut le chien.

ROBYN DAVIDSON

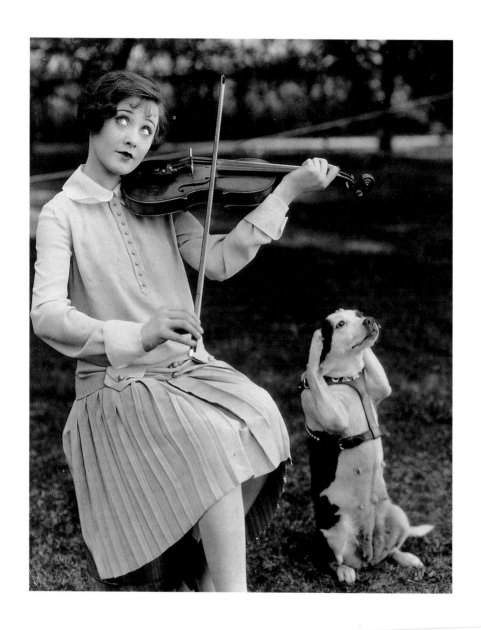

Margaret Chute, c. 1929

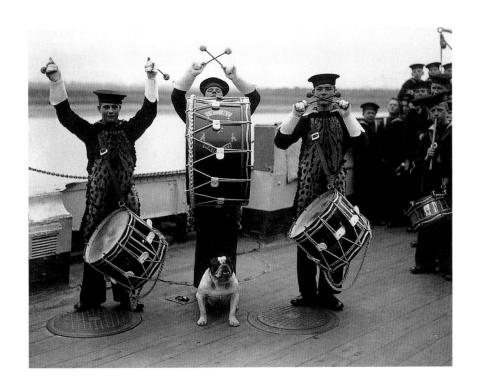

Unknown photographer, 1930

The dog has seldom pulled man up
to his level of sagacity,
but man has frequently
dragged the dog down to his.

Der Hund hat den Menschen nur selten
auf seine Stufe der Weisheit hinaufgezogen,
der Mensch dagegen
den Hund oft hinunter auf die seine.

Le chien a rarement réussi à hisser
l'homme à son niveau de sagesse,
mais l'homme a souvent
rabaissé le chien au sien.

JAMES THURBER

Unknown photographer, c. 1925

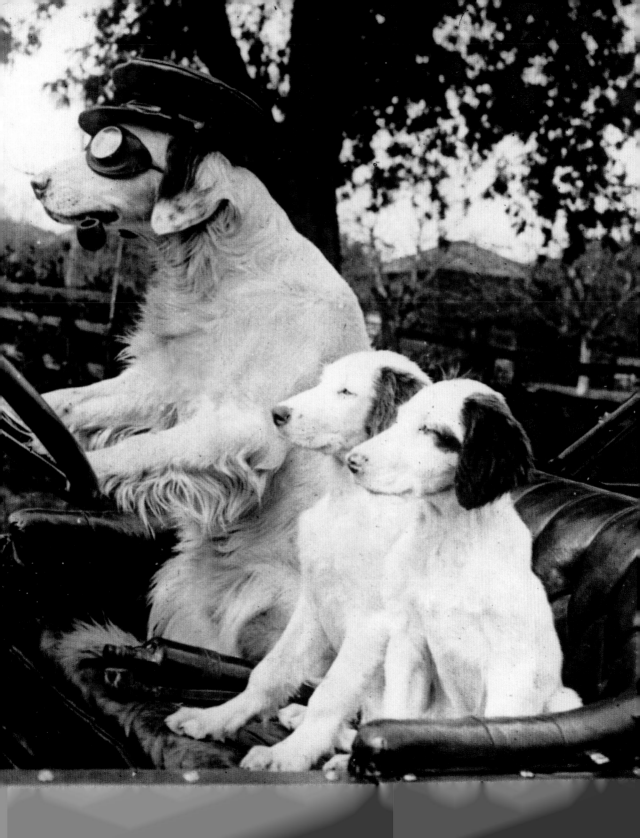

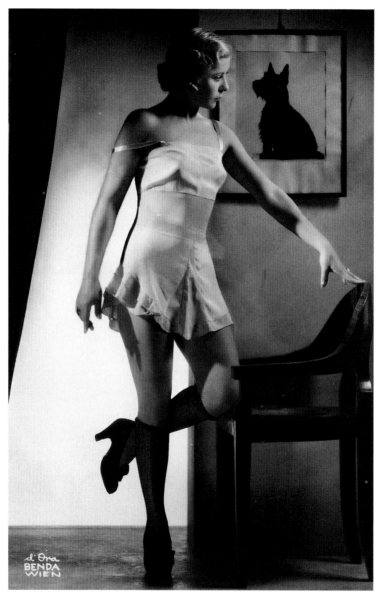

D'Ora (Albert Benda), 1925

G. Riebecke, 1929

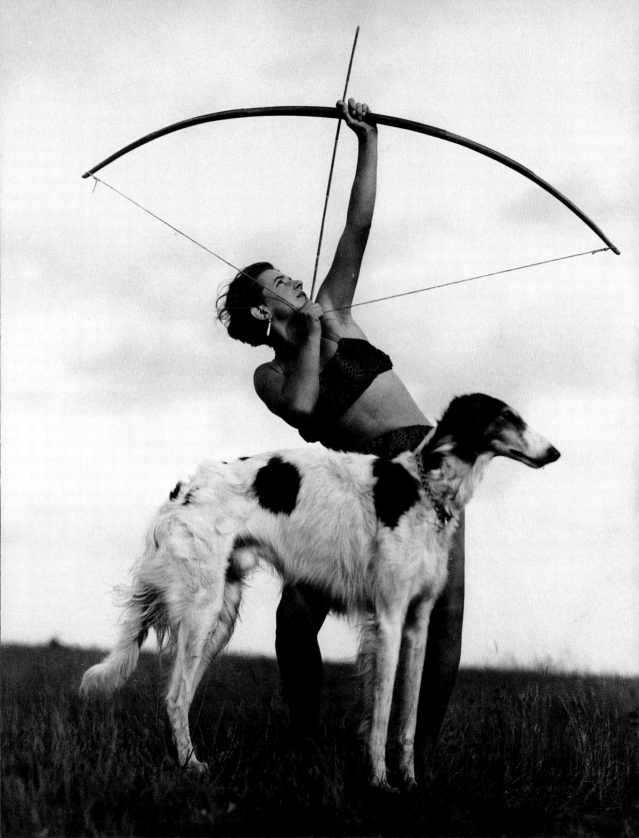

Let us love dogs;
let us love only dogs!
Man and cats are
unworthy creatures.

Lasst uns die Hunde lieben!
Lasst uns ausschließlich Hunde lieben!
Die Menschen und die Katzen
sind unwürdige Wesen.

Aimons les chiens !
N'aimons que les chiens !
Les hommes et les chats sont
de piètres créatures.

MARIA BASHKIRTSEFF

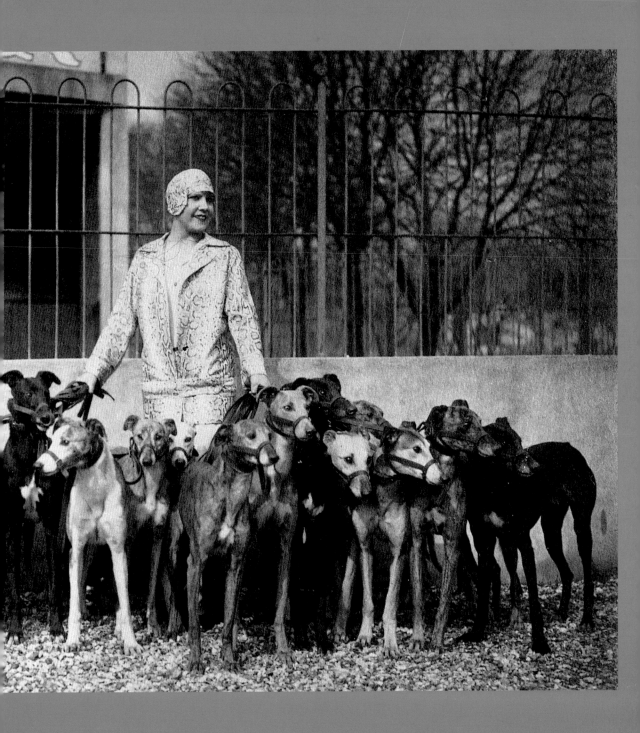

Heroes
Helden
Héros

In life the firmest friend
The first to welcome, foremost to defend,
Whose honest heart is still his master's own
Who labors, fights, lives, breathes for him alone.

Im Leben der beste Freund,
beim Begrüßen der Erste, beim Verteidigen der Eifrigste,
sein treues Herz gehört ganz seinem Herrn,
er schuftet, kämpft, lebt und atmet nur für ihn.

Dans la vie, le plus sûr des amis
Le premier à vous accueillir, le premier à vous défendre
Celui dont le cœur honnête appartient pour toujours à son maître
Qui travaille, se bat, vit et respire pour lui seul.

LORD BYRON

Robert J. Flaherty, c. 1920

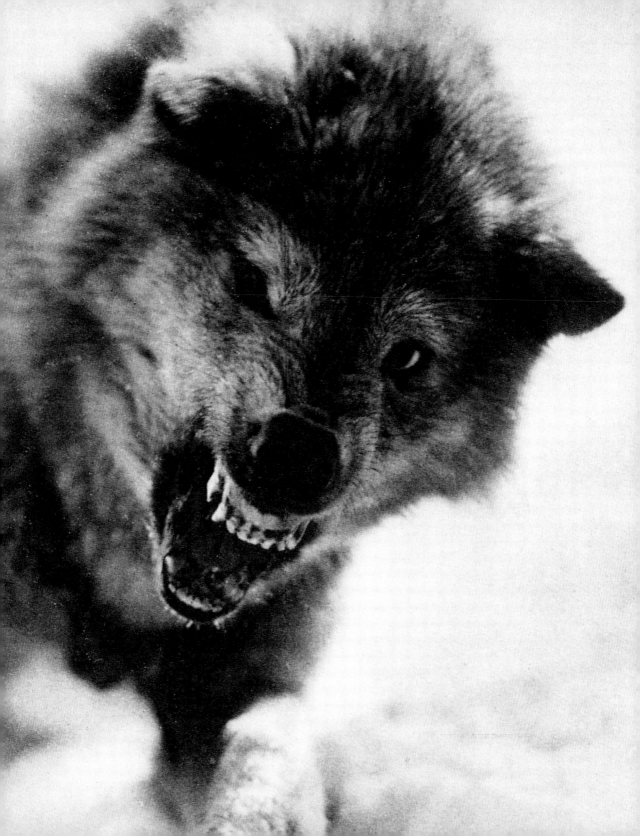

Heroes

The turn of the century marked a new era of individual empowerment, not just for people, but for dogs. Fidelity and obedience, traits that for centuries had defined the very meaning of the word "dog," were supplanted by a new canine image, one not rooted in conditioned response but in the ability to act as a being with a social conscience. Dogs who enjoyed no special favor from pedigree, but instead achieved greatness through acts of selfless courage, were embraced as popular heroes.

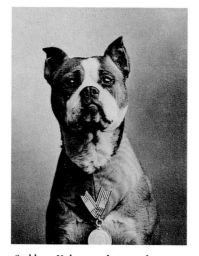

Stubby · Unknown photographer, 1919

These animals did more than amuse – they embodied the growing belief that anybody could succeed, regardless of "breeding" or class affiliation, and therefore was worthy of respect.

The public perceived these heroes of the new century, human and canine, as challenging the status quo and attaining self-improvement through adventure. The writings of Jack London, himself a rebel-hero of near mythic proportion, set the tone in his vastly popular *Call of the Wild*, the story of a domestic dog's rejection of civilization and return to the primal security of the wilderness. London's *White Fang* reversed this odyssey to achieve a different apotheosis. London's use of the heroic dog as a metaphor for man's ambivalence at the arrival of modernity struck an exposed nerve. A need for human adventure pitting man against nature and, later, against his own fellow man, was pervasive in the early part of the new century – in no small part, a reaction to the rapid onset of industrialization.

The craving for adventure was all-consuming. Exploration of the polar caps, then considered as remote and inaccessible as the moon, inspired industrial nations to compete in the race to claim these last frontiers. The dog was an indispensable partner in that effort and in this instance its relationship with its master was not that of servility, but of interdependency. Before mechanical equipment was perfected, the dog was the only creature who possessed the will, stamina, determination, and innate senses to lead man to the ends of the earth. The press followed Arctic explorers Amundsen, Smith, Peary, and Scott with an intensity similar to today's World Cup fever. Of equal media interest were the canines who served as companions to the explorers on these perilous expeditions. To the pet-loving masses, these scrappy dogs were as intriguing as any canine character London could concoct. So great was the fans' adoration of these dogs that American radio broadcast a barking serenade to Peary's canine team upon their successful arrival at the North Pole. Newspapers, magazines, books,

mass-produced postcards, and posters featuring photographs of the real-life "hero dogs" sold out as fast as they could be produced.

From the viewpoint of human-canine relations, the voyage of England's Captain Ernest Shackleton in 1914 stands apart as perhaps the greatest epic of survival. Shackleton, with twenty-seven men and sixty dogs, set out on what was considered the last great overland adventure – to cross the uncharted Antarctic on foot. One day and 100 miles short of land, the ship became icebound. Caught in the ice floes for over 20 months, the crew of the Endurance kept their spirit, if not their sanity, through the company of their dogs. The animals provided the men with purpose and diversion, and when the crew's food supply ran out, necessity forced the unthinkable. In the end, the ultimate canine sacrifice enabled the crew to survive. All of the dogs perished. On the journey was Frank Hurley, a gifted Australian photographer, whose images survived to show that the spirit of pluck and the power to endure had not passed from the human or canine soul.

The onset of World War I again created the need for canine help, heroes,

and sacrifice. There probably has not been a war in which the dog was not at man's side. Nature endowed this animal with unique attributes – an extraordinary sense of smell and hearing, unquestioning faithfulness, intelligence, adaptability, and an utter willingness to serve. In the Great War, the use of dogs was at its zenith. The Kaiser's army pressed over 30,000 into service, the French and Belgians drafted over 10,000. Aside from comfort to the spirit and soul, they transported equipment and supplies, rid the trenches of dreaded rats, carried messages, and searched for wounded. Their superior senses were able to detect the odor of deadly gas, the imminent arrival of artillery shells, and the presence of the enemy long before their human keepers. The cruelty of man's war extracted a heavy price. Over half of the dogs perished during, or as a consequence of, the war. Thousands of canines answered the call to duty, many "volunteered" by proud owners who regarded their pets as "just another member of the family" doing their part for the national good. Newspaper readers were not surprised to learn that the dogs of war often exceeded their training as couriers, scouts, and sentries

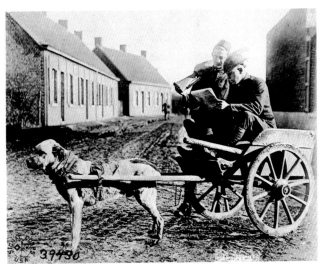

Unknown photographer, c. 1914

to demonstrate a genuine concern for their human compatriots, even at the cost of their lives. Ambulance dogs of the International Red Cross dodged bullets to search for the wounded in the crater-pocked "No Man's Land," prompting governments on both sides of the conflict to recognize these valorous creatures with medals and monuments.

War dogs became focal points for rallying troop morale and civilian support for the war effort. Indeed, such dogs did not belong to any one person but were regarded as pets of the whole nation. Stubby, a homeless mongrel smuggled into France in 1916 as a mascot for America's 102nd "Yankee" Infantry Division, achieved international fame after barking an alert to incoming mustard gas grenades, giving soldiers time to don their protective masks. His fame spread after he was wounded and transferred to a field hospital, where he hobbled about the ward to cheer bedridden troops. By the time Stubby returned stateside in 1918, *The Washington Post* was calling him the "Sergeant York of animals," and photographs of General Pershing decorating the dog for "heroism of the highest caliber" hit the front page of newspapers around the world.

After the war, dog and man settled back into domesticity. Civilian police dogs, sentries of the peacetime front, were praised with the same fervor as the dogs of war. Also publicly recognized were everyday pets who saved their masters from raging housefires or pulled drowning babies to shore. Another special canine appeared on the scene – an unassuming puppy who had been found abandoned during the war. Named Rin Tin Tin, he would be the first dog in a long line of fictional "superdogs" patterned after London's canine heroes, this time immortalized in the newest photographic medium of the modern era, the silent film.

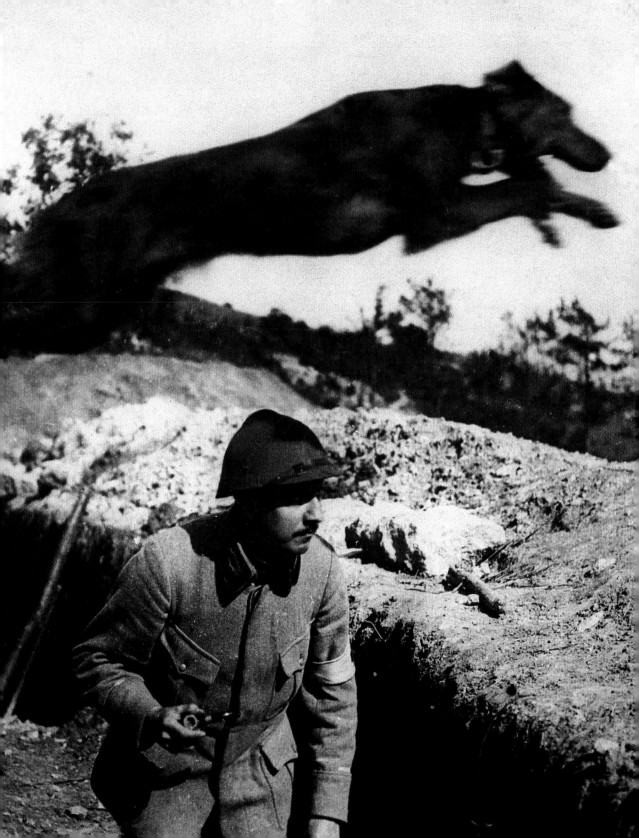

Helden

Die Jahrhundertwende leitete eine neue Ära individueller Freiheit ein, nicht nur für Menschen, sondern auch für Hunde. Treue und Gehorsam, Eigenschaften, die jahrhundertelang die Bedeutung des Wortes „Hund" ausgemacht hatten, wurden durch ein neues Hundebild ersetzt, eines, das nicht auf Erlerntem gründete, sondern auf der Fähigkeit als ein Wesen mit sozialem Gewissen zu handeln. Hunde, die zwar auf keinen besonderen Stammbaum verweisen konnten, dafür aber durch

Underwood & Underwood, 1927

mutiges und selbstloses Handeln Größe erlangten, wurden als Helden gefeiert. Diese Tiere waren nicht nur zur Unterhaltung gut, sie verkörperten den zunehmenden Glauben, dass jeder es zu etwas bringen könne, unabhängig von seiner „Kinderstube" oder Klassenzugehörigkeit, und deshalb Respekt verdiene.

Die Öffentlichkeit erlebte diese Helden des neuen Jahrhunderts, Menschen wie Hunde, als Wesen, die den Status quo in Frage stellten und auf abenteuerliche Art und Weise ihr Leben zum Besseren veränderten. Jack London, selbst ein Rebell und Held von fast mythischen Dimensionen, setzte Maßstäbe mit seinem ungemein populären Roman *Ruf der Wildnis*, der Geschichte eines Haushundes, der der Zivilisation den Rücken kehrt und in die ur-

sprüngliche Sicherheit der Wildnis zurückkehrt. In *Wolfsblut* findet diese Odyssee in umgekehrter Richtung statt und es stehen andere Werte im Mittelpunkt. Dass Jack London den heldenhaften Hund als Metapher benutzte für die Ambivalenz des Menschen zu Beginn der Moderne, traf einen blank liegenden Nerv. Die Sehnsucht nach Abenteuern, bei denen der Mensch seine Kräfte an der Natur und später an seinen Mitmenschen messen konnte, war zu Beginn des neuen Jahrhunderts groß – in nicht unerheblichem Maß eine Reaktion auf die rasch voranschreitende Industrialisierung.

Die Abenteuerlust war übermächtig. Die Erforschung der Pole, die damals noch als so fern und unerreichbar galten wie der Mond, spornte die Industrienationen zu einem Wettlauf an, mit dem Ziel, diese Regionen als Erste in Beschlag zu nehmen. Der Hund war ein unentbehrlicher Partner bei diesem Bemühen, und in diesem Fall war die Beziehung zu seinem Herrn nicht von Unterwürfigkeit geprägt, sondern von gegenseitiger Abhängigkeit. Bevor die Technik andere Möglichkeiten des Fortkommens im ewigen Eis ermöglichte, war der Hund der einzige, der über den Willen, das Durchhaltevermögen, die Entschlossenheit und den angeborenen Orientie-

rungssinn verfügte, um den Menschen ans Ende der Welt zu führen. Die Presse berichtete über jeden Schritt der Polarforscher Amundsen, Smith, Peary und Scott, ähnlich wie heute über die Fußballweltmeisterschaft berichtet wird. Dasselbe Medieninteresse genossen die Hunde, die den Forschern als Gefährten auf diesen gefährlichen Expeditionen zur Seite standen. Den Haustiere liebenden Massen erschienen diese rauflustigen Kerle so faszinierend wie jeder andere Hundetypus, den London zu bieten hatte. Die Fans waren so entzückt von diesen Hunden, dass der amerikanische Rundfunk für Pearys Hunde nach Erreichen des Nordpols ein gebelltes Ständchen ausstrahlte. Zeitungen, Zeitschriften, Bücher, als Massenware produzierte Postkarten und Poster mit Fotos der tierischen Helden konnten gar nicht so schnell gedruckt werden, wie sie verkauft wurden.

Was die Beziehung Mensch – Hund betrifft, unterscheidet sich die Expedition des englischen Kapitäns Shackleton im Jahr 1914 als vielleicht größtes Überlebensepos von allen anderen. Shackleton machte sich mit siebenundzwanzig Mann und sechzig Hunden zu dem, wie man annahm, letzten großen Überland-Abenteuer auf – zur Überquerung der unerforschten Antarktis zu Fuß. Eine Tagesreise und hundert Meilen vom Land entfernt wurde

das Schiff vom Eis eingeschlossen. Die Mannschaft der Endurance, die über zwanzig Monate von Eisschollen umgeben war, verdankte es der Gesellschaft ihrer Hunde, dass sie den Mut nicht verlor, ja vielleicht sogar, dass sie bei Verstand blieb. Die Tiere gaben dem Leben der Männer einen Sinn und boten ihnen Unterhaltung, und als die Lebensmittelvorräte der Mannschaft zu Ende gingen, verlangte die Not das Undenkbare. Am Ende überlebte die Mannschaft dank des Opfers der Hunde. Sämtliche Hunde mussten ihr Leben lassen. Zur Mannschaft gehörte auch Frank Hurley, ein begabter australischer Fotograf, dessen Bilder uns erhalten sind. Sie beweisen, dass Menschen und Hunde zu keiner Zeit Mut und Durchhaltekraft verloren.

Der Ausbruch des Ersten Weltkrieges verlangte wieder nach der Hilfe von Hunden, nach Hunde-Helden und -Opfern. Wahrscheinlich gab es keinen Krieg, bei dem der Hund nicht an der Seite des Menschen stand. Die Natur hat dieses Tier mit einzigartigen Eigenschaften ausgestattet, mit einem außergewöhnlichen Geruchssinn und eben solchem Gehör, bedingungsloser Treue, Intelligenz, Anpassungsfähigkeit und einer nicht zu übertreffenden Bereitschaft zu dienen. Im Ersten Weltkrieg stand der Einsatz von Hunden im Zenit. In der Armee des Kaisers dienten über dreißigtausend, bei den Franzosen und

Frank Hurley, 1915

Belgiern über zehntausend Hunde. Sie waren nicht nur Trost für Seele und Geist, sondern transportierten auch Ausrüstung und Vorräte, säuberten die Schützengräben von den gefürchteten Ratten, übermittelten Nachrichten und suchten nach Verwundeten. Mit ihren scharfen Sinnen spürten sie tödliches Gas, den bevorstehenden Einschlag von Artilleriegeschossen und den Feind lange vor ihren Herren auf. Die Grausamkeit des Krieges forderte einen hohen Preis. Mehr als die Hälfte der Hunde starb während oder infolge des Krieges. Tausende von Hunden wurden eingezogen, viele „meldeten" sich freiwillig. Ihre stolzen Besitzer sahen in ihren Haustieren Familienmitglieder, die wie die anderen ihren Teil beitrugen zum Wohl des Vaterlandes. Zeitungsleser waren nicht überrascht, wenn sie lasen, dass Kriegshunde oft weit mehr taten als das, was sie als Kuriere, Kundschafter und Wachposten gelernt hatten und echte Sorge für ihre menschlichen Mitstreiter an den Tag legten, selbst wenn sie dies mit dem Leben bezahlen mussten. Die Ambulanz-Hunde des Internationalen Roten Kreuzes suchten auch im Kugelhagel in dem von Kratern übersäten Niemandsland nach verwundeten Landsern, was Regierungen auf beiden Seiten dazu veranlasste, diese tapferen Tiere mit Medaillen und Denkmälern zu ehren.

Kriegshunde wurden zu unersetzlichen Helfern, wenn es um die Moral der Truppe und die zivile Unterstützung der Kriegsziele ging. Diese Hunde gehörten nicht mehr Einzelpersonen, sondern der gesamten Nation. Stubby, ein streunender Misch-

ling, der 1916 als Maskottchen der 102. Amerikanischen „Yankee"-Infanterie-Division nach Frankreich geschmuggelt worden war, erlangte internationalen Ruhm, nachdem er beim Anflug von Senfgas-Granaten Alarm gebellt hatte, sodass die Soldaten rechtzeitig ihre Schutzmasken aufsetzen konnten. Noch berühmter wurde er, nachdem er verwundet und in ein Feldlazarett gebracht worden war, wo er durch den Saal humpelte und kranke Soldaten aufmunterte. Als Stubby 1918 in die Staaten zurückkehrte, nannte die Washington Post ihn „Sergeant York der Tiere", und Fotos mit General Pershing, der den Hund für „Tapferkeit höchsten Grades" auszeichnete, erschienen auf den Titelseiten der Zeitungen rund um den Globus.

Nach dem Krieg kehrten Hund und Mensch wieder zum häuslichen Leben zurück. Zivile Polizeihunde, Wachposten an der Friedensfront, standen in genauso hohem Ansehen wie die Kriegshunde. Öffentlich ausgezeichnet wurden auch gewöhnliche Haushunde, die ihre Herrchen aus brennenden Häusern oder Babys vor dem Ertrinken gerettet hatten. Und ein weiterer, ganz besonderer Hund erschien auf der Bildfläche, ein anspruchsloser Welpe, der während des Krieges ausgesetzt und gefunden worden war. Man nannte ihn Rin Tin Tin, und er wurde der erste Hund in einer langen Reihe fiktiver „Superhunde", die Londons Hunde-Helden zum Vorbild hatten, doch nun durch das neueste Medium der modernen Zeit, den Stummfilm, Unsterblichkeit erlangen sollten.

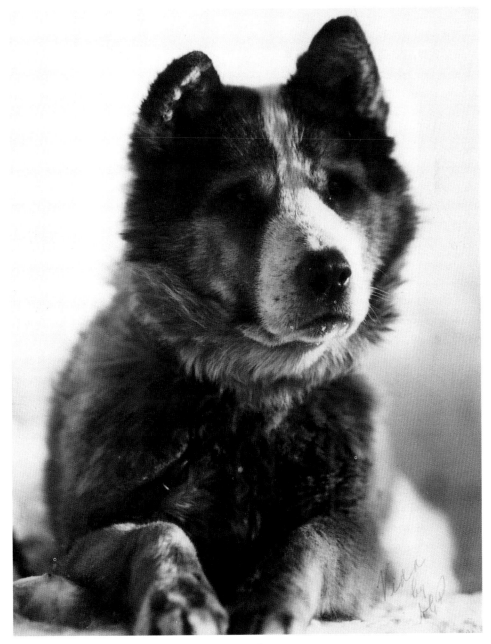

Herbert G. Ponting, c. 1912

Héros

Le tournant du siècle marqua une nouvelle affirmation de l'individualité, pas seulement pour les gens mais aussi pour les chiens. La fidélité et l'obéissance qui, des siècles durant, avaient défini le sens même du mot « chien », furent supplantés par une nouvelle image de cet animal, dont on n'attendait plus une réaction conditionnée mais la capacité d'agir comme un être doué d'une conscience sociale. Des chiens au pedigree sans valeur, mais qui s'étaient signalés par des actions courageuses et altruistes, furent salués comme des héros populaires. Ceux-là firent davantage qu'amuser : ils incarnaient la conviction, de plus en plus répandue, que chacun pouvait réussir, quelles que soient ses origines et sa classe sociale, et, par conséquent que chacun était digne de respect.

Pour le public, ces héros du siècle nouveau, qu'ils fussent humains ou canins, étaient perçus comme des défis à l'ordre établi, capables de s'élever au moyen de l'aventure. Les écrits de Jack London, lui-même héros rebelle d'envergure quasi mythique, donnèrent le ton. Son livre, l'*Appel de la forêt*, connut un formidable succès populaire, avec cette histoire d'un chien domestique qui rejette la civilisation et retourne vers la sécurité primitive de la nature

Unknown photographer, 1925

sauvage. Avec *Croc-Blanc*, il inversa cette odyssée, et atteint une toute autre apothéose. Son utilisation du chien héroïque comme métaphore de l'ambivalence de l'homme face à l'émergence de la modernité, frappa dans le vif du sujet. Dans la première partie du nouveau siècle, on retrouve sans cesse ce besoin d'aventure où l'homme se confronte à la nature, puis à ses propres congénères, pour des raisons dues, en grande partie, à la montée rapide de l'industrialisation.

La soif d'aventure était partout. L'exploration des calottes polaires, considérées jusqu'alors comme aussi lointaines et inaccessibles que la lune, suscita une compétition entre les nations industrielles qui cherchaient à s'approprier ces ultimes territoires. Dans cet effort, le chien s'imposa comme le partenaire indispensable et, dans ce cas précis, sa relation avec son maître ne s'inscrivit plus dans la servilité, mais dans l'interdépendance. Avant les progrès d'équipement mécanique, le chien était le seul animal à posséder la volonté, la résistance, la détermination et ce sens inné lui permettant de mener l'homme aux fins fonds de la planète. La presse suivit les exploits des explorateurs de l'Arctique – Amundsen, Smith, Peary, Scott – avec un intérêt qui n'est pas sans rappeler aujourd'hui notre

Coupe du Monde. On retrouve ce même intérêt médiatique pour les chiens qui servirent de compagnons aux explorateurs, au péril de leur vie. Pour tous les amoureux de chiens de compagnie, ces bêtes hirsutes avaient des comportements aussi étonnants que n'importe quel animal inspiré d'un roman de Jack London. La passion pour ces bêtes se fit si grande que, pour rendre hommage à la meute de Peary et célébrer triomphalement leur arrivée au Pôle Nord, la radio américaine diffusa une sérénade d'aboiements. Journaux, magazines, livres, cartes postales et affiches en séries, avec des photos de ces « chiens-héros », se vendirent aussi vite qu'ils apparaissaient sur le marché.

Du point de vue des relations entre l'homme et le chien, le voyage du capitaine britannique Ernest Shackleton, en 1914, tient une place à part. Il s'agit sans aucun doute de l'épopée la plus grandiose dans le domaine de la survie. Avec 27 hommes et 60 chiens, Shackleton entreprit ce qui fut alors considéré comme la dernière grande aventure sur terre – la première traversée à pied de l'Antarctique inconnu. Un jour, à cent miles de la côte, son bateau fut pris par les glaces. Prisonnier de la banquise pendant plus de vingt mois, l'équipage de l'Endurance garda le moral, sinon la raison, grâce à la compagnie des chiens. Ceux-ci offrirent aux

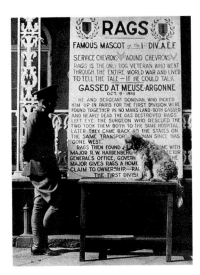

hommes occupation et divertissement, et quand les provisions vinrent à manquer, la nécessité obligea à l'impensable. Pour finir, ce fut le sacrifice des chiens qui permit la survie des hommes. Tous les chiens périrent. A cette expédition participait Frank Hurley, talentueux photographe australien, dont les photos nous sont parvenues pour témoigner que ni le cran ni la capacité d'endurance n'avait manqué à l'âme humaine ou canine.

L'éclatement de la Première Guerre mondiale mit de nouveau en évidence le besoin de la présence canine, de héros et de sacrifices. Il n'y eut, semble-t-il, pas de guerre dans laquelle le chien ne se retrouva aux côtés de l'homme. La nature a doté cet animal d'attributs uniques : un odorat et une ouïe exceptionnels, une fidélité absolue, de l'intelligence, de l'adaptabilité, et le souci profond de se rendre utile. Pendant la Grande Guerre, l'utilisation des chiens fut à son apogée. L'armée du Kaiser en introduisit plus de 30 000 dans ses rangs. Les Français et les Belges en recrutèrent plus de 10 000. En plus du réconfort moral et spirituel qu'ils apportaient, les chiens furent employés au transport de l'équipement et de l'approvisionnement. Ils débarrassèrent les tranchées des terribles rats, ils portèrent les messages, ils recherchèrent les blessés. Leur subtil odorat leur permettait de

détecter, bien avant leurs maîtres et gardiens, les gaz mortels, l'arrivée imminente des obus et la présence de l'ennemi. Ils payèrent un lourd tribut à cette cruelle guerre des hommes. Plus de la moitié d'entre eux périrent pendant, ou des suites, du conflit. Des milliers d'entre eux répondirent à l'appel du devoir, souvent présentés comme « bénévoles » par leurs fiers propriétaires, pour qui leur animal « faisait partie de la famille », et accomplissait son devoir pour le bien la nation. Les lecteurs de journaux ne furent pas surpris d'apprendre que souvent, par-delà leur entraînement en tant que messagers, éclaireurs ou sentinelles, les chiens manifestaient un souci profond pour leurs compatriotes humains, parfois même au prix de leur vie. Les chiens d'ambulance de la Croix Rouge Internationale essuyèrent des coups de feu en partant à la recherche de jeunes poilus blessés dans les no man's lands criblés de cratères, forçant les gouvernants des deux côtés du conflit à octroyer médailles et monuments à ces valeureux animaux.

Ces chiens de guerre devinrent un élément essentiel pour rallier le moral des troupes et le soutien des civils à l'effort de guerre. De fait, ces chiens n'appartenait à personne en particulier, mais ils étaient choyés par la nation toute entière. Bâtard errant, introduit frauduleusement en France en 1916 comme mascotte de la 102e division d'infanterie

américaine, Stubby connut une renommée internationale pour avoir, par ses aboiements, donné l'alerte à l'arrivée imminente de grenades au gaz moutarde, juste à temps pour que les soldats puissent enfiler leur masque. Sa célébrité ne fit que grandir quand, blessé, il fut transporté dans un hôpital de campagne, où il traîna parmi les lits en boitillant et égaya les soldats grabataires. Quand en 1918, Stubby rentra au bercail, le Washington Post l'avait surnommé le « Sergent York des animaux », tandis que des photos du général Pershing le décorant pour « héroïsme au plus haut degré » s'étalaient à la une des journaux du monde entier.

Après la guerre, l'homme et le chien se réinstallèrent dans la vie domestique. Les chiens policiers, sentinelles civiles en temps de paix, furent célébrés avec la même ferveur que les chiens de guerre. De même, on glorifia publiquement les chiens sans grade qui avaient sauvé leur maître d'incendies dévastateurs ou qui avaient tiré des bébés de la noyade. Un autre canin apparut sur le devant de la scène : un gentil petit chiot abandonné pendant la guerre. Affublé du nom de Rin Tin Tin, il allait être le premier d'une longue lignée de « superchiens », calqués sur le modèle des héros londoniens. Mais celui-là allait être immortalisé par le dernier-né des médias photographique : le film muet.

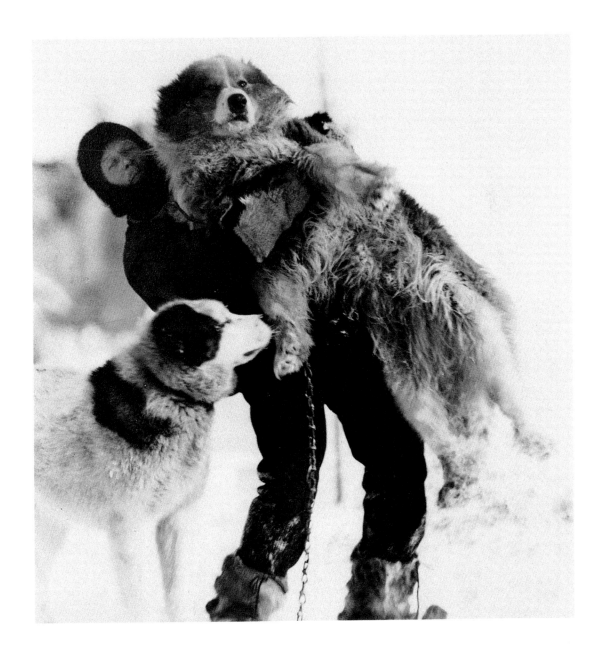

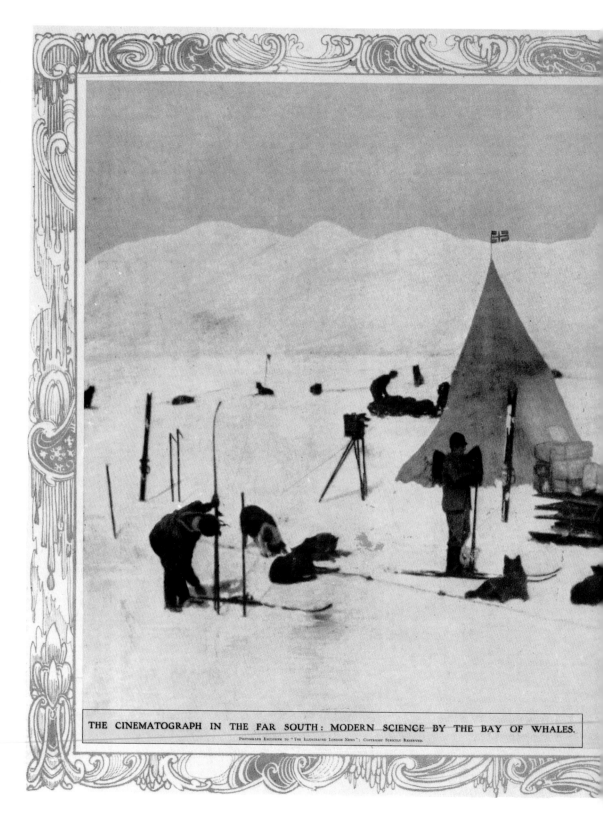

THE CINEMATOGRAPH IN THE FAR SOUTH: MODERN SCIENCE BY THE BAY OF WHALES.

Photograph Exclusive to "The Illustrated London News"; Copyright Strictly Reserved.

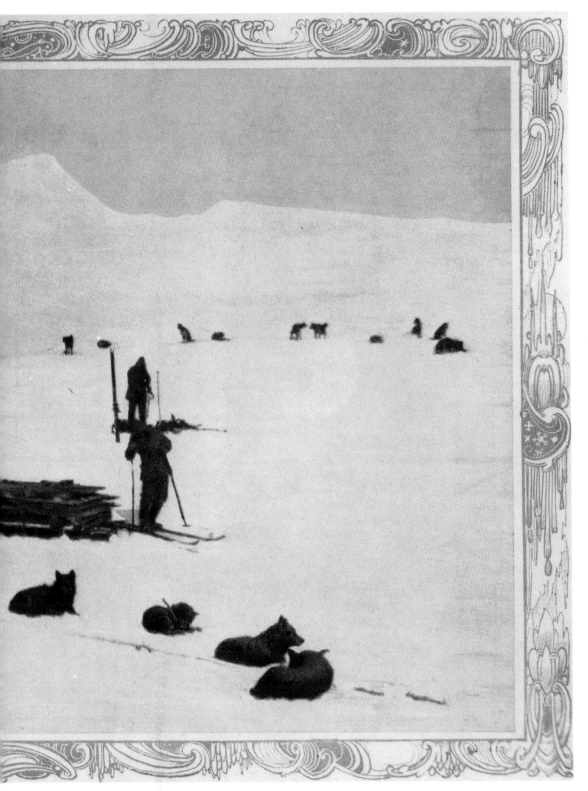

Unknown photographer, 1912

Austrian Archives, 1930

Unknown photographer, 1912

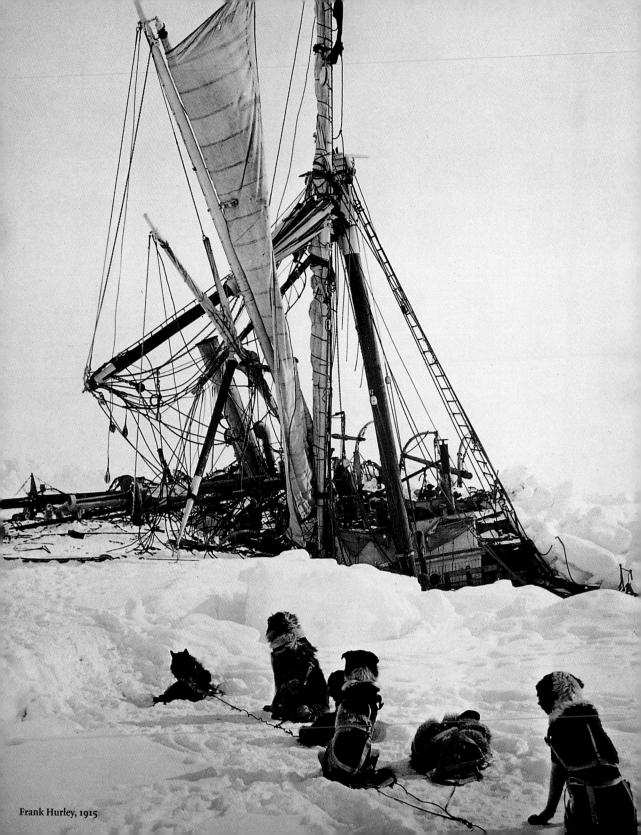

Frank Hurley, 1915

How dreary the frozen captivity of our life but for the dogs. During the winter months, when there was no sun, and the whole world was grey and trackless, when an ice hummock was not distinguishable from a hole, it was impossible for a human being to keep a direct course; but an intelligent leader – such a dog as old Shakespeare – once put on a set course, would pilot his team unerringly.

Astonishing too was the complete understanding and sympathy that grew up between dog and man. Time and again during some moment of acute danger the dogs responded to orders with an alacrity they had never displayed before. The sledge dog is a most accommodating animal in his diet. If pressed by hunger he will cheerfully consume his brother in harness and if hard pushed will make a meal of the harness itself. Fortunately the dogs of the Endurance were never reduced to such desperate straits …

Wie freudlos wäre unser Leben in eisiger Gefangenschaft ohne die Hunde gewesen. Während der Wintermonate, als die Sonne nicht schien und die ganze Welt grau und trostlos war, als ein Hügel aus Eis nicht von einem Loch im Eis zu unterscheiden war, konnte ein Mensch unmöglich einen geraden Kurs halten; doch ein intelligenter Führer, ein Hund wie der alte Shakespeare, lotste seine Mannschaft unbeirrt, wenn man ihm einmal die Richtung gewiesen hatte.

Erstaunlich waren auch das vollkommene Verständnis und die tiefe Sympathie, die zwischen Hund und Mensch herrschten. In Augenblicken akuter Gefahr gehorchten die Hunde immer wieder den Befehlen mit einem Eifer, den sie nie zuvor an den Tag gelegt hatten. Der Schlittenhund ist das am wenigsten wählerische Tier, wenn es ums Futter geht. Wenn der Hunger ihn quält, frisst er bedenkenlos seinen Kameraden im Geschirr, und wenn die Not noch größer wird, das Geschirr dazu. Zum Glück war die Not der Hunde auf der Endurance nie so groß …

Quelle horreur, que cette captivité glaciale qu'était notre vie, si nous n'avions eu la présence des chiens. Pendant les mois d'hiver, en l'absence du soleil, le monde entier était gris et sans chemins. Un monticule de glace étant indiscernable d'un trou. Il était impossible pour l'être humain d'aller droit devant lui. Mais un meneur intelligent, tel notre chien Shakespeare, une fois sur la bonne piste, savait diriger son équipe, sans faille.

Etonnante aussi, la compréhension totale et la sympathie qui se développèrent entre le chien et l'homme. Plus d'une fois, en des moments de cruel danger, les chiens répondirent avec un empressement dont ils n'avaient jamais fait preuve auparavant. Le chien de traîneau est un animal fort accommodant pour son alimentation. Poussé par la faim, il consommera joyeusement son frère de harnais, et acculé à ses limites, il avalera jusqu'à son propre harnais. Heureusement, les chiens de l'Endurance ne furent jamais confrontés à une situation aussi désespérée …

FRANK HURLEY
Argonauts of the South · Argonauten des Südens · Argonautes du Sud

Frank Hurley, 1915

World War I
Der Erste Weltkrieg
La Première Guerre mondiale

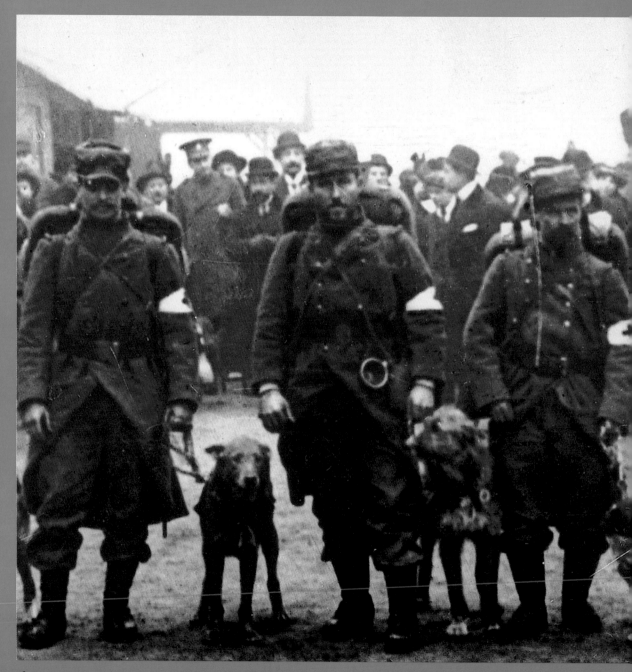

Unknown photographer, 1914

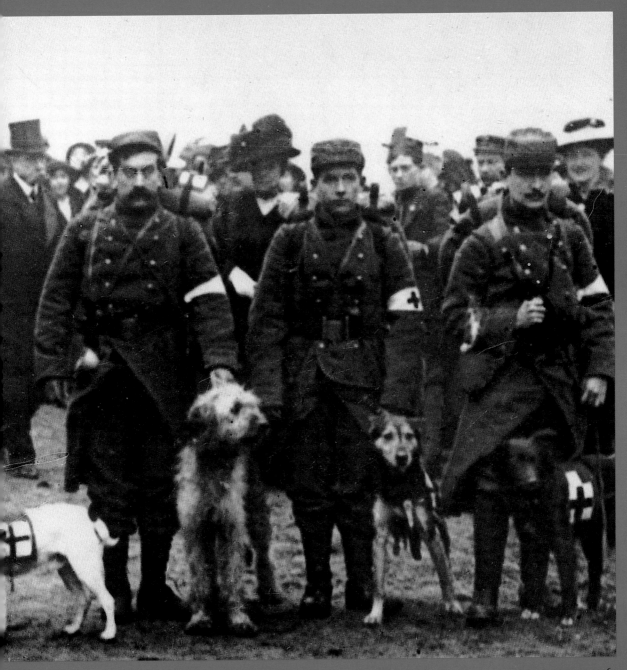

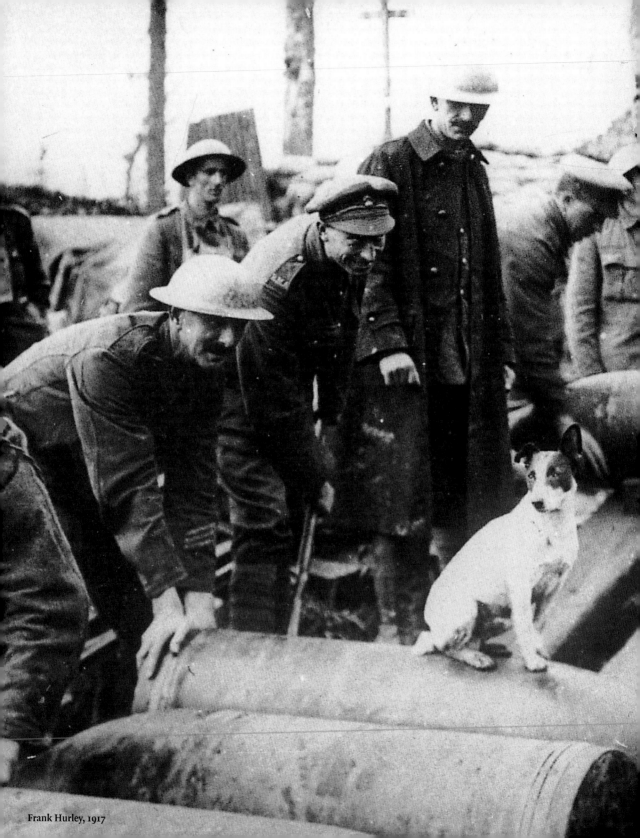

Frank Hurley, 1917

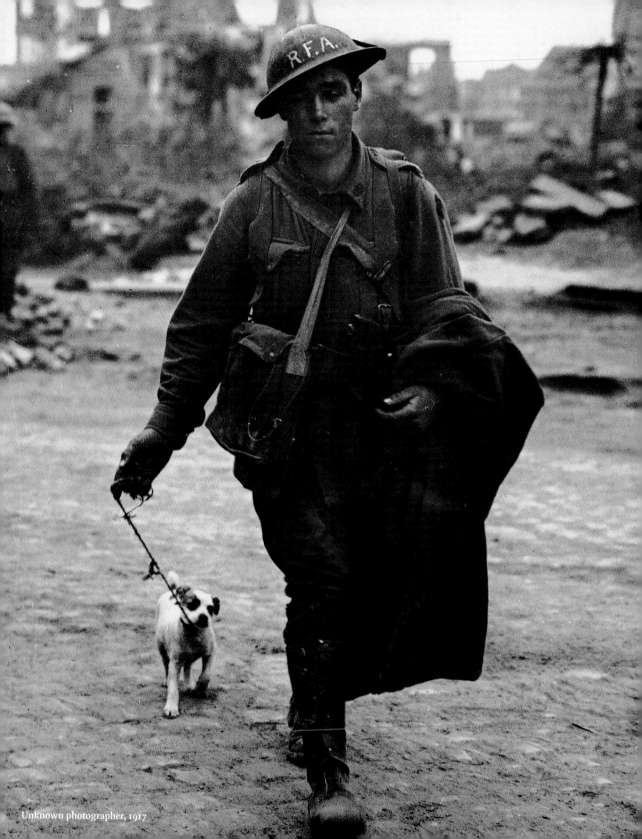

Unknown photographer, 1917

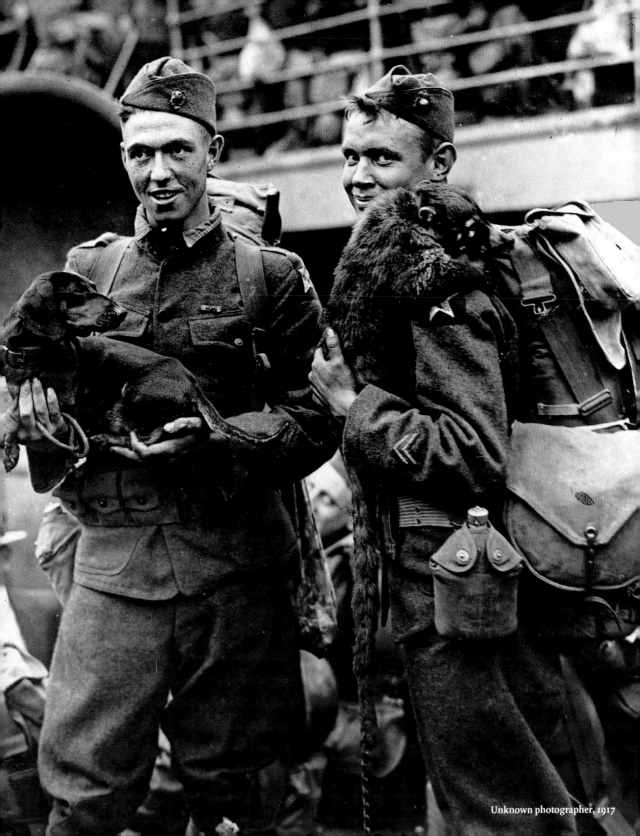

Unknown photographer, 1917

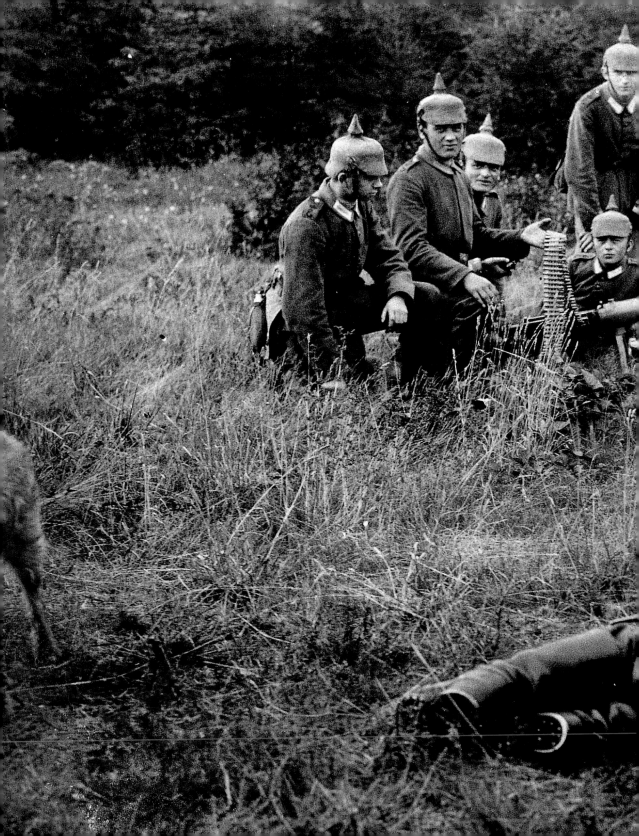

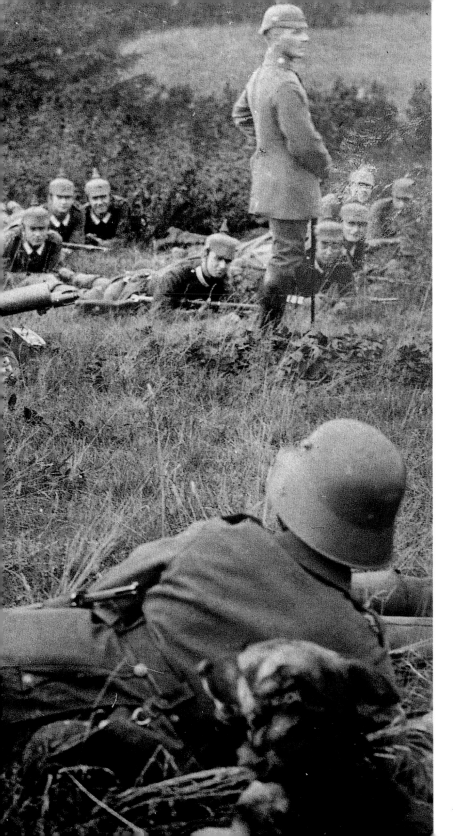

Unknown photographer, 1916

Dogs are the only creatures
gifted to serve us
beyond the call of duty.

Hunde sind die einzigen Wesen,
die bereit sind, uns über den Ruf der Pflicht
hinaus zu dienen.

Les chiens sont les seules créatures
douées pour nous servir
au-delà de l'appel du devoir.

C.W. MEISTERFELD

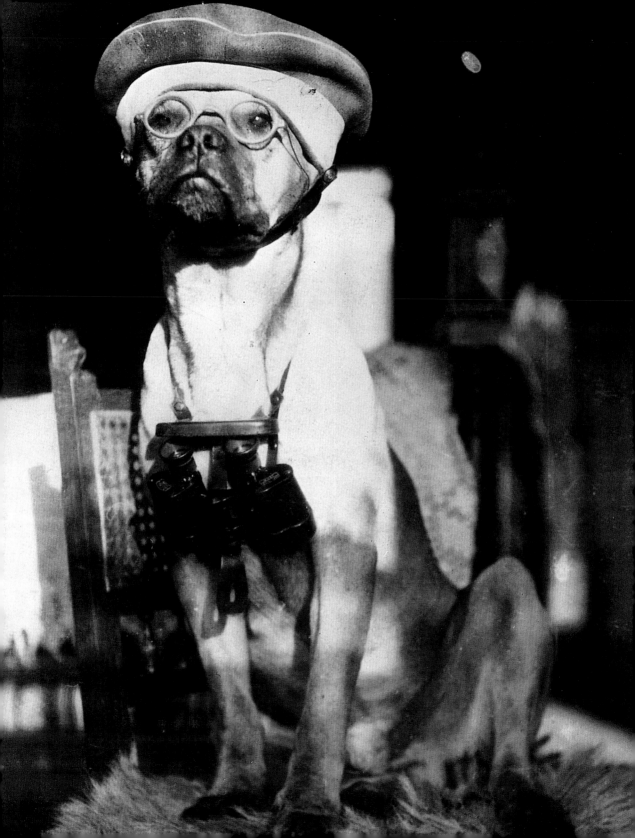

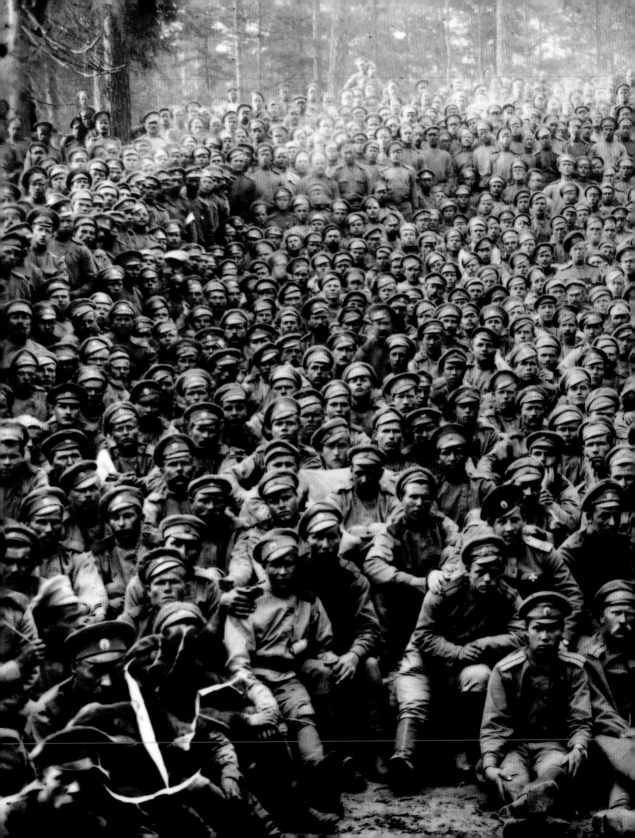

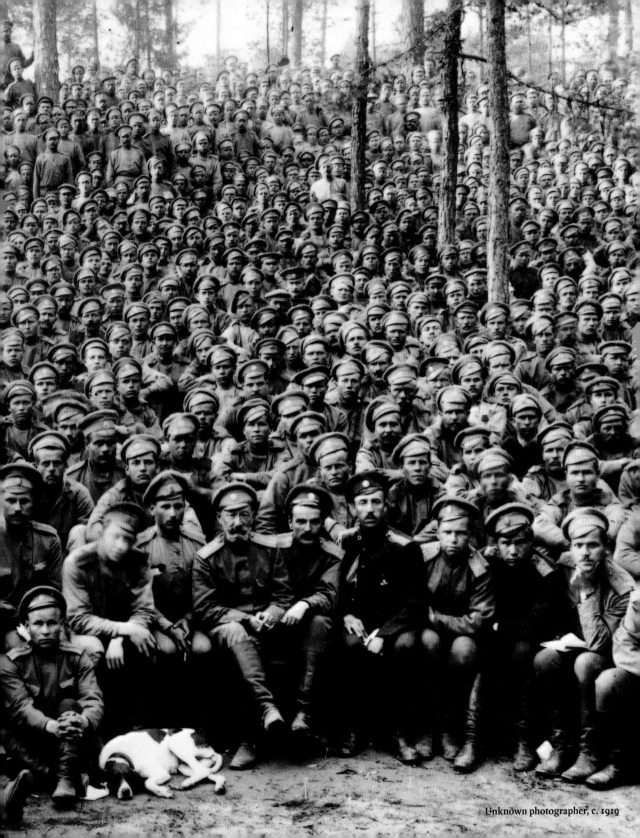

Unknown photographer, c. 1919

Happy is the country
that requires no heroes.

Unglücklich das Land,
das Helden nötig hat.

Heureux le pays
qui n'exige pas de héros.

BERTOLT BRECHT

Unknown photographer, c. 1900

Decades of Development

The turn of the century occurred in the midst of photography's defining decades. The Kodak, the first commercially available handheld camera, was introduced in 1880, featuring rolled film that produced small circular pictures. This singular advance transformed photography from a predominantly professional activity into one in which the general public could now participate. By 1900, the Eastman Kodak Company introduced a further refinement in cameras, the "Brownie" box, named after then popular, fairy-like characters. Its simplicity and low cost made it immensely popular, putting millions of cameras in the hands of people hungry for the opportunity to record life on film, while at the same time expanding the professional's boundaries both commercially and aesthetically. These new advances, involving lighter cameras and equipment and faster film, permitted photographers to take the camera almost everywhere, in virtually all conditions, and to obtain a tonality and sharpness that had heretofore escaped them. Photography became a thoroughly modern pastime compatible with the "age moderne," and, for those born after 1880, it became embroidered into the fabric of everyday life.

In the arts, a movement known as Pictorialism developed and became the predominant photographic mode of the period. Its goal was to transform photography into art. Elevating beauty over factual representation with soft-focus renderings, photographers were able to express themselves in an impressionistic style through print manipulation, as illustrated by the early works of Peter Henry Emerson, Arnold Genthe, Rudolph Eickemeyer, Jr., Gertrude Käsebier, and Alfred Stieglitz.

Freed from the necessity of capturing the mundane, the art photographer could now focus on not only creative but also social concerns. Alice Austen recorded images of the urban rich, while Jacob Riis and Lewis Hine concerned themselves with the camera as a tool for social change. Photography was also suited for documenting swiftly changing societies, and photographers such as William Henry Jackson, Edward S. Curtis, and August Sander were renowned for their work in that genre.

In order to keep photography's artistic toehold intact, an informal organization of influential pictorial photographers known as Photo-Secession was formed by Stieglitz. Barely a concept at first, it became the worldwide focal point for the finest artistic photography in the new century. The spirit of the group was the same as that which guided other similar organizations such as the Linked Ring Brotherhood in England, the Photo-Club de Paris, and the Secessionist Movement in Germany. The goal of these organizations was to secede ideologically from the existing professional photographic societies in order to foster the recognition of photography as a distinctive medium capable of individual artistic expression.

The uncertainties of the times, however, caused tensions to develop. Edward Steichen commented in a letter to Stieglitz that "one is conscious of unrest

and seeking – a weird world, hungry for something that we evidently haven't got and don't understand ... something is being born, or about to be." This angst would lead to innovative initiatives. From the carnage of World War I, photography began to mirror other European art movements. Photographers drew from the Dadaist movement and began to express their intuition through chance effects, valuing expression over content. With the tech-

Edward Steichen, 1915

niques of photomontage, photo-collage, and photograms, photographers were able to display personal ideas and attitudes with new visual potency. Fueled by the energy of the Constructivist, Bauhaus, Werkbund, and Surrealist movements, photographers placed the camera at unconventional vantage points to better express the artist's personal perceptions, often through the symbolism of found objects and chance reflections. Karl Blossfeldt and Albert Renger-Patzsch brought their cameras close to their subjects to eliminate the extraneous, while Alexander Rodchenko's images revealed the shapes, textures, and curious design of ordinary life. These predominantly German techniques and sensibilities found their way to America and into the works of Stieglitz,

Steichen, and Paul Strand. They were also manifest in the works of the great photographers working in France, led by Eugène Atget, André Kertész, and the adolescent Jacques-Henri Lartigue, each of whom added elements of poetry, compassion, and wit to blunt the didactics and formalism of this new vision.

During this same period, photojournalism as we now know it came of age. Improvements in halftone processes in the 1880s and 1890s expanded the use of photography and began to bring a new acuity to periodical illustrations. By the second decade of the twentieth century, major newspapers regularly used line or dothalftones in their pages and issued weekly pictorial supplements of photographs reproduced by the higher-quality rotogravure process. In the mid-twenties Ermanox, with its astonishingly fast f/2 lens, and the Leica, which took thirty-six exposures on a single load of 35mm film, were introduced. Using highly sensitive film, these new cameras made handheld photography feasible utilizing only available light and brought a new sense of spontaneity and intimacy to journalistic imaging.

In the twenties, Germany had more illustrated periodicals with greater circulation than any other

country. Editors were aggressively imaginative in their ideas for stories, attracting photographers who were anxious to undertake the new and difficult assignments. One such photographer was Erich Salomon, who insinuated himself into privileged situations, such as political meetings, courtrooms, and diplomatic gatherings, and was able to capture uniquely candid moments on film. His success made him perhaps the first modern photojournalist. He, along with others such as Robert Capa, David (Chim) Seymour, Martin Munkacsi, Felix H. Man, Alfred Eisenstaedt, Henri Cartier-Bresson, Margaret Bourke-White, and Umbo (Otto Umbehr), set a standard that lasted throughout the rest of the century.

In many respects, this period's photographic advances were pivotal and nothing less than heroic. Walter Lippman's observation about these times was most apt: "We have a world bursting with new ideas, new plans and new hopes. The world was never so young as it is today, so impatient with old and crusty things." Photography's newfound inventiveness and immediacy made it an indisputable stimulus for journalism and advertising without dimming its artistic luster. It became the most potent antidote for modernism's inevitable infection of the human spirit, and, as can be gleaned from the following images, the dog served the photographer well as subject and metaphor to help maintain that spirit.

Thomas Eakins, c. 1890

Jahrzehnte der Weiterentwicklung

Die Jahrhundertwende fiel in die entscheidenden Jahrzehnte der Fotografie. Die Kodak-Kamera, die erste im Handel erhältliche Handkamera, die kleine runde Bilder produzierte, kam 1880 auf den Markt. Diese einzigartige Erfindung veränderte die Fotografie: Wurde sie bisher hauptsächlich von Profis ausgeübt, konnte sich jetzt jedermann darin versuchen. 1900 stellte die Eastman Kodak Company eine weitere Verbesserung in Sachen Kamera vor, die „Brownie", benannt nach damals populären feenhaften Gestalten. Die einfache Handhabung und der geringe Preis machten sie ungeheuer beliebt und eröffnete Millionen von Menschen die Gelegenheit, ihr Leben auf Film zu bannen. Gleichzeitig eröffneten sich den Berufsfotografen sowohl in kommerzieller als auch in ästhetischer Hinsicht ungeahnte Möglichkeiten: Kameras sowie Zubehör waren leichter geworden, die Kamera konnte nun überallhin mitgenommen werden. Das mühselige Wechseln der Platten entfiel, sodass wesentlich mehr Fotos kurz hintereinander geschossen werden konnten. Neue Techniken ermöglichten eine bis dahin unbekannte Schärfe und Abstufung der Tonwerte. Die Fotografie wurde zu einer durch und durch modernen Freizeitbeschäftigung, der neuen Zeit angemessen, und für die nach 1880 Geborenen war sie aus dem täglichen Leben bald nicht mehr wegzudenken.

In der bildenden Kunst formierte sich der Piktoralismus, eine Bewegung, deren Ziel die Anerkennung der Fotografie als Kunstform war und deren Ansätze für die Fotografie dieser Zeit prägend werden sollten. Dem Dogma der realistischen Wiedergabe stellte der Piktoralismus beispielsweise in gewollt unscharfen Aufnahmen eine neue Ästhetik entgegen. Die neuen Möglichkeiten, in den Entwicklungsprozess des einzelnen Fotos einzugreifen, erlaubte es der Fotografie, zu impressionistischen Ausdrucksformen zu finden, wie die frühen Arbeiten von Peter Henry Emerson, Rudolph Eickemeyer jr., Gertrude Käsebier und Alfred Stieglitz zeigen.

Von dem Zwang befreit, das Profane einzufangen, konnte der Fotokünstler sich nicht nur auf kreative, sondern auch auf soziale Belange konzentrieren. Arnold Genthe fotografierte wohlhabende Städter, während Jacob Riis und Lewis Hine die Kamera als Werkzeug für soziale Veränderungen einsetzten und Fotografen wie William Henry Jackson, Edward S. Curtis und August Sander berühmt wurden für ihre fotografischen Dokumentationen des raschen gesellschaftlichen Wandels.

1902 gründete Alfred Stieglitz gemeinsam mit anderen Fotografen die Photo-Secession, eine informelle Vereinigung einflussreicher, hauptsächlich amerikanischer Fotografen, deren Credo die Fotografie als spiritueller Ausdruck des Künstlers war. Was als einfaches Konzept begann, wurde zum weltweiten Sammelpunkt der besten Fotokunst des neuen Jahrhunderts. In Europa fanden diese Ideen ihren Niederschlag in der Gründung der Linked Ring Brotherhood in England, des Photo-Club de Paris und der Sezession in Deutschland. Ziel dieser Gruppierungen war es, sich ideologisch von den

Berufsfotografen abzugrenzen und die Anerkennung der Fotografie als eigenständiges Medium mit der Möglichkeit zu individuellem künstlerischem Ausdruck zu erreichen.

Im Vorfeld des Ersten Weltkriegs waren auf allen Ebenen Spannungen spürbar. Edward Steichen äußerte in einem Brief an Alfred Stieglitz, dass „man sich einer Unruhe und eines Suchens bewusst ist – eine seltsame Welt, gierig nach etwas, das wir offensichtlich nicht haben und nicht verstehen ... etwas wird gerade oder in naher Zukunft geboren." Diese Unruhe sollte zu innovativen Initiativen führen. Vom Ersten Weltkrieg an begann die Fotografie, andere europäische Kunstrichtungen zu spiegeln. Der Dadaismus war eine wesentliche Inspirationsquelle, die Fotografen drückten ihr intuitives Empfinden durch scheinbar dem Zufall überlassene Effekte aus, wobei der Ausdruck über den Inhalt dominierte. Fotomontage, Fotocollage und Fotogramm wurden zu den künstlerischen Formen, die es den Fotografen erlaubten, ihre persönlichen Vorstellungen und Einstellungen visuell neu- und andersartig auszudrücken. Angespornt von der Energie des Konstruktivismus, von Bauhaus, Werkbund und Surrealismus, wählten die Fotografen unkonventionelle Ausgangspunkte für

George Seeley, c. 1907

ihre Arbeiten, wie etwa die Symbolik von Fundstücken oder zufälligen Spiegelungen, um die persönlichen Wahrnehmungen des Künstlers besser zum Ausdruck zu bringen. Um alles Unwesentliche auszuschalten, brachten Karl Blossfeldt und Albert Renger-Patzsch ihre Kameras unmittelbar an das Motiv heran, während Alexander Rodschenkos Bilder die Formen, Strukturen und Merkwürdigkeiten des alltäglichen Lebens sichtbar machten. Diese innovative künstlerische Herangehensweise vorrangig deutscher Fotografen fand ihren Weg nach Amerika und in das Werk von Alfred Stieglitz, Edward Steichen und Paul Strand, manifestierte sich aber auch in der Arbeit der großen Fotografen Frankreichs, darunter André Kertész und der junge Jacques-Henri Lartigue und allen voran Eugène Atget, die eigene Elemente der Poesie, des Gefühls und des Witzes hinzufügten, um Didaktik und Formalismus dieser neuen Darstellungsweise etwas abzumildern.

In derselben Zeit entwuchs der Fotojournalismus, wie wir ihn heute kennen, den Kinderschuhen. Verbesserungen bei Halbton-Aufnahmen in den 1880er und 1890er Jahren erschlossen neue Verwendungsmöglichkeiten für die Fotografie und ermöglichten eine bislang unerreichte Schärfe bei Abbil-

dungen in Zeitschriften. In den zwanziger Jahren des 20. Jahrhunderts wurden die größeren Zeitungen gewöhnlich mit Linien- oder Punktraster gedruckt, die veröffentlichten Fotos wurden im Tiefdruckverfahren reproduziert, das eine bessere Qualität ergab. Mitte der zwanziger Jahre kamen die Ermanox-Kamera mit extrem lichtstarken f/2-Objektiven und die Leica mit 35-mm-Film für 36 Aufnahmen auf den Markt. Diese neuen Kameras, die mit hoch empfindlichem Filmmaterial arbeiteten, führten bei Aufnahmen ohne Stativ zu wirklich brauchbaren Ergebnissen, weil sie das jeweils vorhandene Licht nutzten. Sie brachten in den Bildjournalismus eine neue Spontaneität und Intimität.

Deutschland hatte in den zwanziger Jahren eine größere Vielzahl an auflagenstarken Zeitschriften als jedes andere Land. Die Herausgeber waren auf aggressive Art einfallsreich, was ihre Geschichten betraf, und zogen Fotografen an, die liebend gern die neuen und schwierigen Aufgaben übernahmen. Einer dieser Fotografen war Erich Salomon. Ihm gelang es, zu politischen Sitzungen, Gerichtsverhandlungen oder diplomatischen Treffen zugelassen zu werden, bei denen er einzigartige Momente auf Film bannte. Sein Erfolg machte ihn vielleicht zum ersten modernen Fotojournalisten. Mit Robert Capa, David (Chim) Seymour, Martin Munkacsi, Felix H. Man, Alfred Eisenstaedt, Henri Cartier-Bresson, Margaret Bourke-White, Umbo (Otto Umbehr) und anderen setzte er Maßstäbe, an denen man sich für den Rest des Jahrhunderts orientierte.

In vielerlei Hinsicht waren die Fortschritte auf dem Gebiet der Fotografie in dieser Zeit von zentraler Bedeutung und vorbildhaftem Charakter. Walter Lippmans Einschätzung dieser Zeit trifft es genau: „Unsere Welt platzt fast aus den Nähten vor neuen Ideen, neuen Plänen und neuen Hoffnungen. Die Welt war noch nie so jung wie heute, so ungeduldig gegenüber Altem und Verkrustetem." Der neu entdeckte Einfallsreichtum und die Unmittelbarkeit machten die Fotografie zu einem unbestrittenen Stimulus für Journalismus und Werbung, ohne ihrer künstlerischen Seite den Glanz zu nehmen. Sie wurde zum wirkungsvollsten Mittel gegen die unvermeidliche Ansteckung des menschlichen Geistes durch den Modernismus – und der Hund diente, wie die folgenden Abbildungen dokumentieren, den Fotografen bestens als Motiv und Metapher und half mit, diesen Geist gesund zu erhalten.

Alfred Stieglitz, c. 1911

Les années de développement

Le tournant du siècle fut marqué par des années déterminantes pour l'art photographique. Le Kodak, premier appareil manuel diffusé dans le commerce, fit son apparition en 1880, muni d'une pellicule produisant de petites images circulaires. Cette percée importante transforma la photographie. D'essentiellement professionnelle, elle devint une activité à laquelle tous les publics pouvaient participer. Vers 1900, la Compagnie Eastman Kodak introduisit un raffinement supplémentaire :

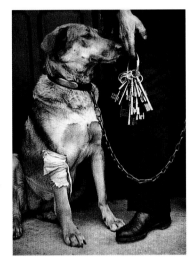

André Kertész, 1928

le boîtier « Brownie », portant le nom d'un personnage populaire de conte. Sa simplicité et son coût réduit lui assurèrent un immense succès, plaçant des millions d'appareils dans la main de gens avides d'enregistrer la vie sur pellicule, tout en élargissant les possibilités commerciales et esthétiques des professionnels. Ces avancées, avec des appareils plus légers et une pellicule plus rapide, permirent aux photographes d'emporter leur appareil presque partout, dans pratiquement n'importe quelles circonstances, et d'obtenir une tonalité et une précision qui, jusque-là, leur avaient été inaccessibles. La photographie devint le passe-temps par excellence, parfaitement inscrit dans cette « modernité ». Pour ceux nés après 1880, elle devint partie intégrante du quotidien.

Dans les arts, un mouvement connu sous le nom de pictorialisme, s'imposa. Il avait pour objectif de faire de la photographie un art, élevant la beauté au-dessus de la représentation factuelle, grâce à des flous artistiques. Des photographes purent s'exprimer dans un style impressionniste, grâce à des manipulations au moment du développement, comme le montrent les premières œuvres de Peter Henry Emerson, Gertrude Käsebier et de Alfred Stieglitz.

Libérés de la nécessité d'immortaliser le quotidien, le photographe d'art put enfin s'intéresser non seulement à l'aspect créatif, mais aussi aux sujets de société. Arnold Genthe prit des images de gens riches dans les villes, tandis que Jacob Riis et Lewis Hine utilisèrent l'appareil comme un outil de promotion du changement social. La photographie permit aussi de montrer les changements rapides de la société. Des photographes comme William Henry Jackson, Edward S. Curtis et August Sander se forgèrent ainsi une renommée à l'intérieur du genre.

Afin de maintenir intacte l'entreprise précaire de la photographie artistique, une association informelle de photographes pictorialistes d'envergure, connue sous le nom de « Photo-Secession » et composée surtout d'Américains, se constitua autour

d'Alfred Stieglitz. D'abord un simple concept, elle devint le point de référence international de la photographie artistique la plus raffinée du siècle nouveau. L'esprit qui animait ce groupe était le même que celui qui avait guidé d'autres organisations similaires telles que le Linked Ring Brotherhood en Angleterre, le Photo-Club de Paris ou le Mouvement Sécessionniste en Allemagne. Le but de ces organisations était d'être en rupture idéologique avec les sociétés professionnelles existantes, afin de favoriser la reconnaissance de la photographie en tant que médium à part entière, capable de son propre mode d'expression artistique.

Toutefois, les incertitudes de l'époque engendrèrent des tensions qui allaient se confirmer. Dans une lettre à Alfred Stieglitz, Edward Steichen remarquait : « Nous sommes bien conscients d'un malaise et d'une quête – un monde étrange, à la recherche de quelque chose qu'à l'évidence, nous n'avons pas et que nous ne comprenons pas ... quelque chose est en train d'être conçu ou proche de l'être ». Ces angoisses allaient mener à des innovations. Après le carnage de la Première Guerre mondiale, la photographie s'était fait le miroir des autres mouvements artistiques européens. S'inspirant du Dadaïsme, les photographes laissèrent libre cours à leur intuition,

Gertrude Käsebier, 1904

utilisant des effets dus au hasard, valorisant l'expression plutôt que le contenu. Avec les techniques du photo-montage, du photo-collage et des photogrammes, les photographes purent exprimer, avec une nouvelle force visuelle, leurs idées et leurs points de vue personnels. Sous l'influence stimulante du Constructivisme, du Bauhaus et du Surréalisme, les photographes placèrent l'appareil photo dans des positions non-conventionnelles, pour mieux exprimer leurs perceptions personnelles, souvent au travers du symbolisme d'objets trouvés et de reflets dus au hasard. Karl Blossfeldt et Albert Renger-Patzsch rapprochèrent leur appareil de leur sujet, pour éliminer tout élément étranger, tandis qu'Alexander Rodchenko révélait la forme, la texture et les bizarres arrangements de la vie quotidienne. Ces techniques et ces sensibilités, essentiellement allemandes, se frayèrent un chemin jusqu'en Amérique, et s'infiltrèrent dans l'œuvre d'Alfred Stieglitz, d'Edward Steichen et de Paul Strand. Elles se retrouvent aussi dans les travaux de grands photographes exerçant en France, notamment Eugène Atget, André Kertész et le jeune Jacques-Henri Lartigue, chacun adoucissant l'aspect didactique et formaliste de cette nouvelle vision, par des éléments de poésie, de compassion et d'humour.

Au cours de la même période, la photo de presse, tel que nous la connaissons aujourd'hui, acquit ses lettres de noblesse. Grâce à des améliorations dans les procédés de demi-tons autour de 1880 et vers 1890, l'utilisation des photos s'imposa et permit une meilleure acuité de l'illustration de presse. A partir de 1920, les journaux les plus importants utilisèrent souvent dans leurs pages et de manière régulière, des demi-tons de ligne ou de points. Ils publièrent un supplément hebdomadaire avec reproductions par photogravure de haute qualité. Vers 1925, l'Ermanox, avec son objectif f/2 étonnamment rapide, et le Leica, avec lequel on pouvait prendre 36 poses sur un seul rouleau 35mm, firent leur apparition. Utilisant des films de haute sensibilité, ces nouveaux appareils rendirent la photographie manuelle praticable avec la seule lumière du jour. Ils dotèrent l'imagerie journalistique d'une spontanéité et d'un intimisme nouveaux.

Dans les années 20, l'Allemagne diffusait davantage de périodiques illustrés, et à de plus forts tirages que n'importe quel autre pays. Dynamiques et imaginatifs dans leurs idées, les rédacteurs attiraient les photographes soucieux de se confronter à des sujets neufs et plus hardis. Parmi eux, Erich Salomon, qui réussit à s'introduire dans des situations exceptionnelles, comme des réunions poli-

tiques, des salles de tribunal ou des entretiens diplomatiques. Ainsi, il put saisir sur pellicule des instants uniques, pris sur le vif. Son succès en fit sans doute le premier reporter photographique des temps modernes. Avec d'autres tels que Robert Capa, David (Chim) Seymour, Martin Munkacsi, Felix H. Man, Alfred Eisenstaedt, Henri Cartier-Bresson, Margaret Bourke-White et Umbo (Otto Umbehr), il fixa un modèle qui allait s'imposer pendant le siècle tout entier.

A bien des égards, ces avancées de la photographie jouèrent un rôle pivot. La remarque de Walter Lippman était fort juste : « Nous vivons un monde qui explose d'idées nouvelles, de projets nouveaux et d'espoirs nouveaux. Jamais le monde n'a été aussi jeune qu'aujourd'hui, aussi peu respectueux des choses anciennes et encroûtées. » Cette inventivité et cette immédiateté nouvelle offertes par la photographie, agirent indéniablement comme un stimulus pour le journalisme et la publicité, sans que son lustre artistique en soit terni. Elle s'inscrivit comme l'antidote le plus puissant contre l'infection inévitable de l'esprit humain par le modernisme et, comme on peut le voir à travers les pages qui suivent, le chien a bien servi le photographe, comme sujet et comme métaphore, pour l'aider à maintenir cette force spirituelle.

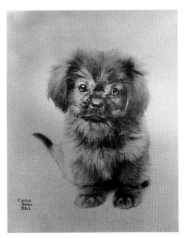

Art cannot exist
without nature.

Ohne die Natur
kann die Kunst nicht sein.

L'art ne peut exister
sans la nature.

WILHELM SCHLEGEL

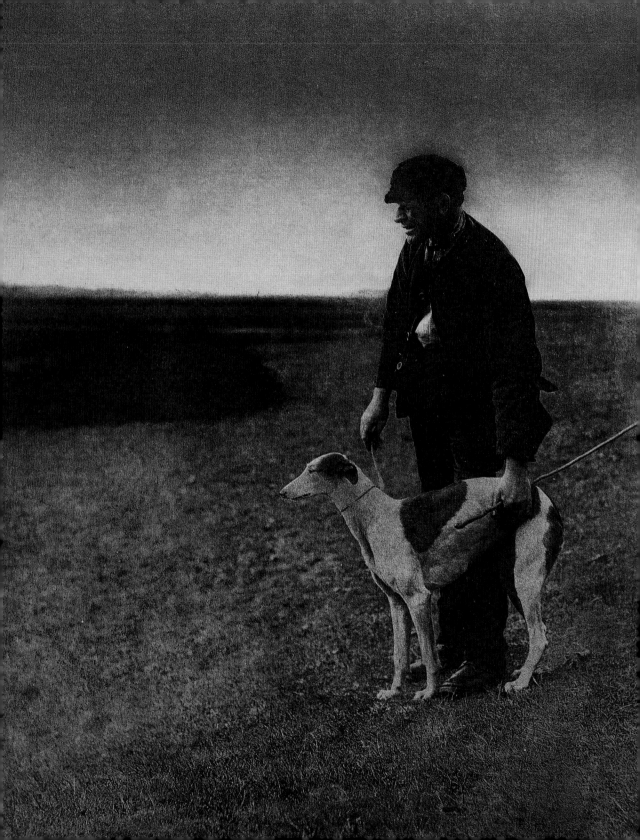

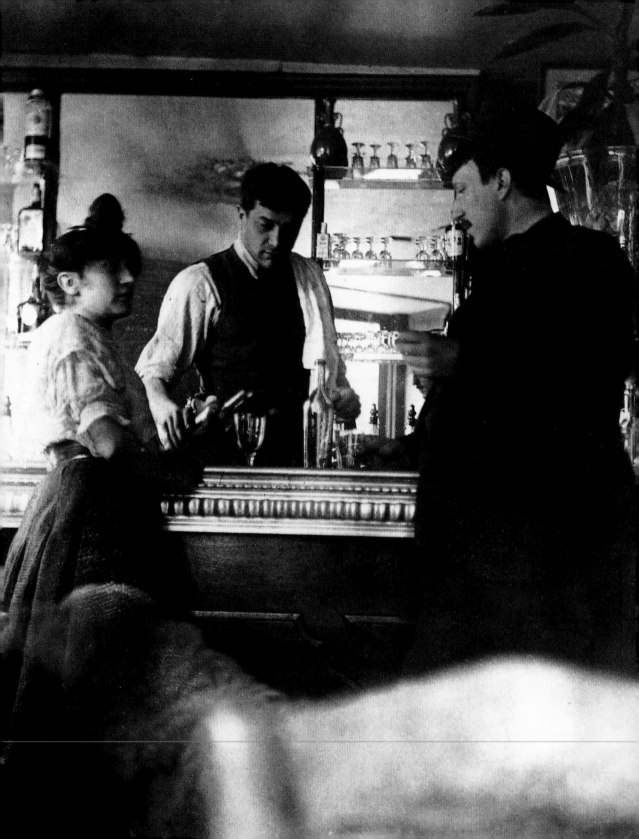

I have discovered photography.
Now I can kill myself.
I have nothing else to learn.

Ich habe die Fotografie entdeckt.
Jetzt kann ich mich umbringen.
Ich habe nichts mehr zu lernen.

J'ai découvert la photographie.
Maintenant je peux me supprimer.
Je n'ai plus rien à apprendre.

PABLO PICASSO

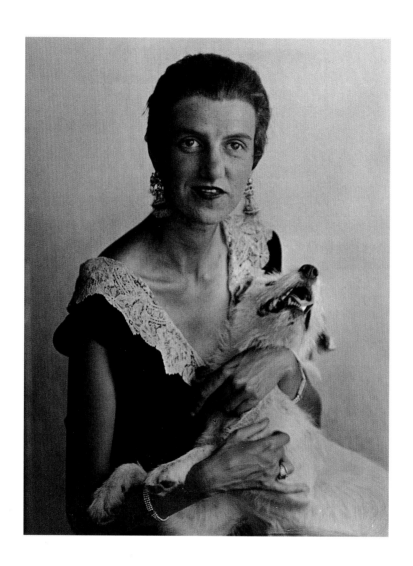

Berenice Abbott, n.d.

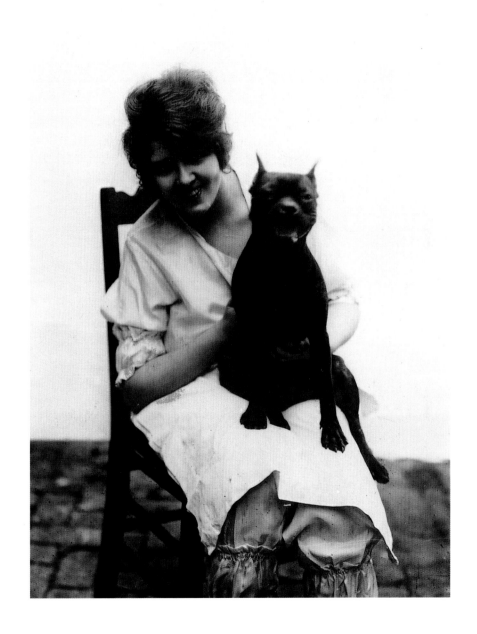

E. J. Bellocq, c. 1912

I think we are drawn to dogs because they are the uninhibited
creatures we might be if we weren't certain we knew better.

Ich glaube, wir fühlen uns zu den Hunden hingezogen, weil sie die ungehemmten
Wesen sind, die wir sein könnten, wenn wir nicht sicher wären, es besser zu wissen.

Je pense que nous sommes attirés par les chiens parce qu'ils sont les
créatures sans inhibition que nous pourrions être, si nous n'étions
pas aussi persuadés de devoir nous comporter autrement.

GEORGE BIRD EVANS

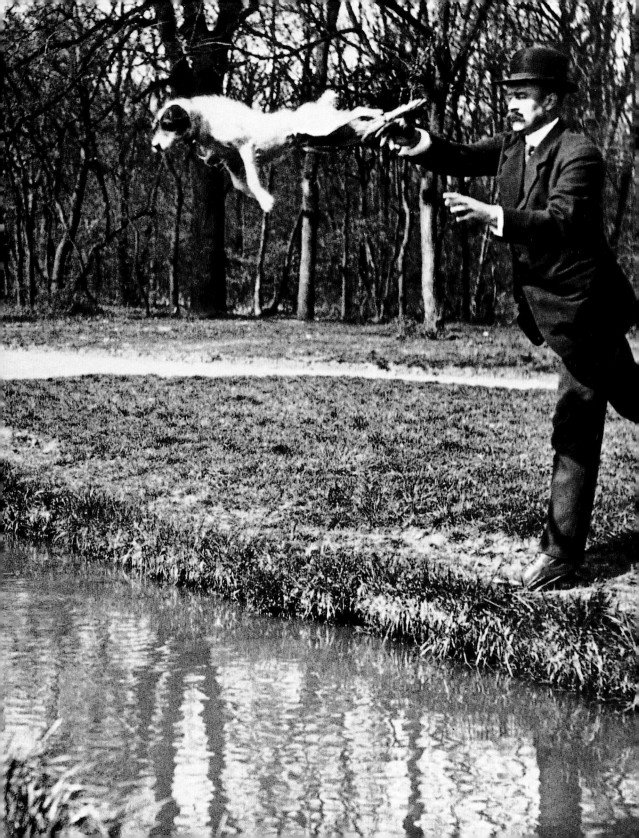

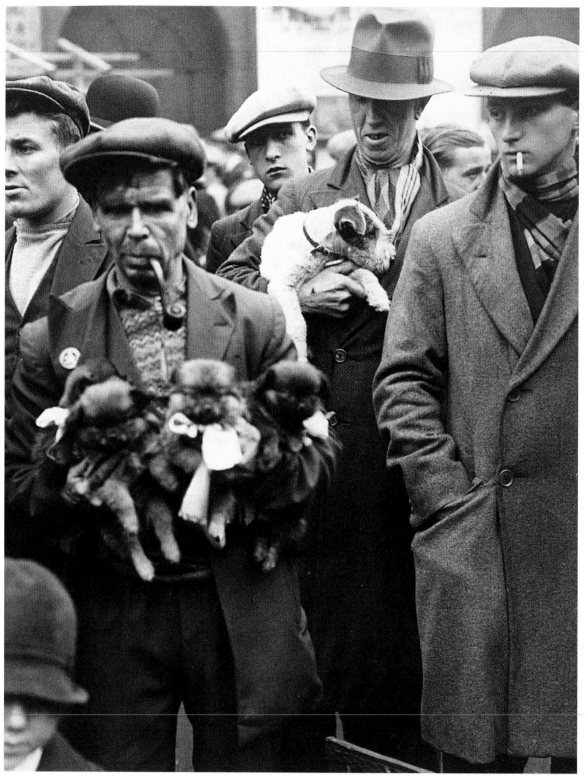

Martin Munkacsi, 1930

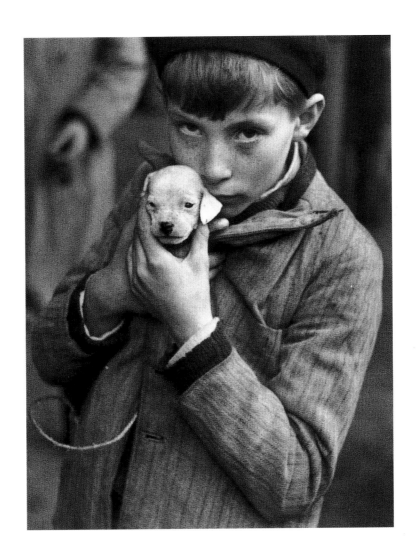

André Kertész, 1928

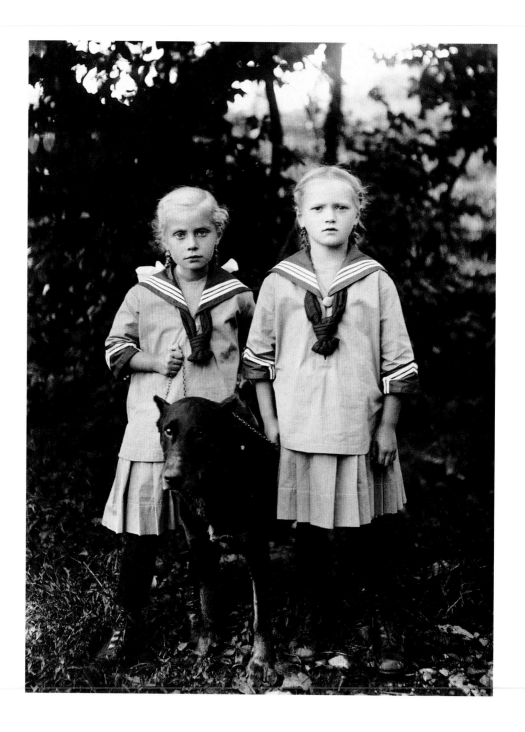

August Sander, after 1920

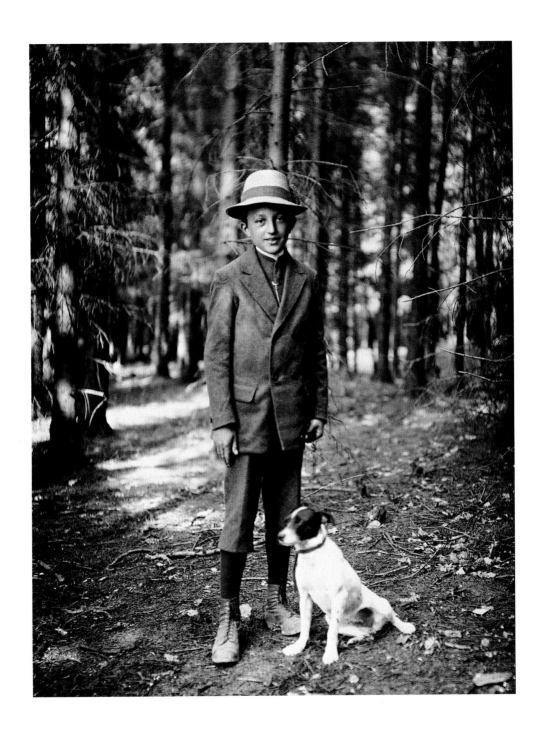

August Sander, 1918

Heinrich Kühn, c. 1905

Albert Renger-Patzsch, c. 1925

Animals are in possession of themselves;
their soul is in possession of their body.

Die Tiere sind Herren ihrer selbst;
ihre Seele ist der Herr ihres Körpers.

Les animaux sont maîtres d'eux-mêmes ;
leur cœur est maître de leur corps.

GEORG WILHELM FRIEDRICH HEGEL

Tina Modotti, 1924

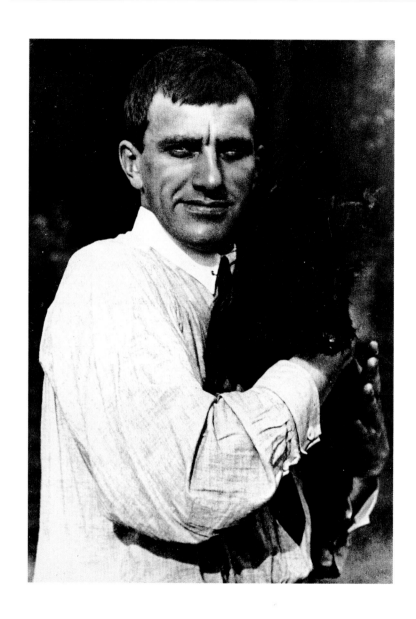

Alexander Rodchenko, c. 1930

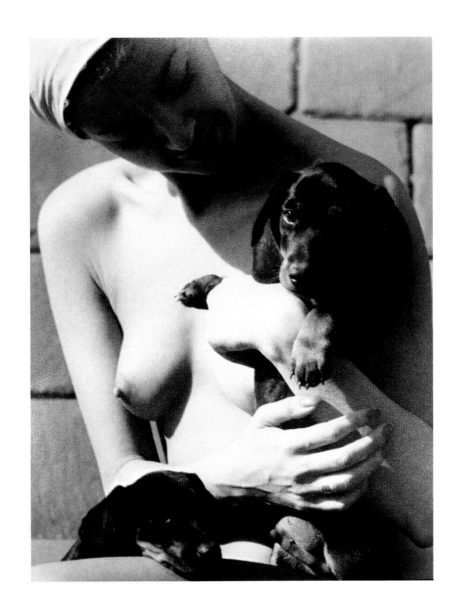

Man Ray, 1925

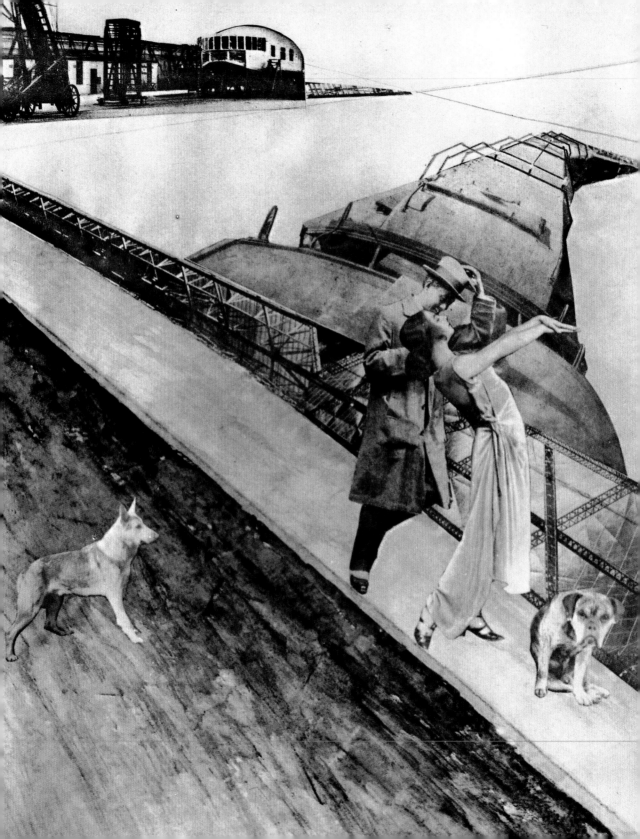

Jaromir Funke, 1929

Histories are more full of
examples of the fidelity of
dogs than of friends.

Es gibt mehr Geschichten mit
Beispielen für die Treue von Hunden
als von Freunden.

On rapporte davantage de
récits de fidélité de chiens
que d'amis.

ALEXANDER POPE

Unknown Photographer, 1948

Weathering the Storms
From Realism to Expressionism

Den Stürmen trotzen
Vom Realismus zum Expressionismus

Contre vents et marées
Du réalisme à l'expressionnisme

1930·1950

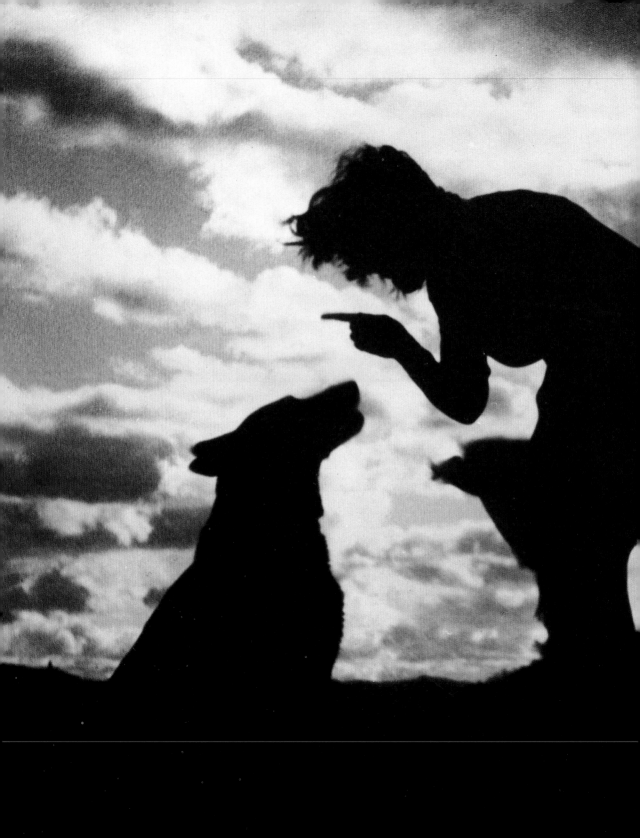

Paul Wolff, 1935

Weathering the Storms
From Realism to Expressionism

The fair weather euphoria spawned by the boisterous boom and social abandon of the twenties proved illusory. Unexpected storm clouds appeared over the Western world. The thunderous crash of the New York stock market signaled the start of a worldwide depression that lasted for over a decade. Prices of staple products dropped precipitously, exports fell, production slowed. People were forced to turn to charities for sustenance – breadlines and soup kitchens were everywhere. In Europe, widespread strikes, hunger marches, and riots were commonplace, paralyzing industrial production. These economic squalls fomented political unrest. Compounding these difficulties, a series of catastrophic dust storms ravaged the American Midwest, leaving death and destruction in their wake and furthering mankind's drift towards poverty, homelessness, and, eventually, war.

Millions of jobs were lost, making mere survival for man and his companion, the dog, a challenge. Throughout the depression, the common man's dog remained a symbol of steadfastness and resourcefulness. In reality, many perished simply due to starvation. Fortunately, most adapted to man's lot in life as they have done since the beginning of their human partnership.

For a fortunate few born to money and rank, the thirties remained a decade of glamour, beauty, and style. People's troubles could be momentarily set aside while they followed the leisurely pursuits of the rich and famous in high society, often with their pampered pet in tow, whether they were royalty, aristocrats, or Hollywood celebrities. They marveled when Garbo talked, Dietrich walked, Shirley Temple smiled, and a King abdicated. The Rockettes strutted in step while Berlin, Gershwin, and Porter provided the music. William Powell and Myrna Loy set styles, while Schiaparelli shocked us with pink. Judy and Toto went to Oz, while Glenn Miller's Band set the mood.

All this froth was to no avail. The world was soon at war again. The resulting devastation in human and animal suffering was incalculable. More civilians died than in all of mankind's previous wars, eighty thousand alone in one moment at Hiroshima. Dogs again answered man's call at the front. Once again paying a heavy price, tens of thousands were killed in combat and hundreds of thousands died as a consequence of the strife. The war storms ended, but the damage to the human and canine population would be felt for the rest of the century.

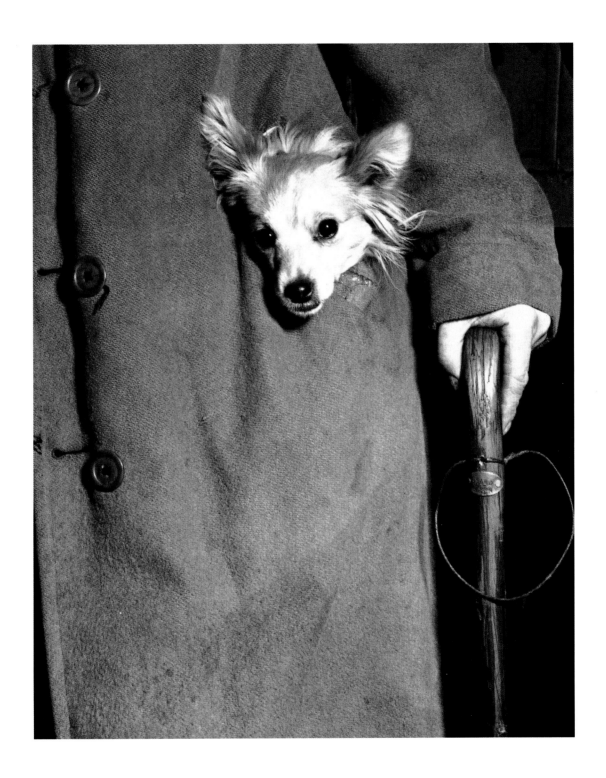

Unknown photographer, 1946

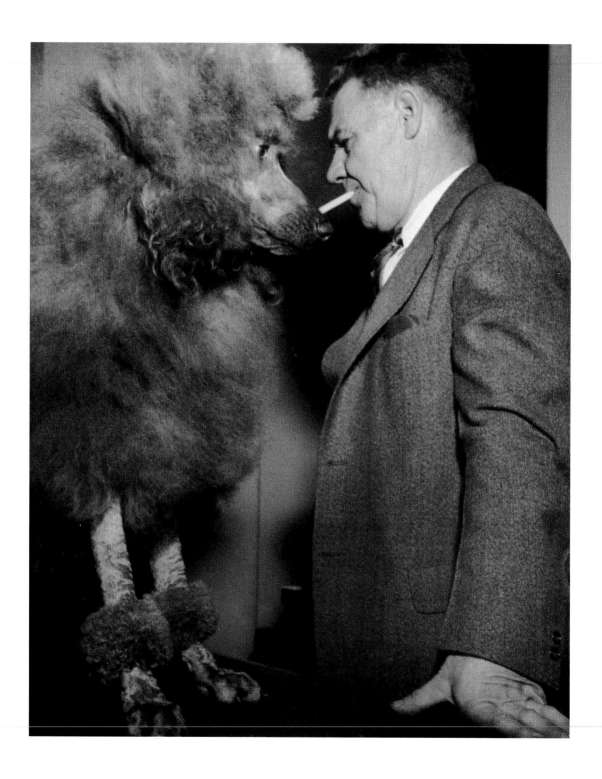

Lisette Model, c. 1946

1930 · 1950
Den Stürmen trotzen
Vom Realismus zum Expressionismus

Die Schönwetter-Euphorie, die der rasante Aufschwung und die soziale Sorglosigkeit der zwanziger Jahre hervorgerufen hatten, erwies sich als trügerisch. Unerwartet tauchten Gewitterwolken über der westlichen Welt auf. Der Donnerschlag an der New Yorker Börse war der Beginn einer weltweiten Depression, die über ein Jahrzehnt dauerte. Die Preise für Handelswaren fielen ins Uferlose, Export und Produktion waren rückläufig. Viele Menschen waren zum Überleben auf die Hilfe wohltätiger Organisationen angewiesen. Überall gab es Suppenküchen und Schlangen an den Lebensmittelausgabestellen. In Europa waren flächendeckende Streiks, Hungermärsche und Plünderungen an der Tagesordnung und lähmten die Industrie. Diese wirtschaftlichen Stürme schürten politische Unruhen. Zu all dem verwüsteten mehrere katastrophale Sandstürme den amerikanischen Mittelwesten, brachten der Region Tod und Zerstörung und beschleunigten den Kurs der Menschheit Richtung Armut, Heimatlosigkeit und schließlich Krieg.

Millionen Arbeitsplätze gingen verloren. Das schiere Überleben wurde zu einer Herausforderung für den Menschen und seinen Gefährten, den Hund. Während der Depression wurde der Hund des kleinen Mannes zum Symbol für Standhaftigkeit und Findigkeit. Tatsächlich starben viele an Hunger. Zum Glück passten sich die meisten Hunde dem Geschick des Menschen an, wie sie es seit Beginn ihrer Partnerschaft mit uns getan haben.

Für einige wenige Glückliche, die in Reichtum und Ansehen hineingeboren wurden, waren auch noch die dreißiger Jahre voller Glamour, Schönheit und Stil. Die einfachen Leute konnten ihre Sorgen für kurze Zeit vergessen, wenn sie den Müßiggang der Reichen und Berühmten der High Society – häufig mit ihren verhätschelten Hündchen im Schlepptau – verfolgten, die einem Königshaus oder dem Adel angehörten oder gefeierte Hollywood-Stars waren. Sie waren entzückt, wenn die Garbo redete, die Dietrich ging, Shirley Temple lächelte oder ein König abdankte. Die Rockettes schwangen die Beine im Takt, und Irving Berlin, Gershwin und Porter lieferten die Musik dazu. William Powell und Myrna Loy waren die modischen Trendsetter, während Schiaparelli mit Pink schockte. Judy und Toto gingen nach Oz, während Glenn Millers Band für Stimmung sorgte.

Doch die ganze Schaumschlägerei half nichts. Bald war die Welt wieder im Krieg. Das Leid, das Mensch und Tier dabei zugefügt wurde, ist unbeschreiblich. Es starben mehr Zivilisten als in allen anderen Kriegen zuvor, allein achtzigtausend in Hiroshima. Und wieder gehorchten die Hunde den Befehlen an der Front. Wieder zahlten sie einen hohen Preis: Zehntausende wurden während der Angriffe getötet, und Hunderttausende starben an den Folgen des Krieges. Der Krieg ging zu Ende, aber die Schäden waren noch für den Rest des Jahrhunderts zu spüren.

Contre vents et marées
Du réalisme à l'expressionnisme

L'euphorie née du fulgurant boom économique et de la libéralisation des mœurs des années 20 ne fut qu'une illusion. Des nuages menaçants se mirent à planer au-dessus du monde occidental. Le crash retentissant de Wall Street marqua le début d'une crise internationale qui allait durer plus de dix ans. Les prix des matières premières s'effondrèrent, les exportations s'écroulèrent, la production ralentit. Les gens durent recourir à des associations caritatives. Des files d'attentes se formèrent devant les cantines distribuant de la soupe et du pain. En Europe, les grèves étaient largement suivies, les manifestations de miséreux et les émeutes étaient fréquentes, paralysant la production industrielle. Ces secousses économiques engendrèrent des troubles politiques. A ces difficultés s'ajoutèrent une série de sécheresses catastrophiques qui ravagèrent le Middle-West américain, ne laissant dans leur sillage que mort et destruction, précipitant l'humanité en dérive dans la pauvreté, la destitution et enfin la guerre.

Des millions d'emplois furent supprimés, rendant encore plus difficile la simple survie, pour l'homme et son compagnon. Tout au long de cette crise, le chien demeura un symbole de constance et d'ingéniosité. En réalité, un grand nombre mourut, tout simplement de faim. Mais la plupart, heureusement, s'adaptèrent à cette nouvelle situation de l'homme, comme ils avaient toujours su le faire, depuis le début de leur compagnonnage.

Pour quelques fortunés, nés dans des milieux aisés, les années 30 restèrent une période de luxe, de beauté et d'élégance. Les gens pouvaient provisoirement oublier leurs soucis en s'occupant des faits et gestes des riches et célèbres, ceux de la haute société, souvent escortés de leur charmant toutou, qu'ils s'agissent de membres de familles royales, d'aristocrates ou de stars hollywoodiennes. On s'émerveilla de voir Garbo parler, Dietrich marcher, Shirley Temple sourire, et un roi abdiquer. Les Rockettes se trémoussaient en rythme sur des musiques de Berlin, Gershwin et Porter. William Powell et Myrna Loy décidaient de la mode. Schiaparelli choquait avec son rose extraordinaire. Judy et Toto partaient au pays d'Oz, et l'orchestre de Glenn Miller créait l'ambiance.

Mais ces envolées retombèrent à plat. Bientôt le monde replongea dans la guerre. Le prix payé en souffrances humaines et animales fut exorbitant. Les pertes en civils furent plus élevées que dans n'importe quel autre conflit. 80 000, en quelque secondes à Hiroshima. Une fois de plus, sur le front, les chiens répondirent à l'appel. Une fois encore, ils payèrent de leur vie. Des milliers périrent au combat, et des centaines de milliers, des suites du conflit. Si l'orage finit par se calmer, les dommages allaient rester visibles le siècle durant.

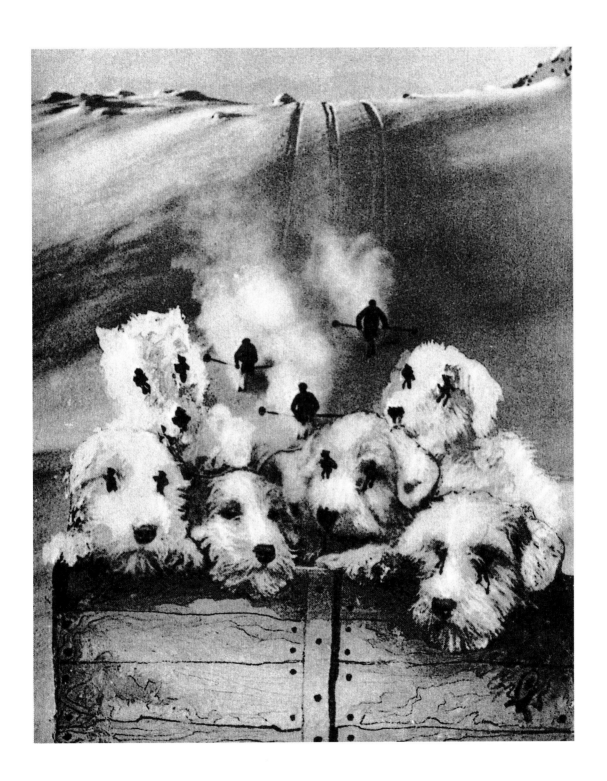

Dora Maar, 1937

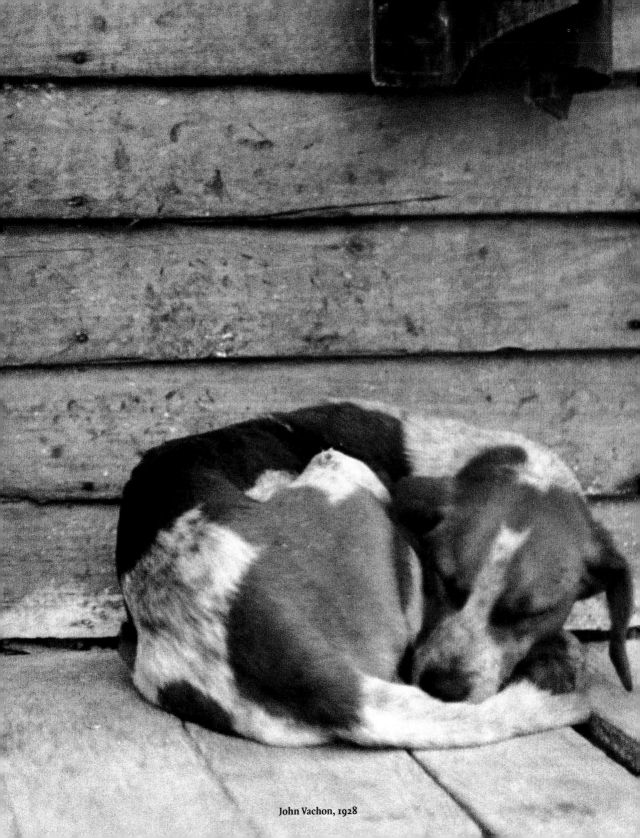

John Vachon, 1928

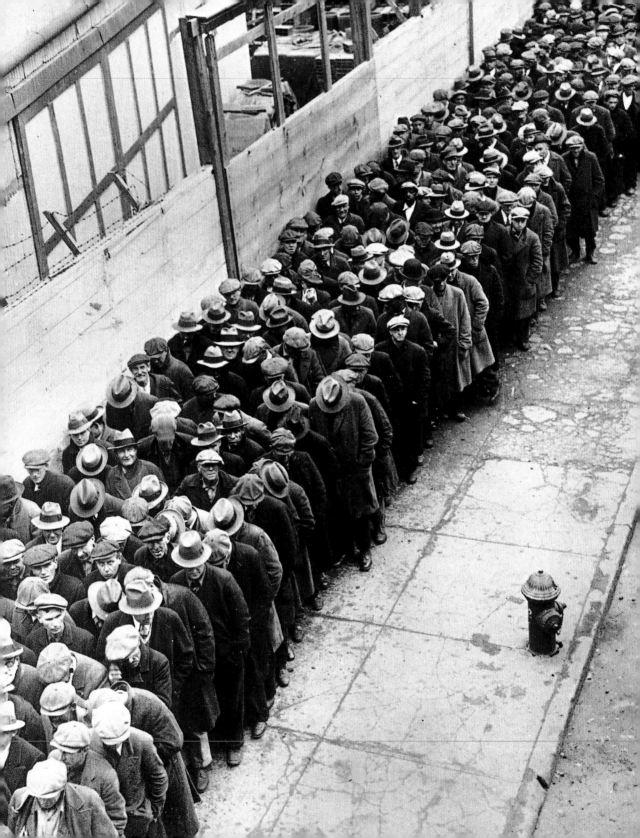

Unknown photographer, 1935

Today we do not want emotion from art; we want solid and substantial food
in which to bite We want truth, not rationalization, not idealizations,
not romanticizations.

Heutzutage erwarten wir von der Kunst keine Gefühle, wir wollen etwas Festes und
Nahrhaftes zum Hineinbeißen Wir wollen die Wahrheit, keine Vernünfteleien, keine
Idealisierung oder romantische Verklärung.

Aujourd'hui, dans l'art, nous ne cherchons pas l'émotion ; nous voulons des
nourritures solides et substantielles, où mordre à pleines dents... Nous
voulons des vérités et non des théories. Rien qui soit idéalisé ou romancé.

ELIZABETH McCAUSLAND, 1939

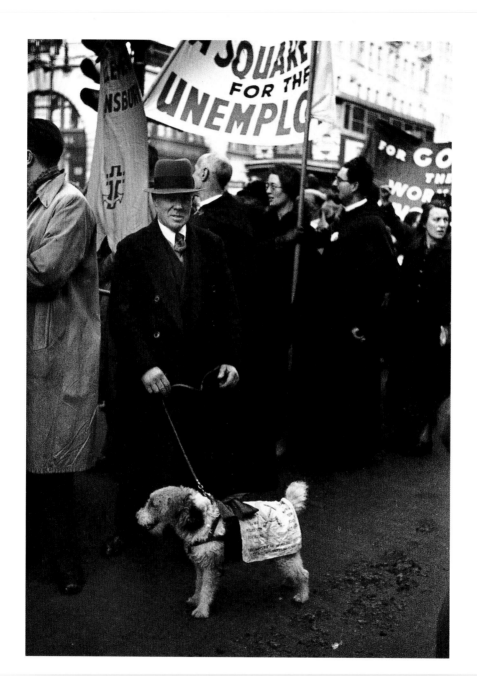

Humphrey Spender, 1930

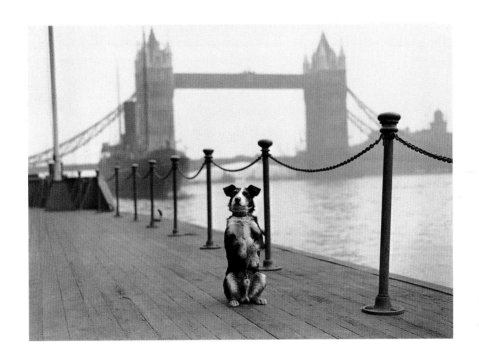

Unknown photographer, 1931

I love this little house because
It offers, after dark,
A pause for rest, a rest for paws,
A place to moor my bark.

Ich liebe dieses Häuschen, denn
es bietet in der Nacht
einen sichren Ort, einen Pfotenhort,
ein Päuschen von der Wacht.

J'aime cette niche, parce qu'elle
offre, à la nuit tombée,
un temps de repos, une pause pour les pattes,
un lieu pour apaiser mes aboiements.

ARTHUR GUITERMAN

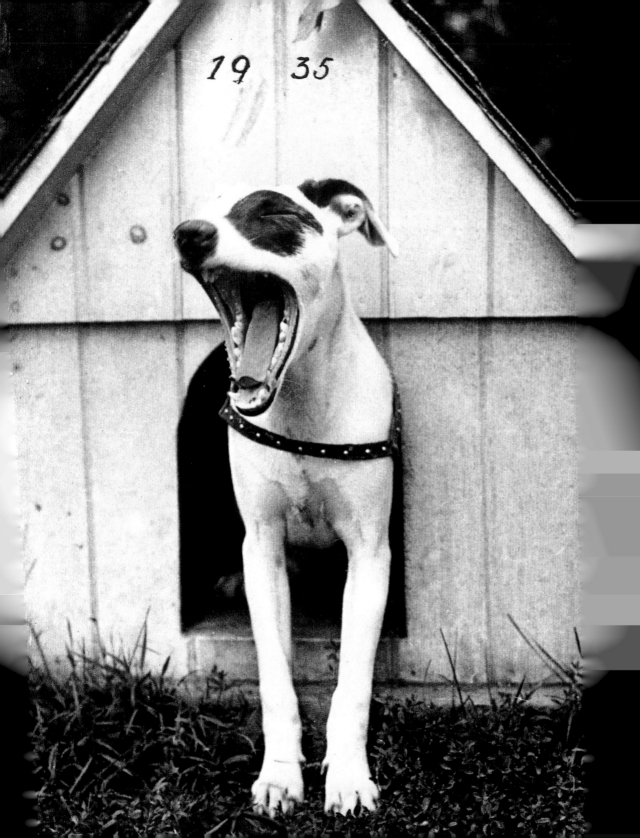

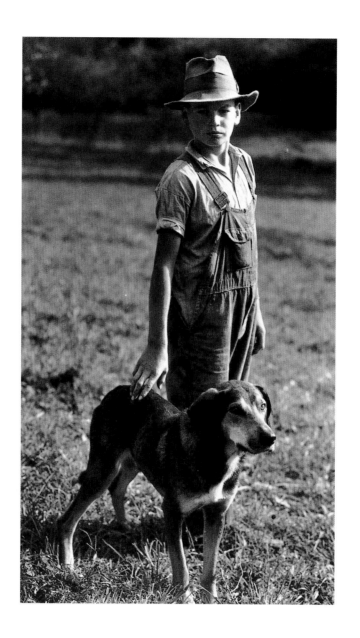

Bayard Wootten, c. 1934

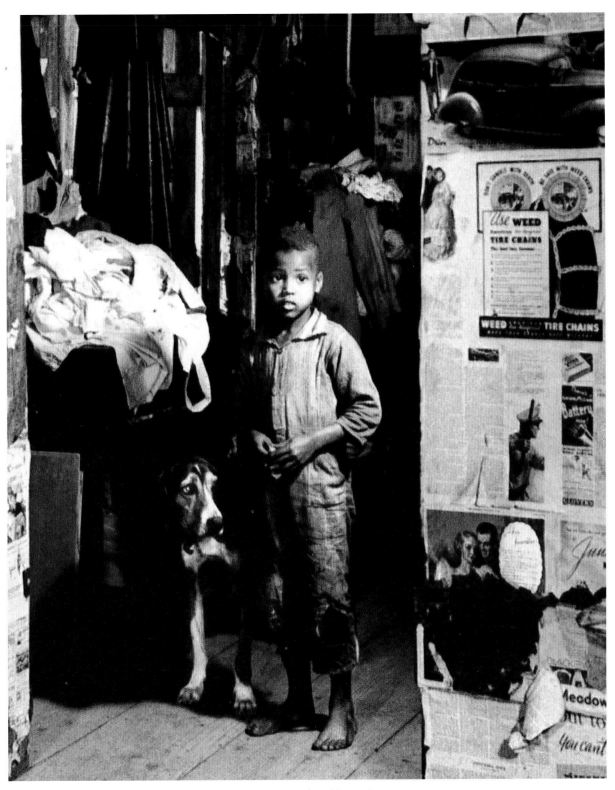

Margaret Bourke-White, 1936

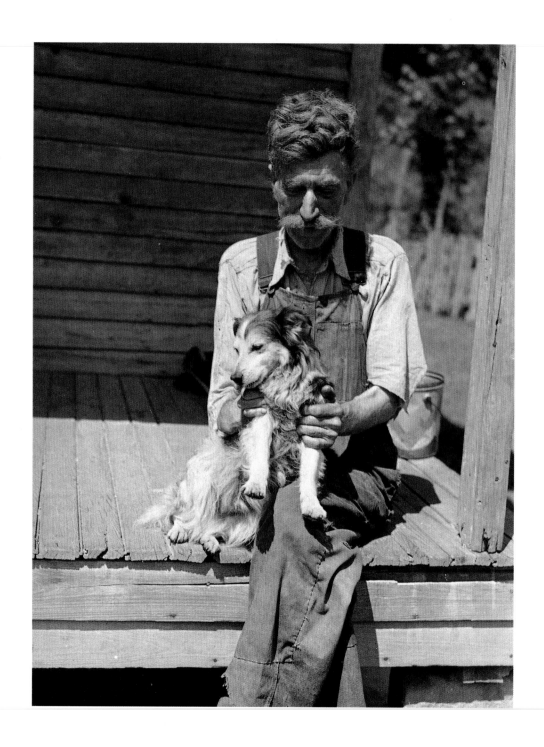

Marion Post Wolcott, 1940

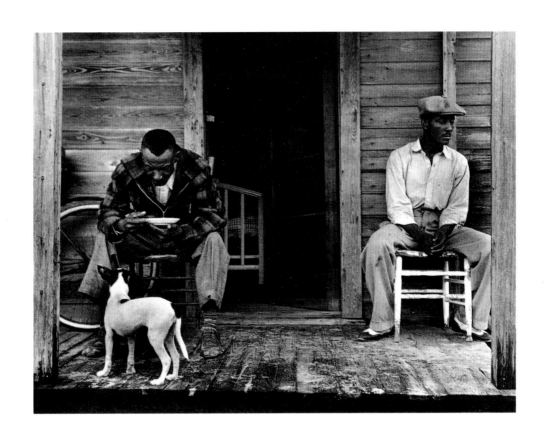

Arnold Newman, 1941

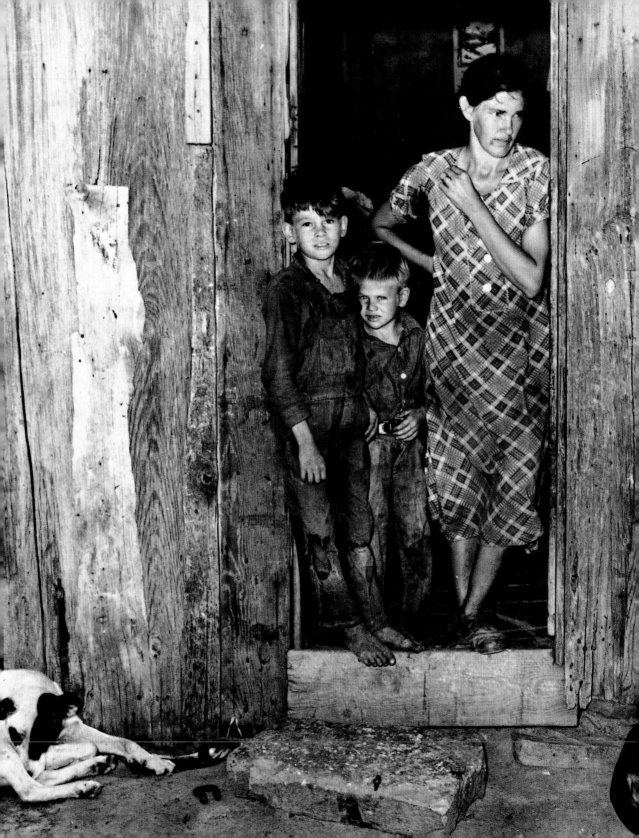

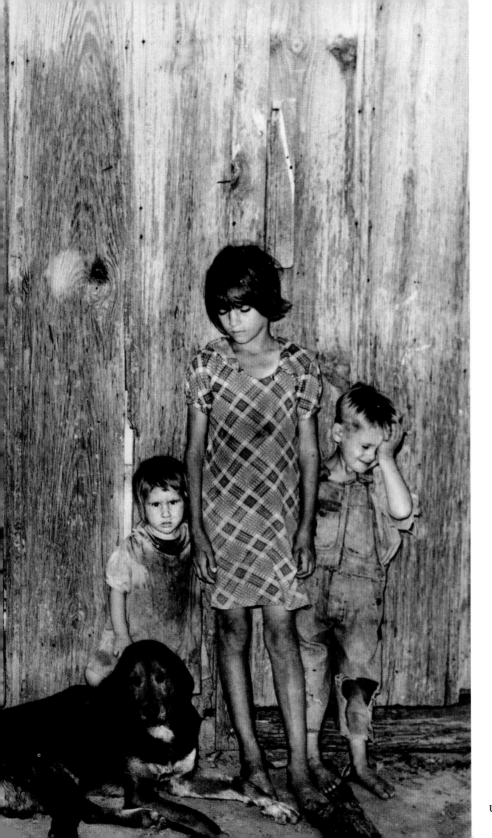

Unknown photographer, 1939

It requires more courage to
suffer than to die.

Es verlangt mehr Mut zu leiden,
als zu sterben.

Souffrir nécessite plus de courage
que mourir.

ANONYMOUS

Hansel Mieth, 1938

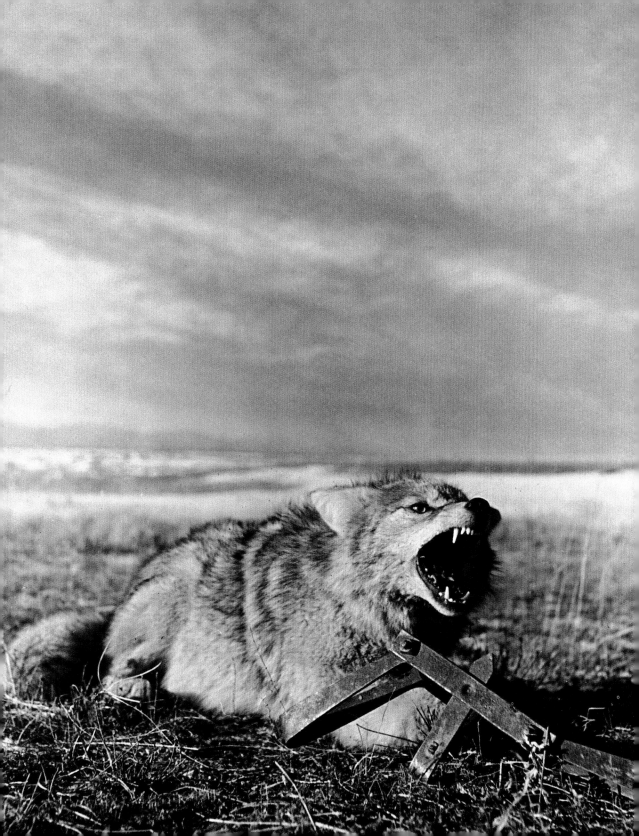

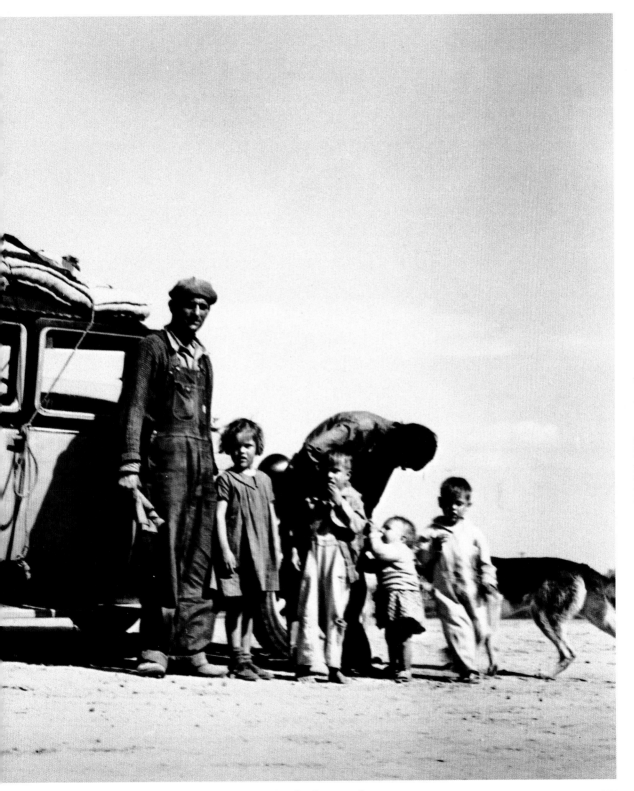

Dorothea Lange, 1938

<u>OMAHA, Nebraska, March 10, 1930</u>:

"Shep" walks only on his hind legs. He
belongs to the Rattigans. Shep saved
his life by chewing off both front
legs when he walked into a wolf trap.
He taught himself to walk upright and
now gets along quite well. The Humane
Society, however, believes the dog
should be shot. The Rattigans are
refusing. They regard the dog as fami-
ly and are more attached than ever
in view of his courage and spunk.

<u>OMAHA, Nebraska, 10. März 1930</u>:

„Shep" geht nur auf seinen Hinterbeinen.
Er gehört den Rattigans. Shep rettete
sich das Leben, indem er sich beide
Vorderbeine abnagte, nachdem er in eine
Wolfsfalle geraten war. Er brachte sich
den aufrechten Gang bei und kommt jetzt
ganz gut zurecht. Die Humane Society
ist allerdings der Meinung, der Hund
sollte erschossen werden. Die Rattigans
weigern sich. Für sie gehört der Hund
zur Familie, und angesichts seiner
Courage und seines Lebenswillens hängen
sie mehr denn je an ihm.

<u>OMAHA, Nebraska, le 10 Mars 1930</u>:

«Shep» ne marche que sur ses pattes
arrière. Il appartient aux Rattigan.
Shep s'est sauvé la vie en se rongeant
les deux pattes avant, un jour où il
avait été pris dans un piège à loups.
Il a appris à marcher debout, et ne se
débrouille pas mal du tout. La société
des hommes, cependant, pense qu'il
faudrait l'abattre. Les Rattigan s'y
opposent. Pour eux, le chien fait par-
tie de la famille, et ils lui sont
plus attachés que jamais, étant donné
son courage et son cran.

Unknown photographer, c. 1940

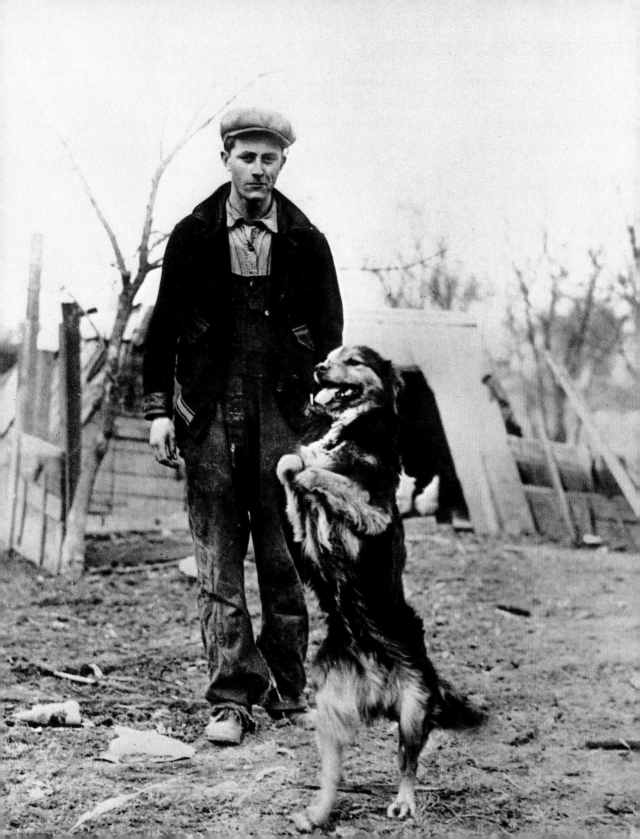

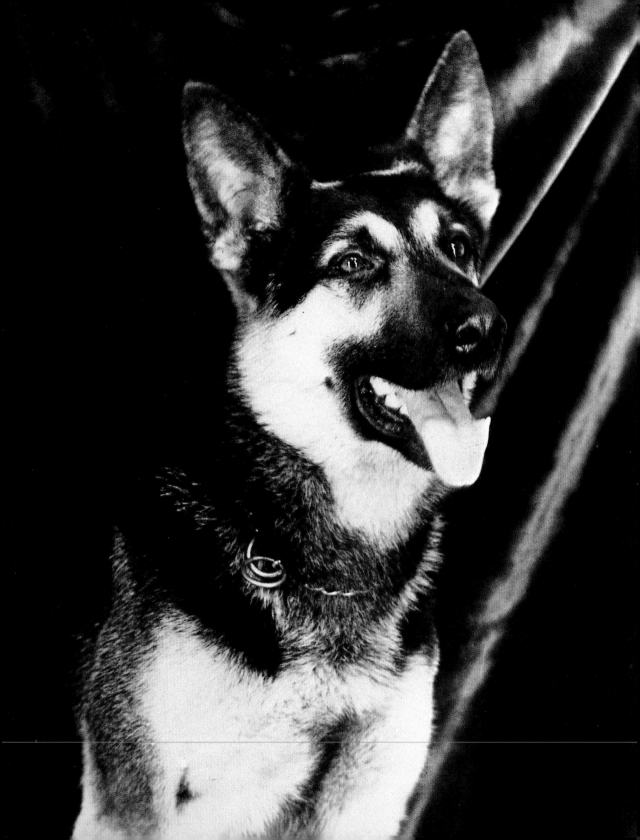

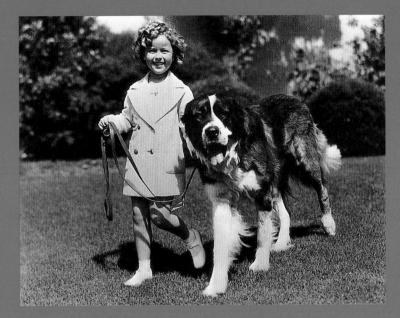

Unknown photographer, 1935

I class myself with Rin Tin Tin. At the end of the Depression, people were perhaps looking for something to cheer them up. They fell in love with a dog, and with a little girl.

Ich sehe mich auf einer Stufe mit Rin Tin Tin. Nach der Depression sehnten sich die Menschen vielleicht nach etwas, das sie aufmunterte. Sie schlossen einen Hund in ihr Herz und ein kleines Mädchen.

Je me place au même rang que Rin Tin Tin. Après la Crise de 29, les gens recherchaient sans doute de quoi se remonter le moral. Ils tombèrent amoureux d'un chien et d'une petite fille.

SHIRLEY TEMPLE

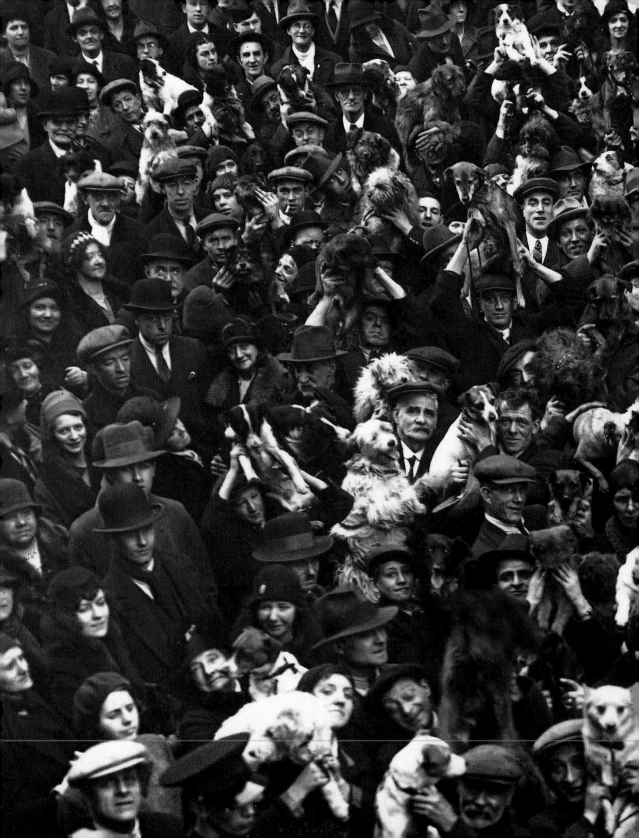

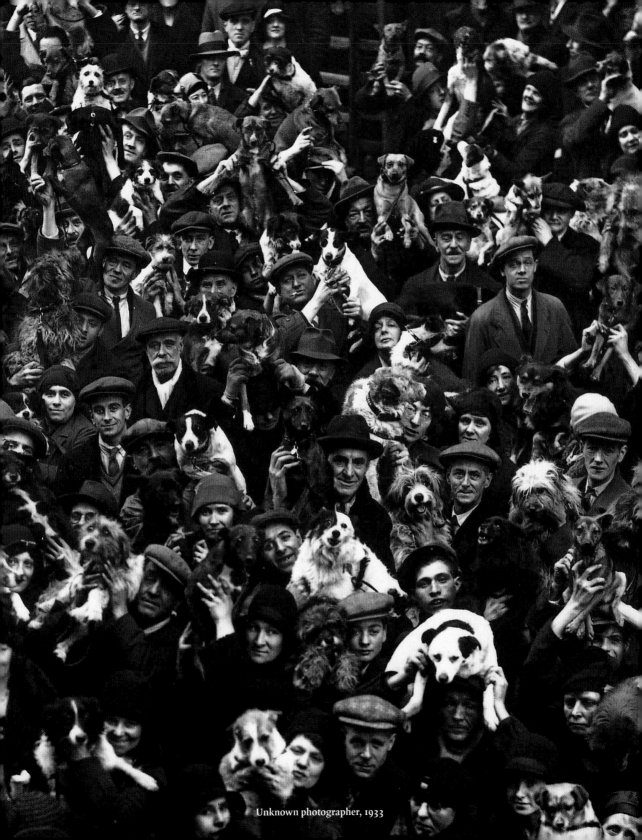

Unknown photographer, 1933

Dogs love company. They place it first
in their short list of needs.

Hunde lieben Gesellschaft. Sie steht an erster Stelle
auf der kurzen Liste ihrer Bedürfnisse.

Les chiens adorent la compagnie. Il la placent en haut,
sur leur modeste liste des nécessités premières.

J.R. ACKERLEY

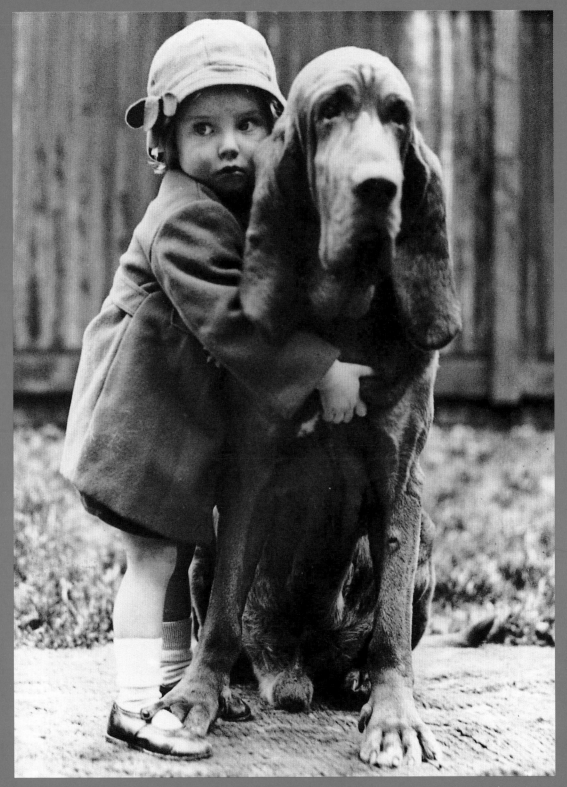

William Vanderson, 1935

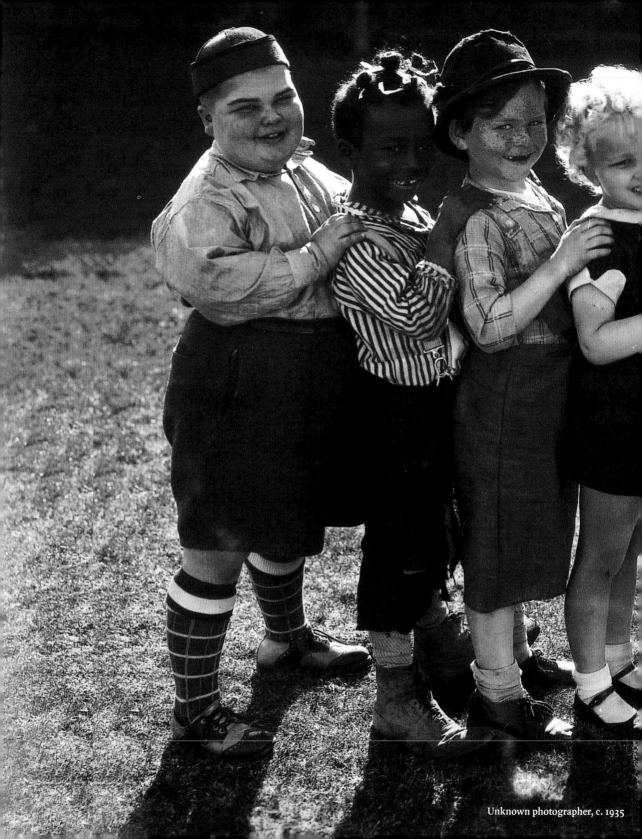

Unknown photographer, c. 1935

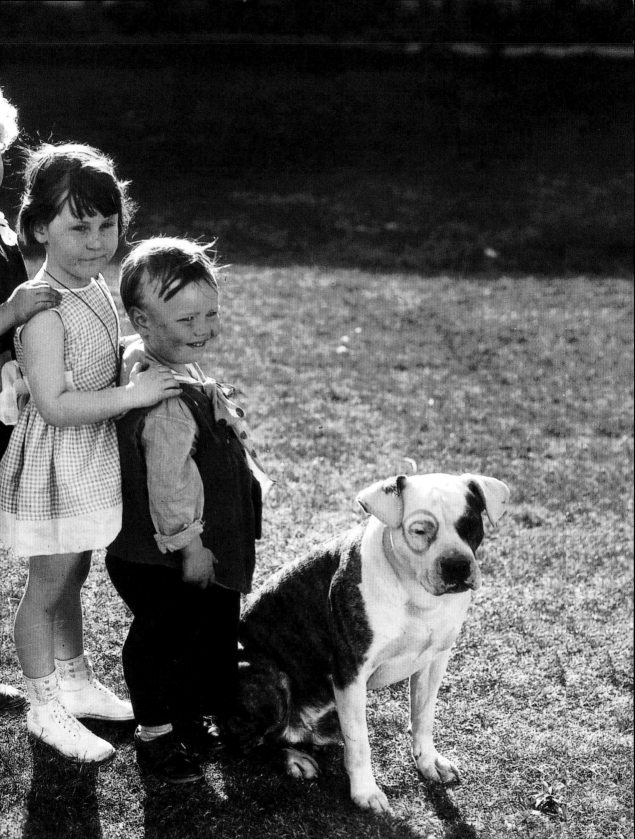

Unknown photographer, 1932

Unknown photographer, 1934

Ralph Bartholomew, 1938

Gifts of Love

He stirred. I knew it was time for us to rise, but I remained still, musing.
We eat, sleep, shop and stroll together whenever we can. It has been
three enchanting years since that first night he brought me home to his
bed and I have never left. "Good morning, my love," he whispers as he
touches me. Without hesitation I roll over and wag my tail.

Liebesbeweise

Er rührte sich. Ich wusste, es war Zeit für uns aufzustehen, aber ich bleibe in Gedanken
versunken liegen. Wir essen, schlafen, gehen gemeinsam einkaufen und spazieren,
wann immer wir können. Drei Jahre sind vergangen seit jener Nacht, als er mich nach
Hause in sein Bett brachte, und ich habe ihn nie mehr verlassen. „Guten Morgen, mein
Lieber", flüstert er, wobei er mich berührt. Augenblicklich rolle ich mich auf die Seite
und wedle mit dem Schwanz.

Dons d'amour

Il remua. Je savais que c'était l'heure de nous lever, mais je restai immo-
bile, à méditer. On mange, on dort, on fait les courses et on se promène
ensemble dès que possible. Trois années enchanteresses se sont
écoulées depuis cette nuit où il m'a amené dans son lit, que je n'ai plus
quitté. « Bonjour, mon amour », chuchote-t-il, en me caressant. Sans
hésiter, je me mets sur le dos et je remue la queue.

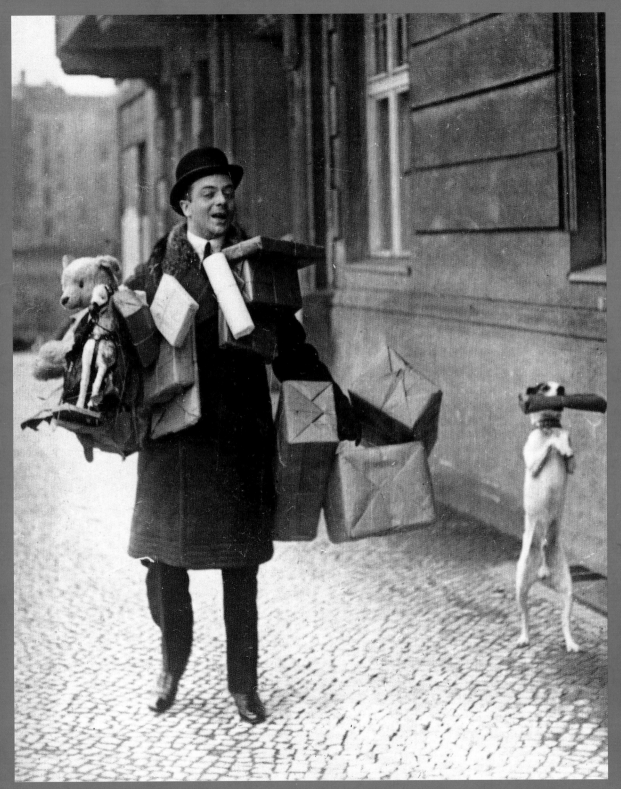

Unknown photographer, 1941

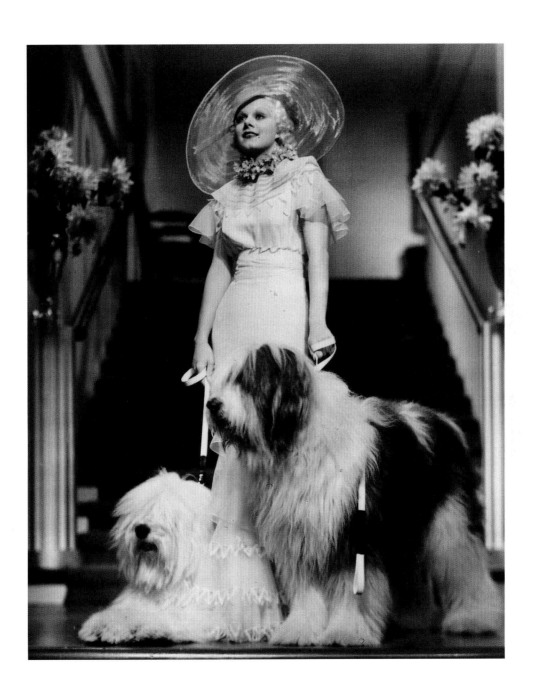

Unknown photographer, c. 1930

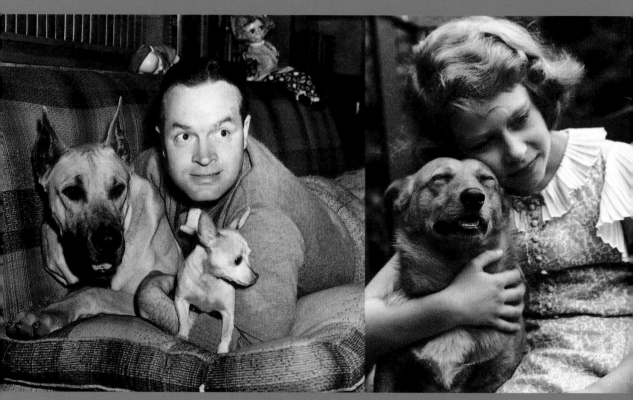

Bob Hope, 1945

Princess Elizabeth, 1936

Doris Day, 1949

Bing Crosby, 1933

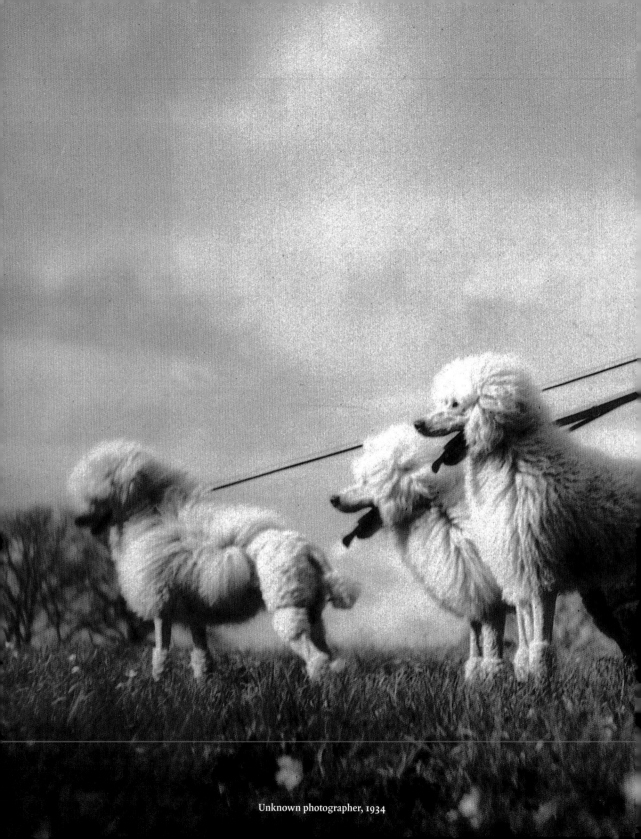

Unknown photographer, 1934

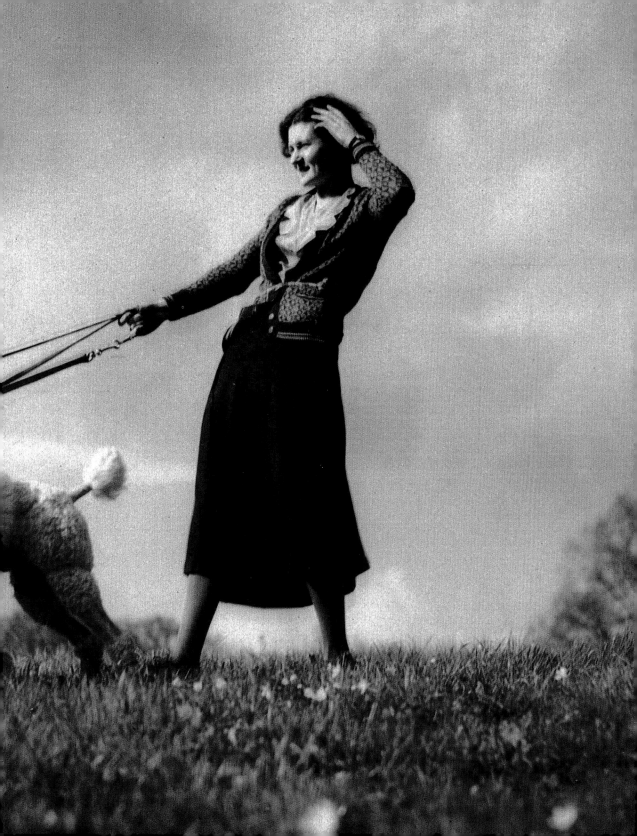

Dog

A kind of additional or subsidiary deity designed to catch
the overflow and surplus of the world's worship.

Hund

Eine zusätzliche Gottheit oder deren Ersatz, um den Überschuss
und den Überfluss an Liebe in der Welt aufzufangen.

Chien

Une sorte de déité complémentaire ou d'accessoire conçu pour saisir le
trop-plein et le surplus d'amour en ce monde.

AMBROSE BIERCE

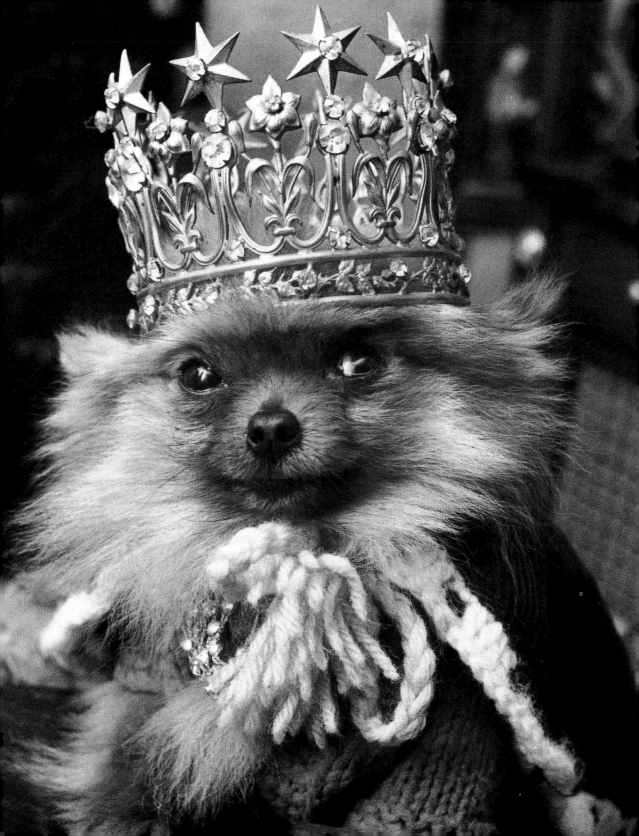

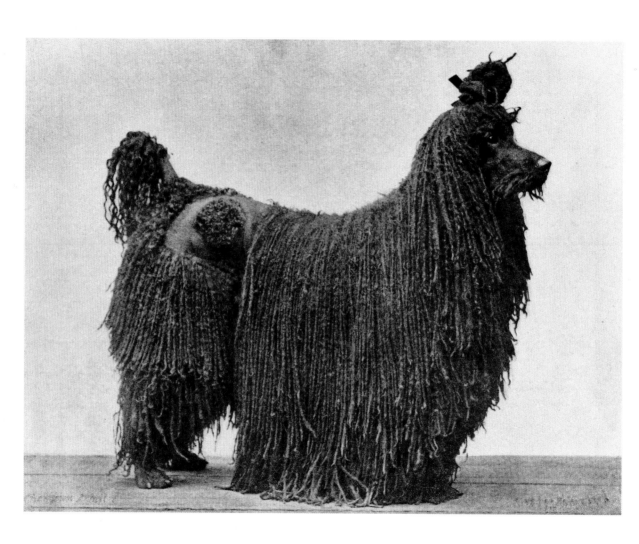

Gambier Bolton, 1930

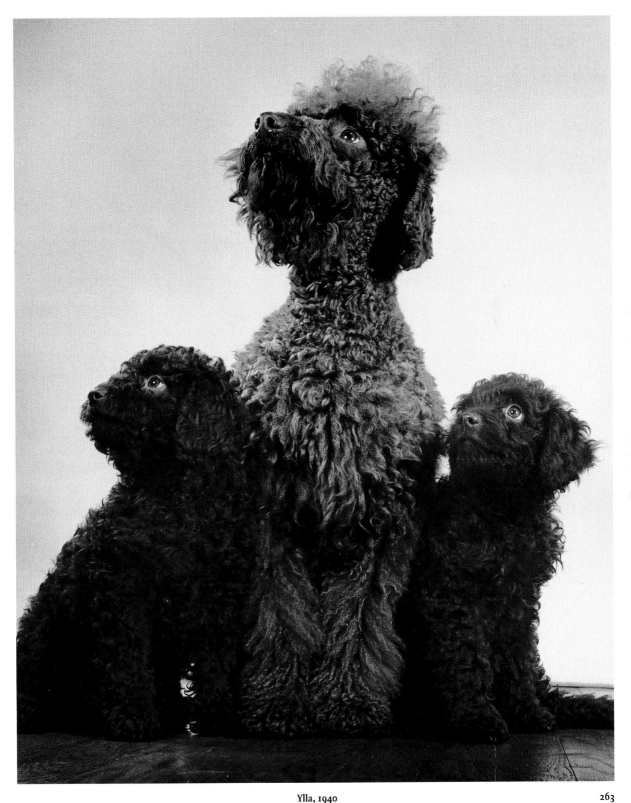

Ylla, 1940

Ylla, c. 1944

Unknown photographer, c. 1910

The charming relations I have had with a long succession of dogs result from their happy spontaneity. Usually they are quick to discover that I cannot see or hear. Truly, as companions, friends, equals in opportunities of self-expression, they unfold to me the dignity of creation.

Dass mich mit einer langen Folge von Hunden so wunderbare Beziehungen verbanden, lag an ihrer fröhlichen Spontaneität. Gewöhnlich merken sie schnell, dass ich weder hören noch sehen kann. Tatsächlich haben sie mir als Kameraden und Freunde, als mir Gleichgestellte in den Möglichkeiten sich auszudrücken, die Erhabenheit der Schöpfung nahe gebracht.

Les relations charmantes que j'ai entretenues avec une succession de chiens s'expliquent par leur spontanéité et leur joie. En général, ils ne tardent pas à comprendre que je ne peux ni voir ni entendre. En vérité, comme compagnons, amis, égaux en capacité à s'exprimer, ils me montrent ce qu'il y a de plus digne dans la création.

HELEN KELLER

Bradley Smith, 1960

Byron Studio, c. 1930

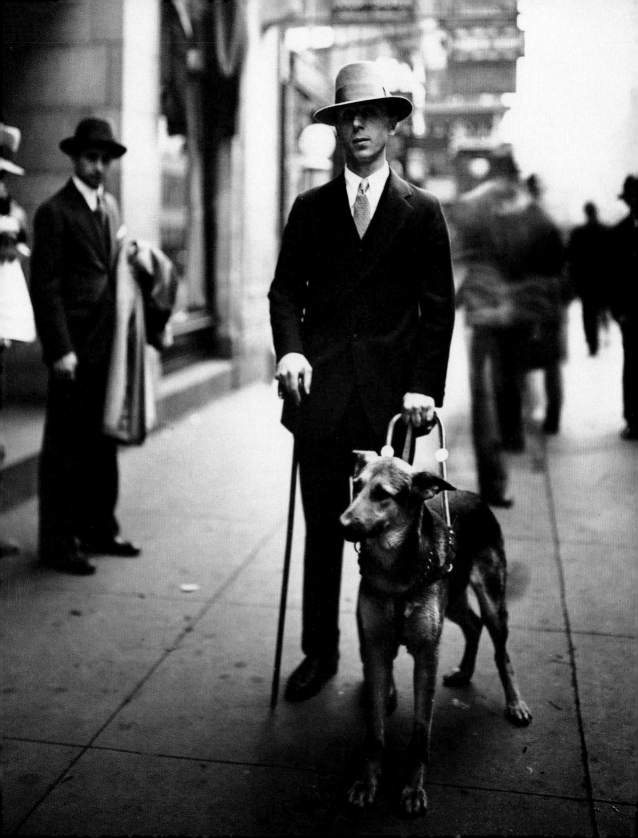

Unknown photographer, 1935

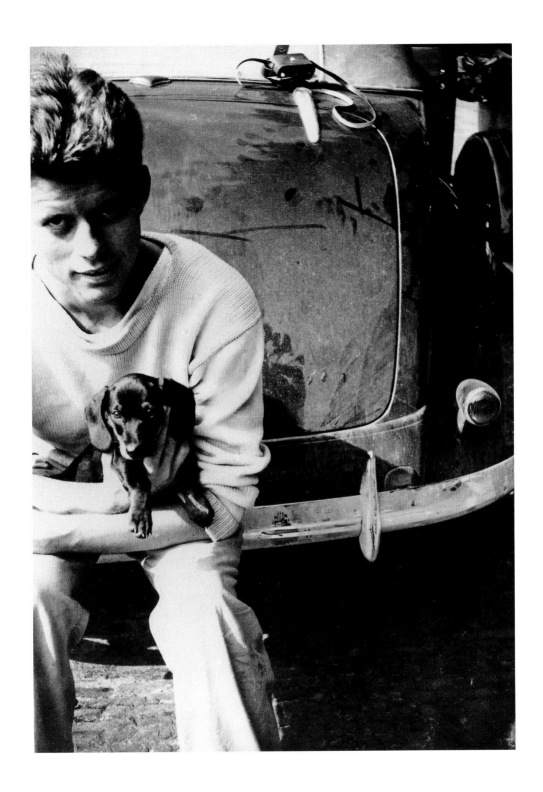

Unknown photographer, 1949

The ravages of the world economic depression of the thirties inevitably altered the iconography of the arts. With mere survival the paramount objective, society was no longer receptive to artistic experimentation with modernism and hungered for the unmanipulated depiction of society's ills. Photography in particular sought to satisfy this hunger by directing its lens toward contemporary life. In general, the modernist abstract composition of the twenties gave way to realism as artists narrowed their interests to the quotidian. In the United States, the government underwrote a massive project to record rural culture during this difficult period. The Farm Security Administration, under the direction of Roy Stryker, enlisted some of America's greatest photographers, including Dorothea Lange, Russell Lee, Jack Delano, and John Vachon. Their work introduced the world to an America they had never seen, showing an abundance of dignity that transcended their subjects' plight.

This period also saw the arrival of the photography magazine. Throughout Europe, magazines such as *Berliner Illustrierte Zeitlund*, *Vu*, *Picture Post*, *Paris Match*, and *Der Spiegel* and, in America, *LIFE*, *Harper's Bazaar*, and eventually *Look*, gave new outlets to the works of great photographers such as Margaret Bourke-White, Alfred Eisenstaedt, Kurt Hutton, and Humphrey Spender. *LIFE* came to represent the apogee of photojournalism. It sought to expose its audience to an almost encyclopedic array of photographic images. Coinciding with the political strife through-out Africa, Asia, and Europe that eventually led to World War II, LIFE's photojournalists, covering world events as they occurred, were able to capture the pathos of human suffering while recording the strength of the human spirit. In doing so, photography – perhaps for the first time – was able to fundamentally alter its audience's perception of the world. In this pre-television era, it was illustrated newspapers and weekly magazines that offered a window to the world, however tinted by editorial bias.

After the war, photojournalism continued to provide photographers with creative outlets due to the voracious appetite for photographic imagery in advertising, fashion, and public relations. Louise Dahl-Wolfe, Toni Frissell, Irving Penn, and Horst P. Horst gave viewers new, distinctive, precise imagery rooted in the *Neue Sachlichkeit* style popular in Europe. During this period, photography continued to emphasize straightforward, sharply focused images created through photographic, rather than painterly means. This style is perhaps best represented by the works of Ansel Adams, Berenice Abbott, and Walker Evans.

A greater diversity in photographic approach developed after the war. The trauma of the forties brought a different set of sensibilities to society, which in turn were reflected in art photography. With social documentation continuing to dominate, urban photography began to emerge as an art form, in a sense a precursor to what would later be coined "street photography." Berenice Abbott set the stand-

ard with her complex visual compendium of New York City. Walker Evans' direct and clear vision captured the American Northeast. Additionally, photographers such as Weegee (Arthur Fellig), Lisette Model, and Helen Levitt put their own mark on this style. The period from 1930 to 1950, which began so firmly rooted in documentation, ended with a renewed appetite for expressionism and experimentation, with no particular photographic mode dominating. That impulse would compel photography's continued growth for the rest of the century.

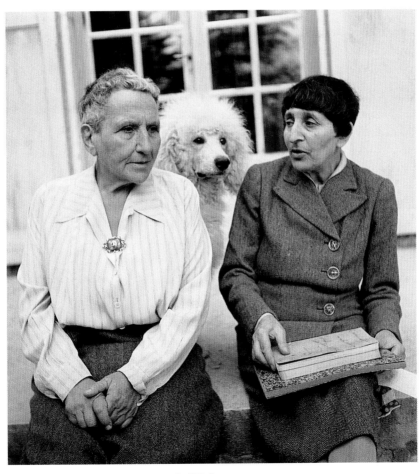

Carl Mydans, 1944

Die Augen der Welt

Die verheerenden Folgen der Weltwirtschaftskrise der dreißiger Jahre veränderten zwangsläufig die Ikonografie der Künste. Wo es ums schiere Überleben ging, war die Gesellschaft nicht mehr empfänglich für künstlerische Experimente mit der Moderne, sondern hungerte nach einer unverfälschten Darstellung der gesellschaftlichen Missstände. Vor allem die Fotografie versuchte diesen Hunger durch Bilder vom Alltagsleben zu stillen. Ganz allgemein machte die modernistische, abstrakte Komposition der zwanziger Jahre dem Realismus Platz, weil die Künstler ihre Interessen auf das Alltägliche beschränkten. In den USA setzte sich die Regierung für ein gewaltiges Projekt zur Dokumentation der ländlichen Kultur in dieser schwierigen Zeit ein. Roy Stryker von der Farm Security Administration verpflichtete dazu einige der berühmtesten Fotografen Amerikas, darunter Dorothea Lange, Russell Lee, Jack Delano und John Vachon. Ihre Arbeit zeigte der Welt ein bis dato unbekanntes Amerika, das selbst Not und Elend mit Würde erduldete.

In dieser Zeit erschienen die ersten Fotomagazine. In ganz Europa boten Magazine wie die Berliner Illustrierte Zeitung, Vu, Picture Post, Paris Match, Der Spiegel und in den USA LIFE, Harper's Bazaar und später Look ein neues Forum für die Arbeiten berühmter Fotografen wie Margaret Bourke-White, Alfred Eisenstaedt, Arthur Rothstein, Kurt Hutton und Humphrey Spender. Das Beste, was der Fotojournalismus zu bieten hatte, wurde in LIFE gezeigt. Das Magazin versuchte seinen Lesern eine fast enzyklopädische Bandbreite von Fotografien zu präsentieren. In einer Zeit der politischen Auseinandersetzungen in Afrika, Asien und Europa, die schließlich zum Ausbruch des Zweiten Weltkriegs führten, gelang es den Fotojournalisten von LIFE, die immer vor Ort waren, wenn sich Großes in der Welt ereignete, das Pathos menschlichen Leidens einzufangen und gleichzeitig die Kraft des menschlichen Geistes zu dokumentieren. Dadurch war die Fotografie – vielleicht zum ersten Mal – in der Lage, die Art und Weise, wie die Öffentlichkeit die Welt sah, von Grund auf zu verändern. In dieser Prä-TV-Ära waren es bebilderte Zeitungen und wöchentlich erscheinende Zeitschriften, die den Menschen ein Fenster zur Welt öffneten, mochte es durch redaktionelle Vorlieben noch so eingefärbt sein.

Nach dem Krieg gab der Fotojournalismus den Fotografen dank des unersättlichen Appetits auf Fotografien für Werbung, Mode und PR wieder ein kreatives Betätigungsfeld. Louise Dahl-Wolfe, Toni Frissell, Irving Penn und Horst P. Horst präsentierten dem Betrachter neue, ausgesprochen präzise Bilder im Stil der in Europa populären Neuen Sachlichkeit. Auch in dieser Zeit legte die Fotografie Wert auf klare, scharfe Bilder, die mit fotografischen und nicht mit malerischen Mitteln kreiert worden waren. Am deutlichsten zu erkennen ist dieser Stil vielleicht in den Arbeiten von Ansel Adams, Berenice Abbott und Walker Evans.

Nach dem Krieg entwickelte sich eine größere Vielfalt im fotografischen Ansatz. Das Trauma der

vierziger Jahre brachte eine veränderte Sicht der Gesellschaft mit sich, die sich in der künstlerischen Fotografie widerspiegelte. Vorherrschend war immer noch die Sozialdokumentation, doch begann sich die Stadtfotografie als eine Kunstform herauszukristallisieren, in gewisser Weise als Vorläufer dessen, was später als „Straßenfotografie" bezeichnet wurde. Berenice Abbott setzte den Maßstab mit ihrer komplexen Bilddokumentation von New York. Walker Evans fing mit seinen klaren und direkten Bildern den amerikanischen Nordosten ein. Darüber hinaus drückten Fotografen wie Weegee (Arthur Fellig), Lisette Model und Helen Levitt diesem Stil ihren eigenen Stempel auf. Die Zeit zwischen 1930 und 1950, deren Anfang eindeutig von der Dokumentation geprägt war, endete mit einem neu erwachten Hunger nach Expressionismus und Experimenten, ohne dass ein bestimmter fotografischer Stil vorherrschte. Dieser Impuls sollte für den Rest des Jahrhunderts der Fotografie eine ständig wachsende Popularität bescheren.

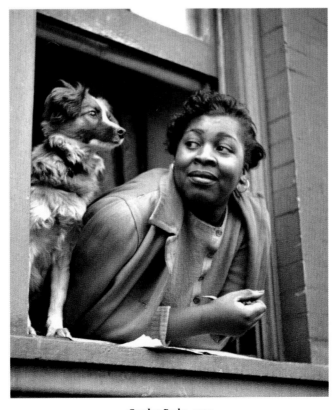

Gordon Parks, 1943

Les yeux du monde

Inévitablement, la crise des années 30 et ses ravages ne purent que modifier l'imagerie artistique. Avec pour seul objectif leur propre survie, les gens perdirent de leur intérêt pour l'expérimentation moderniste, ne recherchant que des descriptions sans fard des maux qui les affectaient. La photographie, en particulier, s'efforça de satisfaire cette demande et braqua ses objectifs sur la vie contemporaine. Dans l'ensemble, les compositions modernistes et abstraites des années 20 cédèrent le pas au réalisme, tandis que les artistes se concentraient sur le quotidien. Aux Etats-Unis, le gouvernement finança un énorme projet visant à consigner la culture rurale de cette difficile période. Sous la houlette de Roy Stryker, La Farm Security Administration engagea certains des plus grands photographes américains, tels Dorothea Lange, Russell Lee, Jack Delano et John Vachon. Leurs œuvres présentèrent au monde une Amérique que, jusqu'alors, personne n'avait jamais vue, mettant en lumière l'extraordinaire dignité qui transcendait la cruauté du sort.

Au même moment, on assista à l'arrivée des magazines de photographie. Dans toute l'Europe, des revues comme le Berliner Illustrierte Zeitung, Vu, Picture Post, Paris-Match et Der Spiegel ou, en Amérique, LIFE, Harper's Bazaar et enfin Look, offrirent de nouveaux débouchés à de grands photographes comme Margaret Bourke-White, Alfred Eisenstadt, Arthur Rothstein, Kurt Hutton ou Humphrey Spender. LIFE s'imposa comme le maître absolu du reportage photographique. Son but était de soumettre au public un ensemble quasi encyclopédique d'images. Dans un temps de conflits politiques qui secouaient l'Afrique, l'Asie et l'Europe, et qui allaient mener à la Seconde Guerre mondiale, les photoreporters de LIFE couvrirent à chaud ces événements et réussirent à saisir l'intensité de cette souffrance humaine, tout en montrant le courage dont les gens étaient capable. Ainsi – et sans doute pour la première fois – la photographie parvint à changer de manière fondamentale la perception que le public avait du monde. Dans cette époque d'avant la télévision, ce furent les journaux et les hebdomadaires illustrés qui ouvrirent, pour le public, une fenêtre sur le monde. Parfois, ce ne fut pas sans parti pris politique.

Après la guerre, ces reportages continuèrent d'offrir des débouchés aux plus créatifs, compte tenu des énormes quantités d'images consommées par la publicité, la mode et les relations publiques. Louise Dahl-Wolfe, Toni Frissell, Irving Penn et Horst P. Horst proposèrent aux lecteurs une imagerie nouvelle, précise et pertinente, ancrée dans le style de la Neue Sachlichkeit, alors populaire en Europe. Au cours de ces années, la photographie continua de produire des images sans maniérisme, à la mise au point précise, à partir de moyens techniques et non décoratifs. Ce style est particulièrement bien représenté par les œuvres de Ansel Adams, Berenice Abbott et Walker Evans.

Après la guerre, la conception de la photographie se diversifia. L'expérience traumatisante des

années 40 permit le développement de nouvelles sensibilités sociales, qui se retrouvèrent dans la photographie d'art. Tandis que cette documentation trouvait sa place, la photographie urbaine émergea en tant que forme artistique, annonçant en un sens ce que l'on allait appeler la « photographie de rue ». Berenice Abbott s'imposa comme porte-drapeau avec sa foisonnante collection visuelle sur New York. Walker Evans saisit avec netteté et acuité le nord-est américain. Par ailleurs, des photographes comme Weegee (Arthur Fellig), Lisette Model ou Helen Levitt imposèrent leur propre personnalité. Les années 1930-1950, qui avaient débuté comme un art essentiellement documentaire, s'achevèrent sur un nouvel appétit pour l'expressionnisme et l'expérimentation, sans qu'aucune mode ne domine. Pendant le reste du siècle, cet élan allait marquer l'évolution de la photo.

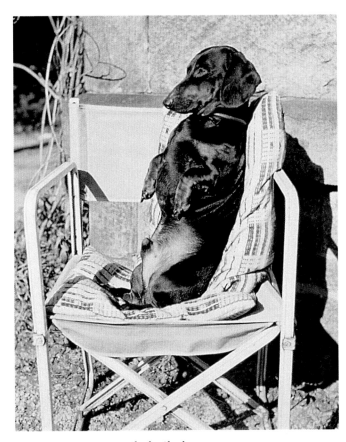

Charles Sheeler, c. 1945

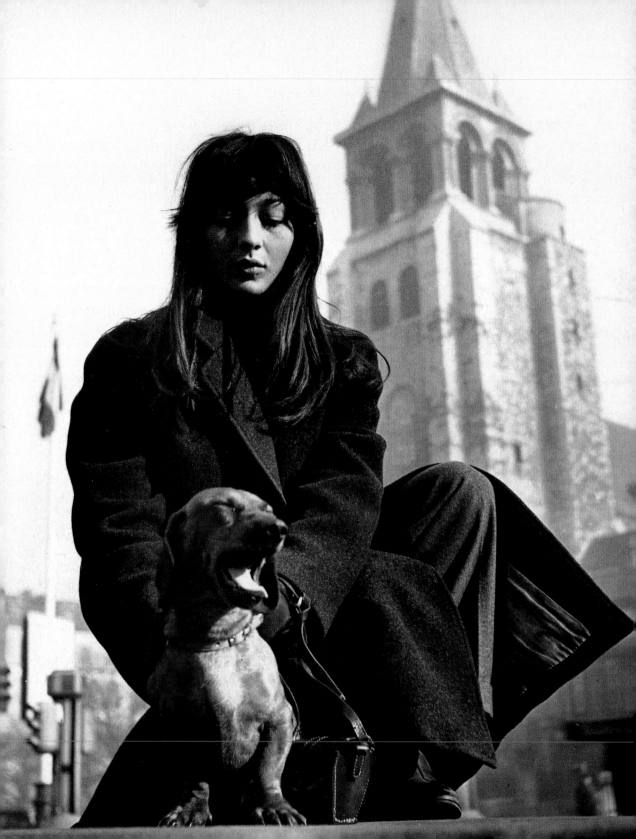

Art depends on there being affection in its creator's life and an artist must find ways, like everyone else, to nourish it. A photographer down on his or her knees picturing a dog has found pleasure enough to make many things possible.

Die Kunst weckt die Liebe im Leben ihres Schöpfers, die der Künstler – genau wie jeder andere – nähren muss. Ein Fotograf oder eine Fotografin, der oder die kniend einen Hund fotografiert, hat genügend Freude gefunden, um viele Dinge möglich werden zu lassen.

L'art exige dans la vie de son créateur une sensibilité que l'artiste doit trouver, comme tout un chacun, le moyen de nourrir. Un ou une photographe, agenouillé(e) pour saisir un chien, y trouve suffisamment de plaisir pour que tout soit possible.

ROBERT ADAMS

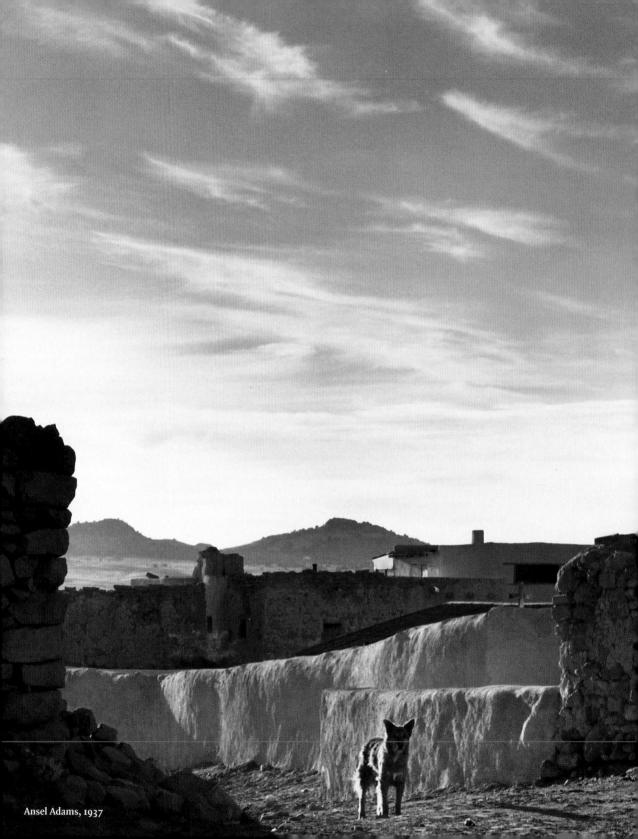

Ansel Adams, 1937

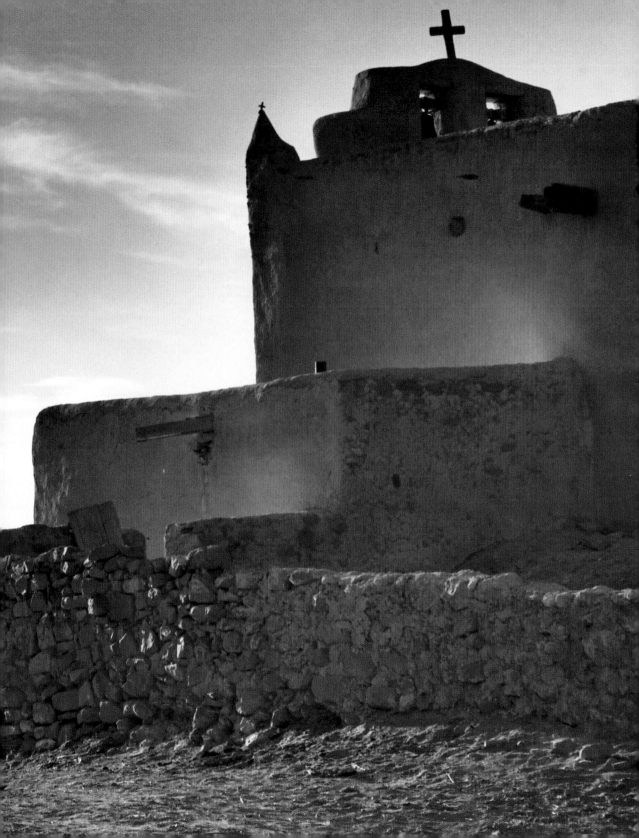

Where do dogs go? You ask, you unmindful people. They go about their business. Business meetings, love meetings. Through fog, through snow, through mud, during biting dog-days, in streaming rain, they go, they come, they trot, they slip under carriages, urged on by fleas, passion, need, or duty. Like us, they get up early in the morning, and they seek their livelihood or pursue their pleasures.

Wohin Hunde gehen? Das fragt ihr euch, ihr unaufmerksamen Menschen. Sie gehen ihren Geschäften nach. Hier eine geschäftliche Verabredung, da ein Rendevous. Durch Nebel, Schnee und Schmutz, an beißenden Hundstagen und in strömendem Regen kommen, gehen, trotten sie, schlüpfen sie unter Wagen, getrieben von Flöhen, Begierden, Notwendigkeiten oder Pflichten. Wie wir stehen sie frühmorgens auf, um sich ihr Auskommen zu suchen oder ihren Vergnügungen nachzugehen.

Où vont les chiens ? Vous vous le demandez, gens indifférents. Ils font ce qu'ils ont à faire. Des rendez-vous d'affaires, des rendez-vous d'amour. A travers le brouillard, dans la boue, par temps de chien, sous la pluie battante, ils vont, ils viennent, ils trottent, ils se glissent sous les voitures, aiguillonnés par les puces, la passion, le besoin ou le devoir. Comme nous, ils se lèvent tôt le matin et partent à la recherche de leur gagne-pain ou de leur plaisirs.

CHARLES BAUDELAIRE

Henri Cartier-Bresson, 1932

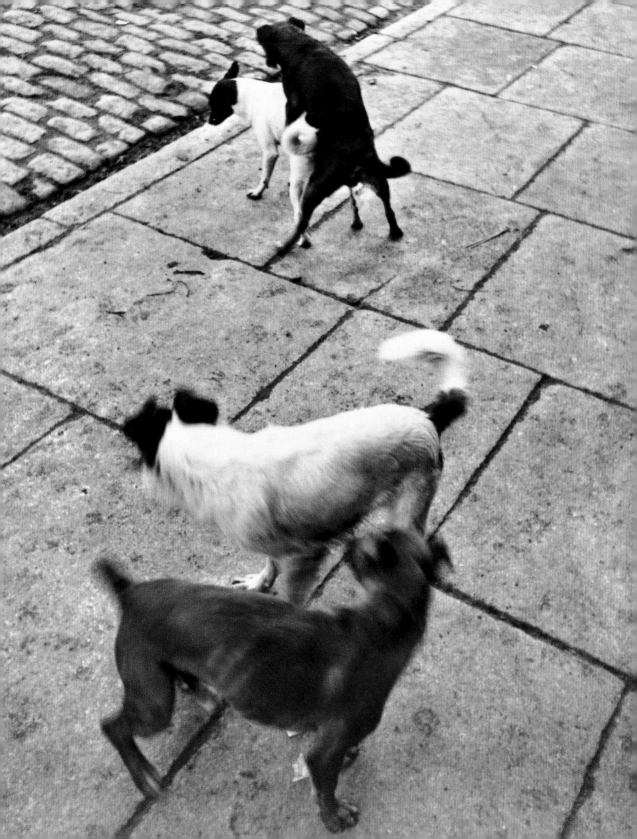

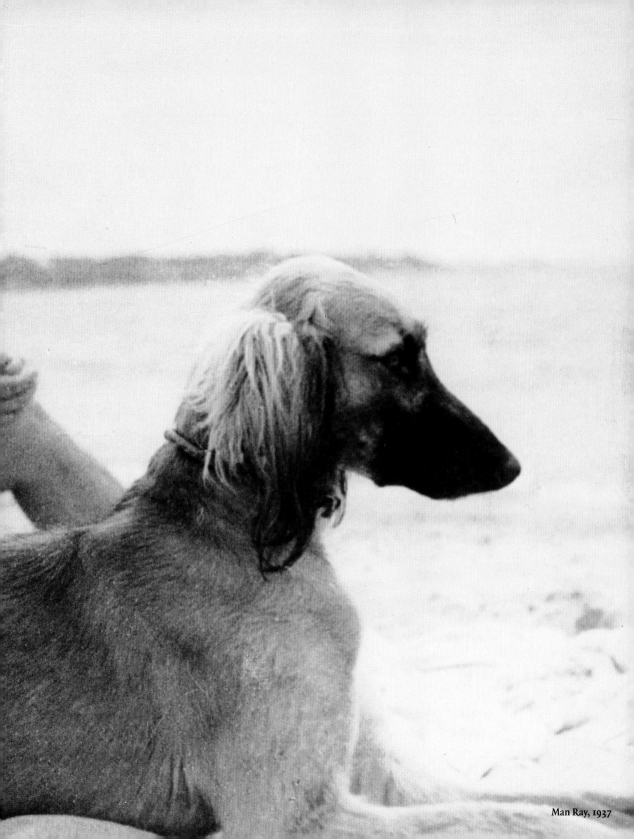

Man Ray, 1937

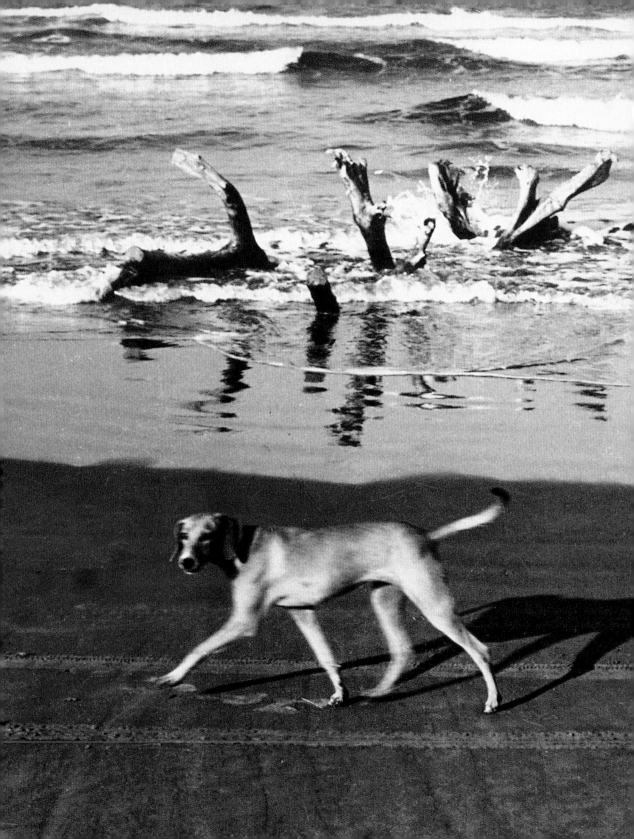

My approach to photography is based on my belief in the vigor and values of the work of nature and in the relation of man to nature. And I believe in photography as one means of expressing this affirmation and of achieving ultimate happiness and faith.

Mein fotografischer Ansatz gründet sich auf meinen Glauben an die Kraft und die Werte der Natur und an die Beziehung des Menschen zur Natur. Und ich glaube an die Fotografie als ein Mittel, dieses Bekenntnis zum Ausdruck zu bringen und Glück und Glaube in ihrer höchsten Form zu erlangen.

Je crois en la photographie parce que je crois en la vigueur et la valeur du travail de la nature, et en la relation que l'homme entretient avec elle. Et je suis sûr que la photographie est l'un des moyens d'exprimer cette certitude et de parvenir à un bonheur et à une foi suprêmes.

ANSEL ADAMS

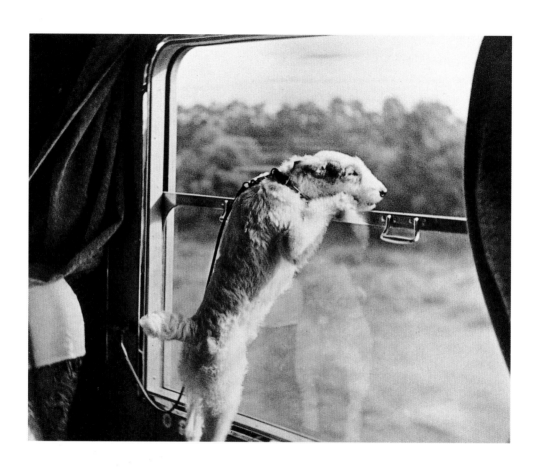

Erich Salomon, 1932

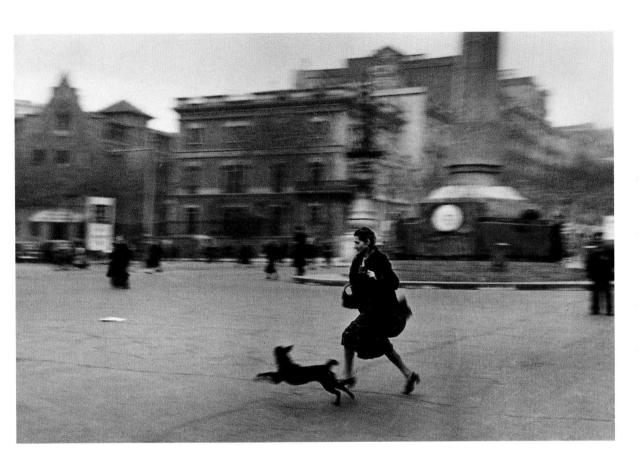

Robert Capa, 1936

The reason a dog has so many friends is
that he wags his tail instead of his tongue.

Der Grund, weshalb ein Hund so viele Freunde hat, liegt darin,
dass er mit dem Schwanz wedelt und nicht mit der Zunge.

La raison pour laquelle un chien a tant d'amis,
c'est qu'il agite sa queue et non sa langue.

ANONYMOUS

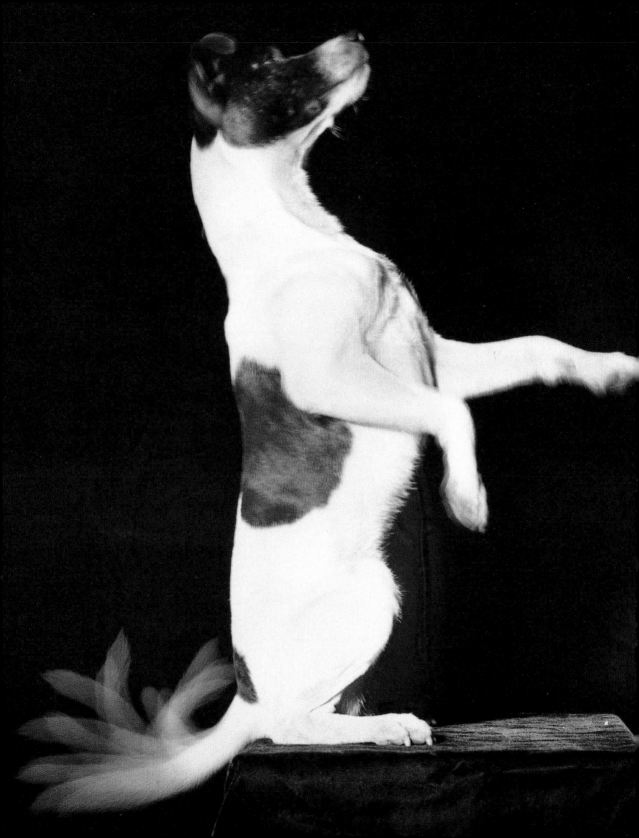

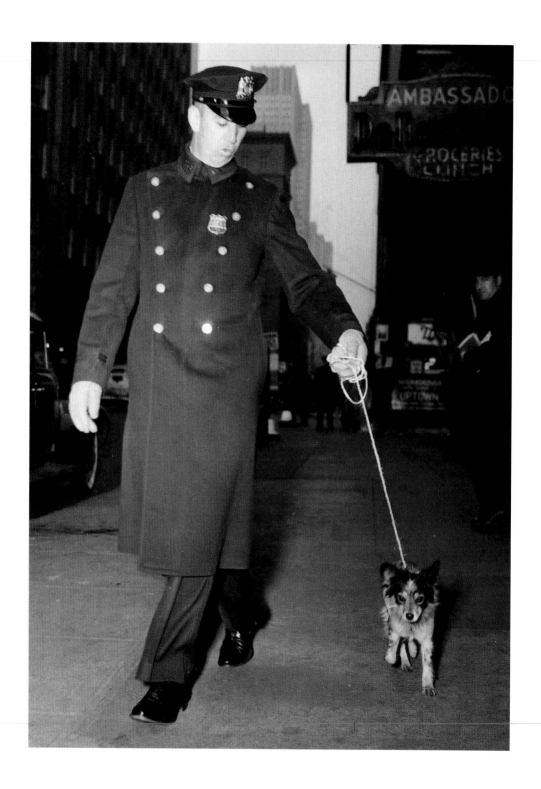

Weegee (Arthur Fellig), 1940

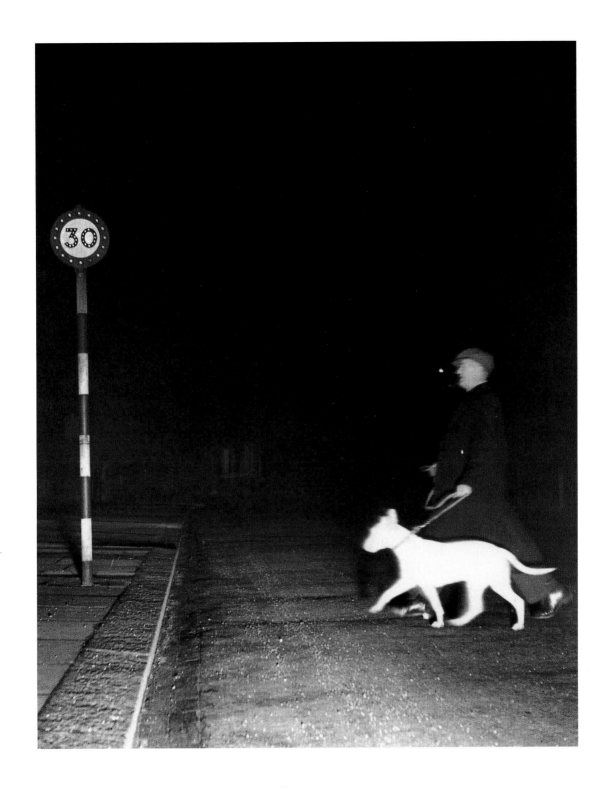

Bill Brandt, 1945

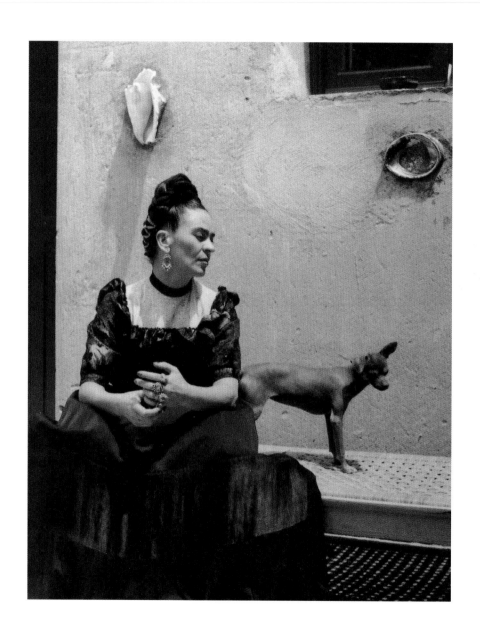

Lola Alvarez Bravo, 1944

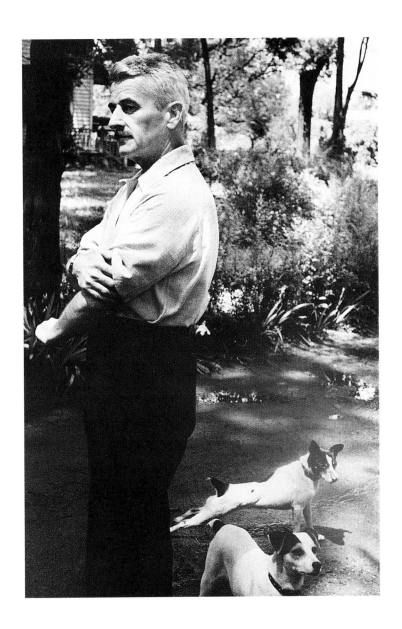

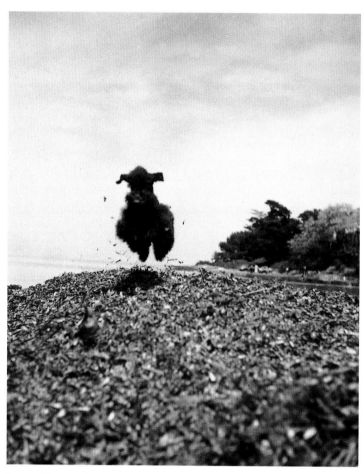

Jacques-Henri Lartigue, 1940

Herbert List, 1936

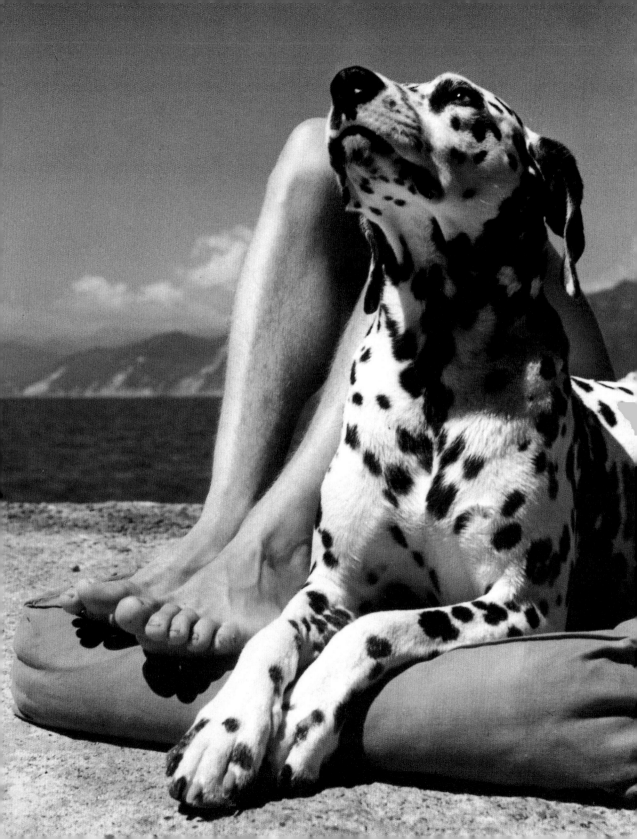

World War II
Der Zweite Weltkrieg
La Deuxième Guerre mondiale

Cry havoc and let slip
the dogs of war.

„Vernichtung!" schreien und
die Kriegshunde herauslassen.

Hurlez à la destruction
et déchaînez les chiens de guerre.

WILLIAM SHAKESPEARE, *Julius Caesar*

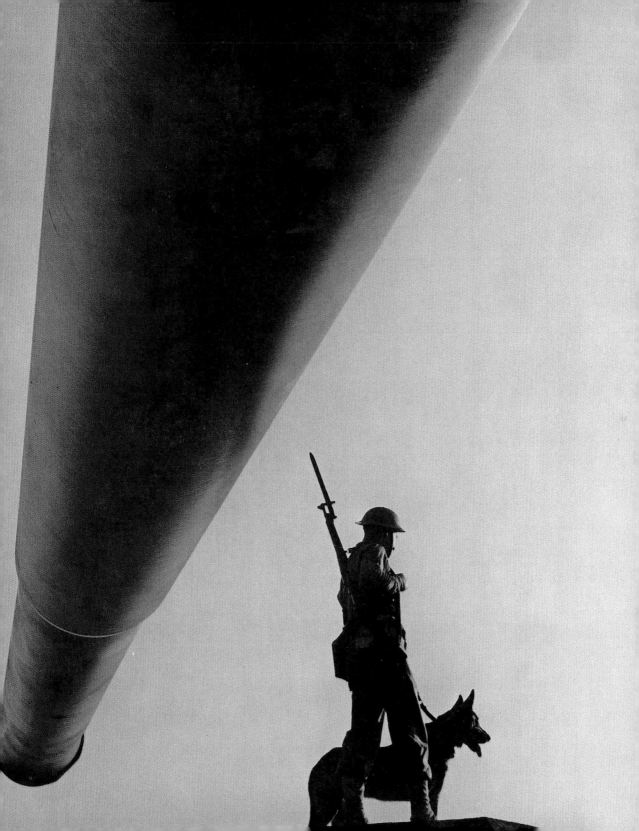

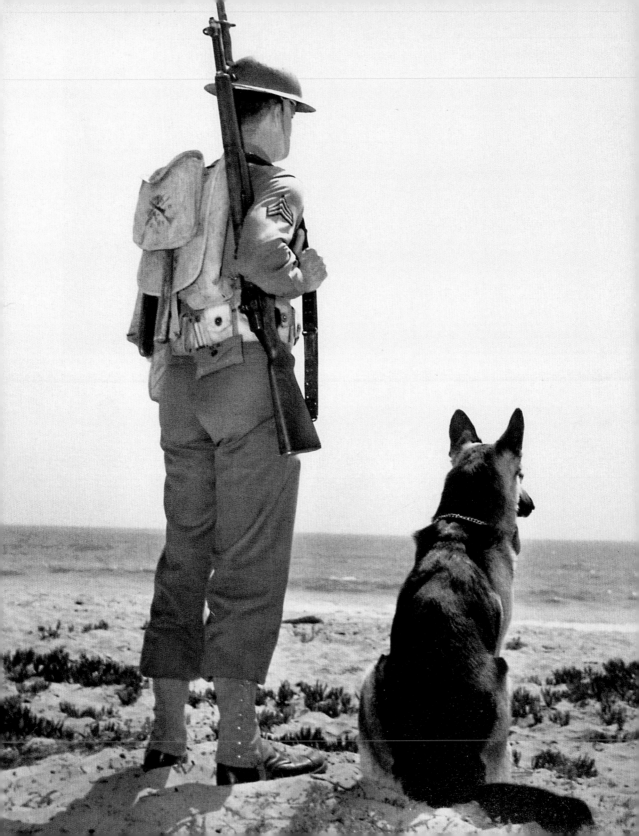

Every dog is
a lion at home.

Zu Hause ist jeder Hund
ein Löwe.

Chaque chien est,
chez lui, un vrai lion.

H.G. BOHN

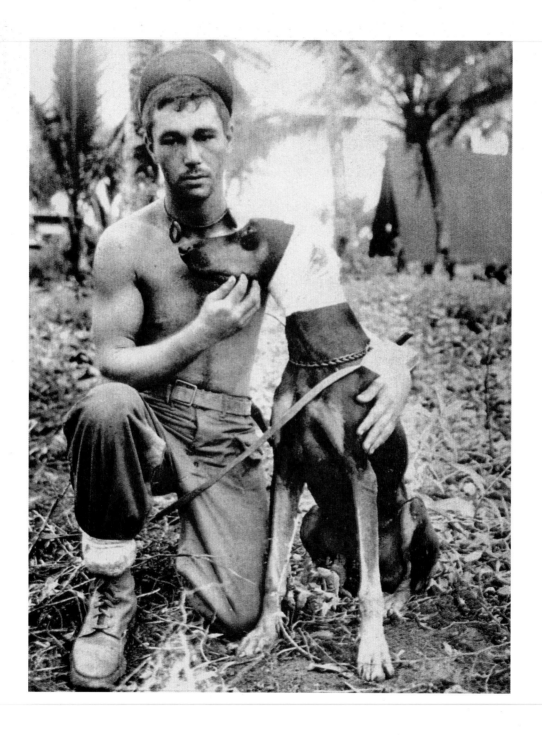

Unknown photographer, 1944

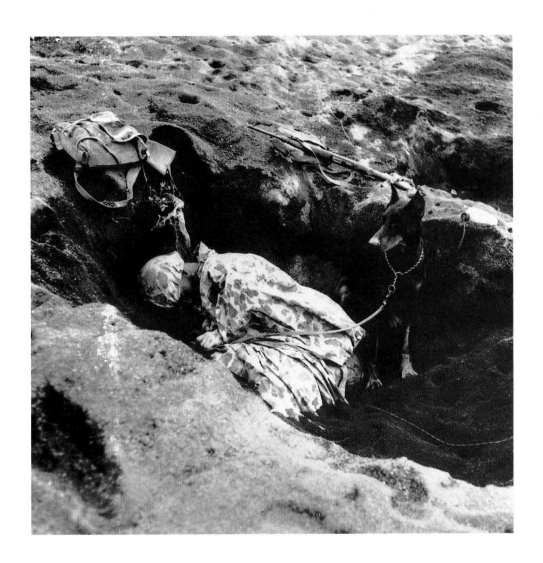

Heroism feels and never reasons
and therefore is always right.

Das Heldentum ist ein Gefühl,
das sich niemals besinnt
und ist deshalb immer im Recht.

L'héroïsme est un sentiment
qui jamais ne se raisonne
donc jamais ne se trompe.

RALPH WALDO EMERSON

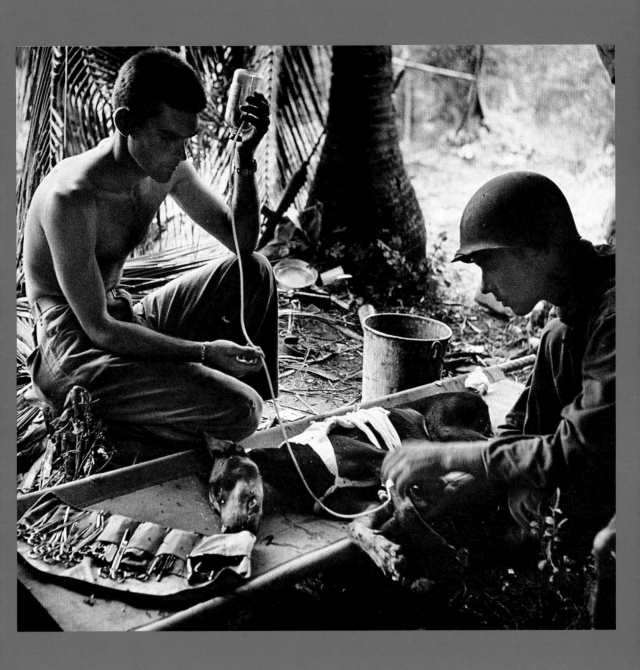

W. Eugene Smith, 1943

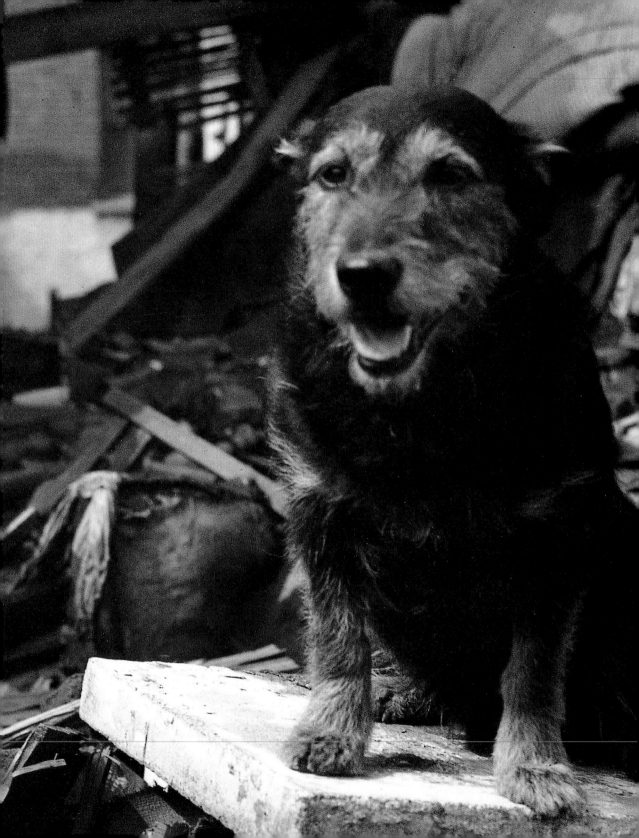

London · Unknown photographer, 1943

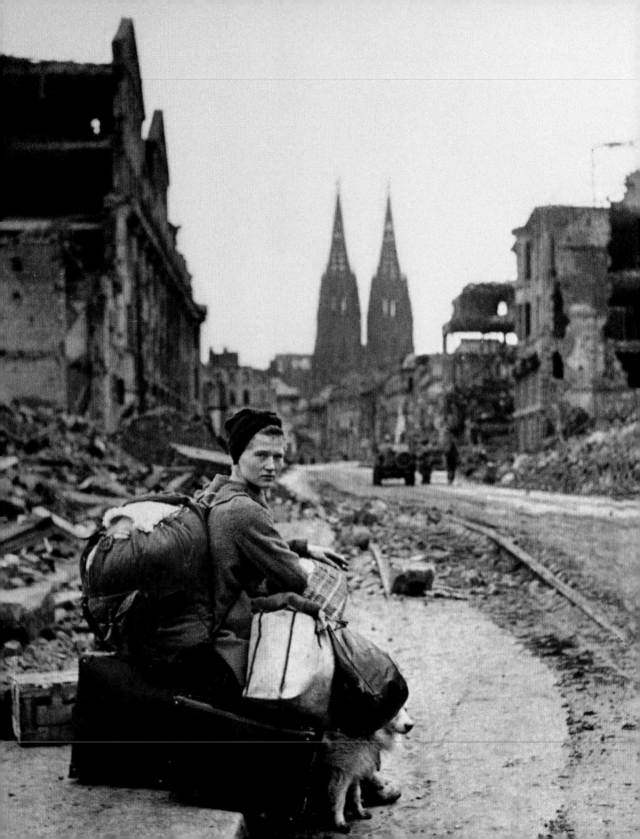

The dog has an enviable mind.
It remembers the nice things in life
and quickly blots out the nasty.

Der Hund ist um sein Gemüt zu beneiden.
Er erinnert sich an die schönen Dinge im Leben
und vergisst sehr schnell die unangenehmen.

Le chien possède un esprit enviable.
Il se souvient des choses agréables de la vie
et efface très vite les autres.

BARBARA WOODHOUSE

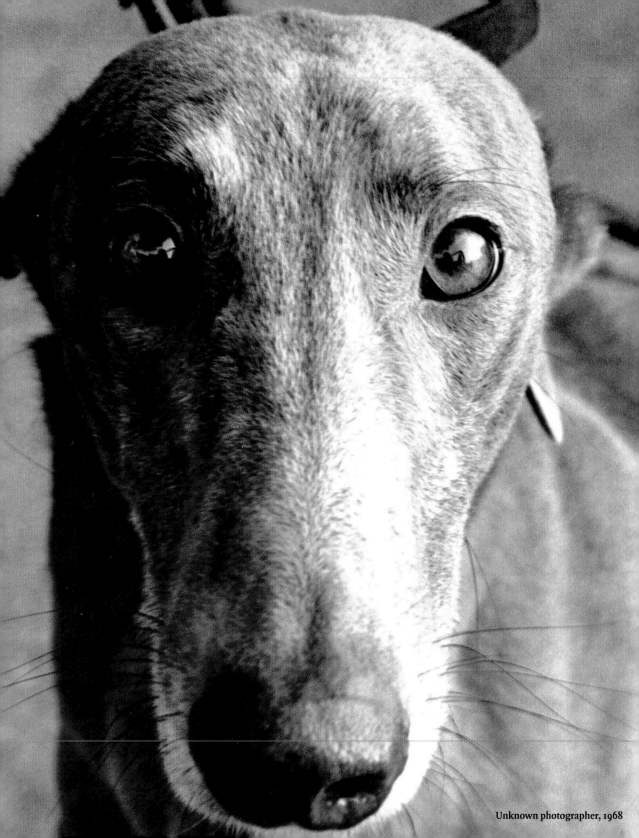

Unknown photographer, 1968

Looking Within
From Public Perception to Personal Perspective

Hinter den Kulissen
Vom öffentlichen Interesse zum persönlichen Anliegen

Regard à l'intérieur
De la perception publique à l'intérêt personnel

1950·1980

The **50**s

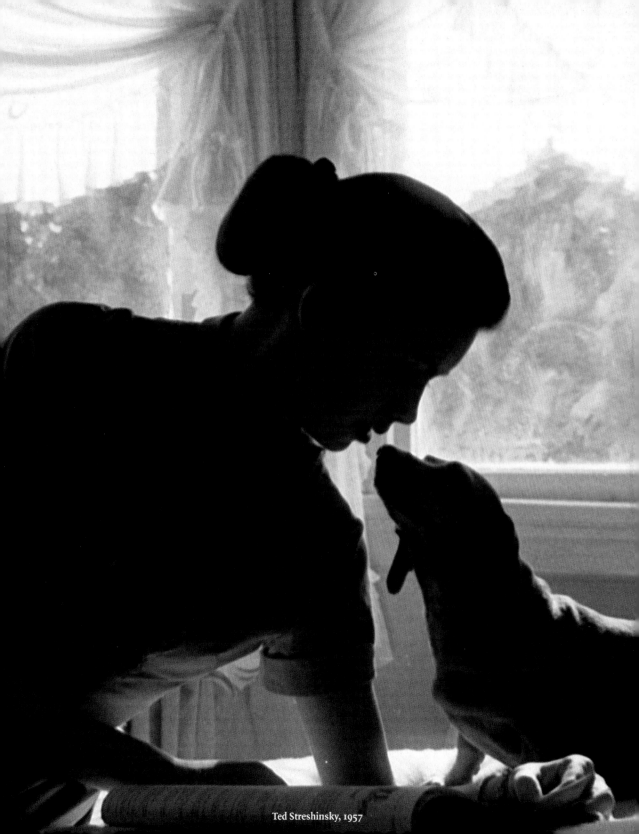
Ted Streshinsky, 1957

The Fifties

World War II failed to produce a peaceful world. Capitalism and communism snapped at each other, with the "Bomb" a constant threat. Korea, Tibet, Hungary, East and West Berlin, Algeria, and the Congo were engulfed in conflict. Despite regional strife, the Western world was overwhelmed by demands for goods and services, with jobs plentiful and opportunities unlimited. Technology gave society a host of household appliances, from vacuum cleaners to washing machines, freeing the populace to pursue leisure activities long suspended by the war. Color TV, polyester, Disneyland, MacDonald's, and family vacation camps became the social markers of the decade. The birth rate zoomed. Snoopy, Barbie, Frisbees, and Hula-Hoops amused the young, while Marilyn made the rest of us itch. Gillespie and Armstrong provided the music, God created Bardot, Grace became a princess, and Elvis was still in the building.

Politically, the old order held the day. Corporal and capital punishment remained preferred deterrents. Homosexuality was a crime, illegitimacy was shameful, and divorce unacceptable. Whales were slaughtered, forests denuded, and waters polluted. Patience gave way to hysteria. America obsessed over spies, England misjudged the Suez, and the French were misguided in Vietnam. The latter part of the fifties witnessed the murmurings of social protest as people began to rally against the paramount threats to humanity – racial discrimination and nuclear proliferation.

While all of this "shakin'" was "goin' on," two social phenomena emerged – the "teenager" and the "family dog." How and why the dog's status was enhanced is a matter of some conjecture. The dog, left behind by those who went to war, became the soldier's surrogate – the mother's substitute child, the father's youthful and loving companion, the child's missing father. Families took care that their warrior son's dog remained healthy and was there to welcome their boy home. The house pet moved inside the home and took its place as a full-fledged family member. Its new status was underscored as the dog took center stage in the developing television broadcast industry. No longer simply the hero's faithful companion, the dog became in its own right a hero. Lassie taught us loyalty, love, and sacrifice. For millions, she became the exemplar of family values and virtues.

During the same time, the world's youth came into its own. The teenager was recognized as a force in society. The "daddy-os" stood proud, with Brando and Dean as their icons and Holden Caulfield their muse. Their "cool" looks – sneakers and dungarees – nudged into fashion acceptability, while their music captured their elders' attention. The teenyboppers became a social and marketing force to be reckoned with.

Perhaps not as dramatically, but with equal effect, photography expanded its influence in the Fifties. Photographic imagery permeated all segments of society and became the paramount instrument of

communication. It was at once the tool of the marketer, the instrument of the artist, and the indispensable device of the masses to record family and friends. Like all of the arts during this period, photography began to look within itself, at the artist's personal vision, his "private realities." The leading figures in photography remained, in large part, the photojournalists of Look and LIFE – Alfred Eisenstaedt, W. Eugene Smith, Richard Avedon, and, in fashion, the ever-present Henri Cartier-Bresson and Irving Penn. Brassaï and Robert Doisneau in

Paris, Bill Brandt in London, Manuel Alvarez Bravo in Mexico, and Ansel Adams and Paul Strand in America continued to perfect their artistry by making their photographs resonate. The Swiss photographer, Robert Frank, exposed America's moral impoverishment in his seminal work, *The Americans*. No other photographic book had ever achieved such acclaim or had such an impact on future generations of photographers. The power of the image would never again be doubted.

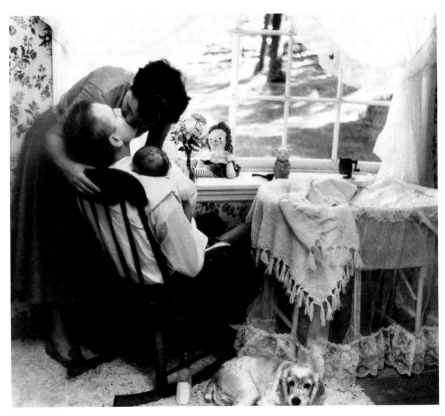

Eve Arnold, 1957

Die fünfziger Jahre

Aus dem Zweiten Weltkrieg ging keine friedlichere Welt hervor. Kapitalismus und Kommunismus standen einander als verfeindete Blöcke gegenüber, die Atombombe war eine permanente Bedrohung. Die neuen Konfliktherde hießen Korea, Tibet, Ungarn, das geteilte Berlin, Algerien und Kongo. Trotz regionaler Konflikte herrschte in der westlichen Welt eine enorme Nachfrage nach Gütern und Dienstleistungen, es gab genug Arbeitsplätze, und die Möglichkeiten schienen unbegrenzt. Technologische Neuerungen überschwemmten den Markt mit Haushaltsgeräten, vom Staubsauger bis zur Waschmaschine, verschafften der Bevölkerung freie Zeit, in der sie Aktivitäten nachging, die der Krieg lange Zeit unmöglich gemacht hatte. Fernseher, Polyester, Disneyland, MacDonald's und Familienferien wurden in den USA zu den gesellschaftlichen Markenzeichen des Jahrzehnts. Die Geburtenrate stieg rasant an, die Jugend erfreute sich an Snoopy, Barbie, Frisbee-Scheiben und Hula-Hoop-Reifen, während die Monroe uns Erwachsene unruhig werden ließ. Gillespie und Amstrong machten die Musik, Grace wurde Prinzessin und Elvis war im Kommen.

Politisch galt immer noch die alte Ordnung. Prügel- und Todesstrafe sollten abschreckende Wirkung zeigen, Homosexualität war ein Verbrechen, Unehelichkeit eine Schande und Scheidung inakzeptabel. Wale wurden abgeschlachtet, Wälder abgeholzt und Gewässer verschmutzt. An die Stelle der Geduld trat die Hysterie. Amerika plagte sich mit Spionen herum, England schätzte die Suezkrise

falsch ein, und die Franzosen wurden in Vietnam irregeleitet. Die zweite Hälfte der Fünfziger erlebte eine erste Welle des Protests, als die Menschen auf die Straße gingen, um gegen zwei der größten Übel der Menschheit zu demonstrieren: Rassendiskriminierung und die Verbreitung von Atomwaffen.

Die gesellschaftlichen Phänomene in den USA dieser Jahre waren der „Teenager" und der „Familienhund". Wie und weshalb der Status des Hundes sich verbesserte, lässt sich nur vermuten. Der Hund, zurückgelassen von denen, die in den Krieg zogen, wurde zum Ersatz für den Soldaten – der Mutter ersetzte er das Kind, dem Vater den Sohn und dem Kind den Vater. Die Familien achteten darauf, dass der Hund des Sohnes, der im Krieg war, gesund blieb und zur Begrüßung zur Stelle war, wenn der Junge heimkehrte. Das Haustier zog ins Haus und nahm dort den Platz eines vollwertigen Familienmitglieds ein. Der neue Status des Hundes wurde gestärkt, als ihn das aufstrebende Medium Fernsehen entdeckte. Der Hund war nicht mehr nur der treue Kamerad des Helden, sondern der Held selbst. Lassie lehrte uns Loyalität, Liebe und Opferbereitschaft. Für Millionen Menschen wurde dieser Collie zum Musterbeispiel für Werte und Tugenden innerhalb der Familie.

In dieser Zeit zeigte die Jugend der Welt, was in ihr steckte. Der Teenager wurde als gesellschaftlich relevante Größe erkannt. Die „Halbstarken" gaben sich selbstbewusst, Brando und Dean waren ihre Idole und Holden Caulfield ihre Muse. Ihr „cooles"

Outfit – Jeans und Turnschuhe – rührte an den Grundfesten dessen, was modisch noch vertretbar war, während ihre Musik auch bei der älteren Generation ankam. Die Teenybopper wurden zu einer gesellschaftlichen und marktwirtschaftlichen Größe, mit der man rechnen musste.

Vielleicht nicht ganz so dramatisch, aber mit demselben Effekt konnte auch die Fotografie ihren Einfluss in den fünfziger Jahren ausweiten. Das Medium Fotografie durchdrang alle Bereiche der Gesellschaft und wurde zum wichtigsten Instrument der Kommunikation. Die Fotografie war Werkzeug des Marketingfachmanns, Instrument des Künstlers und gleichzeitig unentbehrliches Hilfsmittel der Massen, um Familie und Freunde zu verewigen. Wie alle Künste jener Zeit begann auch die Fotografie sich auf sich selbst zu besinnen, auf die persönliche Sichtweise des Fotografen, seine „private Wirklichkeit". Die führenden Köpfe in der Fotografie waren zum großen Teil weiterhin die Fotojournalisten von Look und LIFE, Alfred Eisenstaedt, W. Eugene Smith, Richard Avedon und auf dem Sektor Mode Henri Cartier-Bresson und Irving Penn. Brassaï und Robert Doisneau in Paris, Bill Brandt in London, Manuel Alvarez Bravo in Mexiko sowie Ansel Adams und Paul Strand in Amerika perfektionierten ihre Kunst und ließen ihre Fotografien für sich selbst sprechen. Der Schweizer Robert Frank zeigte in seinem zukunftsweisenden Werk *The Americans* die moralische Verarmung Amerikas auf. Kein anderer Bildband hatte je solchen Beifall gefunden oder hat zukünftige Fotografengenerationen so stark beeinflusst. Die Macht des Bildes sollte nie mehr in Zweifel gezogen werden.

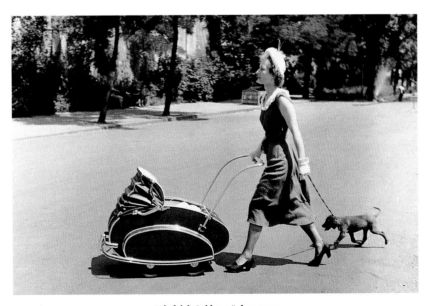

Friedrich Seidenstücker, 1950

Les années 50

La Seconde Guerre mondiale échoua à produire un monde paisible. Capitalisme et communisme se retrouvèrent face à face, se menaçant mutuellement de la bombe atomique. La Corée, le Tibet, la Hongrie, Berlin-Est et Berlin-Ouest, l'Algérie et le Congo restaient enlisés dans les conflits. Malgré ces dissensions, le monde occidental regorgeait de demandes en biens et services, d'une abondance d'emplois et d'opportunités illimitées. La technologie offrait aux ménages pléthore d'appareils ménagers, de l'aspirateur à la machine à laver, permettant ainsi aux gens de s'adonner aux loisirs auxquels ils avaient dû renoncer pendant la guerre. Les télévisions couleur, le polyester, Disneyland, MacDonald et les campings marquèrent de leur sceau la décennie. Le taux des naissances s'envola. Snoopy, Barbie, frisbees et hula-hoops divertissaient les plus jeunes ; Marilyn faisait rêver les autres. Gillespie et Armstrong inventaient la musique. Dieu créait Bardot, Grace se mariait comme une princesse et Elvis était encore des nôtres.

Politiquement, l'ordre ancien se perpétra. Punitions corporelles, et peine de mort servaient de dissuasifs. L'homosexualité était un crime, le mariage était sanctifié et le divorce impensable. Les baleines étaient massacrées, les forêts dévastées et les eaux polluées. A la patience succéda l'hystérie. L'Amérique fut obsédée par les espions, l'Angleterre sous-estima Suez et les Français s'enlisèrent au Vietnam. A la fin des années 50, on commença à entendre quelques murmures de protestation, à voir les gens se rassembler et protester contre les dangers menaçant l'humanité, la discrimination raciale et la prolifération nucléaire.

Tandis que ces différentes « ondes » se propageaient, on assista à l'émergence de deux phénomènes sociaux : le « teen-ager » et « le chien de la famille ». Comment et pourquoi le statut de ce dernier s'imposa, nul ne saurait le dire. Abandonné par ceux qui partaient sous les drapeaux, le chien remplaça le soldat : pour la mère, il fut l'enfant, pour le père, le copain attentif, pour le bambin, le père absent. Les familles firent en sorte que ce chien reste en pleine forme pour attendre le retour du maître. L'animal s'installa dans la maison et devint un des membres de la famille. De plus, il se mit à jouer un rôle essentiel dans l'industrie de la télévision, alors en plein développement. Non seulement compagnon fidèle, il devint héros à part entière. Lassie enseigna la loyauté, l'amour et le sacrifice. Pour des millions de gens, elle incarna valeurs et vertus familiales.

A la même époque, dans le monde entier, la jeunesse s'affirmait. L'adolescent devint un force sociale. Les « johnny-guitare » s'imposèrent, avec pour modèle Brando et Dean, et pour muse Holden Caulfield. Avec leur air blasé, leurs jeans et leurs baskets, ils créèrent la mode, tandis que leur musique étonnait leurs aînés. Le danseur de be-bop devint une valeur sociale et commerciale avec laquelle il fallut compter.

Ces années-là, de manière peut-être moins spectaculaire, mais avec un effet similaire, l'influence de la photographie alla croissant. L'image

s'infiltra dans tous les aspects de la société, jusqu'à devenir le moyen de communication par excellence. Elle devint l'outil de l'agent commercial, l'instrument de l'artiste et, pour les masses, le moyen indispensable pour immortaliser sa famille et ses amis. Puis, comme tous les arts de l'époque, la photographie commença à s'examiner de l'intérieur, à évaluer la vision particulière de l'artiste, « sa réalité personnelle ». Les personnages phares furent surtout des reporters de Look et de LIFE , tels Alfred Eisenstaedt, W. Eugene Smith, Richard Avedon et, pour la mode,

les toujours présents Henri Cartier-Bresson et Irving Penn. Brassaï et Robert Doisneau à Paris, Bill Brandt à Londres, Manuel Alvarez Bravo à Mexico, comme Ansel Adams et Paul Strand en Amérique, portèrent leur art encore à force de travail. Le Suisse Robert Frank montra l'appauvrissement moral de l'Amérique dans son œuvre remarquable : *The Americans.* Jamais aucun recueil photographique n'avait connu un tel succès ni un tel impact sur les générations à venir. Le pouvoir de l'image n'allait plus jamais être mis en doute.

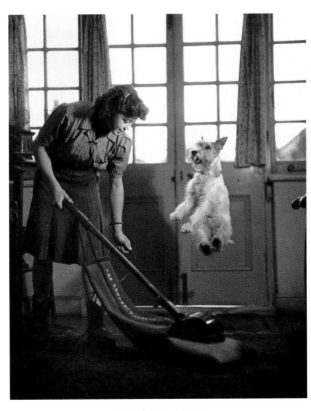

Kurt Hutton, c. 1950

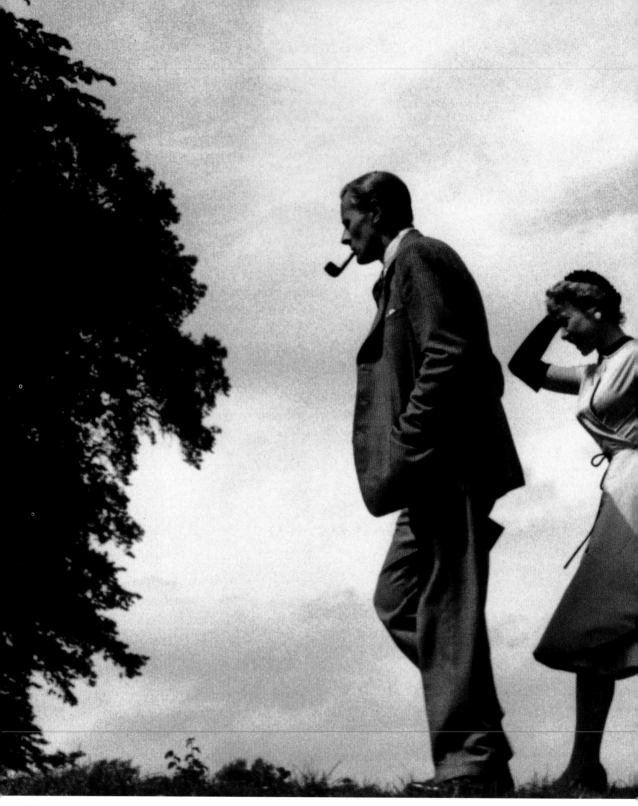

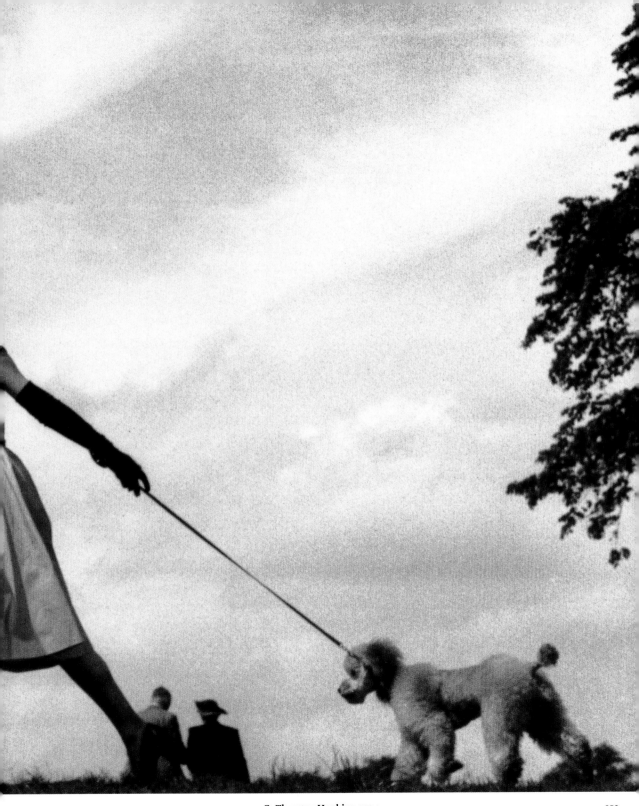

It is a strange thing, love. Nothing but love has made the dog lose
his wild freedom, to become the servant of man.

Die Liebe ist eine merkwürdige Sache. Nur um der Liebe willen hat der Hund seine
wunderbare Freiheit aufgegeben und ist zum Diener des Menschen geworden.

C'est une drôle de chose, l'amour. N'était-ce pour l'amour, jamais
le chien n'aurait renoncé à sa merveilleuse liberté, pour se faire le
serviteur de l'homme.

D.H. LAWRENCE

Marc Riboud, c. 1950

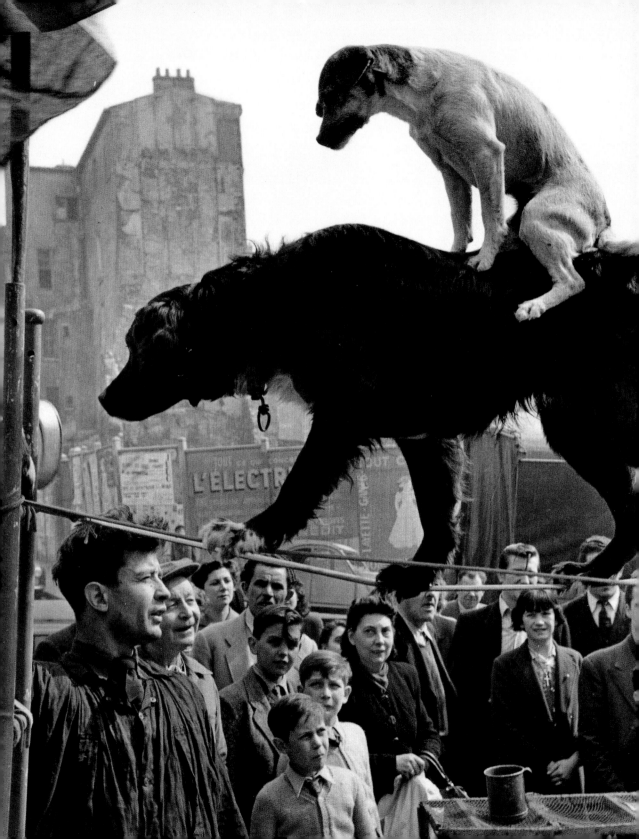

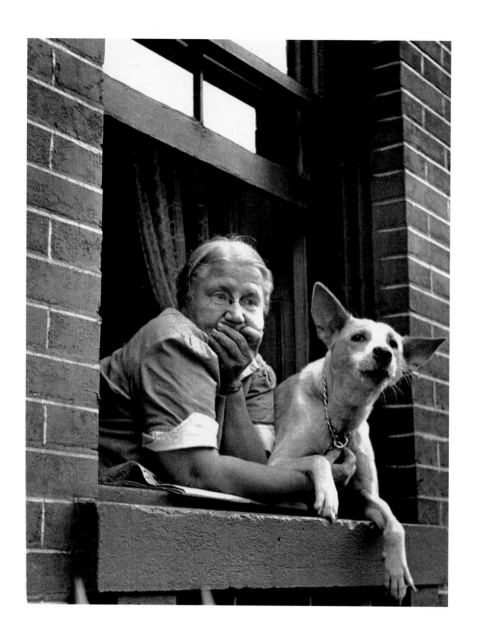

Erika Stone, 1959

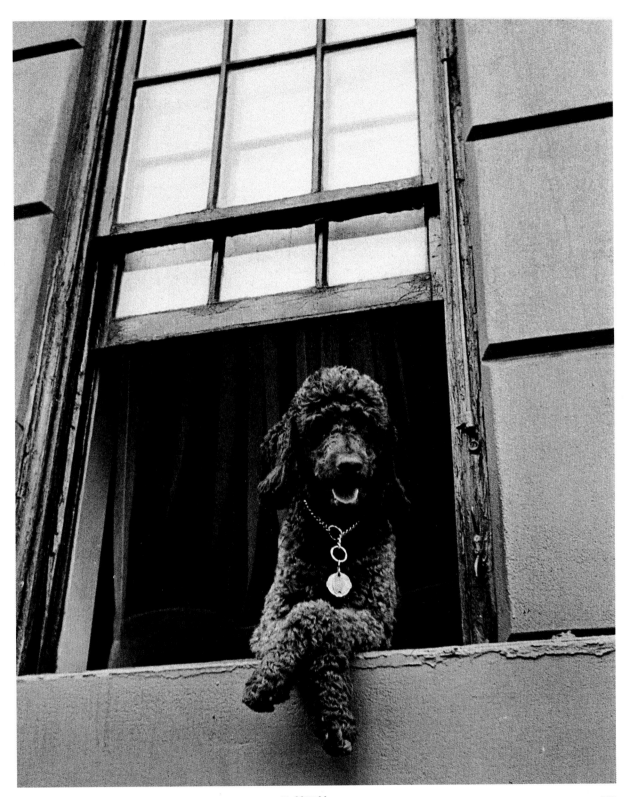

Todd Webb, 1952

The noblest dog of all is the hot dog;
it feeds the hand that bites it.

Der nobelste aller Hunde ist der Hot Dog:
Er nährt die Hand, die ihn isst.

Le plus noble de tous les chiens, c'est le hot dog.
Il nourrit la main qui le mord.

LAURENCE J. PETER

Dennis Stock, 1955

Unknown photographer, 1955

Audrey Hepburn, 1954 Elvis Presley, c. 1955 Liz Taylor, 1957

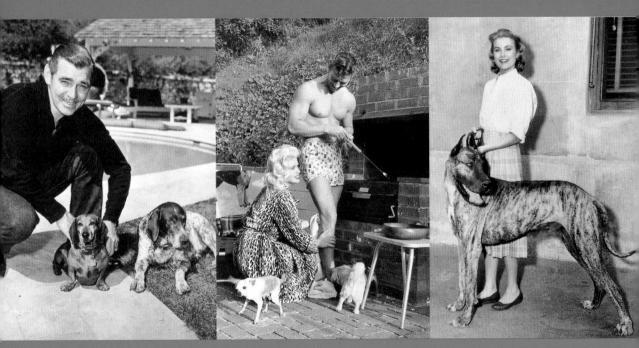

Clark Gable, 1950 Jayne Mansfield, 1958 Grace Kelly, c. 1950

Slim Aarons, c. 1955

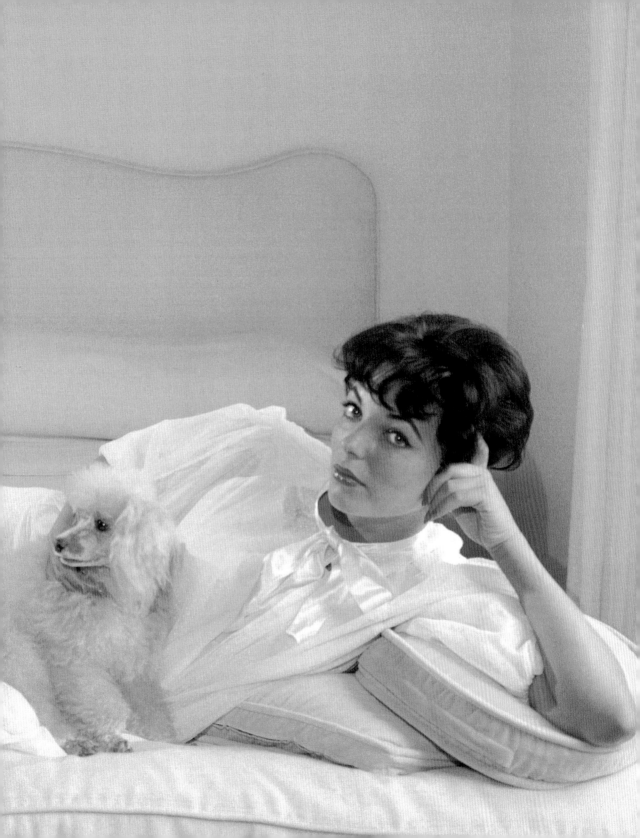

John Springer, c. 1948

Dogs never lie
about love.

Hunde lügen nie,
wenn es um Liebe geht.

Les chiens ne mentent jamais
quand ils parlent d'amour

JEFFREY MOUSSAIEFF MASSON

Baron, 1954

Genevieve Naylor, 1954

Not Carnegie, Vanderbilt, and Astor together could have raised money enough to buy a quarter share in my little dogs.

Selbst Carnegie, Vanderbilt und Astor zusammen hätten nicht genug Geld aufbringen können, um auch nur einen einzigen Anteil an meinem kleinen Hund zu kaufen.

Même Carnegie, Vanderbilt et Astor réunis n'auraient pu rassembler assez d'argent pour s'offrir une seule action sur mes petits chiens.

ERNEST THOMPSON SETON

David (Chim) Seymour, 1950

Frances Clark, 1958

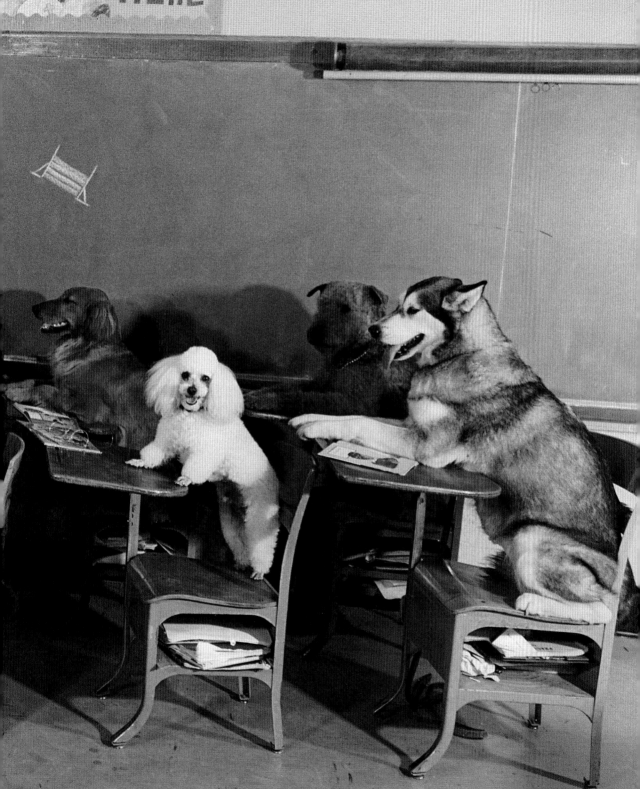

Living with a dog is easy –
like living with an idealist.

Das Leben mit einem Hund ist einfach –
wie das Leben mit einem Idealisten.

Vivre avec un chien, c'est facile
Comme vivre avec un idéaliste.

H.L. MENCKEN

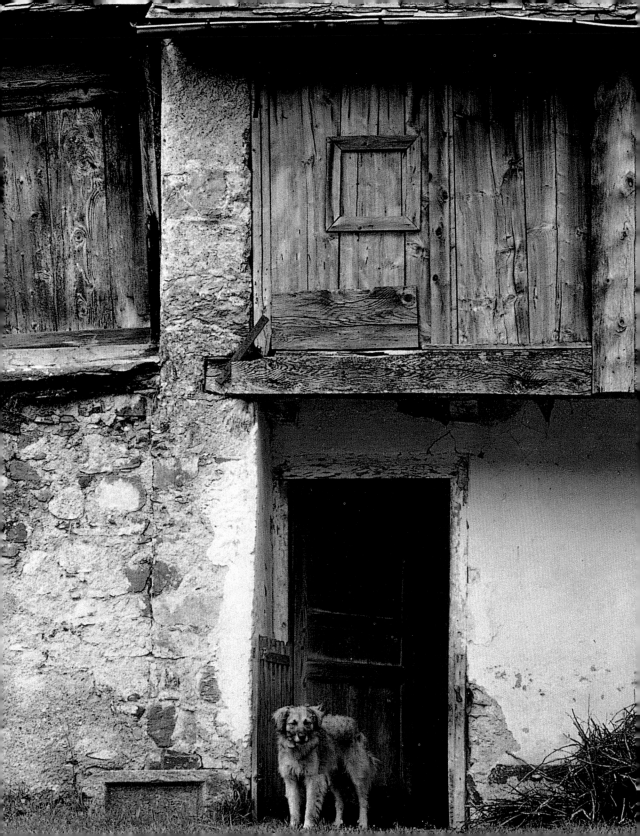

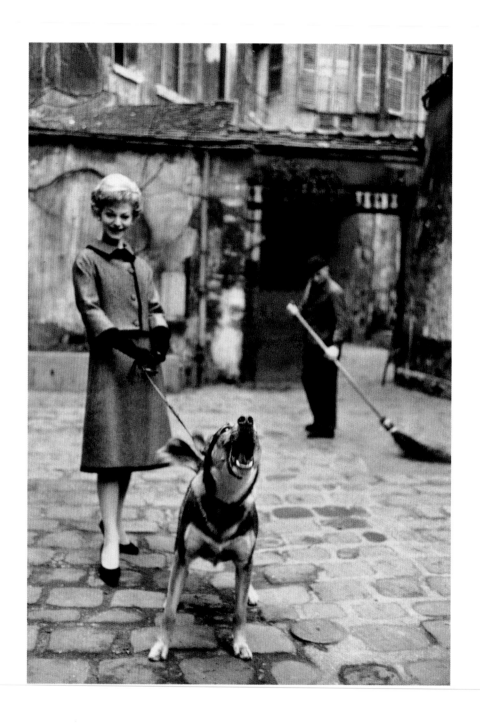

Elliott Erwitt, 1958

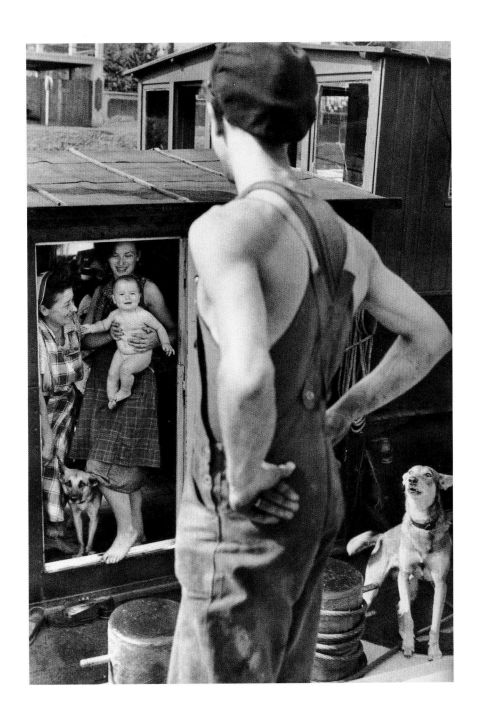

Henri Cartier-Bresson, 1956

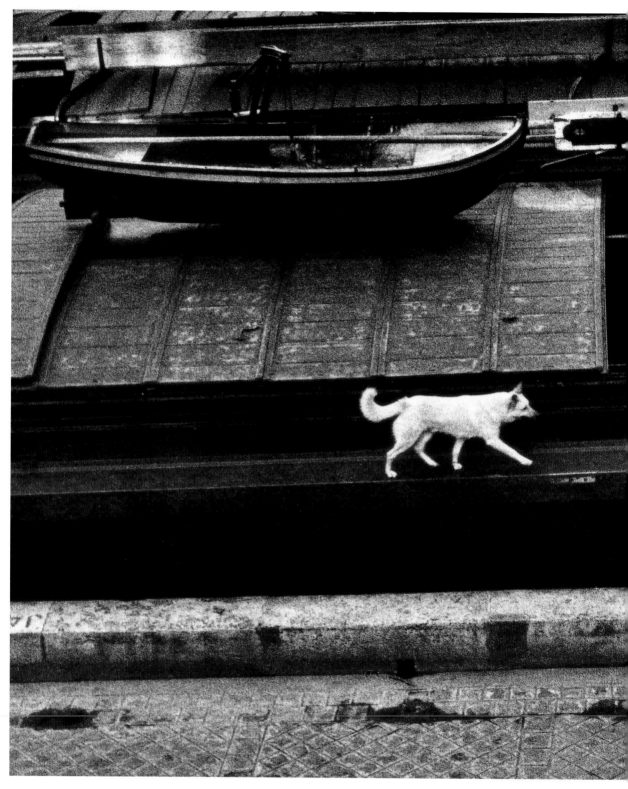

Jeanloup Sieff, 1958

Extraordinary creature!
So close a friend and yet so remote.

Ein außergewöhnliches Wesen!
Ein so guter Freund und doch so verschieden.

Etre extraordinaire !
Si proche de l'ami, et pourtant
si lointain.

THOMAS MANN

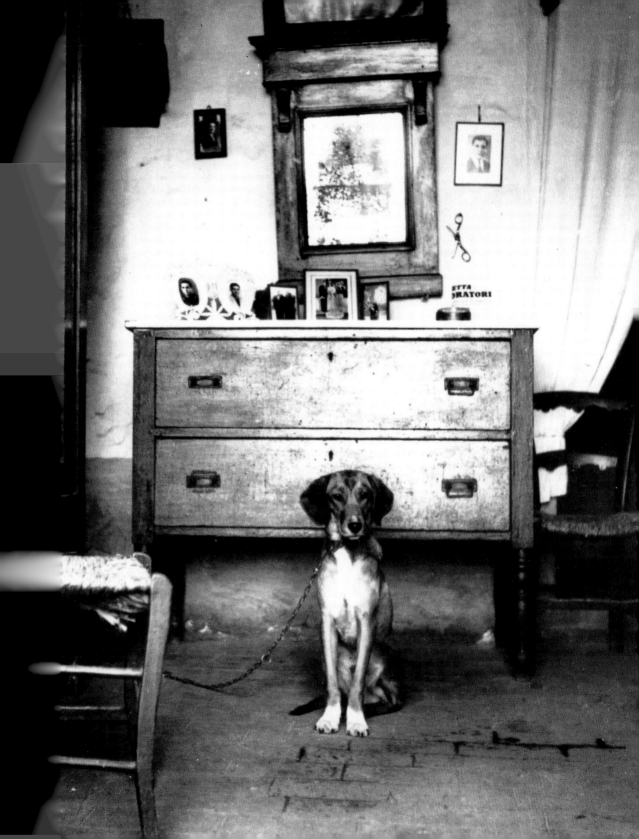

Edouard Boubat, 1955

Marvin Newman, 1951

Mario Giacomelli, 1957

The 6Os

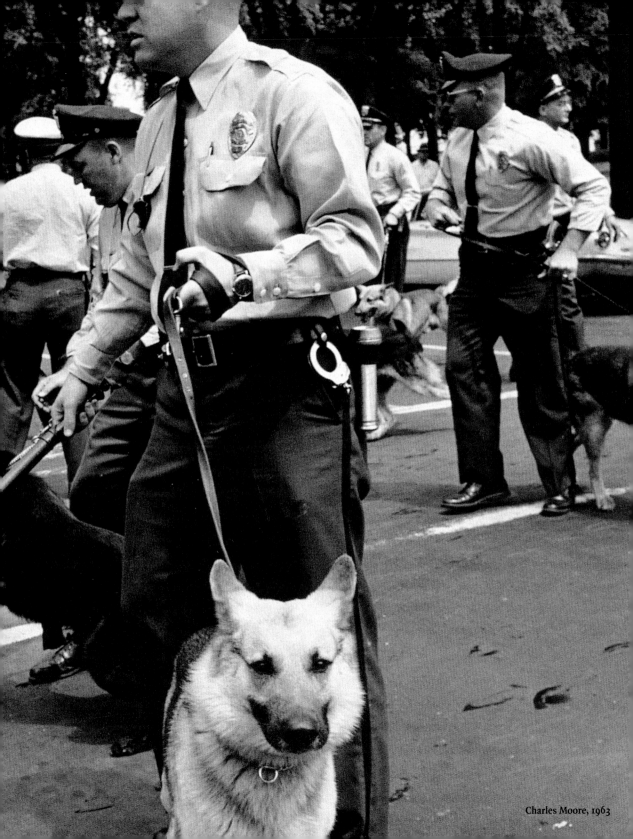

Charles Moore, 1963

The Sixties

The decade of the sixties saw impatient youths gain world attention. It was a time of experimentation and initiative. America elected John F. Kennedy its youngest President, passing the torch of leadership to a new generation. Things were "blowin' in the wind." Skirts got shorter, the Beats howled, Bond got licensed, and Twiggy got thinner. *Playboy* and the pill encouraged a new sexual freedom. Snoopy and Monroe continued to hold center stage, while the Stones gave us a certain satisfaction. Yet underlying this psychedelic sizzle and swing, societal corrosion began to appear. Vietnam, Algeria, Biafra, and Cuba rattled world stability. The Wall in Berlin, barricades in Paris, and racial inequality in the West prompted potent protests. The Kennedy consensus turned to factious fragmentation. Flower-bedecked, drug-enhanced youths found their personal Nirvanas. Some took to demonstrating, others just tuned out, while Lennon extolled that love was all that was needed to give peace a chance.

The arts, as usual, kept pace with the times. The Pop that permeated music informed the arts. Jasper Johns, Robert Indiana, Robert Rauschenberg, Roy Lichenstein, and Andy Warhol created their own revolution with a representational artistry that both cuckolded and celebrated the prevailing commercial culture. Their crisp graphics appealed to the fifties teenager who had become the sixties pop consumer. To a certain degree, photography followed their lead, crafting what has come to be called "snapshot aesthetics," a casual style lacking artifice or cant. Lee Friedlander, Garry Winogrand, Joel Meyerowitz, and Elliott Erwitt seemed to serendipitously capture creatures, human and canine, with disarming wit. Their images presented at first glance a noneventful slice of everyday life, yet upon further study, the images often revealed subtle and significant meaning, again demonstrating the camera's limitless facility to provoke and educate. One consequence of this new aesthetic was the return of the dog as subject and muse. In both America and Europe, photographers were embracing man's bond with animals in a less formal way; the witticism of Lartigue was returning to photographic art. Photographers such as Elliott Erwitt, William Wegman, Mary Ellen Mark, and Josef Koudelka began to develop canine imagery that would become important motifs in their work.

In some respects, the sixties defined photography as no other period did. Introspective analysis gave new meaning and definition to the medium. Photography had been perceived for over a century as the prism through which man faithfully observed his world. It had now become apparent that the photograph, in fact, mediated between the objective world and the viewer and, as a consequence, placed thereon a subtle but immutable sheen. The photograph was an object to be read, and, consequently, its interpretation was personal and subjective, not only to the artist but to the viewer. It still embodied a "moment of truth," but the question was: whose truth?

Bill Eppridge, 1965

Die sechziger Jahre

In den sechziger Jahren erlangten ungeduldige Jugendliche weltweit Aufmerksamkeit. Es waren Jahre des Experimentierens und der Initiativen. Amerika wählte John F. Kennedy zu seinem jüngsten Präsidenten und übergab die Macht einer neuen Generation. Alles befand sich im Umbruch, „blowin' in the wind". Die Röcke wurden kürzer, die Beatniks heulten; Bond erhielt seine Lizenz und Twiggy wurde immer dünner. Der Playboy und die Pille waren die Garanten einer neuen sexuellen Freiheit. Snoopy und die Monroe standen immer noch im Mittelpunkt, und die Stones verschafften eine gewisse „Satisfaction". Doch hinter diesem psychedelischen Brodeln und Swingen begann die Zersetzung der Gesellschaft sichtbar zu werden. Vietnam, Algerien, Biafra und Kuba rüttelten an der Stabilität der Welt. Die Berliner Mauer, die Pariser Barrikaden und die westliche Rassendiskriminierung riefen starke Protestbewegungen auf den Plan. Der Kennedy-Konsens kippte, Parteienzersplitterung war die Folge. Blumengeschmückte, unter bewusstseinserweiternden Drogen stehende junge Menschen fanden ihr persönliches Nirwana. Einige gingen auf die Straße, andere schalteten einfach ab, während John Lennon verkündete, dass Liebe alles sei, was man brauche, um dem Frieden eine Chance zu geben.

Die Kunst hielt wie immer mit der Zeit Schritt. In der Musik setzte sich der Pop durch und inspirierte die Malerei. Jasper Johns, Robert Indiana, Robert Rauschenberg, Roy Lichtenstein und Andy Warhol machten ihre eigene Revolution mit einer gegenständlichen Kunst, die der überwiegend kommerziellen Kultur Hörner aufsetzte und sie gleichzeitig feierte. Ihre klaren Bilder sprachen die Teenager der Fünfziger an, die zu den Pop-Konsumenten der Sechziger geworden waren. Bis zu einem gewissen Grad folgte die Fotografie diesem Trend; sie entdeckte die so genannte Schnappschuss-Ästhetik, einen zwanglosen Stil ohne erkennbare Kunstkniffe und ohne eigene Sprache. Lee Friedlander, Garry Winogrand, Joel Meyerowitz und Elliott Erwitt schienen ihre Kreaturen, Menschen wie Hunde, mit mehr Glück als Verstand und entwaffnendem Witz abzulichten. Ihre Bilder zeigten auf den ersten Blick ein ereignisloses Stück Alltagsleben, bei genauerem Hinsehen jedoch offenbarte sich oft eine kluge und viel sagende Botschaft, was wieder einmal die grenzenlosen Möglichkeiten der Kamera zu provozieren und zu erziehen demonstrierte. Eine Folge dieser neuen Ästhetik war die Rückkehr des Hundes als Motiv und Muse. Sowohl in Amerika als auch in Europa nahmen sich Fotografen der Bande zwischen Mensch und Tier in einer weniger formeller Art und Weise an, der Geist und Witz von Lartigue kehrten in die Fotokunst zurück. Fotografen wie Elliott Erwitt, William Wegman, Mary Ellen Mark und Josef Koudelka fotografierten Hunde, die zu einem wichtigen Motiv ihrer Arbeit wurden.

In gewisser Hinsicht prägten die sechziger Jahre die Fotografie wie keine andere Zeit. Introspektive Analysen verhalfen dem Medium zu neuer Bedeutung und Definition. Über ein Jahrhundert lang

hatte Fotografie als das Prisma gegolten, durch das der Mensch seine Welt realitätsgetreu betrachtete. Nun war offensichtlich geworden, dass die Fotografie tatsächlich zwischen der objektiven Welt und dem Betrachter vermittelte und sie folglich mit einem zarten, aber nicht wegzuleugnenden Schimmer überzog. Die Fotografie war etwas, das gedeutet werden musste, und somit war die Interpretation persönlich und subjektiv, und das nicht nur für den Künstler, sondern auch für den Betrachter. Sie zeigte immer noch einen „Augenblick der Wahrheit", die Frage war nur: wessen Wahrheit?

Joel Meyerowitz, 1964

Les années 60

Les années 60 virent une jeunesse impatiente retenir l'attention du monde. Ce fut une époque d'expérimentation et d'initiative. L'Amérique élit John F. Kennedy, son plus jeune président, transmettant le flambeau à une nouvelle génération. On entendit des chansons « dans le vent. » Les jupes se raccourcirent, les rythmes « beat » s'endiablèrent, Bond se fit immatriculer 007 et Twiggy ne cessa de mincir. Playboy et la pilule encouragèrent la liberté sexuelle. Snoopy et Monroe continuaient d'occuper la scène, tandis que les Stones promettaient enfin « Satisfaction ». Toutefois, sous cette effervescence psychédélique, on sentait poindre l'effritement social. Le Vietnam, l'Algérie, le Biafra et Cuba résonnaient de bruits de bottes. A Berlin le mur, à Paris les barricades, les inégalités raciales provoquaient de violentes émeutes dans l'Ouest américain. Le consensus Kennedy se diluait en factions. Bardés de fleurs, inspirés par les drogues, les jeunes partirent chacun à la recherche de son propre nirvana. Certains se mirent aux manifs, d'autres se turent à tout jamais, pendant que Lennon nous persuadait que, pour vivre en paix « All you need is Love ».

Comme toujours, les arts reflétèrent l'époque. Le Pop qui avait envahi la musique, inspira les arts. Jasper Johns, Robert Indiana, Robert Rauschenberg, Roy Lichenstein et Andy Warhol firent leur propre révolution avec des tableaux qui célébraient et dénonçaient la culture commerciale dominante. La fulgurance de leur graphisme attira les adolescents des années 50, devenus les consommateurs des années 60. Dans une certaine mesure, la photographie suivit, créant ce que l'on a appelé « l'esthétique du cliché », un style décontracté, sans artifice ni hypocrisie. Lee Friedlander, Garry Winogrand, Joel Meyerowitz et Elliott Erwitt semblèrent avoir trouvé le chic pour saisir toutes les créatures, les hommes comme les chiens, avec un humour désarmant. Leurs images présentaient au premier abord des tranches de vie quotidienne parfaitement banales. Pourtant, à y regarder de plus près, elles révélaient souvent un sens subtil et caché, prouvant une fois de plus que l'appareil photo pouvait provoquer et éduquer. Une des conséquences de cette nouvelle esthétique fut la réapparition du chien comme sujet et comme muse. Tant en Amérique qu'en Europe, les photographes s'intéressèrent aux liens entre l'homme et les animaux, d'une façon moins formaliste. La fantaisie de Lartigue trouva un nouvel écho. Des artistes comme Elliott Erwitt, William Wegman, Mary Ellen Mark et Josef Koudelka commencèrent à s'adonner à la représentation canine, qui allait occuper une place importante dans leur œuvre.

D'une certaine façon, les années 60 précisèrent, plus que toute autre période, ce qu'était la photographie. L'analyse introspective lui donna une nouvelle signification et une nouvelle définition. Jusque-là, la photographie avait été perçue comme le prisme à travers lequel l'homme observait fidèlement le monde alentour. A présent, il devenait évident que le photographe était en fait un médiateur entre le monde objectif et le spectateur, introduisant par là un brillant subtil mais inaltérable. La photographie

était un objet qu'il fallait déchiffrer, et donc l'interprétation qu'on en faisait était personnelle et subjective, tant pour l'artiste que pour le spectateur. Elle continua d'incarner « un moment de vérité », mais la question : la vérité de qui ? était posée.

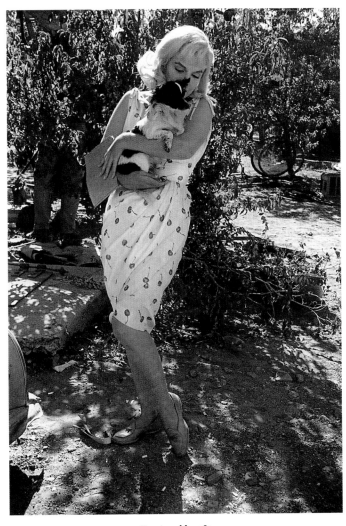

Eve Arnold, 1960

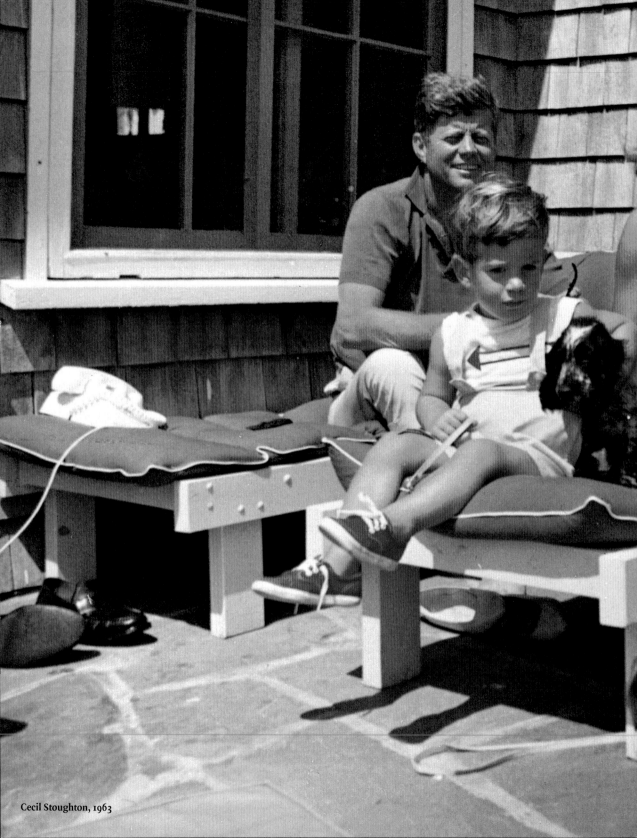

Cecil Stoughton, 1963

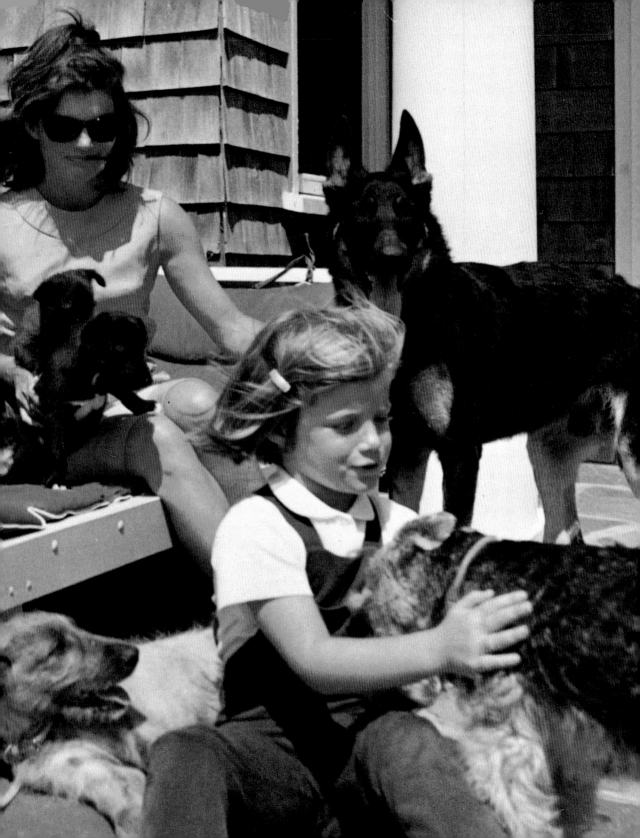

Melvin Sokolsky, 1960

Soviet Press Agency, c. 1960

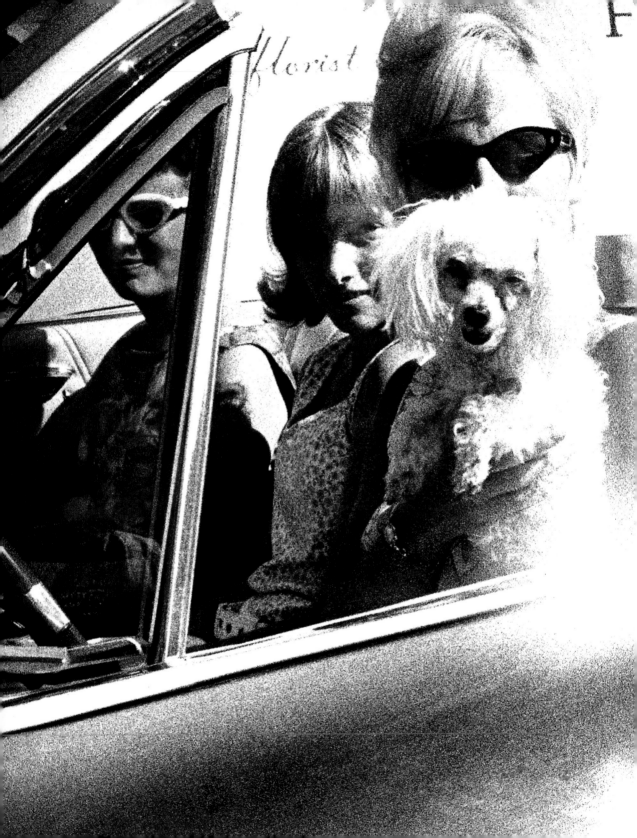

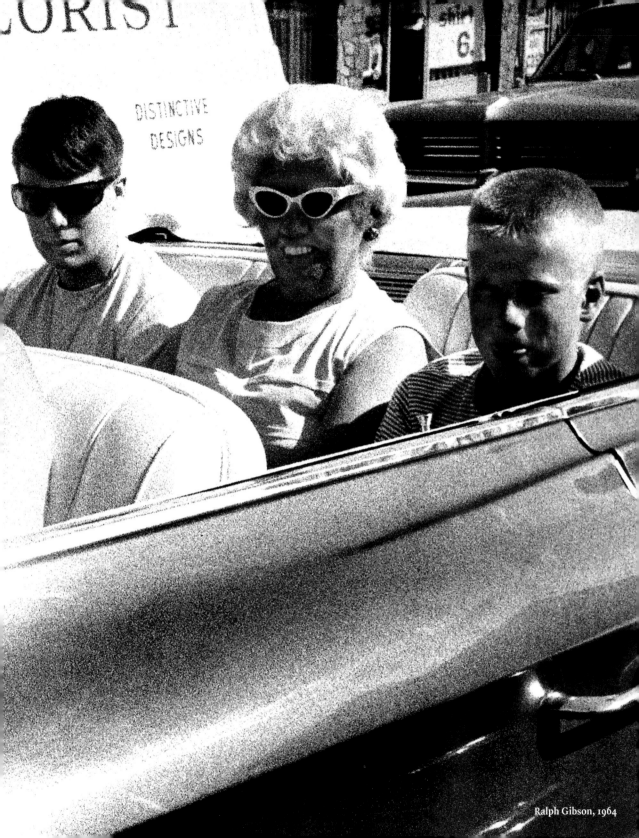

Ralph Gibson, 1964

Charley was born in Bercy on the outskirts of Paris and trained in France, and while he knows a little poodle-English, he responds quickly only to commands in French. Otherwise he has to translate, and that slows him down.

Charley wurde in Bercy, einem Vorort von Paris, geboren und in Frankreich ausgebildet. Auch wenn er ein bisschen Pudel-Englisch versteht, reagiert er nur auf Kommandos in Französisch unverzüglich. Ansonsten muss er übersetzen, und das braucht seine Zeit.

Charley est né à Bercy, faubourg de Paris. Il fut dressé en France, et s'il sait parler l'anglais des caniches, il ne répond vivement qu'aux ordres donnés en français. Sinon, il est obligé de traduire, ce qui le ralentit.

JOHN STEINBECK

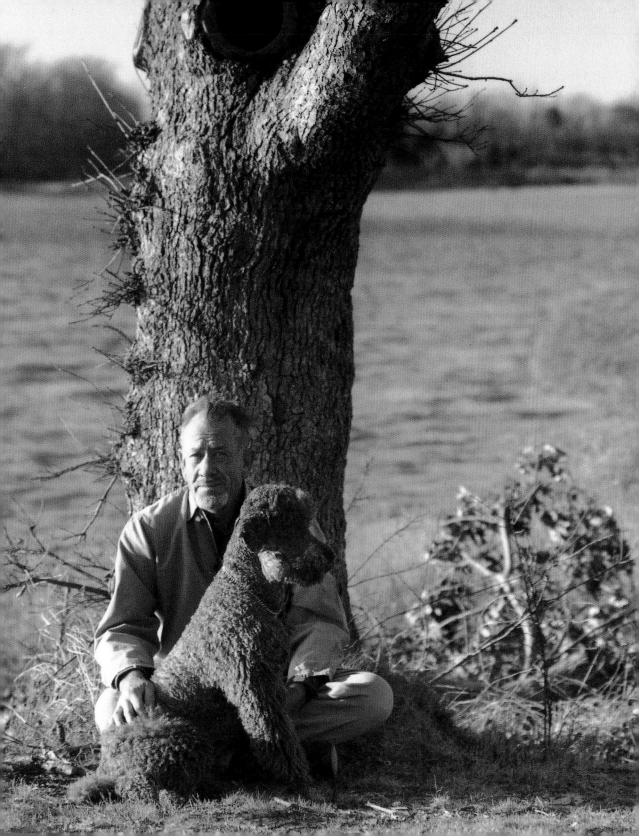

Julius Shulman, c. 1960

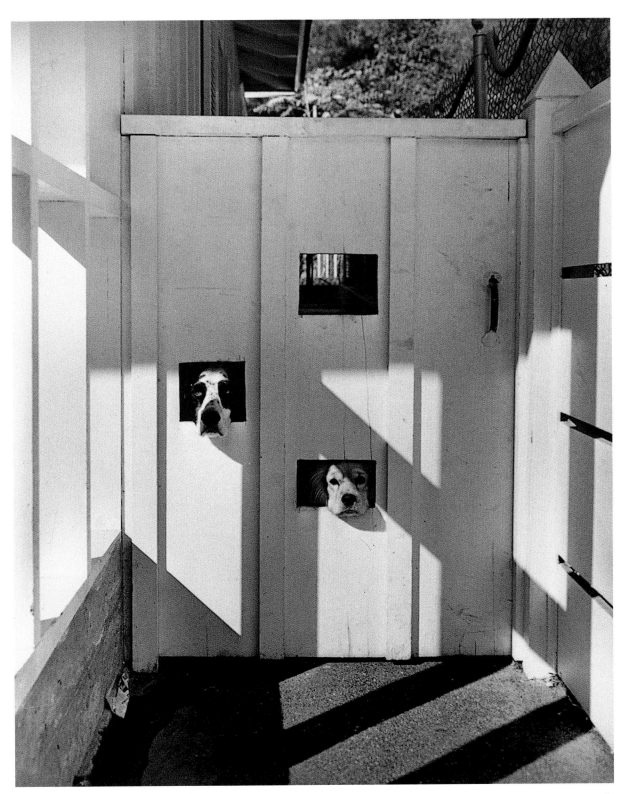

Julius Shulman, c. 1960

To be without a dog is worse
than being without a song.

Ohne einen Hund zu leben
ist schlimmer als ohne Lieder zu leben.

Vivre sans chien c'est pire
que vivre sans chanter.

HENRY BEETLE HOUGH

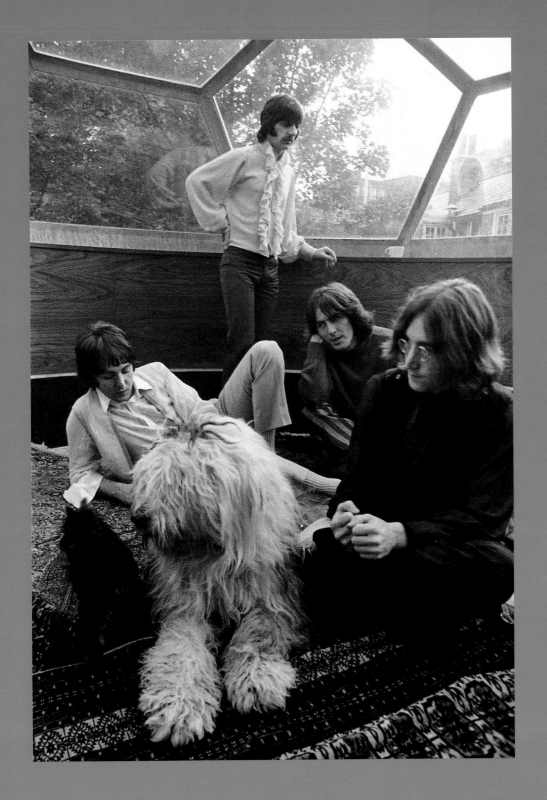

Don McCullin, 1968

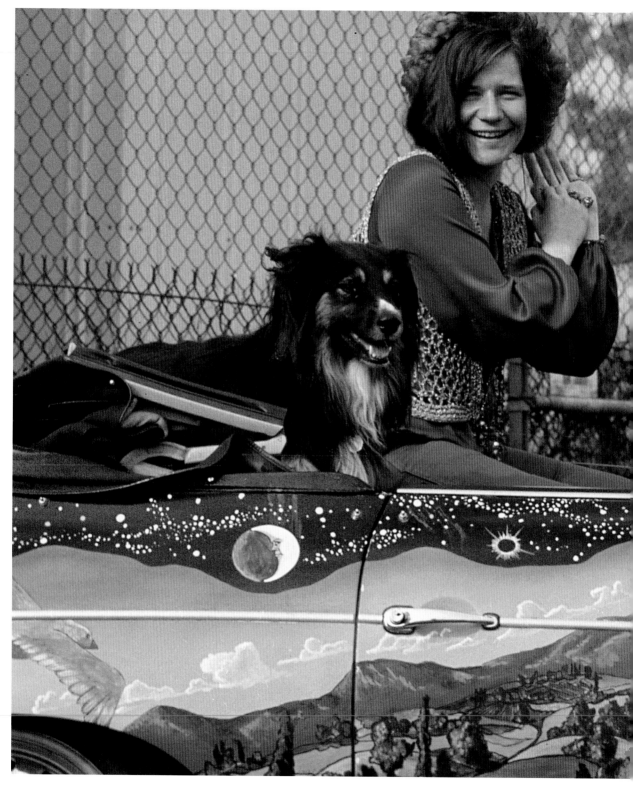

To man, freedom is another word
for nothing left to lose; to a dog,
it is the synonym for despair.

Für den Menschen bedeutet Freiheit,
dass er nichts zu verlieren hat; für einen
Hund ist sie das Synonym für Verzweiflung.

Pour l'homme, la liberté signifie qu'il
n'a plus rien à perdre. Pour le chien,
c'est synonyme de désespoir.

Yoram Kahana, 1969

TOUCH OF LOVE

Old men simply need to touch
The brow of a dog,
To look into its eyes
To feel its lick
So that they may experience again
The freshness and joy of life.

Alte Männer brauchen nur
die Stirn eines Hundes zu berühren,
in seine Augen zu schauen,
sein Lecken zu spüren,
um noch einmal die Frische und
Freude des Lebens zu fühlen.

Il suffit aux vieillards de toucher
le front d'un chien,
de plonger leurs yeux dans les siens,
de sentir son coup de langue,
afin de connaître, une fois encore,
la gaieté et la joie de vivre.

Thomas Höpker, 1964

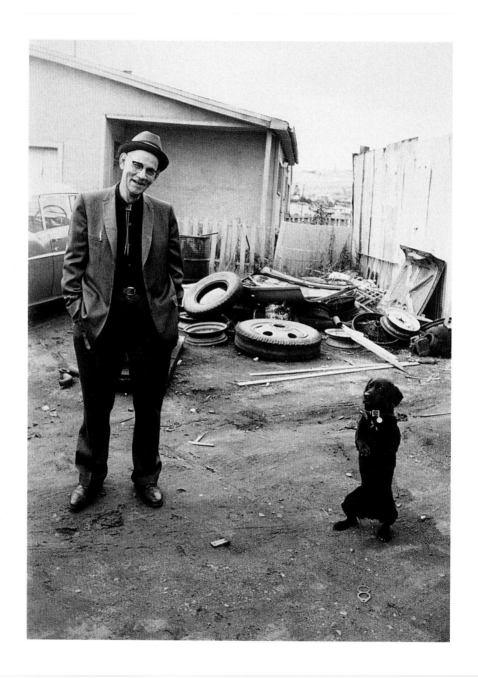

Garry Winogrand, 1964

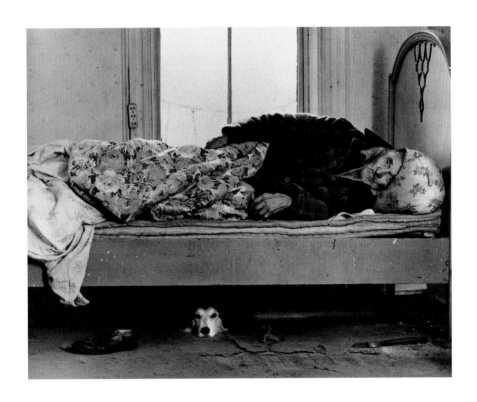

Bruce Davidson, 1966

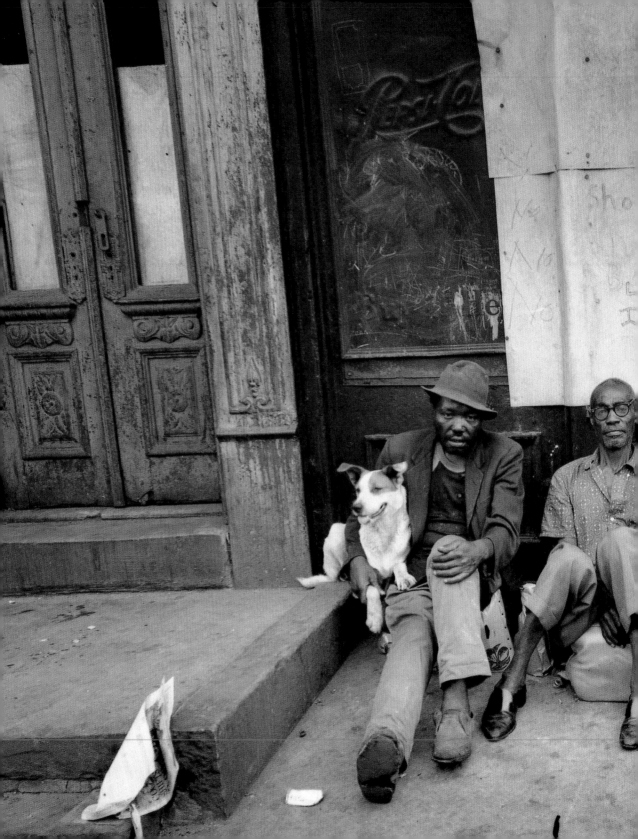

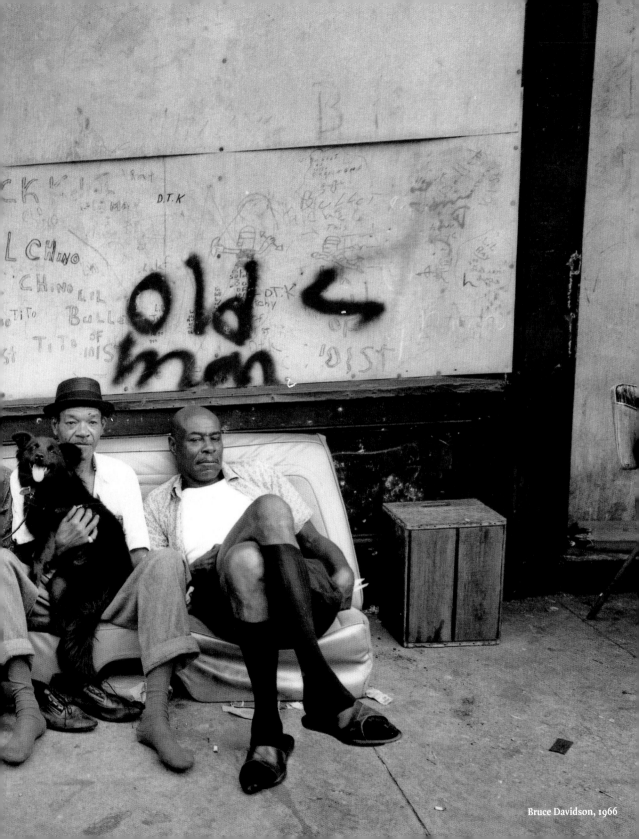

Bruce Davidson, 1966

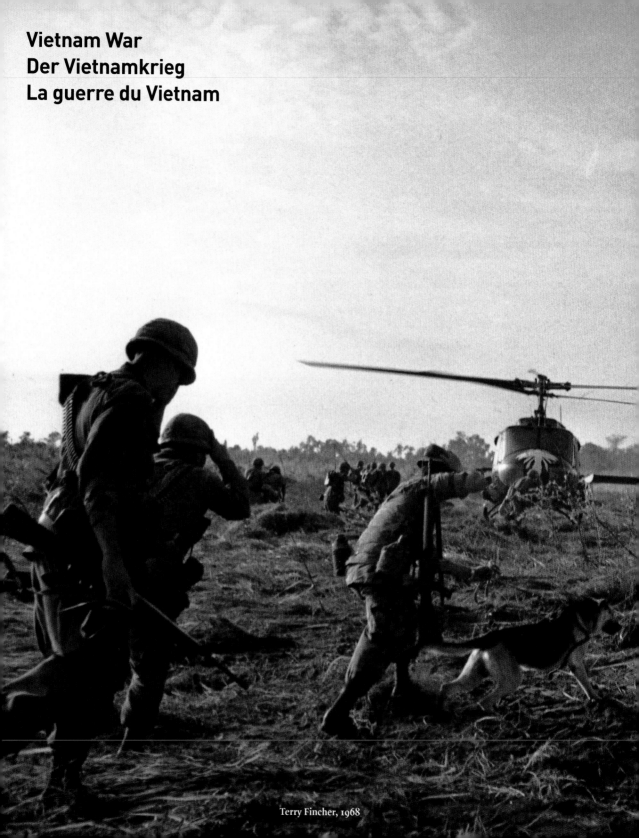

Vietnam War
Der Vietnamkrieg
La guerre du Vietnam

Terry Fincher, 1968

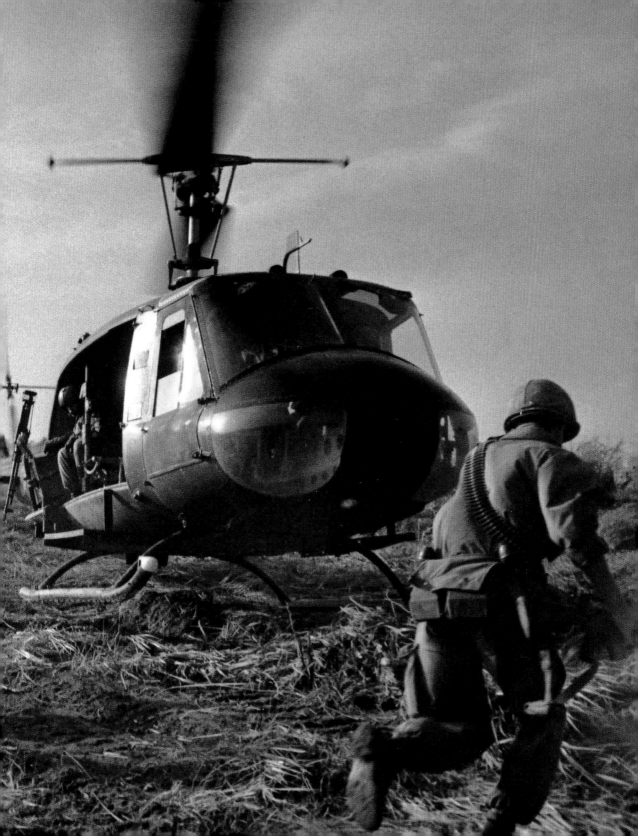

Dogs are us,
only innocent.

Hunde sind wie wir,
nur unschuldig.

Les chiens, c'est nous,
seulement innocents.

CYNTHIA HEIMEL

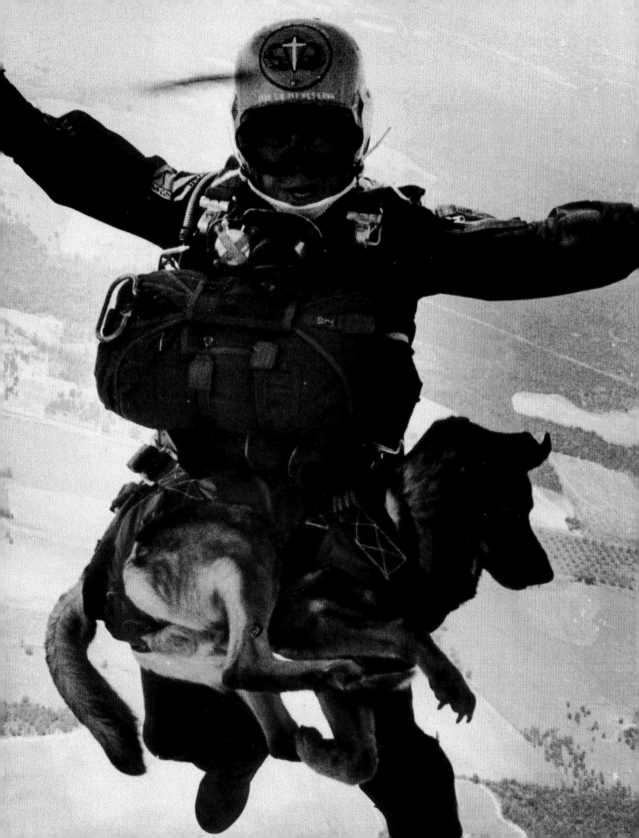

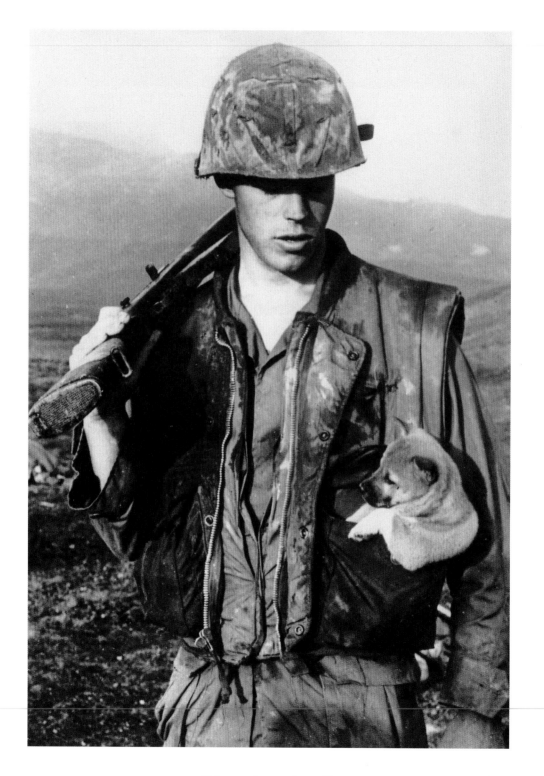

Unknown photographer, 1968

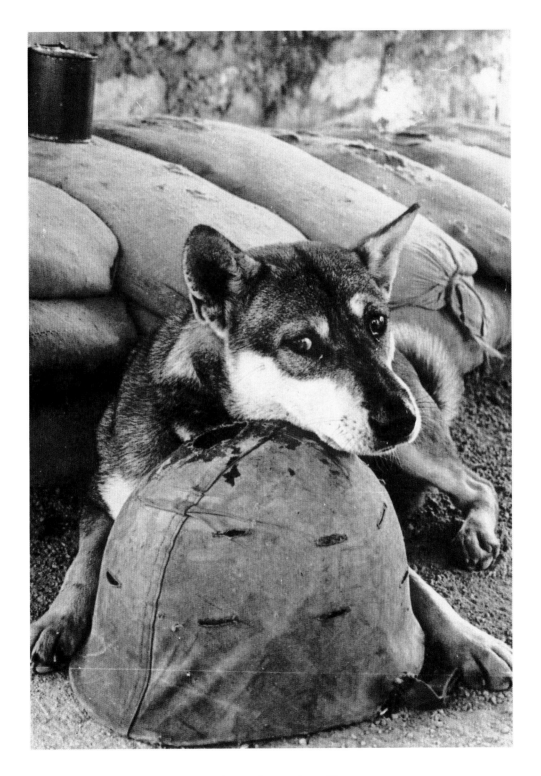

Unknown photographer, 1966

Larry Clark, 1963

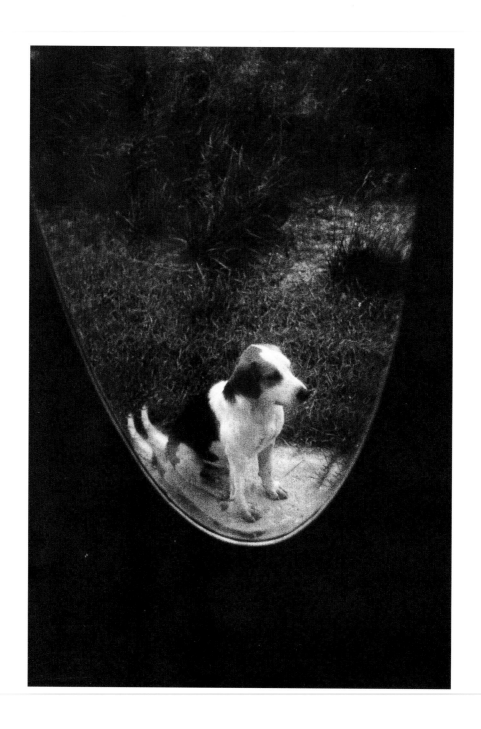

Ralph Gibson, 1968

We are alone, absolutely alone, on this chance planet; and amid all
the forms of life that surround us, not one, excepting the dog, has
made an alliance with us.

Wir sind allein, vollkommen allein auf diesem Planeten, der zufällig der unsere ist;
und unter all den Lebensformen, die uns umgeben, ist keine, mit Ausnahme des
Hundes, eine enge Verbindung mit uns eingegangen.

Nous sommes seuls, absolument seuls sur cette planète de hasard
et, parmi toutes les formes de vie qui nous entourent, aucune, à
l'exception du chien, n'a passé alliance avec nous.

MAURICE MAETERLINCK

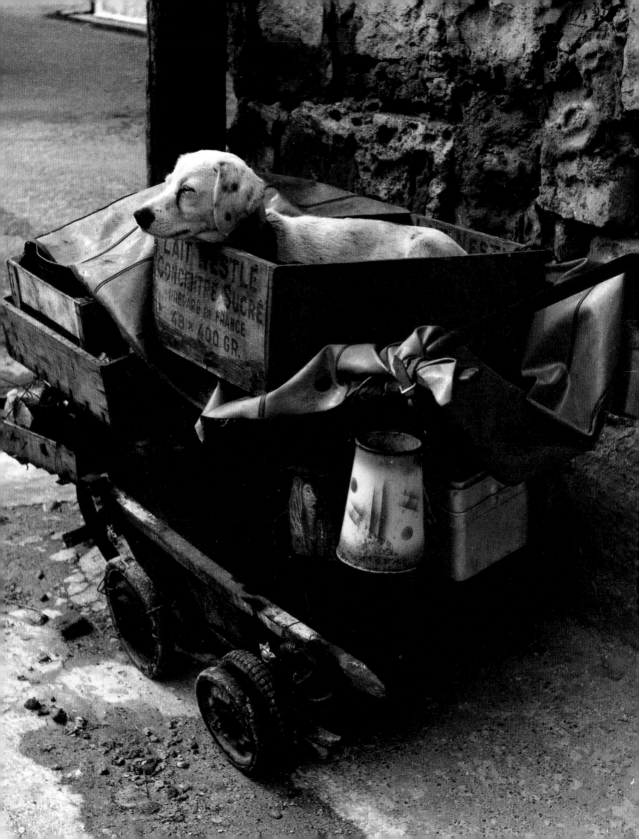

Danny Lyon, 1967

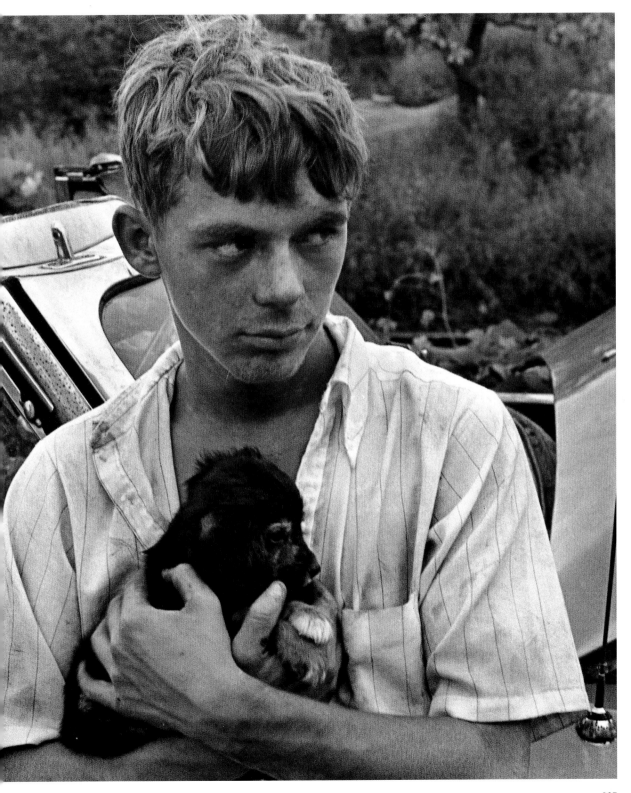

The 70s

William Wegman, 1976

The Seventies

Some have argued that the seventies, as a decade, never took on its own personality. The political, cultural, and social events that transpired were arguably the expiation of the angst of the sixties. Terrorism – the Red Brigade, Baader-Meinhof, Carlos, The Weathermen, the Symbionese Liberation Army – was ever-present. It was truly an uneasy decade. Politically, the "liberation movements" – black power, women's empowerment, gay power, and animal rights – took center stage. Martin Luther King's personal vision lived on throughout the world as far away as Soweto, where strikes, marches, and demonstrations continued the struggle for self-rule. Gays began coming out with pride and purpose. For the feminist movement, NOW led the way. Bras were burned and, in the end, the movement reassessed and redefined the role of women in the twentieth century.

A new social awareness was also emerging. There were new concerns that industrialized society was overstepping its bounds, exterminating species, and destroying pristine natural habitats with urban sprawl and rampant air and water pollution. New films and books cherishing the diversity of animal life appealed to a mass audience.

The pioneering work of explorer Jacques Cousteau and behaviorist Jane Goodall served as reality checks – chiding and humbling us with just how little we really knew about the natural world of animals. Nature was portrayed as a vibrant community – its "citizenry" composed of feeling, thinking beings in their own right, with their own ways of life. Respect, compassion, and noninterference formed the heart of the animal-rights movement, fundamental tenets that continue to this day.

As an understandable consequence, the welfare of the animals who share our civilized lives also became of greater concern through the Seventies. The numbers of dogs being adopted from the ASPCA in New York City rocketed from an average of four per day in 1955 to eighty per day by the mid-seventies. For the first time, there was international media coverage of pet overpopulation – viewed by many as another manifestation of urban pollution – as well as proactive campaigns to get people to take responsibility for the reproductive lives of their dogs.

Culturally, the young still wanted it their way. The pill gave them freedom, pot made them mellow, and music caught their fire – glitter and glam, punk and disco. The Bee Gees, Abba, Queen, Kraftwerk, and the Sex Pistols were the musical muses of the day.

Art photography was subjected to the same social forces and criticism as the rest of society. Most prominent photographers of this era were themselves rebels, often out to make intense personal statements. Two prime examples were friends Larry Clark and Ralph Gibson. Clark's book *Tulsa* (1970) gave the world an insider's view of a segment of society some dismissed as mere dropouts by pumping pathos into the outlaw life. This masterful work was followed by his equally powerful book *Teenage*

Lust (1971), which showed the public a complexity and worldliness in the adolescents of the sixties and seventies that an older generation could hardly comprehend. At the same time, Ralph Gibson, in his trilogy, *Somnambulist* (1970), *Déjà-Vu* (1973), and *Days at Sea* (1975), made a striking and lasting impact by sequencing in book form enigmatic images, often faceless or isolated body parts, with seemingly mundane elements of everyday life. The masterful juxtapositions of these images made people think, not just see. The works of these artists helped define the medium for the rest of the century and generated enthusiasm and respect for photography as an art form.

Unknown photographer, 1971

Die siebziger Jahre

Es wird gelegentlich behauptet, dass die siebziger Jahre als Jahrzehnt nie ein eigenes Gesicht hatten. Die politischen, kulturellen und gesellschaftlichen Ereignisse jener Zeit dürften der Ausgleich für die Angst der Sechziger gewesen sein. Terrorismus – die Roten Brigaden, Baader-Meinhof, Carlos, The Weathermen, Patty Hurst und die Nationale Befreiungsarmee – war ständig präsent. Es war ein wahrhaft ungemütliches Jahrzehnt. Politisch gesehen rückten die „Befreiungsbewegungen" – Black Power, Frauenpower, Schwulen-Power, Tierschutz – in den Mittelpunkt. Martin Luther Kings Vision lebte überall auf der Welt weiter, selbst in Soweto, wo mit Streiks, Märschen und Demonstrationen der Kampf um Selbstbestimmung fortgesetzt wurde. Schwule hatten ihr selbst gewähltes, stolzes Coming-out. In der feministischen Bewegung stand NOW an der Spitze. Die BHs wurden verbrannt, und schließlich konnte die Frauenbewegung die weibliche Rolle im 20. Jahrhundert neu definieren.

Es entwickelte sich ein neues gesellschaftliches Bewusstsein. Die Sorge machte sich breit, dass die industrialisierte Gesellschaft ihre Grenzen überschritt, wenn sie Tier- und Pflanzenarten ausrottete und durch rücksichtslose Urbanisation sowie Luft- und Wasserverschmutzung im großen Stil unberührte natürliche Lebensräume zerstörte. Neue Filme und Bücher, die die Vielfalt der Tierwelt zum Thema hatten, kamen bei den Massen gut an.

Die Pionierarbeiten des Forschers Jacques Cousteau und der Verhaltensforscherin Jane Goodall verdeutlichten uns, wie wenig wir im Grunde über Tiere und ihr natürliches Umfeld wussten, und beschämten uns angesichts unserer Unwissenheit. Die Natur wurde uns als lebendige Gemeinschaft vor Augen geführt, deren „Bürgerschaft" sich aus fühlenden, denkenden Wesen mit einer je eigenen Art zu leben zusammensetzte. Respekt, Mitgefühl und Nichteinmischung waren die Kernstücke der Tierschutzbewegung, fundamentale Forderungen, die bis zum heutigen Tag Gültigkeit haben.

Als verständliche Folge richtete man in den siebziger Jahren verstärkt das Augenmerk auch auf das Wohlergehen derjenigen Tiere, die das zivilisierte Leben mit uns teilen. Die Zahl der Hunde, die täglich von den Tierheimen der ASPCA (American Society for the Prevention of Cruelty to Animals) in New York City „adoptiert" wurden, stieg von durchschnittlich vier pro Tag im Jahr 1955 auf achtzig pro Tag Mitte der siebziger Jahre. Zum ersten Mal wurde auf breiter Ebene in den Medien auf die unkontrollierte Vermehrung von Haustieren hingewiesen – was für viele nur eine weitere Facette der Verschmutzung der Städte war –, und es wurden Kampagnen gestartet, um die Leute dazu zu bringen, die Verantwortung für die Vermehrung ihrer Hunde zu übernehmen.

In kultureller Hinsicht ging die Jugend immer noch ihren eigenen Weg. Die Pille machte sie frei; Hasch machte sie high und Musik machte sie an – Glitzer und Glamour, Punk und Disco. Die Bee Gees, Abba, Queen, Kraftwerk und die Sex Pistols waren die musikalischen Musen jener Tage.

Die künstlerische Fotografie unterlag denselben gesellschaftlichen Kräften und derselben Kritik wie die übrige Gesellschaft. Die meisten berühmten Fotografen jener Zeit waren selbst Rebellen, oft darauf aus, großartige persönliche Statements abzugeben. Zwei Paradebeispiele hierfür sind die Freunde Larry Clark und Ralph Gibson. Indem er das Pathos im Leben der Menschen am Rande der Gesellschaft offenbarte, erlaubte Clark mit seinem Buch *Tulsa* (1970) der Welt einen Insiderblick auf einen Teil der Gesellschaft, den einige als asozial abtaten. Diesem Meisterwerk folgte sein ebenso starkes Buch *Teenage Lust* (1971), das der Öffentlichkeit eine Komplexität und weltliche Einstellung bei den Jugendlichen der sechziger und siebziger Jahre

zeigte, die eine ältere Generation kaum verstehen konnte. Zur gleichen Zeit erzielte Ralph Gibson mit seiner zukunftsweisenden Trilogie *Somnambulist* (1970), *Déjà-Vu* (1973) und *Days at Sea* (1975) eine gewaltige und anhaltende Wirkung durch die Aneinanderreihung enigmatischer Bilder, oft gesichtsloser Körper oder einzelner Körperteile zusammen mit scheinbar profanen Elementen des Alltagslebens. Die meisterliche Gegenüberstellung dieser Bilder brachte die Leute zum Nachdenken, nicht nur zum Hinschauen. Unter anderem waren es die Arbeiten dieser Künstler, die das Medium für den Rest des Jahrhunderts definierten, die Begeisterung weckten und Respekt für die Fotografie als Kunstform.

Unknown photographer, 1973

Selon certains, les années 70 ne sont jamais parvenues à se trouver une personnalité. Les événements politiques, culturels et sociaux qui les marquèrent ne furent, considère-t-on, que l'aboutissement des angoisses des années 60. Le terrorisme (Brigades Rouges, Bande à Baader, Carlos, les Weathermen, ceux de Patty Hurst et de l'armée de Libération nationale) régnait en maître. Ce fut une décennie d'immense malaise. Politiquement, les « mouvements de libération » – Black Power, féminisme, homosexualité, droits de défense des animaux – occupèrent le devant de la scène. La vision de Martin Luther King s'imposa au monde entier, et jusqu'à Soweto, où se répétaient grèves, manifestations et défilés pour obtenir l'autonomie. Les homosexuels commencèrent à s'afficher, avec orgueil et détermination. Pour le mouvement féministe, c'était l'heure du « Maintenant ». Les soutiens-gorge furent brûlés, et le mouvement parvint enfin à redéfinir le rôle de la femme moderne.

Par ailleurs une nouvelle conscience sociale émergeait. On se rendit compte que la société industrielle outrepassait ses droits, exterminait certaines espèces et détruisait à tout jamais l'environnement naturel par la prolifération urbaine, la pollution galopante de l'air et celle des eaux. Des films et des livres célébrant la diversité de la vie animale recueillirent l'attention d'un immense public.

L'œuvre innovante de Jacques Cousteau et de la comportementaliste Jane Goodall nous ramenèrent à la réalité, pointant l'index contre notre immense ignorance pour tout ce qui concerne les animaux sauvages. La nature nous fut alors montrée comme une communauté pleine de vie – composée de citoyens pensants et vibrant d'émotions, à leur façon, avec leurs propres modes de vie. Respect, compassion et non-ingérence formèrent la base même du mouvement pour les droits des animaux, et ces principes fondamentaux se perpétuent jusqu'à aujourd'hui.

En conséquence, évidemment, le bien-être des animaux qui partagent nos vies civilisées nous préoccupa davantage. Rien que pour New York, le nombre de chiens adoptés à la ASPCA passa de quatre par jour, en moyenne en 1955, à 80 vers 1975. Pour la première fois, les médias du monde entier firent état de la surpopulation des animaux de compagnie – que certains considèrent comme une preuve supplémentaire de la pollution urbaine. De même, on assista à des campagnes actives visant à inciter les gens à prendre leurs responsabilités pour ce qui concerne la vie reproductive de leur chien.

Culturellement, les jeunes continuèrent de n'en faire qu'à leur tête. La pilule leur garantissait la liberté, le hasch les amolissait et la musique reflétait leurs rêves – strass et paillettes, punk et disco. En musique, les Bee Gees, Abba, Queen, Kraftwerk et les Sex Pistols furent les muses de l'époque.

L'art photographique fut soumis aux mêmes forces sociales et aux mêmes critiques. Les artistes les plus notoires d'alors furent aussi des rebelles, souvent avides d'affirmer des positions engagées. Parmi les grands exemples citons les compères Larry

Clark et Ralph Gibson. Avec son album *Tulsa* (1970), Clark proposa au monde une vision intime d'un segment de la société parfois qualifié de marginal, en posant un regard compatissant sur ces laissés-pour-compte. Cette œuvre puissante fut suivie d'une autre qui ne l'était pas moins, *Teenage Lust* (1971), qui montra au public la complexité et le matérialisme de ces adolescents des années 60 et 70, que les adultes d'alors avaient du mal à comprendre. Au même moment, Ralph Gibson, avec son étonnante trilogie *Somnambulist* (1970), *Déjà-vu* (1973) et *Days at Sea* (1975), frappa l'attention avec ses images énigmatiques, souvent avec des personnages sans visage ou des parties du corps isolées, associés à des éléments apparemment banals de la vie quotidienne. Ces magistrales juxtapositions d'images forcèrent les gens à penser, et non simplement à voir. L'œuvre de ces artistes apposa son sceau sur le reste du siècle tout en soulevant l'enthousiasme et le respect pour la photographie en tant que forme d'art.

Brigitte Bardot · Sveva Vigeveno, c. 1975

Wolf von dem Bussche, 1970

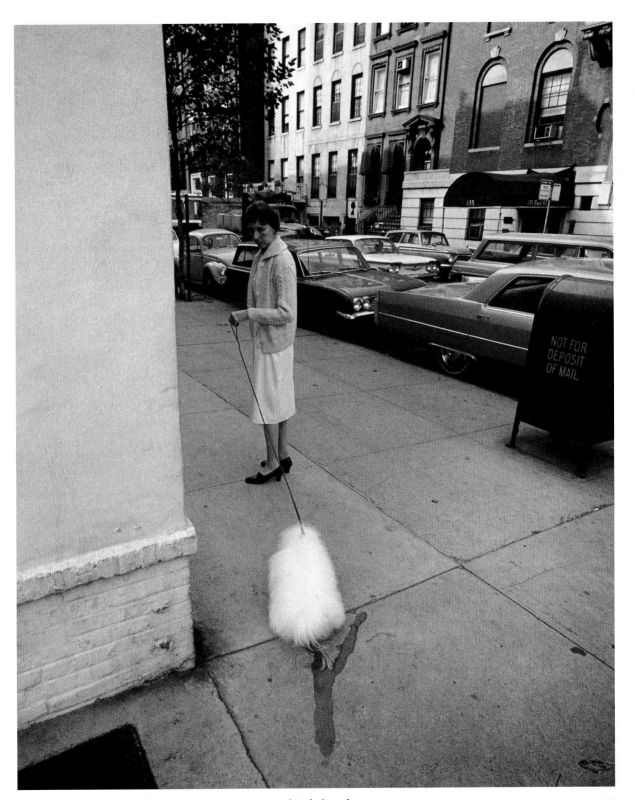

Tío Cabrón, n.d.

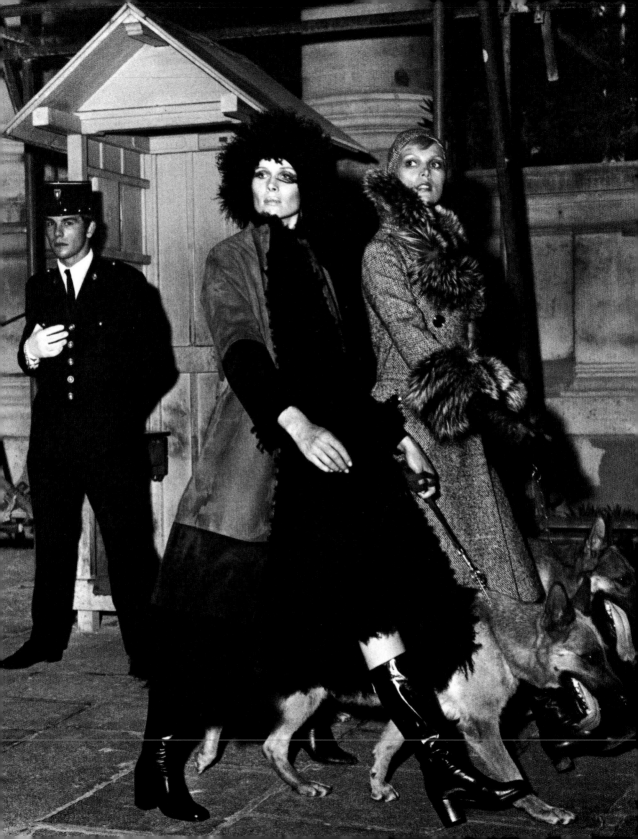

I like a bit of mongrel myself, whether it's in a man or a dog;
they're the best for everyday.

Ich mag es, wenn nicht immer alles ganz reinrassig ist, sei es bei
einem Menschen oder einem Hund. Für alle Tage gibt es nichts Besseres.

Pour ma part, j'aime un peu de bâtardise, qu'on soit homme ou
chien. C'est qu'il y a de mieux, pour la vie de tous les jours.

GEORGE BERNARD SHAW

Ferdinando Scianna, 1972

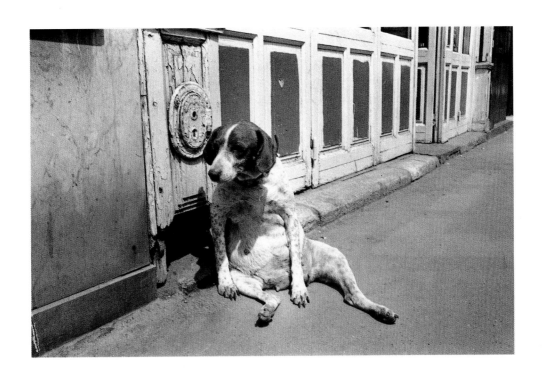

Richard Kalvar, 1974

Yesterday, I was a dog.
Today, I am a dog.
Tomorrow, I will probably be a dog.
There's just so little hope of advancement.

Gestern war ich ein Hund.
Heute bin ich ein Hund.
Morgen werde ich wahrscheinlich ein Hund sein.
Es gibt einfach so wenig Hoffnung auf ein Fortkommen.

Hier, j'étais un chien,
aujourd'hui, je suis un chien.
Demain, je serai sans doute un chien.
Je n'ai pratiquement aucun espoir de promotion.

SNOOPY

Albert Kozák and János Sarkady, 1976

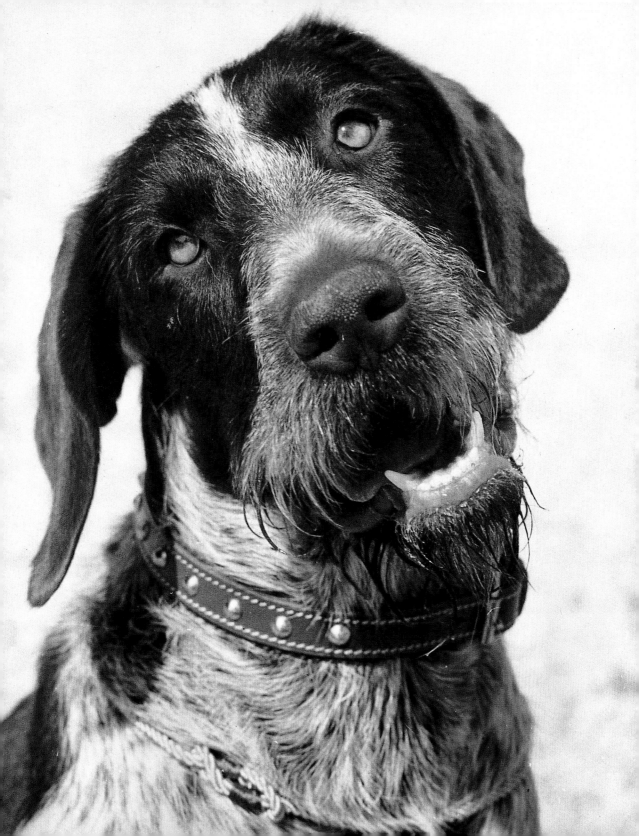

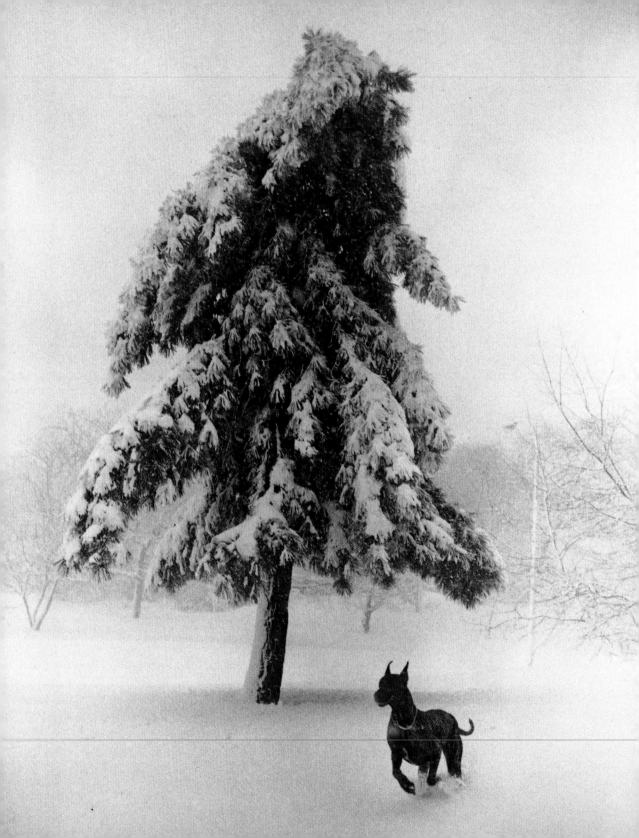

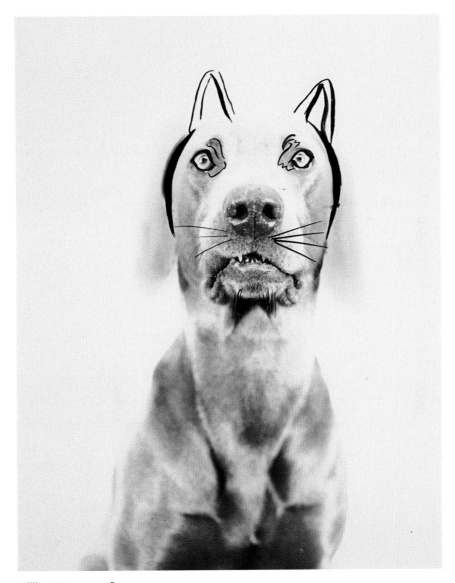

William Wegman, 1978

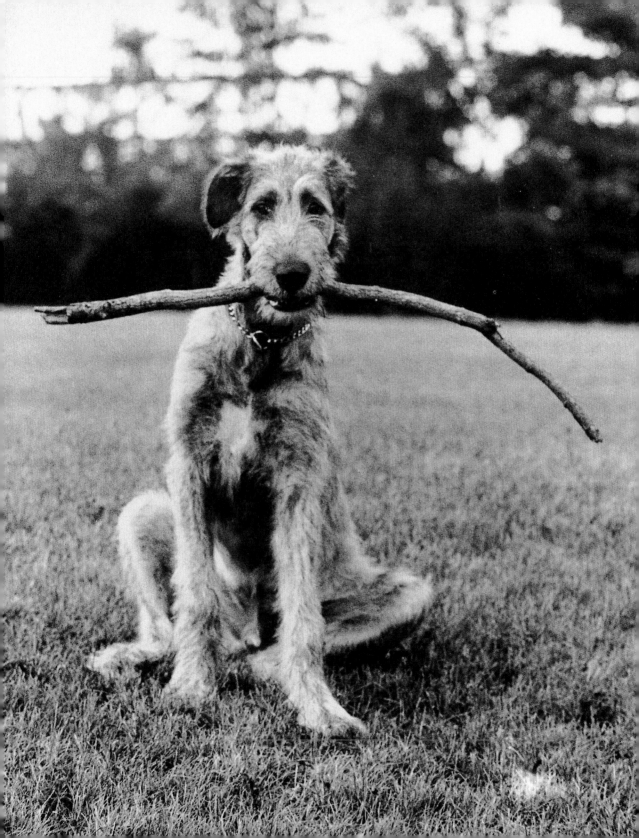

The love between dog and man is idyllic,
dogs were never expelled from paradise.

Die Liebe zwischen Hund und Mensch ist das letzte Idyll,
kein Hund wurde je aus dem Paradies vertrieben.

L'amour entre chien et homme est idyllique :
jamais chien ne fut chassé du paradis.

MILAN KUNDERA

Andy Warhol, c. 1979

Robert Mapplethorpe, c. 1973

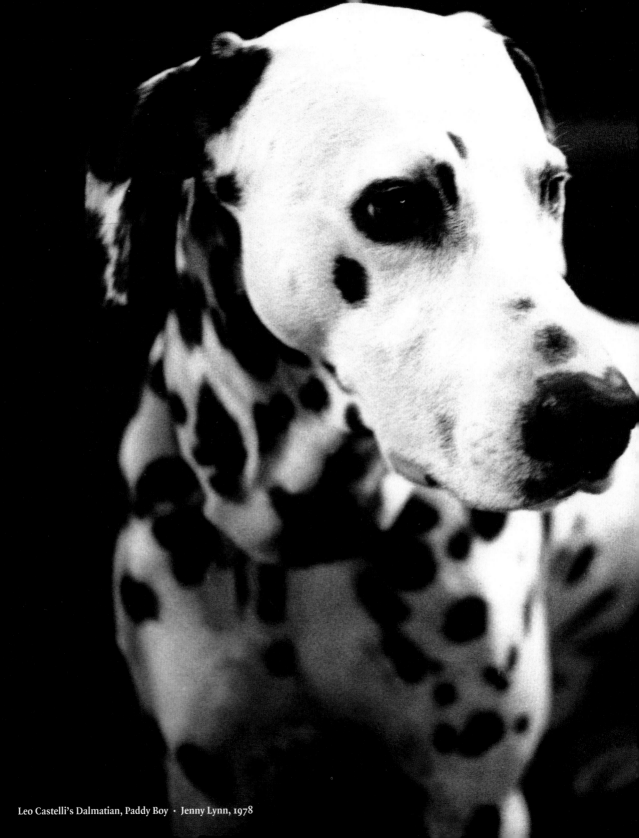

Leo Castelli's Dalmatian, Paddy Boy · Jenny Lynn, 1978

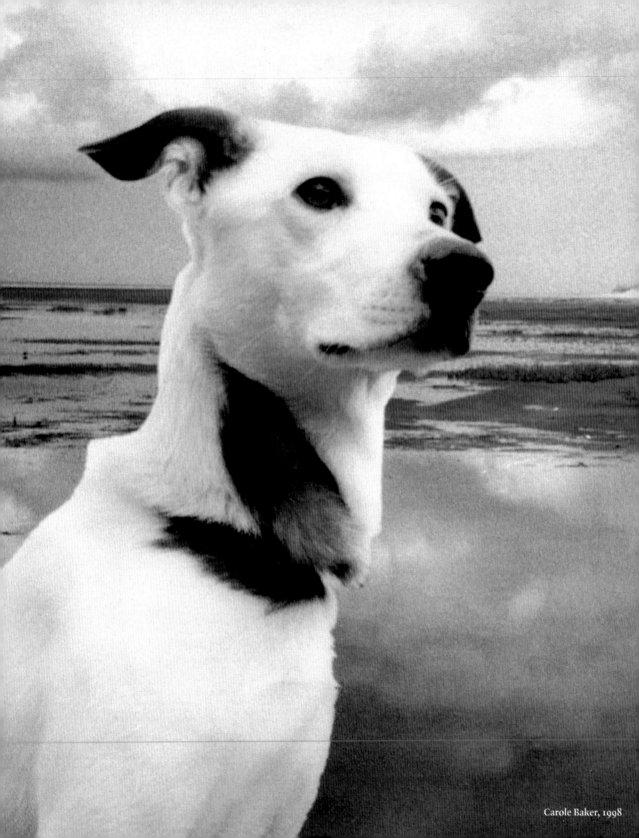

Carole Baker, 1998

Closing the Circle
From Acceptance to Absorption

Den Kreis schließen
Von Akzeptanz zu Absorbtion

La boucle est bouclée
De l'acceptation à l'absorption

1980 · 2000

Anne Turyn, 1983

Jacques-Henri Lartigue, 1923

1980·2000
Closing the Circle
From Acceptance to Absorption

This book has attempted to present, by way of words and pictures, an overview of the progress of human society, canine-human relations, and the medium of photography over the last century and a half – progress that in some sense is like lines turning in the form of a circle. At the millennium, it is encouraging that the end of these three lines seem to be drawing closer.

From a societal standpoint, the twentieth century topped off with a frothy concoction of technological advances. Dot.com-ing introduced the world to a new millennium: a world literally and figuratively at one's fingertips, one less polarized, less pauperized, more often at peace, and more anxious than ever to complete the circle of compassion with those who share the planet.

Photography's advances have virtually completed its circle of acceptance and absorption. Photography is now implanted in our consciousness. As Roberta Smith, a leading New York art critic, so aptly put it: "A century and a half after its invention, photography is less a 'form of human expression' than an inextricable part of the human condition and contemporary landscape. ... And it is the most omnipresent of all art forms. Despite talk of the rise of video or the return of painting or the dominance of installation art, nothing in the last three decades of art can match the triumph of photography." From the artist's vantage point, photography is now both an end and a means. It serves as tool, canvas, and, perhaps most importantly, inspiration. As subject and muse, the dog remains a recurring theme. The dog's presence, often the result of photographic appropriation, is found across the full range of artistic endeavors, whether in works of painting luminaries such as Fischl, Salle, or Hockney or of post-modern conceptualists, such as Wolfgang Tillmans, Franciso Toledo, or Matthew Barney.

This book celebrates this phenomenon by showcasing those photographers whose work has most clearly captured the presence of dogs throughout the last one hundred and fifty years. Without diminishing the achievements of other artists shown herein, there are four whose work places them apart and who deserve special mention: Keith Carter, Jacques-Henri Lartigue, Elliott Erwitt, and William Wegman. These artists have been selected because their respective work highlights distinctly different yet essential elements of the canine essence.

Keith Carter lives and works in Texas. His photographs capture the dog's uniquely unaffected consciousness and emotional life. There is a primal, even primordial, grace about his imagery. In his works we see the dog's innate beauty – its "canine-ness." One senses the dog is informed, conscious and perhaps spiritual – less complex but perhaps more complete than man.

Jacques-Henri Lartigue, the great self-taught French photographer, approached the dog with somewhat less reverence but more unabashed familiarity. He saw the dog as only a child could (his most arresting images being produced during his adolescence). No other artist has been able to capture consistently that special bond between the innocence of youth and the guilelessness of their dogs.

Elliott Erwitt, born of American parents in Paris, is known primarily as a preeminent photojournalist and unparalleled visual humorist. His more mature vision moves photography of dogs into adulthood and effectively captures with sublime wit dogs' partnership with man. Although humor has never been highly regarded in the visual arts, Erwitt's photographic puns constantly find animal and man on a comic stage. Vicki Goldberg, one of photography's more profound commentators, noted that "the main thrust of Erwitt's work lies in his comic awareness of the gap between nobility and reality or between subject and setting, which blunder unpredictably into rhyme or battle with each other. He has forged a happy alliance with incongruity."

No work on the subject of dogs would be complete without lifting a paw to William Wegman, who reigns first among equals. Born in America, his multilevel body of work produced over a span of thirty years places him at the apex

of the genre. With deceptive simplicity, he playfully alters the way the viewer experiences reality. His early black-and-white work, which lasted through the seventies, has an austerity to it that is mystifying while amusing; questions are posed and left unanswered. In the eighties, Wegman turned to color, using the commercial sheen of Polaroid to capture a seemingly endless series of morality playlets. Once again the dog – his dog – serves as his collaborator and does so with willing but bemused resignation. Wegman's work represents, in some respect, the completion of the circle of dog photography. The process of posing animals for arranged photographs dates back to an earlier time – the so-called art photography of the nineteenth century. Yet Wegman has added to it much more; he makes his art arrestingly hilarious. Like a Jack London novel, it can be appreciated on several levels – at once a visually amusing anthropomorphic trope, while at the same time an intense metaphor for man's condition in a postmodern society.

Each of these photographers has visually advanced our understanding of those creatures we call our dogs. As Carter continues to capture the nobility of dogs, Wegman collaborates with them to ridicule the ignobility of man. Earlier, Lartigue showed us their ability to make us happy, and Erwitt continues to show them making us whole.

Elliott Erwitt, 1998

As we conclude this survey, the question still persists as to why man and the artist in man remain fascinated by the dog. Why this continued obsession? The answer might well be quite complex. It cannot be denied that the dog holds a curious status in our society, in a sense, as an honorary human. Perhaps the answer is quite simple. It is our way to repay our debt to a creature we altered and made totally dependent on us for survival. Or perhaps the answer is more selfish. Wegman once commented that dogs make us feel better, and they do. They are unique companions who often stay with us their entire lives, giving us an abundance of pleasure. It is no longer debatable that children who have dogs grow up to be more sympathetic and caring adults, while adults frequently overcome the pressures of human society and live longer and with better life quality when dogs remain part of their lives. They often become true soulmates. They manifest whimsy, evoke pathos, and exude elegance. And perhaps for these reasons, the dog remains a recurrent metaphor and symbol for the contemporary artist. Many scholars believe that animal symbolism is, in essence, man's attempt to acknowledge the animal in himself. Animals often become potent markers of our failures and the fragility of our world; yet at the same time, they represent icons of the virtues we espouse but often cannot sustain – unquestioning love, enduring fidelity, inner peace, unassuming grace, and inexhaustible verve. Robert Adams, one of America's photographic giants, put it best: "My guess is that what sustains the artists' affection for dogs is above all the animal's enlivening sense of possibility. Artists live by curiosity and enthusiasm, qualities readily evident as inspiration in dogs. Propose to a dog a walk and its response is absolutely yes."

These creatures possess qualities that continue to intrigue, amuse, entertain, and educate in ways that cannot be measured in profits. From them we learn lessons about living and loving that serve us well, and so it may be appropriate to end with the adage, "we have seen the dog and the dog is us."

William Wegman, 1978

Keith Carter, 1993

William Wegman, 1993

1980 · 2000
Den Kreis schließen
Von Akzeptanz zur Absorbtion

Dieses Buch war ein Versuch, in Wort und Bild einen Überblick zu geben über die Entwicklung unserer Gesellschaft, der Beziehung Hund – Mensch und des Mediums Fotografie in den vergangenen eineinhalb Jahrhunderten, Entwicklungen, die in gewissem Sinn Linien entsprechen, die sich zur Kreisform krümmen. Kurz nach der Jahrtausendwende ist es ermutigend zu sehen, dass die Enden der drei Linien sich anzunähern scheinen.

Vom gesellschaftlichen Standpunkt aus glänzte das 20. Jahrhundert mit einer bunten Mischung technologischen Fortschritts. Das Internet präsentierte der Welt ein neues Jahrtausend: eine Welt, die wir im wörtlichen wie im übertragenen Sinn in den Fingerspitzen haben, die weniger polarisiert, weniger verarmt, friedlicher und mehr denn je bestrebt ist, den Kreis des Mitgefühls mit all denen zu schließen, die mit uns diesen Planeten teilen.

Die Fortschritte in der Fotografie haben den Kreis von der Akzeptanz zur Absorbtion so gut wie geschlossen. Die Fotografie ist heute in unserem Bewusstsein fest verankert. Roberta Smith, eine führende New Yorker Kunstkritikerin, drückte das sehr treffend aus: „Eineinhalb Jahrhunderte nach ihrer Erfindung ist die Fotografie weniger eine ‚Ausdrucksform des Menschen‘ als etwas, das mit dem Menschen und seinem derzeitigen Umfeld untrennbar verbunden ist ... Und sie ist allgegenwärtig wie keine andere Kunstform. Trotz des Geredes um den Aufstieg des Videos oder die Rückkehr der Malerei oder die Dominanz der Installationskunst kann nichts in der Kunst der letzten drei Jahrzehnte es mit dem Triumph der Fotografie aufnehmen." Vom Standpunkt des Künstlers aus ist die Fotografie heute sowohl Zweck als auch Mittel. Sie dient als Werkzeug, Leinwand und – was vielleicht am wichtigsten ist – als Inspiration. Als Motiv und Muse taucht der Hund immer wieder auf. Den Hund finden wir, oft aufgrund von Fotografien als Vorlage, in der gesamten Bandbreite künstlerischer Bemühungen, sei es im Werk von Koryphäen der Malerei wie Fischl, Salle und Hockney oder in der postmodernen Konzeptkunst von Wolfgang Tillmans, Francisco Toledo, Matthew Barney und anderen.

Der vorliegende Band trägt diesem Phänomen Rechnung, indem Bilder der Fotografen gezeigt werden, die sich in den letzten einhundertfünfzig Jahren in ihrem Werk am offenkundigsten mit dem Hund befassten. Ohne die Verdienste anderer hier gezeigter Künstler schmälern zu wollen, gibt es vier, deren Œuvre wir genauer betrachten wollen. Keith Carter, Jacques-Henri Lartigue, Elliott Erwitt und William Wegman. Wir haben diese Künstler ausgewählt, da in ihrem Werk ebenso unterschiedliche wie grundlegende Charakteristika, die zum Wesen des Hundes gehören, veranschaulicht werden.

Keith Carter lebt und arbeitet in Texas. Seine Bilder halten das herrlich unverdorbene Bewusstsein und emotionale Leben des Hundes fest. Sie strahlen

eine ungekünstelte, ja urtümliche Anmut aus. In seinen Arbeiten kommt die natürliche Schönheit des Hundes zum Ausdruck, sein Hundsein. Der Betrachter spürt, dass der Hund Wissen besitzt, ein Bewusstsein und vielleicht Spiritualität, dass er weniger komplex, aber vielleicht vollkommener ist als der Mensch.

Jacques-Henri Lartigue, der berühmte französische Autodidakt unter den Fotografen, nähert sich dem Hund mit etwas weniger Ehrfurcht, dafür mit umso größerer Vertrautheit. Er sieht den Hund mit der Unbefangenheit eines Kindes (seine faszinierendsten Fotos machte er als junger Mann). Kein anderer Künstler war in der Lage, das eigentümlich Verbindende zwischen der Unschuld der Jugend und der Arglosigkeit ihrer Hunde so konsequent einzufangen.

Elliott Erwitt, in Paris als Sohn amerikanischer Eltern geboren, ist vor allem als herausragender Fotojournalist und unübertroffener visueller Humorist bekannt. Durch seine reifere Sichtweise wird die Hundefotografie erwachsen; effektvoll und mit unvergleichlichem Witz dokumentiert sie die Partnerschaft zwischen Hund und Mensch. Auch wenn Humor bei den visuellen Künsten nie hoch angesehen war, sind bei Erwitts fotografischen Scherzen Tier und Mensch ständig Teil einer Komödie. Vicki

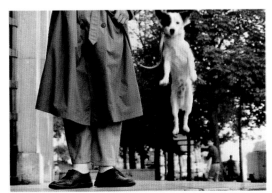

Goldberg, eine renommierte Kritikerin der Fotografie, meinte einmal, dass „das Faszinierende an Erwitts Werk in seinem komischen Wissen um die Kluft zwischen Vornehmheit und Realität liegt oder zwischen Motiv und Umgebung, die sich vielleicht zufällig arrangieren oder aber bekriegen. Er hat eine glückliche Allianz mit dem Unvereinbaren zustande gebracht."

Keine Arbeit zum Thema Hunde wäre vollständig ohne William Wegman, Erster unter Gleichen. Er wurde in Amerika geboren, und sein vielschichtiges, über einen Zeitraum von dreißig Jahren entstandenes Werk stellt ihn an die Spitze des Genres. Mit trügerischer Schlichtheit verändert er spielerisch die Art und Weise, wie der Betrachter Realität erfährt. Seine frühe Schwarzweißphase der siebziger Jahre strahlt eine Strenge aus, die Rätsel aufgibt und gleichzeitig amüsiert; es werden Fragen aufgeworfen und unbeantwortet stehen gelassen. In den achtziger Jahren ging Wegmann zu Farbaufnahmen über. Er bediente sich der kommerziellen Beliebtheit der Polaroidkamera und lichtete eine scheinbar endlose Reihe von Moralitäten ab. Wieder sind es die Hunde – seine Hunde –, die ihm als Mitarbeiter dienen und diese Rolle zwar willig, aber in irritierter Resignation spielen. Mit Wegmans Werk schließt sich in gewisser Hinsicht der Kreis. Die Praxis, Hunde

für gestellte Fotografien in Szene zu setzen, geht schon auf frühere Zeiten zurück, nämlich auf die so genannte künstlerische Fotografie des 19. Jahrhunderts. Wegmann hat ihr unendlich viel hinzugefügt. Seine Kunst ist unwiderstehlich komisch. Wie ein Jack-London-Roman eröffnen seine Aufnahmen verschiedene Lesarten – als fürs Auge amüsanter Anthropomorphismus und gleichzeitig als starke Metapher für die Situation des Menschen in der postmodernen Gesellschaft.

Alle diese Fotografen haben durch ihre Bilder für ein besseres Verständnis der Wesen gesorgt, die wir unsere Hunde nennen. Während Carter weiterhin das Erhabene der Hunde einfängt, tut sich Wegman mit ihnen zusammen, um das wenig Erhabene des Menschen lächerlich zu machen. Der frühe Lartigue zeigte uns die Fähigkeit der Hunde, uns glücklich zu machen, während Erwitt sie weiterhin als diejenigen darstellt, die uns vervollständigen.

Auch am Ende unserer Betrachtungen bleibt die Frage, weshalb der Hund den Menschen und den Künstler im Menschen noch immer fasziniert. Woher rührt diese ungebrochene Besessenheit? Die Antwort ist möglicherweise recht komplex. Wir können nicht leugnen, dass der Hund in unserer Gesellschaft einen eigenwilligen Status hat, in gewisser Hinsicht den eines Menschen ehrenhalber. Vielleicht ist die Antwort aber auch ganz einfach. Es liegt schlicht in unserer Natur, unsere Schuld an einer Kreatur, die wir domestiziert haben und deren Überleben so völlig von uns abhängt, wieder gut-

machen zu wollen. Die Antwort kann auch egoistischer sein. Wegman sagte einmal, Hunde würden uns gut tun und dem ist auch so. Sie sind einzigartige Kameraden, die oft ihr Leben lang an unserer Seite bleiben und uns unendlich viel Freude bereiten. Es ist inzwischen erwiesen, dass aus Kindern, die mit Hunden aufwachsen, mitfühlendere und fürsorglichere Erwachsene werden, und dass Erwachsene dem sozialen Druck oft besser standhalten, länger leben und eine bessere Lebensqualität haben, wenn Hunde Teil ihres Lebens sind. Diese werden oft zu wahren Seelenverwandten. Sie bringen Spleens ans Tageslicht, wecken Pathos und verbreiten Eleganz. Und vielleicht sind dies die Gründe, weshalb der Hund für den Künstler von heute immer wiederkehrende Metapher und Symbol bleibt. Viele Wissenschaftler sind der Meinung, dass Tiersymbolik im Grunde nichts anderes ist als der Versuch des Menschen, das Tier in sich zu akzeptieren. Tiere weisen uns oft nachhaltig auf unsere Fehler hin, auf die Zerbrechlichkeit unserer Welt. Gleichzeitig stehen sie für Tugenden, für die wir eintreten, die wir aber oft nicht leben können: bedingungslose Liebe, ewige Treue, inneren Frieden, bescheidene Anmut und nie versiegenden Schwung. Robert Adams, einer der großen amerikanischen Fotografen, fand die treffenden Worte: „Ich vermute, dass das, was die Liebe des Künstlers zu Hunden aufrecht erhält, in erster Linie deren Mut machender Sinn für das Mögliche ist. Künstler leben von Neugier und Begeisterung, Eigenschaften, die im Hund jederzeit

als Inspiration zu finden sind. Fragen Sie einen Hund, ob er spazieren gehen möchte, und seine Antwort ist unbedingt ja." Diese Tiere besitzen Eigenschaften, die immer noch faszinieren, amüsieren, unterhalten und erziehen, und das in einer Art und Weise, die nicht in Geld gemessen werden kann. Sie erteilen uns Unterricht in Sachen Leben und Lieben, von dem wir nur profitieren können, und so mag der Schlusssatz angebracht sein: „Wir haben den Hund gesehen, und der Hund sind wir."

Jacques-Henri Lartigue, 1968

La boucle est bouclée
De l'acceptation à l'absorption

Cet ouvrage a tenté de présenter, avec des mots et des images, l'ensemble des progrès réalisés au cours des cent cinquante dernières années, par l'homme en société, l'homme dans sa relation avec le chien, parallèlement aux progrès de la photographie. A l'aube du nouveau millénaire, il est encourageant de noter que les extrémités de ces trois boucles semblent se rapprocher. Du point de vue société, le XXᵉ siècle s'est achevé glorieusement, dans un foisonnement d'avancées technologiques : le réseau Internet a ouvert grand ses portes sur le nouveau millénaire, avec un monde, au sens propre comme au figuré, au bout de nos doigts, un monde moins polarisé, moins paupérisé, davantage en paix et plus soucieux que jamais de boucler la boucle de compassion entre ceux qui se partagent la planète.

Les progrès de la photographie ont virtuellement accompli le cercle de l'acceptation et de l'absorption. Aujourd'hui, la photographie est implantée dans nos consciences. Comme l'a si bien formulé Roberta Smith, éminente critique new-yorkaise : « Un siècle et demi après son invention, la photographie est moins ‹ une forme d'expression de l'homme › qu'une partie inextricable de la condition humaine et du paysage contemporain... Et, de toutes les formes d'art, c'est la plus omniprésente. On a beau épiloguer sur la montée de la vidéo, ou le retour de la peinture, ou la domination de ‹ l'art d'installation ›, rien,

au cours des trente dernières années, ne peut égaler le triomphe la photographie. » Pour l'artiste, la photographie est aujourd'hui à la fois une fin et un moyen. Elle sert d'outil, de canevas et surtout d'inspiration. En tant que muse et sujet, le chien demeure un thème récurrent. On le trouve dans tout l'éventail des recherches artistiques, que ce soit chez nos plus grands peintres, comme Fischl, Salle et Hockney, ou chez les conceptualistes post-modernes comme Wolfgang Tillmans, Franciso Toledo ou Matthew Barney.

Pour rendre hommage à ce phénomène, nous avons choisi de mettre en lumière des artistes qui, au cours des cent cinquante dernières années, ont su pleinement saisir la présence des chiens. Sans pour autant minimiser le travail des autres artistes cités, il en est quatre dont l'œuvre se détache et qui méritent une mention spéciale : Keith Carter, Jacques-Henri Lartigue, Elliott Erwitt and William Wegman. Ceux-là ont retenu notre attention parce que leurs efforts ont su mettre en lumière des aspects différents, mais néanmoins essentiels, de la race canine.

Keith Carter vit et travaille au Texas. Ses photos savent saisir chez le chien sa manière d'être et sa vie émotionnelle, dans ce qu'elle a de plus spontané. Dans ses images, on trouve une grâce essentielle, voire primordiale. On y voit la beauté innée du chien, son aspect « typiquement » canin. On s'aperçoit que le chien est au fait des choses, éveillé, conscient, peut-

Keith Carter, 1995

William Wegman, 1974

être doté d'une dimension spirituelle, qu'il est moins complexe mais plus complet que l'homme.

Jacques-Henri Lartigue, grand autodidacte de la photographie, a abordé le chien avec un peu moins de révérence, mais avec une familiarité plus franche. Il a vu le chien avec des yeux d'enfants (ses photos les plus saisissantes ayant été produites quand il était adolescent). Aucun autre artiste n'a su mieux capter ce lien particulier entre l'innocence de la jeunesse et la candeur du chien.

Né à Paris de parents américains, Elliott Erwitt est surtout connu comme un éminent reporter photographique et un humoriste à la vision inégalable. Plus mature, son regard propulse la photographie de chiens vers l'âge adulte et parvient à saisir de manière extrêmement drôle le rapport étroit entre le chien et l'homme. Bien que l'humour soit rarement apprécié dans le monde des arts visuels, les plaisanteries photographiques d'Erwitt placent constamment l'animal et l'homme sur une scène de comédie. Vicki Goldberg, dans un de ses commentaires les plus profonds, a noté que « la force principale d'Erwitt est sa façon comique de percevoir le fossé qui sépare

noblesse et réalité ou sujet et environnement qui, sans que l'on sache comment, s'harmonisent bon gré mal gré, ou alors font discordance. Erwitt a su forger une heureuse alliance avec l'incongru. »

Un ouvrage sur les chiens ne saurait se conclure sans tendre la patte à William Wegman qui, dans ce domaine, règne sans partage. Né aux Etats-Unis, il a produit, en plus de trente ans, une œuvre diversifiée qui le place au sommet du genre. Avec une simplicité trompeuse, il s'amuse à modifier la façon dont le spectateur ressent la réalité. Ses premières œuvres en noir et blanc, tout au long des années 70, font preuve d'une austérité à la fois mystifiante et amusante. Des questions sont posées, mais restent sans réponse. Dans les années 80, Wegman aborde la couleur, mettant à profit le lustre et le commercial du Polaroïd pour immortaliser une série apparemment infinie de saynètes morales. Là encore, le chien – ses chiens – lui sert volontiers de collaborateur, avec une résignation amusée. Dans une certaine mesure, l'œuvre de Wegman représente la perfection du cercle en matière de photographie canine. Faire poser des animaux pour des photos avec mise en scène, remonte au XIXe siècle, à l'époque de ce l'on a appelé « la photo d'art ». Mais Wegman a su y apporter sa touche, en y ajoutant une note carrément hilarante. Comme

Jacques-Henri Lartigue, 1904

pour un roman de Jack London, on peut lire ses photos à différents niveaux : à la fois trope anthropomorphique amusant, et métaphore puissante de la condition humaine dans notre société post-moderne.

Chacun de ces photographes a fait progresser notre compréhension de ceux que nous appelons « nos » chiens. Tandis que Carter continue de capter leur noblesse, Wegman collabore avec eux afin de ridiculiser l'homme et ses bassesses. Jadis, Lartigue nous avait montré leur capacité à nous rendre heureux. Désormais, Erwitt illustre leur aptitude à nous faire sentir comme un tout.

Au moment de conclure cette étude, la question persiste de savoir pourquoi l'homme et l'artiste demeurent fascinés par le chien. Pourquoi cette obsession permanente ? La réponse pourrait bien être complexe. Nul ne saurait nier que le chien occupe un curieux statut dans notre société. Il est, en quelque sorte, un humain honoraire. La raison en est peut-être simple. Ce serait notre façon de rembourser notre dette à l'égard d'une créature que, pour sa survie, nous avons transformée et rendue totalement dépendante de nous. A moins que la réponse ne soit plus égoïste. Un jour, Wegman a fait remarquer que les chiens nous aident à nous sentir mieux, ce qui est vrai. Ce sont des compagnons exceptionnels qui souvent passent leur vie entière avec nous, nous procurant des plaisirs infinis. Aujourd'hui, chacun sait que les enfants qui possèdent un chien seront des adultes plus tolérants et plus attentionnés. De même, les adultes qui partagent leur vie avec celle d'un chien,

parviennent à surmonter les pressions de la vie sociale, vivent plus vieux, et avec une meilleure qualité de vie. Souvent, le chien joue le rôle de l'âme sœur. Il sait se monter fantaisiste, pathétique et surtout élégant. C'est peut-être pour ces raisons que, pour l'artiste contemporain, le chien demeure une métaphore et un symbole. Selon certains intellectuels, le symbolisme animal est, par essence, chez l'homme, la tentative pour reconnaître en lui sa propre partie animale. Souvent les animaux deviennent le marqueur évident de nos échecs, de nos faiblesses, de la fragilité du monde. Pourtant, ils sont également les icônes des vertus que nous prônons mais que nous sommes souvent incapables de respecter : l'amour éternel, la fidélité infaillible, la paix intérieure, la grâce naturelle et la verve inépuisable. Robert Adams, l'un des plus grands photographes américains, a su parfaitement le formuler : « Selon moi, ce qui nourrit l'affection des artistes pour les chiens, c'est surtout ce formidable sens du possible qu'offre l'animal. Les artistes vivent de curiosité et d'enthousiasme, qualités que ne peuvent qu'inspirer les chiens. Proposez à un chien de l'emmener promener, et sa réaction sera oui, sans hésiter. »

Ces créatures sont douées de qualités qui continuent d'intriguer, d'amuser, de divertir et d'éduquer, d'une façon qui ne peut être quantifiée en profits. Grâce à eux, nous apprenons des choses sur la vie et l'amour, et il paraît donc pertinent de conclure sur l'adage : « Nous avons vu le chien et le chien, c'est nous. »

Elliott Erwitt, 1979

Until he extends the circle of his compassion to all living things,
man will not himself find peace.

Bevor er sein Mitgefühl nicht auf alles Lebendige ausdehnt,
wird der Mensch selbst keinen Frieden finden.

Tant qu'il n'aura pas élargi le cercle de sa compassion à toutes
les créatures vivantes, jamais l'homme ne trouvera la paix.

ALBERT SCHWEITZER

Companions
Freunde
Compagnons

Dogs are not our whole life, but they make
our lives whole.

Hunde sind nicht unser ganzes Leben, aber
durch sie wird unser Leben erst vollständig.

Les chiens ne sont pas notre vie toute entière,
mais il font que notre vie est entière.

ROGER CARAS

To me, to live without dogs would mean
accepting a form of blindness.

Ohne Hunde zu leben, hieße für mich,
eine Form der Blindheit zu akzeptieren.

Pour moi, vivre sans chien serait comme
accepter une forme d'aveuglement.

THOMAS McGUANE

Martha Casanave, 1996

Nina Schmitz and Bernd Schaller, 1996

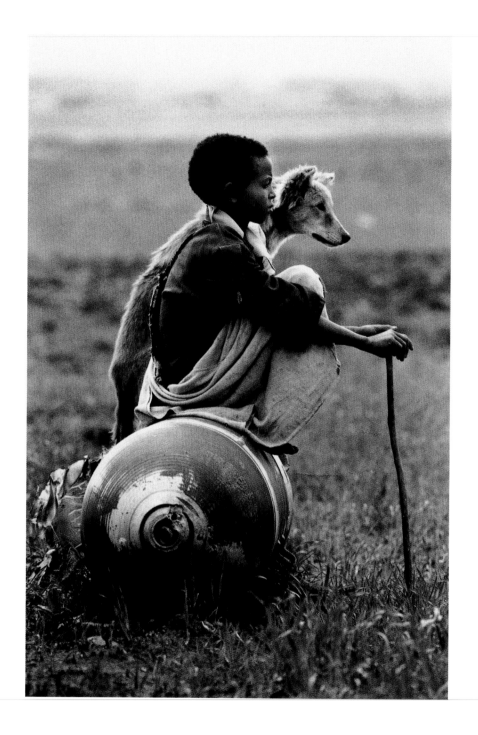

Dario Mitidieri, 1991

444 Tina Barney, 1994

David Bailey, 1986

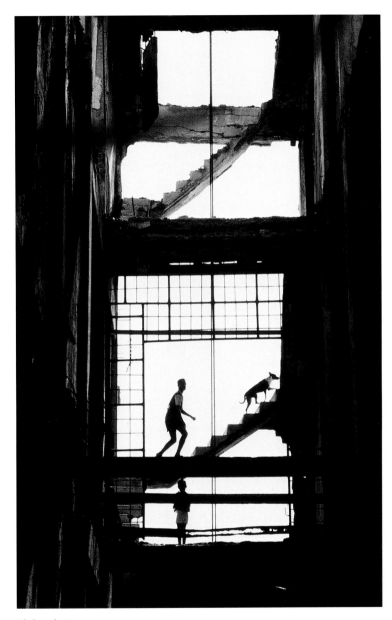

Christophe Agou, 1999

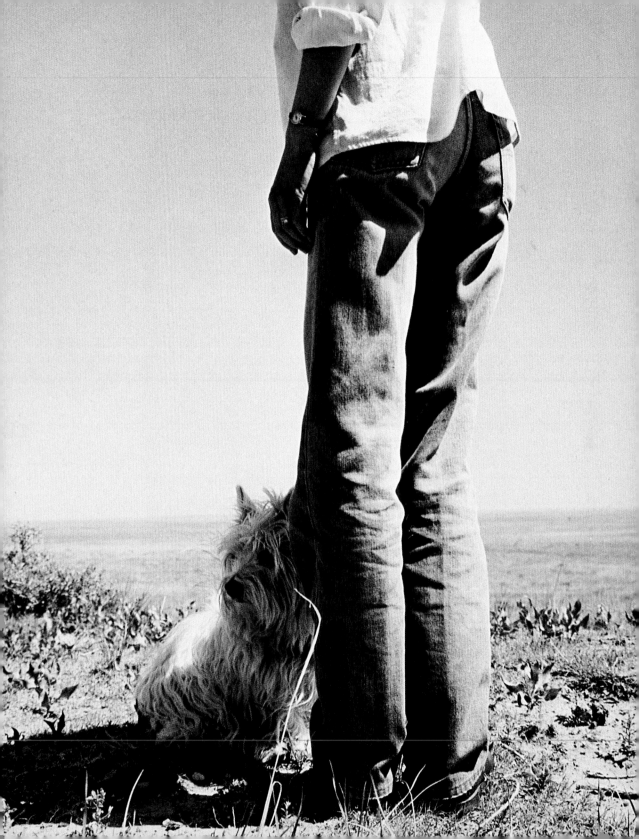

He is very imprudent, a dog is. He never makes it his business to inquire
whether you are in the right or in the wrong, never bothers as to whether you
are going up or down upon life's ladder, never asks whether you are rich or
poor, silly or wise, sinner or saint. You are his pal. That is enough for him, and
come luck or misfortune, good repute or bad, honor or shame, he is going to
stick by you, to comfort you, guard you, give his life for you, if need be –
foolish, brainless, soulless dog!

Er ist höchst unklug, der Hund. Er fragt nie, ob du im Recht bist oder im Unrecht, kümmert sich
nicht darum, ob du im Leben gerade auf dem aufsteigenden oder absteigenden Ast bist, fragt nicht,
ob du reich bist oder arm, dumm oder klug, Sünder oder Heiliger. Du bist sein Kumpel. Das genügt
ihm, und was immer das Leben bringen mag, Glück oder Unglück, hohes oder geringes Ansehen,
Ehre oder Schande, er bleibt an deiner Seite, tröstet dich, passt auf dich auf, gibt sein Leben für
dich, wenn es sein muss – törichter, dummer, seelenloser Hund!

Il est fort imprudent, le chien. Il ne s'inquiète jamais de savoir si vous avez
tort ou raison, ne se préoccupe jamais de votre ascension ou de votre chute
le long de l'échelle sociale, ne vous demande jamais si vous êtes riche ou
pauvre, bête ou intelligent, saint ou pécheur. Vous êtes son copain. Pour lui,
cela suffit, et qu'advienne la chance ou le malheur, la bonne ou la mauvaise
renommée, les honneurs ou la honte, il va rester à vos côtés, vous réconforter,
vous garder, donner sa vie pour vous si nécessaire : ce chien stupide, sans
cervelle, et sans âme.

JEROME K. JEROME

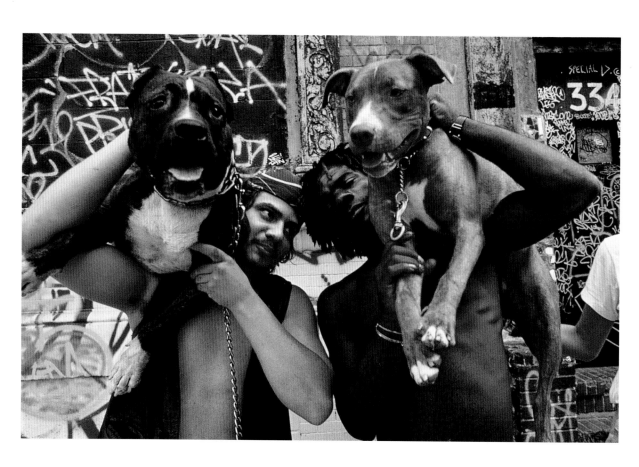

Donna Ferrato, 1987

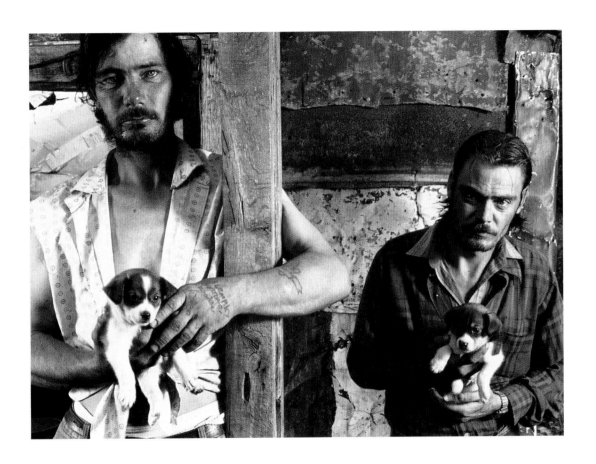

Nina Schmitz, 1999

David Hockney, 1990

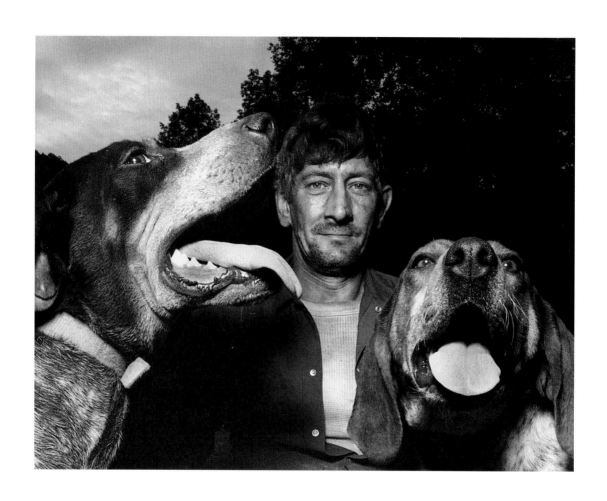

Shelby Lee Adams, 1992

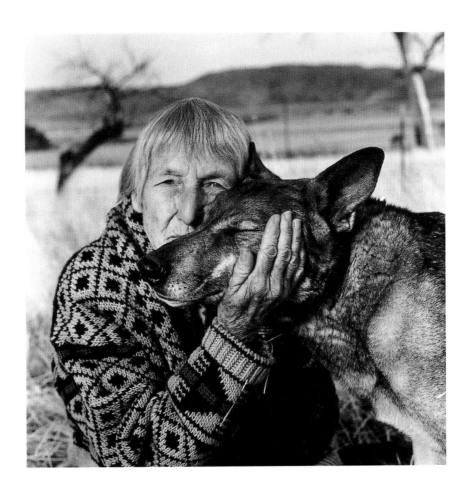

Mary Ellen Mark, 1990

The one absolutely unselfish friend that a man can have in this selfish world, the one that never deserts him ... is his dog. A man's dog stands by him in prosperity and poverty, in health and sickness. He will sleep on the cold ground, when the wintry winds blow and the snow drives fiercely, if only he can be near his master's side. He will kiss the hand that has no food. He guards the sleep of a pauper as if he were a prince.

If fortune drives the master forth, an outcast in the world, the faithful dog asks no higher privilege than that of accompanying him to guard against danger, to fight against his enemies, and when the last scene of all comes, and death takes the master in its embrace, there by his graveside will the noble dog be found, his head between his paws, his eyes sad but open in alert watchfulness, faithful and true.

GEORGE GRAHAM VEST

Der einzige absolut selbstlose Freund, den ein Mensch in dieser selbstsüchtigen Welt haben kann, der Freund, der ihn nie im Stich lässt ... ist sein Hund. Eines Menschen Hund ist an seiner Seite in Wohlstand und Armut, Gesundheit und Krankheit. Er schläft auf dem kalten Boden, wenn die Winterwinde wehen und der Schnee übers Land fegt, solange er nur in der Nähe seines Herrn ist. Er küsst die Hand, die kein Futter hat. Er bewacht den Schlaf eines Armen, als wäre er ein Fürst.

Wenn das Schicksal seinen Herrn aus der Gesellschaft ausstößt, gibt es für den treuen Hund kein größeres Privileg als das, ihn begleiten zu dürfen, um ihn vor Gefahren zu schützen und gegen seine Feinde zu verteidigen, und wenn der letzte Akt beginnt und der Tod seinen Herrn zu sich ruft, so wird man den braven Hund an seinem Grab finden, den Kopf zwischen den Pfoten, die Augen voller Trauer, aber hellwach und aufmerksam, treu und wahrhaftig.

GEORGE GRAHAM VEST

Suzanne Shaker, 1998

Le seul ami sans le moindre égoïsme qu'un homme puisse avoir, dans ce monde égoïste, l'ami qui ne l'abandonne jamais … c'est son chien. Le chien d'un homme reste à ses côtés dans la prospérité comme dans la pauvreté, en temps de bonne santé comme de maladie. Il dormira sur le sol glacé, quand le vent d'hiver souffle et que la neige tombe en rafales, pourvu qu'il puisse rester auprès de son maître. Il embrassera la main qui n'apporte pas de nourriture. Il monte la garde auprès du pauvre, comme s'il était un prince.

Si la fortune fait de son maître un proscrit, le chien fidèle se contentera du privilège de l'accompagner pour le préserver du danger, le défendre de ses ennemis, et quand sonnera la dernière heure et que la mort prendra son maître entre ses bras, là, près de sa tombe, le noble chien veillera, la tête entre les pattes, le regard triste mais vigilant, fidèle et honnête.

GEORGE GRAHAM VEST

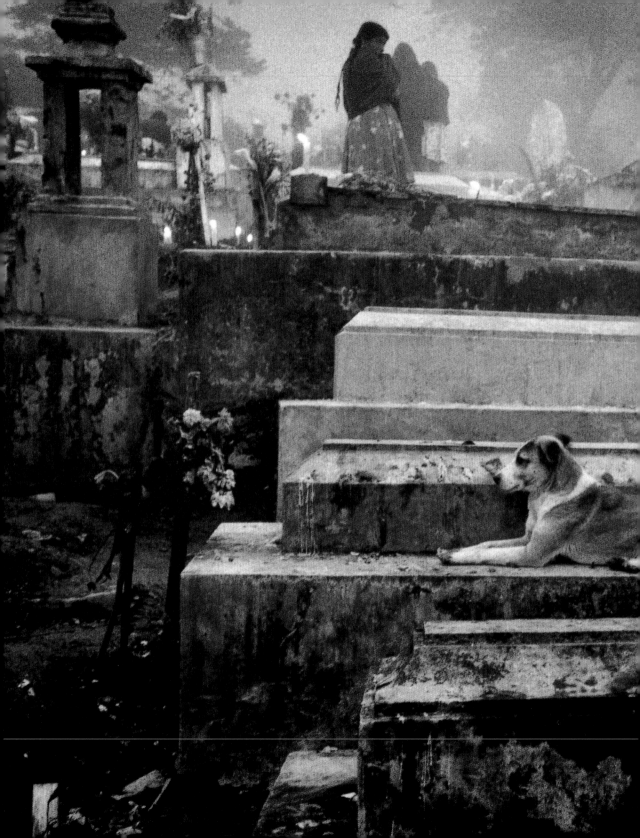

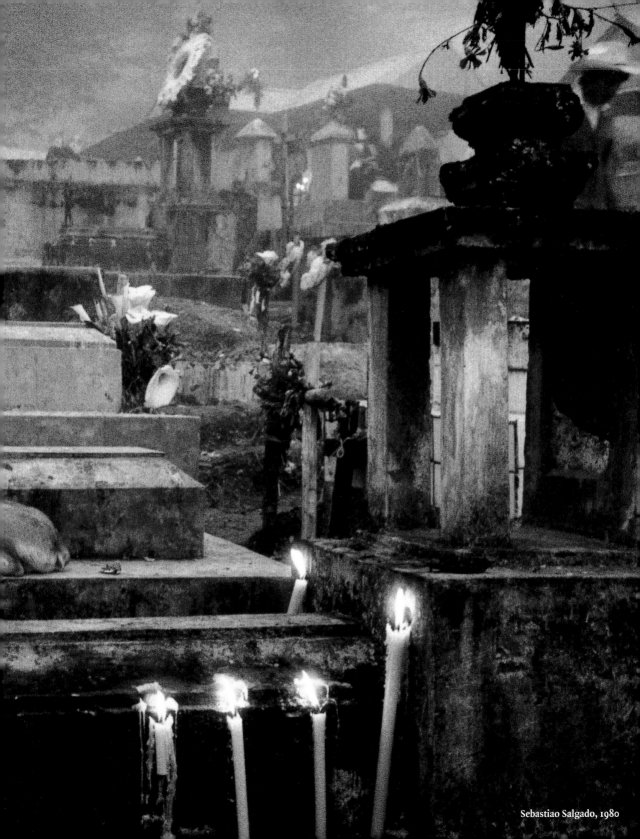

Sebastiao Salgado, 1980

The worst sin towards our fellow creatures is not to hate them,
but to be indifferent to them. That is the essence of inhumanity.

Die größte Sünde gegenüber unseren Mitgeschöpfen ist nicht, sie zu hassen,
sondern ihnen gegenüber gleichgültig zu sein. Das ist Unmenschlichkeit per se.

Le pire des péchés à l'égard des animaux, ce n'est pas de les haïr,
mais de leur être indifférent. Voilà l'essence même de l'inhumanité.

GEORGE BERNARD SHAW

I expect to pass through this world but once. Any good thing I can do,
or any kindness I can show to any fellow creature, let me not defer or
neglect it, for I shall not pass this way again.

Ich gehe davon aus, dass ich nur einmal auf dieser Welt bin. Lass mich alles Gute,
das ich tun kann, und jede Freundlichkeit, die ich einem anderen Wesen erweisen kann,
ohne zu zögern auch wirklich tun, da ich diesen Weg nicht noch einmal gehen werde.

Je pense ne passer en ce monde qu'une seule fois. Tout le bien dont je serai
capable, toute la tendresse que je pourrai montrer aux autres créatures,
puissè-je ne jamais les refuser ni les négliger. Car jamais, je ne repasserai
par ce chemin-là.

STEPHEN GRELLET

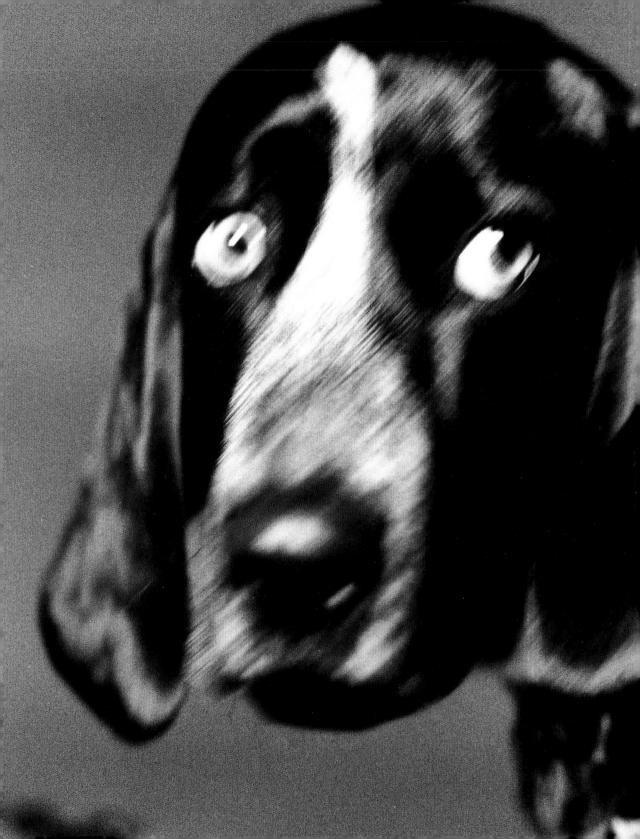

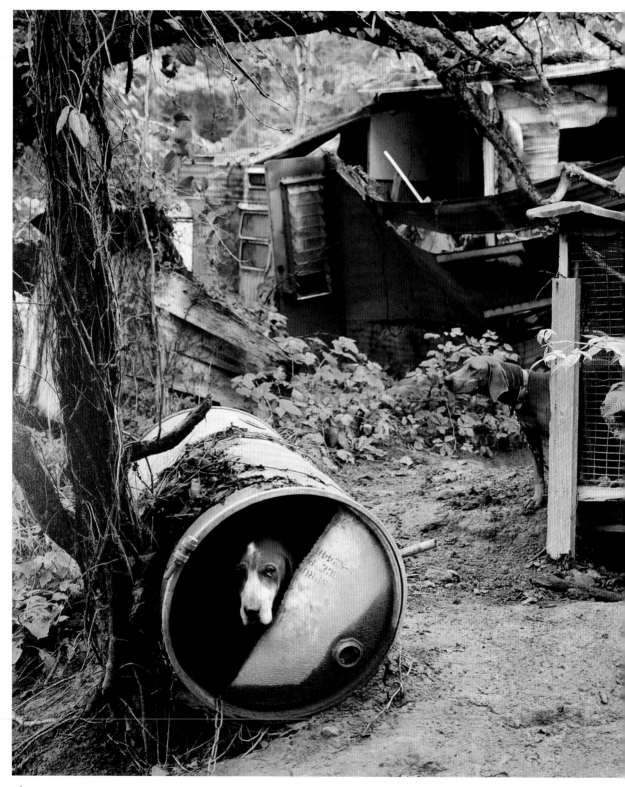

Nowadays we don't think much of a man's love for animals. ... But if we stop loving animals, aren't we bound to stop loving humans too?

ALEXANDER SOLZHENITSYN

Heutzutage gilt die Liebe des Menschen zu Tieren nicht viel ... Doch wenn wir aufhören, die Tiere zu lieben, werden wir dann nicht auch unweigerlich aufhören, die Menschen zu lieben?

ALEXANDER SOLSCHENIZYN

Aujourd'hui, nous accordons peu d'importance à l'amour de l'homme pour les animaux. Mais si nous cessons de les aimer, ne sommes-nous pas condamnés à cesser aussi d'aimer le genre humain ?

ALEXANDRE SOLJENITSYNE

Michael Smith, 1999

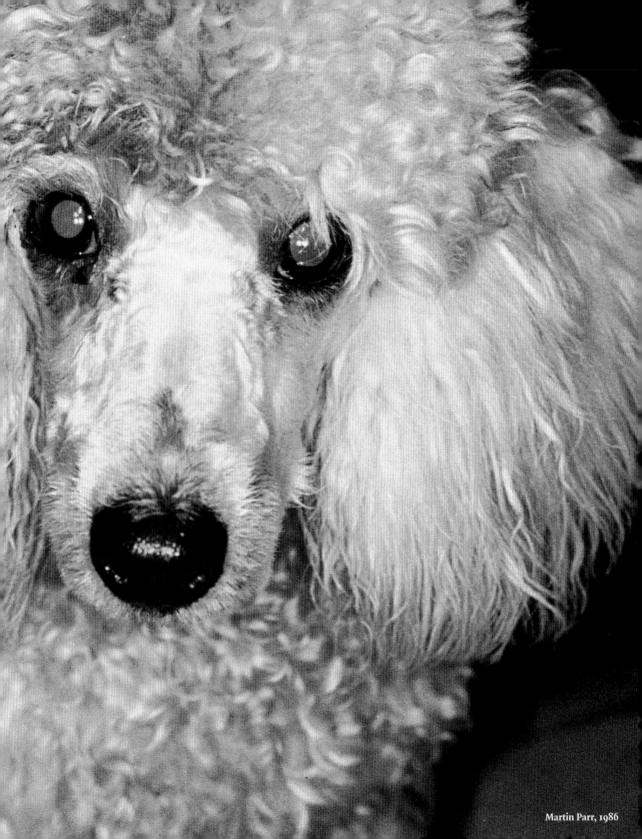
Martin Parr, 1986

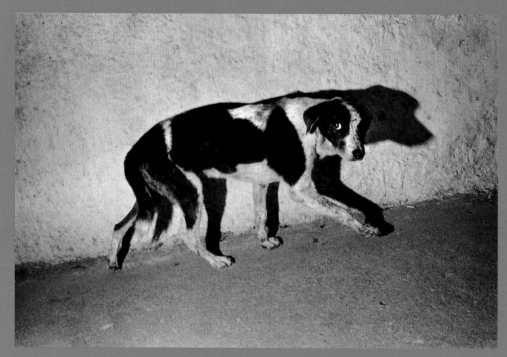

Bruce Gilden, 1990

Dogs' eyes speak a special language that comes
directly from their souls.

Die Augen eines Hundes sprechen eine ganz besondere Sprache,
die direkt aus dem Herzen kommt.

Le regard des chiens s'exprime dans une langue
particulière qui provient directement de leur âme.

ANONYMOUS

Leon Kuzmanoff, 1985

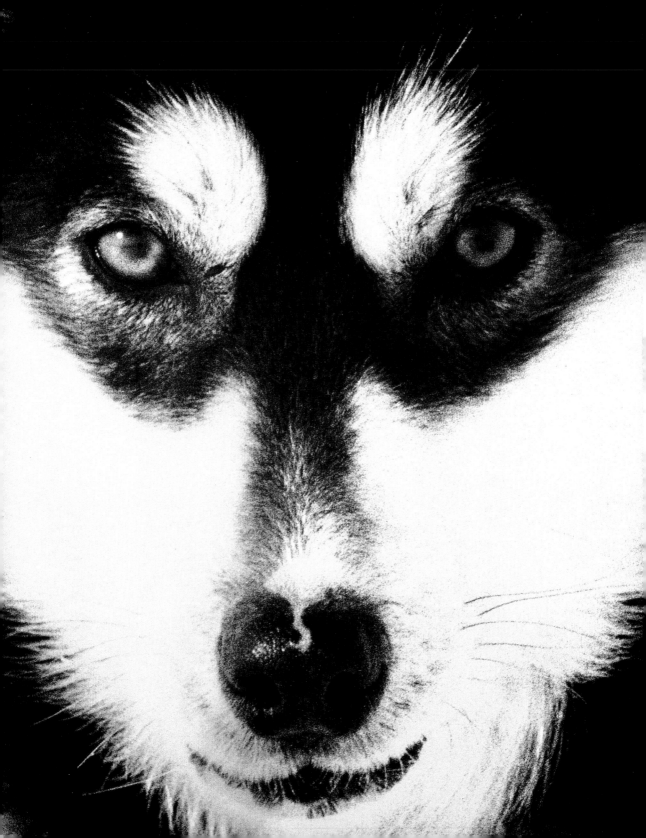

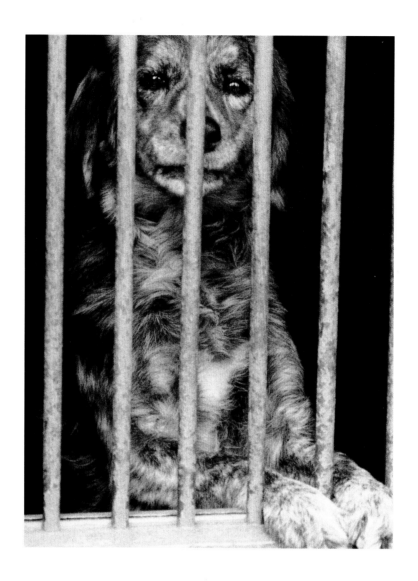

Freddie Reed, 1980

Marianne Courville, 1997

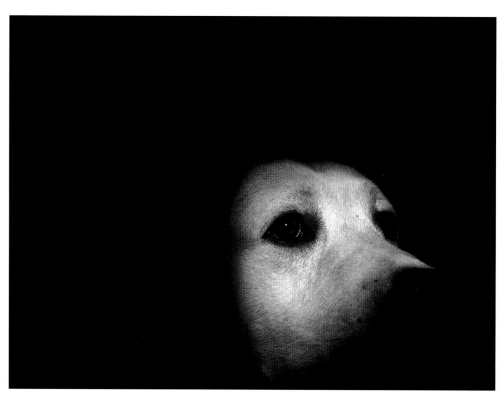

James Balog, 1993

Keith Carter, 1992

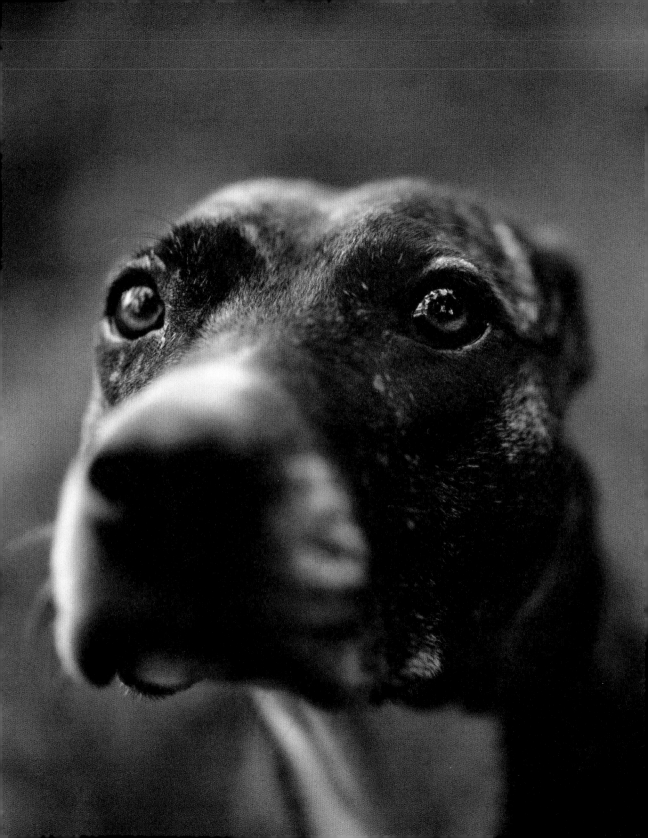

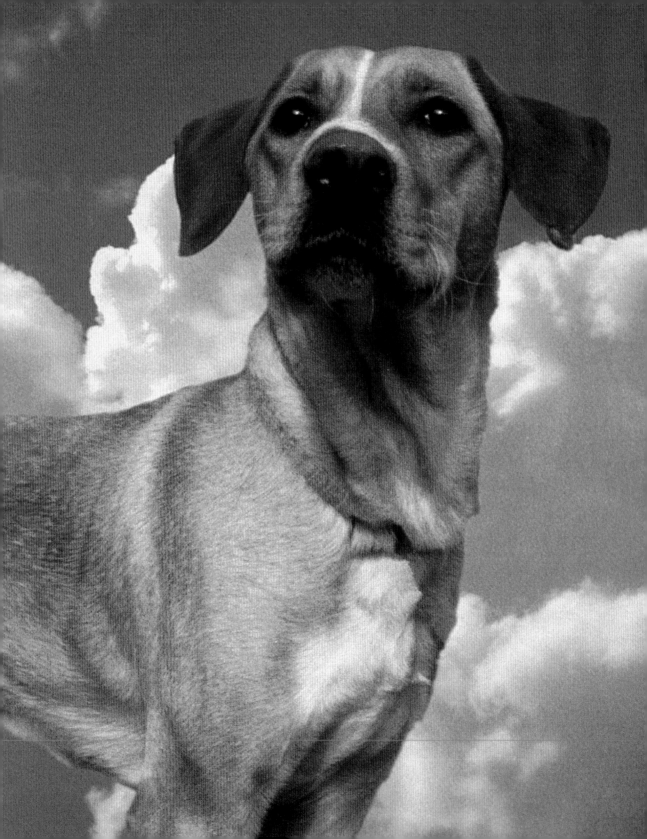

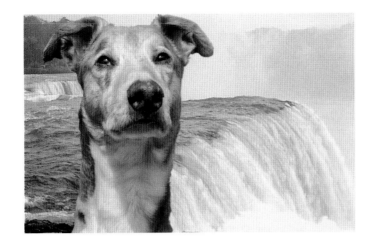

Strays

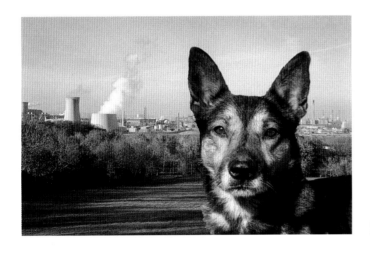

Streuner

Chiens errants

The day may come when the rest of the animal creation may acquire those rights which never could have been withheld from them but by the hand of tyranny …. A full-grown dog is beyond comparison a more rational, as well as a more conversable animal, than an infant of a day, or a week, or even a month old. But suppose the case were otherwise, what would it avail? The question is not, Can they reason? nor, Can they talk? but, Can they suffer?

Vielleicht wird der Tag kommen, an dem der Rest der tierischen Schöpfung die Rechte erhält, die ihm nie hätten versagt werden können, es sei denn durch Tyrannei … Ein ausgewachsener Hund ist fraglos ein verständigeres und auch unterhaltsameres Wesen als ein Kind, das einen Tag, eine Woche oder sogar einen Monat alt ist. Doch angenommen, die Sache wäre anders herum, was würde es nützen? Die Frage ist weder: Können sie logisch denken?, noch: Können sie sprechen?, sondern: Können sie leiden?

Le jour viendra peut-être où les autres animaux pourront acquérir ces droits que rien, sinon la main de la tyrannie, n'aurait jamais pu leur retirer… Un chien d'âge adulte est, sans conteste, un animal plus raisonnable et de meilleur commerce qu'un bébé d'un jour, d'une semaine, ou même d'un mois. Mais à supposer qu'il en soit autrement, qu'en résulterait-il ? La question n'est pas : peuvent-ils raisonner, ni : peuvent-ils parler ? Mais : peuvent-ils souffrir ?

JEREMY BENTHAM

New York · Max Aguilera-Hellweg, 1999

Kosovo · Gilles Peress, 1999

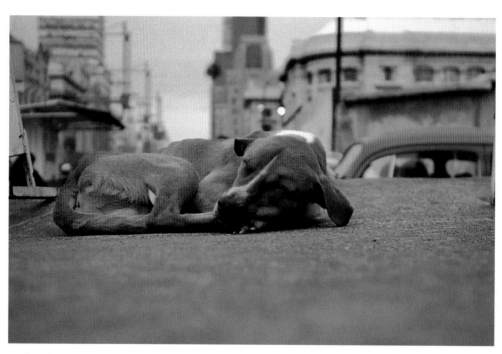

Mexico City · Francis Alÿs, 1999

Los Angeles · Camilo José Vergara, 1997

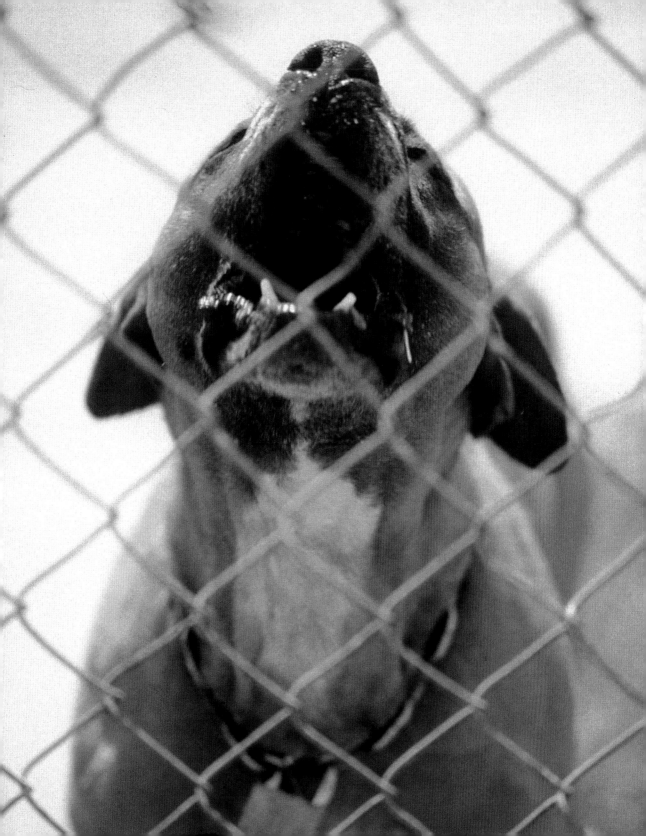

Robert Adams, 1989

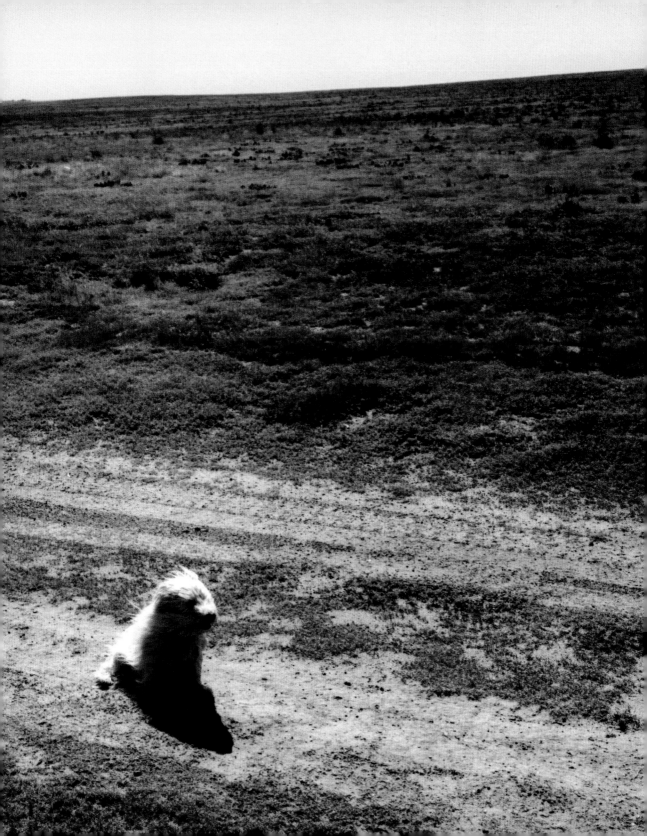

The Path to a New Ethic
Der Weg zu einer neuen Ethik
Vers un nouvelle éthique

MARY ELIZABETH THURSTON

History tells us that the welfare of the individual, human or canine, is irrevocably tied to the welfare of the community. Now we have studies showing that children who care for dogs are more likely to mature into emotionally healthier adults, and that canine companionship prolongs the length and quality of life. Capable of a remarkable love, the dog gives us what we crave most – a sense of belonging.

Throughout our shared history with dogs, it has been the spark of love between one person and one pet that became the catalyst for social change. That this canine "epiphany" is now happening with increasing frequency points to a revolution in our concept of ourselves – our growing acceptance that we are part of the community of animals, not above or separate from it. With overpopulation, urbanization, and habitat destruction threatening our personal links to the natural world, the role of the dog in bringing us to this new awareness cannot be trivialized.

Pet keeping is now one of the Western values being exported to cultures where animals have traditionally been viewed as consumable resources. With only the affluent in these countries able to afford keeping dogs for pleasure, pets again are becoming emblems of prestige, just as they were in nineteenth-century Europe. So we might ask, as the far reaches of the globe are transformed by a second wave of industrialization, whether the human-dog relationship in these developing nations will follow the same evolutionary pattern. Will the camera again document a canine pilgrimage from slave to soulmate as these societies grapple with concepts of self-determination and a compassionate ethic that embraces all?

Die Geschichte lehrt, dass das Wohlergehen des Einzelnen, ob Mensch oder Hund, unwiderruflich mit dem Wohl der Gemeinschaft verbunden ist. Untersuchungen belegen, dass Kinder, die mit Hunden aufwachsen, mit größerer Wahrscheinlichkeit zu emotional gesunden Erwachsenen heranwachsen, und dass die Gesellschaft von Hunden die Lebensqualität steigert und sogar das Leben zu verlängern vermag. Zu beachtlicher Liebe fähig, erfüllt der Hund unser Verlangen nach Zugehörigkeit.

Im Laufe unserer gemeinsamen Vergangenheit wurde die Liebe zwischen Mensch und Tier immer wieder zum Katalysator gesellschaftlicher Veränderungen. Dass diese „Epiphanie" des Hundes heute ausgeprägter ist, deutet auf ein revolutionär neues Bild unserer selbst hin: Wir haben akzeptiert, dass wir Teil der Gemeinschaft aller Geschöpfe sind. Angesichts der Gefahr, dass Überbevölkerung, Verstädterung und die Vernichtung natürlicher Lebensräume unsere Bindung zur Natur zerstören, darf die Bedeutung des Hundes, der uns zu diesem neuen Bewusstsein verhilft, nicht unterschätzt werden.

Das Halten von Haustieren ist zu einem westlichen Wert geworden, der in Kulturen exportiert wird, in denen Tiere traditionell primär als Nahrungsquelle dienen. Da sich in diesen Ländern nur die Wohlhabenden einen Hund zum Vergnügen leisten können, werden Haustiere – wie im Europa des 19. Jahrhunderts – wieder zu einem Prestigeobjekt. Jetzt, da auch in den letzten Winkeln der Erde durch eine zweite Welle der Industrialisierung ein gesellschaftlicher Wandel eintritt, stellt sich Frage, ob sich dort die Beziehung Mensch – Hund genauso wie bei uns entwickeln wird.

Wird die Kamera wieder den langen Weg des Hundes vom Sklaven zum Gefährten festhalten, während diese Gesellschaft sich um ihre Selbstbestimmung und eine mitfühlende Ethik, die alle einschließt, bemüht?

L'histoire nous enseigne que le bien-être de l'indivi-du, qu'il soit homme ou chien, est profondément lié à celui de la communauté. Aujourd'hui, nous dispo-sons d'études démontrant que les enfants qui aiment les chiens feront, selon toute probabilité, des adultes plus sains du point de vue émotionnel et que la com-pagnie des chiens prolonge la durée et la qualité de la vie. Avec son extraordinaire capacité d'amour, le chien nous offre ce dont nous avons le plus besoin : le sens de notre identité.

Tout au long de notre histoire commune, c'est cette étincelle d'amour entre gens et animaux fami-liers qui a servi de catalyseur au changement social. Que cette « épiphanie » canine se produise de plus en plus fréquemment, est la marque d'une révolution dans notre conception de nous-même – l'acceptation progressive que nous aussi, nous faisons partie de la communauté animale, que nous ne sommes ni au-dessus, ni à part. Avec la surpopulation, l'urbanisa-tion, la destruction de l'environnement qui menacent nos liens personnels avec le monde naturel, le rôle du chien, dans cette nouvelle prise de conscience que nous devons atteindre, est loin d'être négligeable.

Avoir un animal chez soi, c'est aujourd'hui l'une des valeurs occidentales exportées vers des civilisations où les animaux ont toujours été consi-dérés comme des biens consommables. Puisque seuls, dans ces pays, les riches peuvent entretenir un chien pour le plaisir, les animaux de compagnie redeviennent des emblèmes de prestige, exacte-ment ce qu'ils étaient autrefois, dans l'Europe du XIXe siècle. Aussi pourrait-on se demander, alors que les confins du globe se développent grâce à une deuxième vague d'industrialisation, si, dans ces nations en voie de développement, la relation homme-chien va suivre la même évolution. L'appareil photo va-t-il, une fois encore témoigner du lent pas-sage canin, d'esclave à âme sœur, à mesure que ces sociétés intègrent les concepts d'autodétermination et une éthique de la compassion qui s'étende à toute la création ?

Lorna Bieber, 1999

The greatness of a nation and its moral progress can be measured by the way its animals are treated.

Die Größe einer Nation und ihr moralischer Fortschritt können daran gemessen werden, wie sie ihre Tiere behandelt.

La grandeur d'une nation et son progrès moral se mesurent à la façon dont elle traite ses animaux.

MAHATMA GANDHI

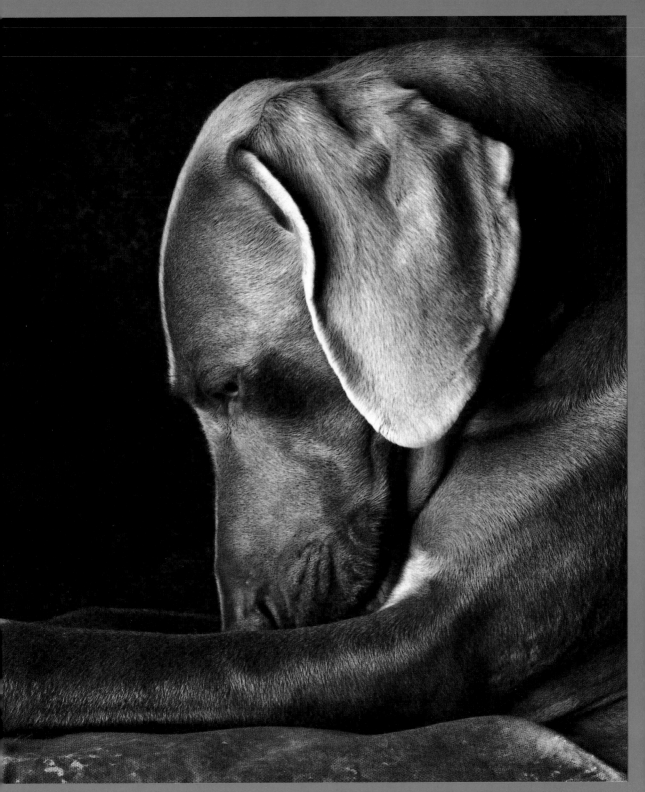

Animals are good to think with.

In der Gesellschaft von Tieren
fällt das Denken leicht.

Il fait bon penser
en compagnie d'un animal.

CLAUDE LÉVI-STRAUSS

In metaphor, the boundary separating human from animal is not rigid and simple, but fluid and complex.

Metaphorisch gesprochen ist die Grenze, die den Menschen vom Hund trennt, nicht starr und einfach, sondern fließend und komplex.

Métaphoriquement parlant, la frontière qui sépare l'homme de l'animal n'est pas rigide et simple, mais fluide et complexe.

CAROLE BAKER

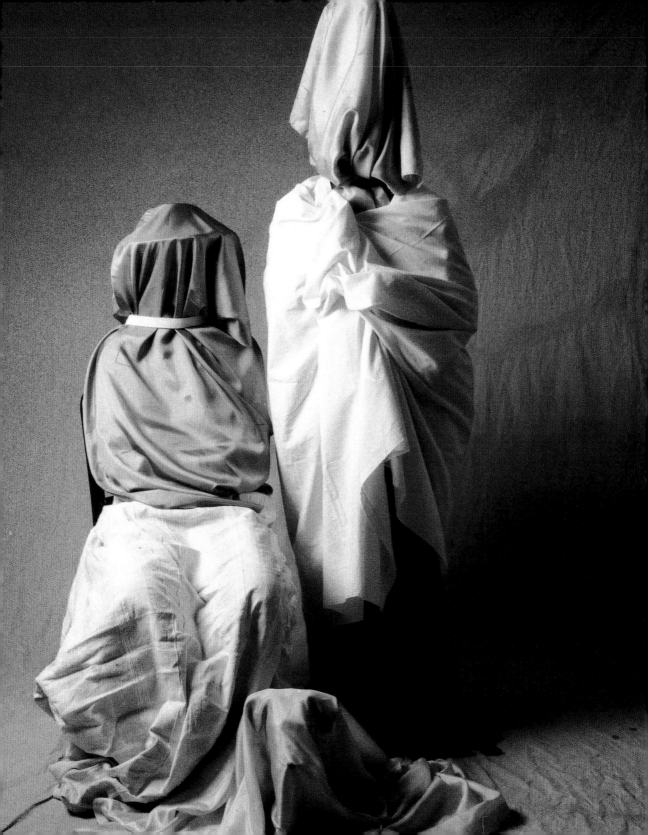

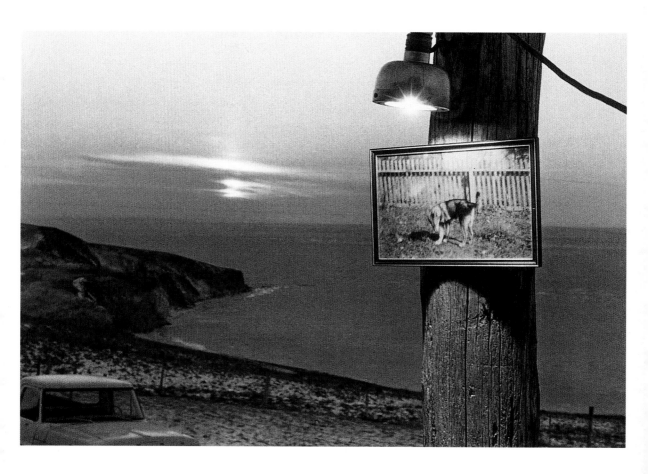

Robert Frank, 1980

All knowledge, the totality of all questions
and all answers, is contained in the dog.

Alles Wissen, alle Fragen und alle Antworten
finden sich im Wesen des Hundes.

Tout le savoir, toutes les questions et
toutes les réponses se trouvent dans le chien.

FRANZ KAFKA

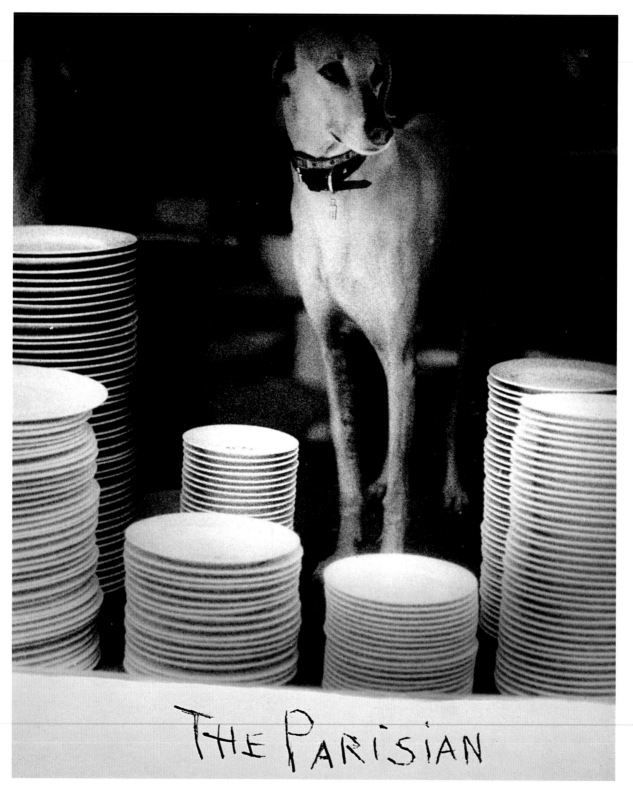

THE PARISIAN

David Seltzer, 1988

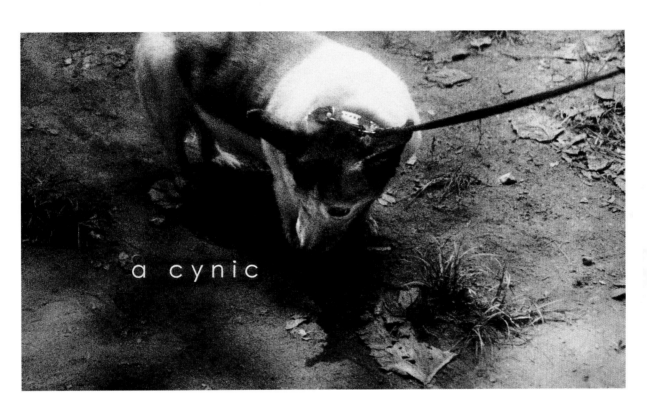

a cynic

A long time ago, dogs were regularly mistreated – unfed, unloved, and abused. So they gathered together and wrote a letter to God, selected a messenger dog and inserted the letter inside him below his tail – so he would not drop it when he ate or barked, for the journey would be long and hard. Generations passed and the dogs are still waiting. That is why they sniff each other – they are searching for God's reply!

CHIAPAS FOLKLORE

Vor ewigen Zeiten fristeten die Hunde ein kärgliches Dasein, schlecht ernährt, ungeliebt und misshandelt. Da taten sie sich zusammen und schrieben einen Brief an Gott. Sie wählten einen der ihren als Überbringer, dem sie den Brief unter dem Schwanz ins Hinterteil schoben, damit er ihn nicht beim Fressen oder Bellen verlor, denn die Reise würde lang und beschwerlich werden. Es folgten viele Hundegenerationen, und die Hunde warten immer noch. Deshalb beschnüffeln sie sich – sie suchen nach Gottes Antwort!

LEGENDE AUS CHIAPAS

Il y a bien longtemps les chiens étaient régulièrement maltraités : mal nourris, mal-aimés et malmenés. Alors ils se réunirent et écrivirent une lettre à Dieu. Puis ils choisirent un chien pour messager et insérèrent leur lettre en lui, en dessous de sa queue. Il ne fallait pas qu'elle tombe au moment où il mangerait ou aboierait, car le voyage allait être long et difficile. Les générations se sont succédé, mais les chiens attendent toujours. Voilà pourquoi ils ne cessent de se renifler : ils cherchent la réponse que Dieu leur aurait envoyée !

FOLKLORE CHIAPAS

Graciela Iturbide, 1995

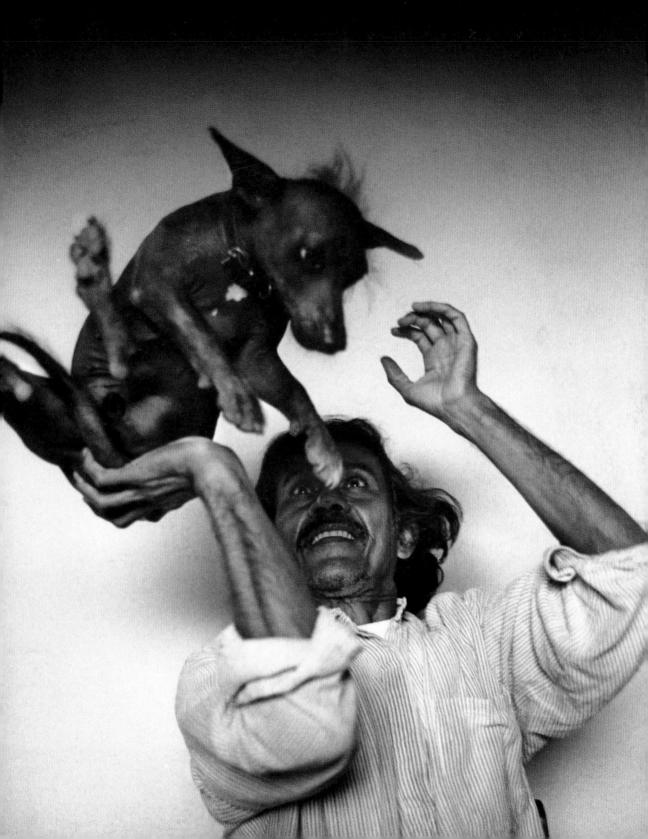

David Hiscock, 1982

Canis Major

ROBERT FROST

The great Overdog, That heavenly beast With a star in one eye, Gives a leap in the east.	Der große Overdog, dieses himmlische Biest mit dem Stern im Auge springt im Osten auf.	Le Seigneur chien Cet animal céleste Avec une étoile dans un œil Fait un bond à l'Est.
He dances upright All the way to the west And never once drops On his forefeet to rest.	Aufrecht tanzt er bis in den Westen, fällt nie auf alle viere um einmal zu rasten.	Il danse droit dressé En direction du plein Ouest Sans pas une fois retomber Sur ses pattes avant pour se reposer.
I'm a poor underdog, But tonight I will bark With the great Overdog That romps through the dark.	Ich bin ein armer Underdog, doch heute Nacht werde ich bellen mit dem großen Overdog, der durch die Dunkelheit tollt.	Je suis un pauvre petit chien Mais ce soir j'aboierai Avec le Seigneur chien de garde Qui cabriole dans le noir.

Michal Rovner, 1987

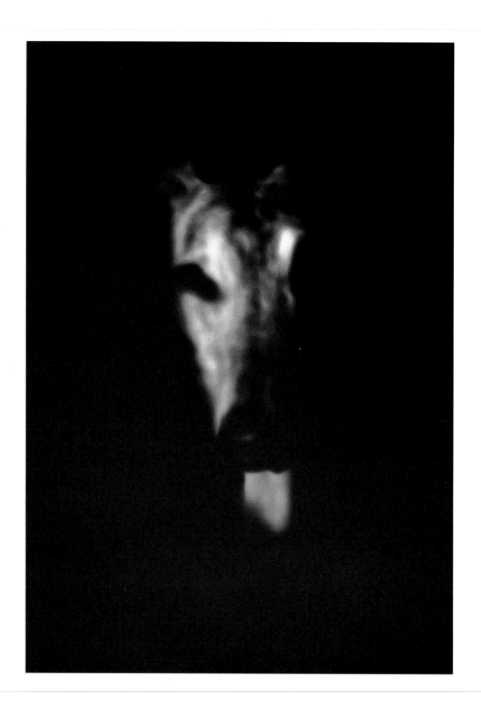

Robert Stivers, 1996

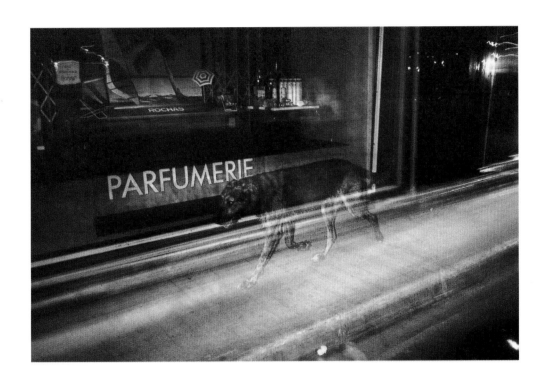

Felicia Murray, 1995

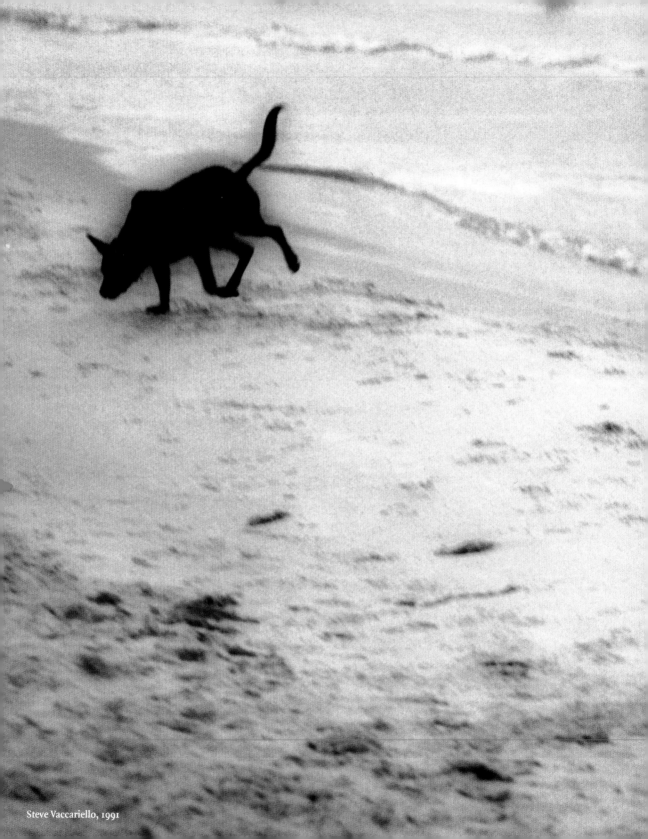

Steve Vaccariello, 1991

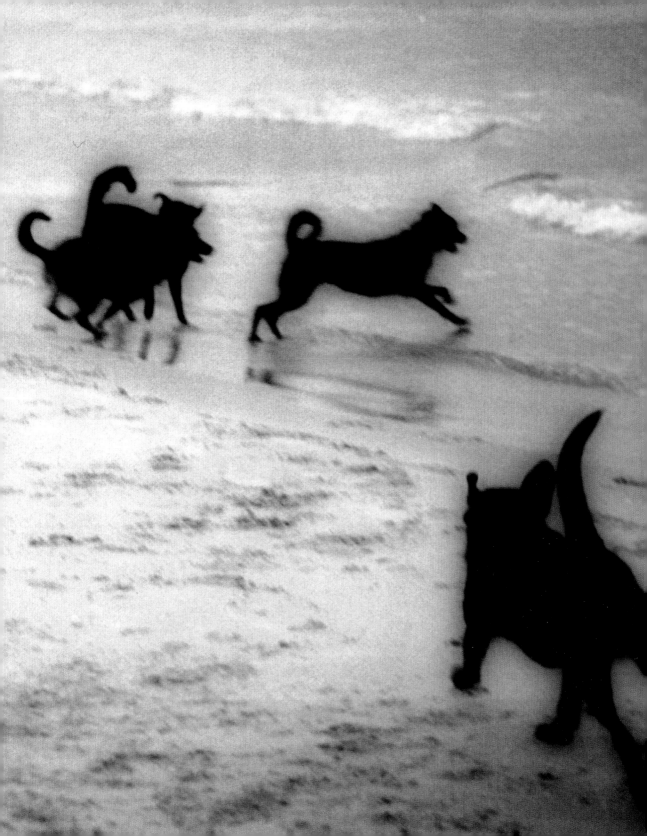

RUND
OGRU
NDOG
RUN

Christopher Wool, 1991

David Wojnarowicz, 1988

I have always had a trust for the animal world that I never developed for the human world. Animals allow us to view certain things that we wouldn't allow ourselves to see in regard to human activity.

Ich hatte in die Welt der Tiere ein Vertrauen, das ich in die Welt der Menschen nie hatte. Die Tiere erlauben uns gewisse Dinge wahrzunehmen, die wir uns nicht zu sehen gestatten würden, wenn es um menschliches Tun geht.

J'ai toujours eu, pour le monde des animaux, une confiance que je n'ai jamais partagée avec le genre humain. Les animaux nous permettent de percevoir certaines choses qu'on ne se sentirait pas autorisés à voir en ce qui concerne les activités humaines.

DAVID WOJNAROWICZ

Gregory Crewdsen, 1998

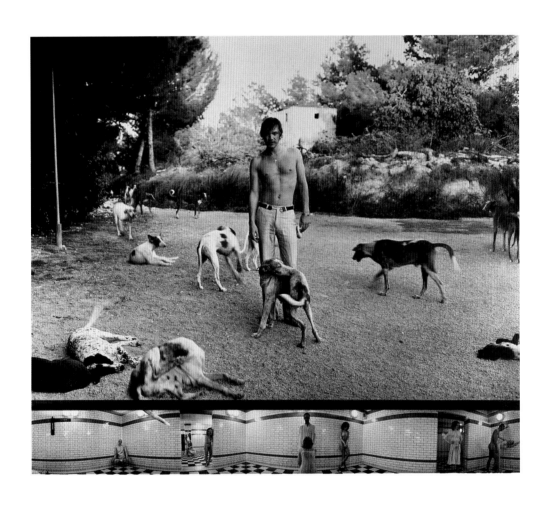

Sam Taylor-Wood, 1998

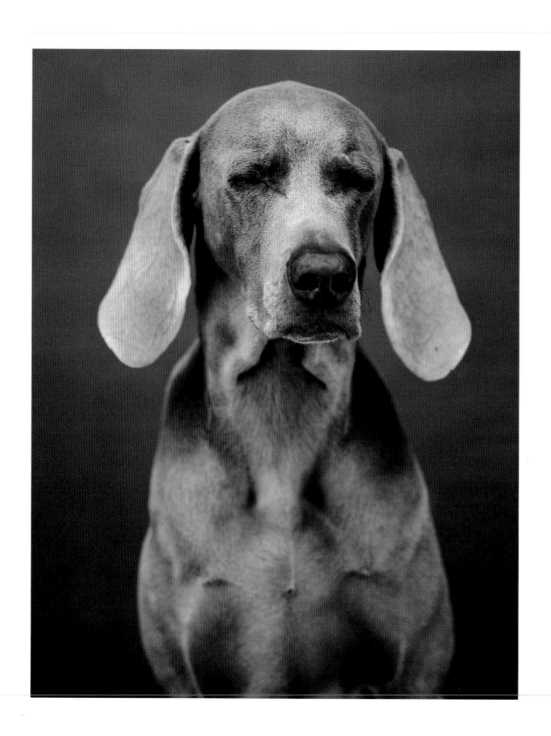

William Wegman, 1995

Jan Saudek, 1994

Pentti Sammallahti, 1992

Soulmates
Kameraden
Copains

A friend who makes salt sweet
and blackness bright.

Ein Freund, der Salz süß werden lässt
und die Dunkelheit erhellt.

Un ami qui adoucit le sel et
éclaire l'obscurité.

JOHN MASEFIELD

My best friend, my well-spring
in the wilderness.

Mein bester Freund, meine Quelle
in der Wüste.

Mon meilleur ami, ma source
dans le désert.

GEORGE ELIOT

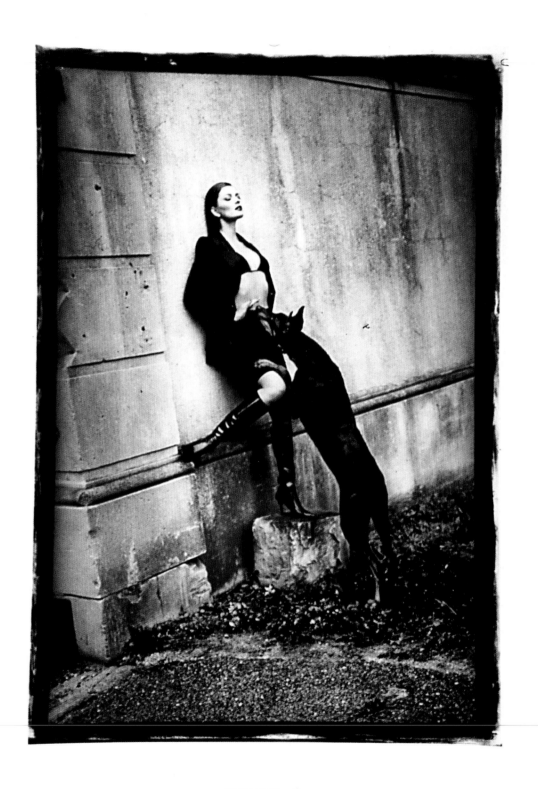

Wayne Maser, 1980

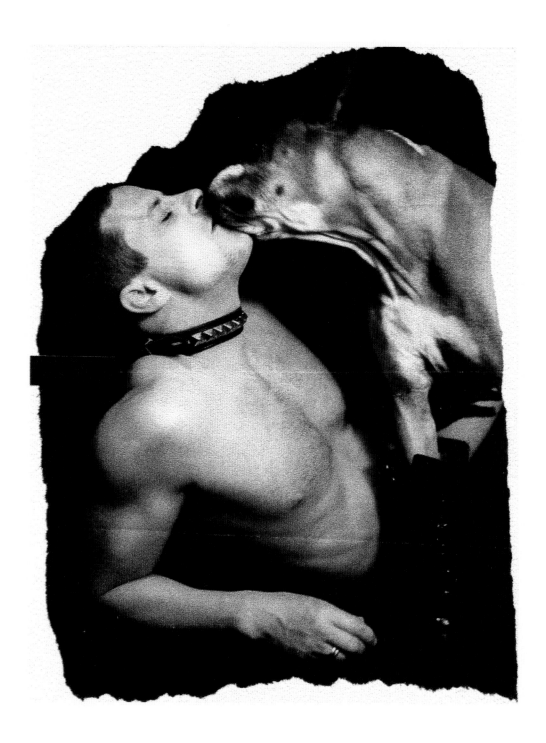

David Jensen, 1996

Love, genuine passionate love, was Buck's for the first time.
This he had never experienced … love that was feverish and
burning, that was adoration, that was madness, it had taken
John Thornton to arouse.

Liebe, echte leidenschaftliche Liebe, erlebte Buck zum ersten Mal. So etwas
hatte er noch nie erfahren … eine fiebernde, brennende Liebe, die Verehrung
war, die Verrücktheit war, und es war John Thornton, der sie geweckt hatte.

L'amour, passionné, absolu, voilà ce que Buck ressentait
pour la première fois. Jamais il n'avait connu ça… un amour
fiévreux et brûlant, qui était adoration, qui était folie, et que
seul John Thornton avait su susciter.

JACK LONDON, *Call of the Wild · Ruf der Wildnis · L'appel de la forêt*

Bruce Weber, 1989

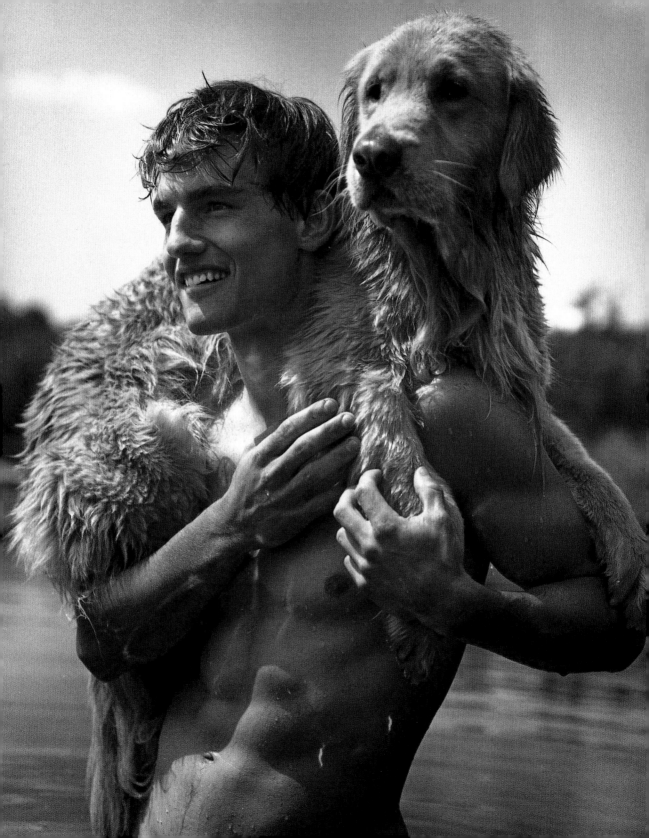

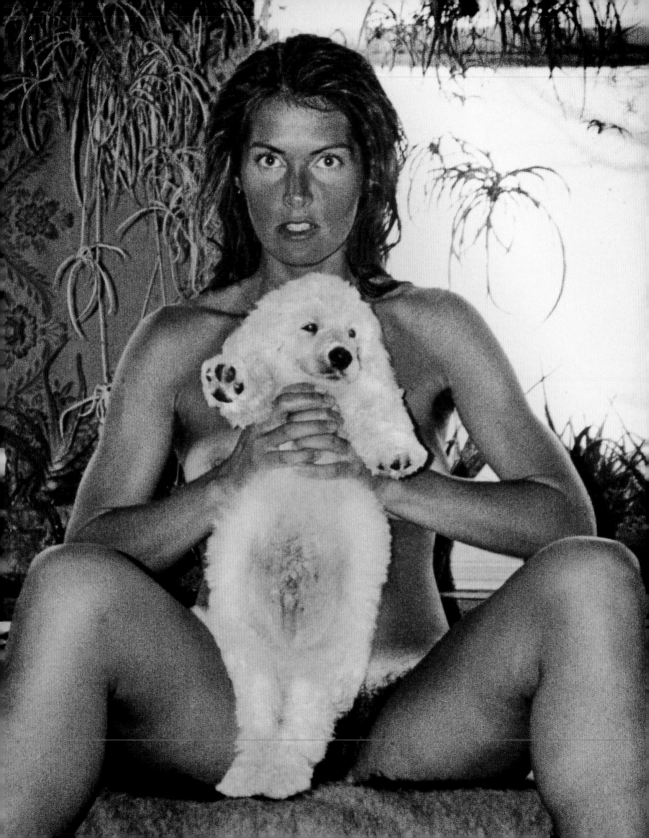

A man and his dog is a sacred relationship.
What nature hath put together let no woman pull asunder.

Die Beziehung zwischen einem Mann und seinem Hund ist heilig.
Was die Natur vereint hat, soll keine Frau je scheiden.

L'homme et son chien entretiennent une relation sacrée.
Ce que la nature a uni, aucune femme ne le désunira.

A.R. GURNEY

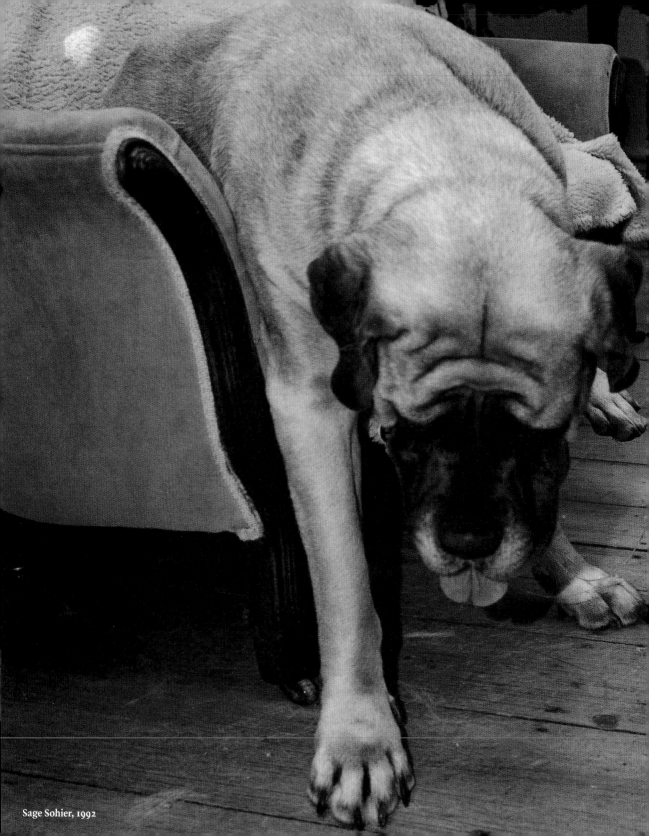

Sage Sohier, 1992

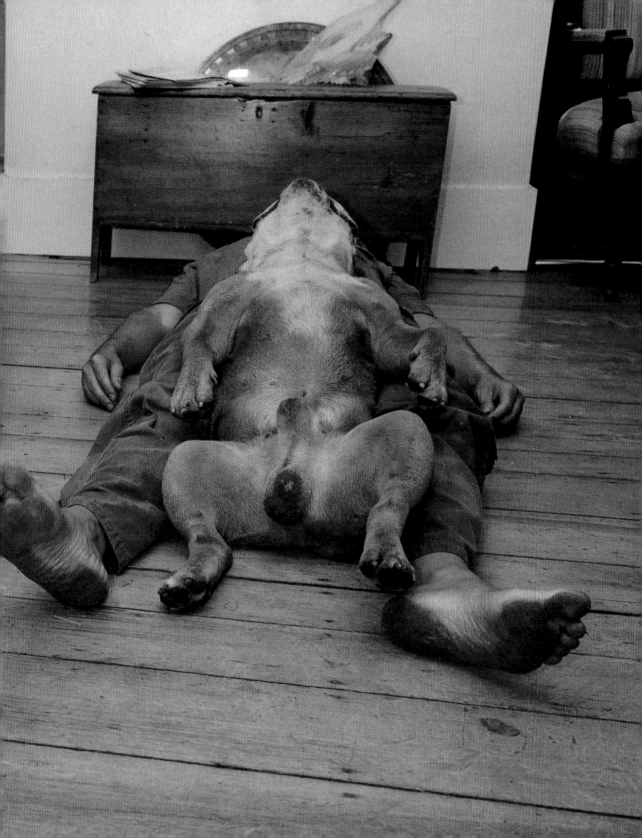

Joy
Freude
Joie

The great thing about a dog is that you may make a fool of yourself with him and not only will he not scold you, but he will make a fool of himself too.

Das Schöne an einem Hund ist, dass man sich mit ihm zum Narren machen kann und dass er einen nicht nur nicht ausschimpft, sondern sich selbst ebenfalls zum Narren macht.

Le grand plaisir d'un chien, c'est que vous pouvez vous ridiculiser en sa présence et que non seulement il ne vous grondera pas, mais il vous accompagnera dans vos fantaisies.

SAMUEL BUTLER

Julie McConnell, 1999

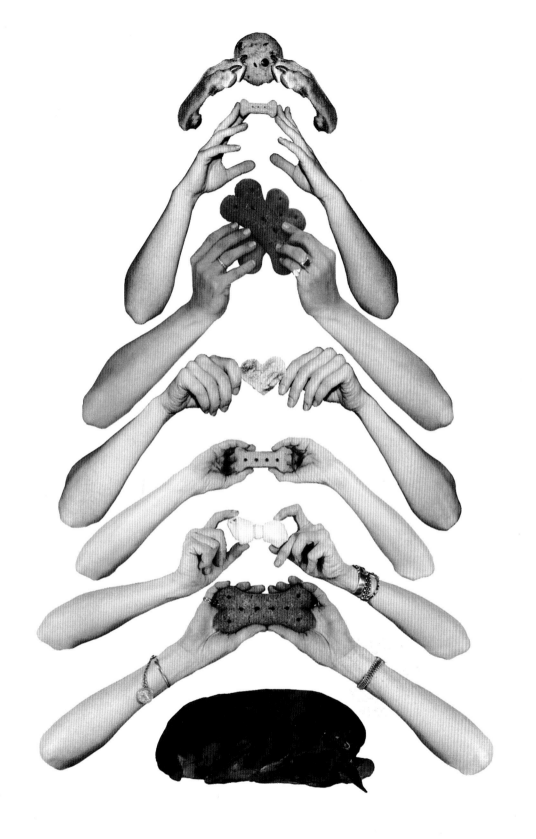

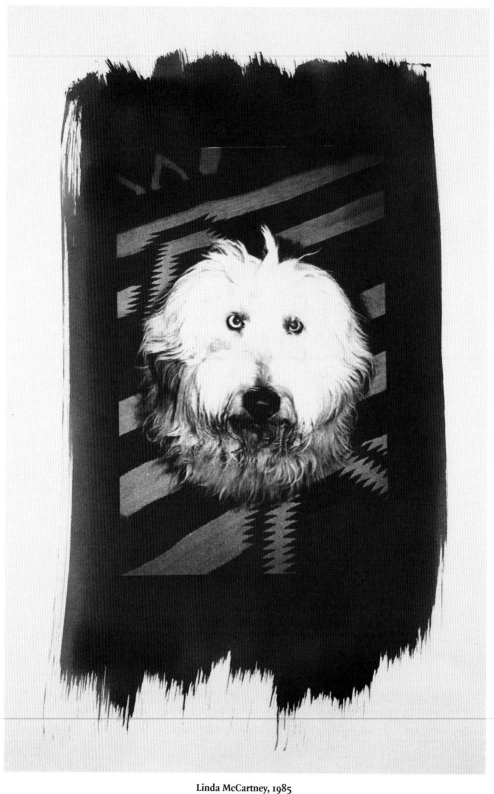

Linda McCartney, 1985

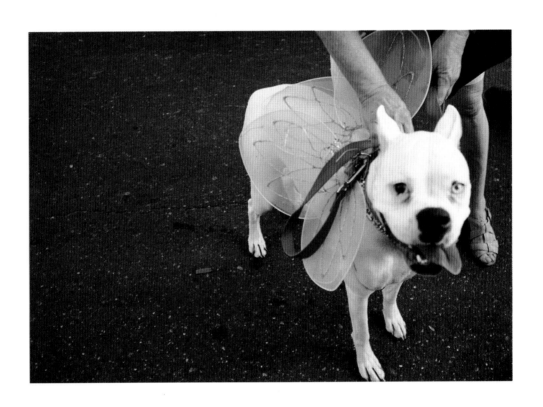

Andy Hervey, 1991

Bruce Cratsley, 1990

David Levinthal, 1994

Nic Nicosia, 1983

Max Below Toledo-Paris and Kim Irwin, 1998

Sandy Skoglund, 1990

Humor springs not ... from the head but from the heart;
its essence is love. It issues not in laughter, but in still smiles,
which lie far deeper.

Humor entspringt nicht ... dem Kopf, sondern dem Herzen. Sein Wesen ist Liebe.
Er mündet nicht in Gelächter, sondern in leises Lächeln, das viel tiefer liegt.

L'humour ne jaillit pas de la tête mais ... du cœur. Son essence,
c'est l'amour ; son prolongement, ce n'est pas le rire mais quel-
ques sourires tranquilles, bien plus profonds.

THOMAS CARLYLE

Michael Kenna, 1995

Paul McCarthy, 1996

Arthur Tress, 1988

Chris Schiavo, 1992

Stuart Hart, 1999

Vik Muniz, 1994

Dogs don't mind being photographed
in compromising situations.

Hunden macht es nichts aus,
in peinlichen Situationen fotografiert zu werden.

Les chiens se fichent d'être photographiés
dans des situations compromettantes .

ELLIOTT ERWITT

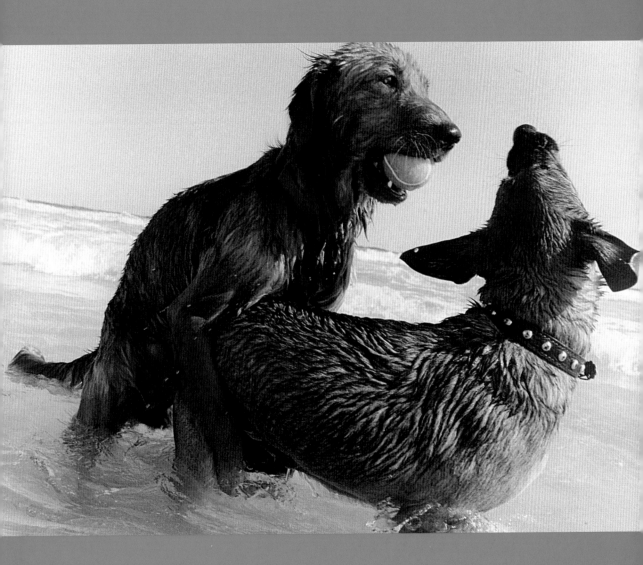

Tony Mendoza, 1990

Jed Devine, 1991

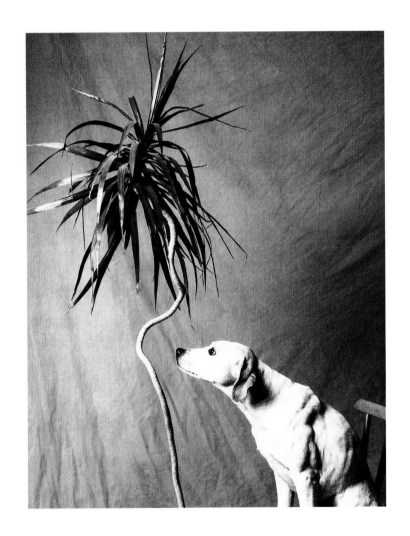

Ulrich Tillmann, 1989

Outside of a dog, a book is man's best friend.
Inside of a dog it's too dark to read.

Außer dem Hund ist ein Buch der beste Freund des Menschen.
Im Hund ist es zu dunkel zum Lesen.

En dehors du chien, le livre est le meilleur ami de l'homme.
Car en dedans du chien, il fait trop sombre pour lire.

GROUCHO MARX

Donald Lokuta, 1997

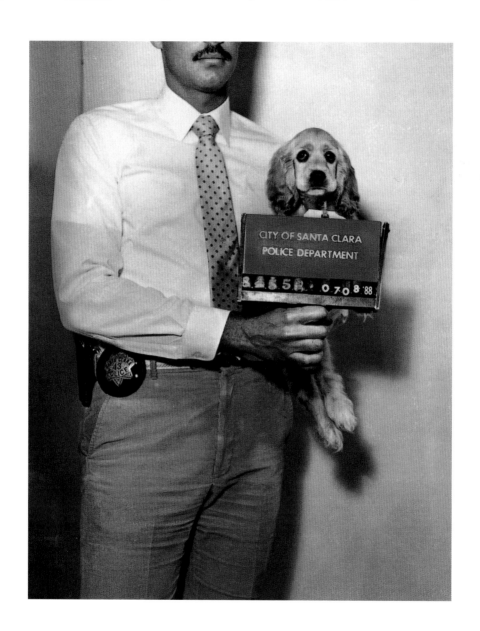

Unknown photographer, 1988

Roger F. Ballen, 1996

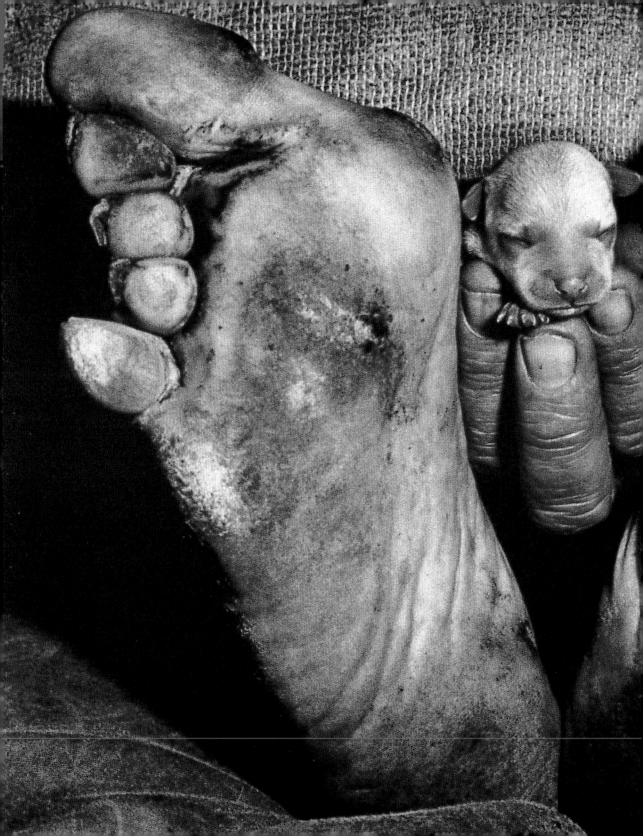

Elegance
Eleganz
Elégance

Elegance is courage and audacity, and an animal instinct that shows in every movement. It is harmony and oneness, and enjoying one's body.

Eleganz ist Mut und Tollkühnheit – ein tierischer Instinkt, der in jeder Bewegung zum Ausdruck kommt. Sie ist Harmonie, Einssein und Freude am eigenen Körper.

L'élégance, c'est le courage, l'audace, et un instinct animal qui apparaît dans chaque mouvement. C'est l'harmonie, l'identité et la jouissance de son propre corps.

THIERRY MUGLER

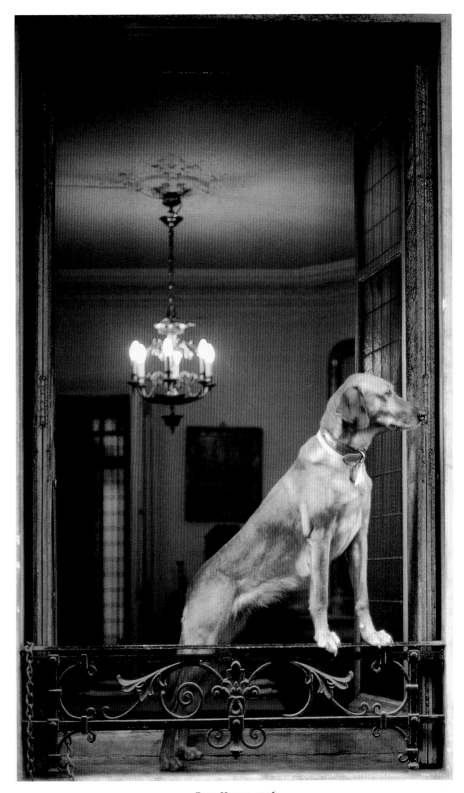

Barry Haynes, 1996

William Wegman, 1997

Elegance ... really only emanates from within. Most animals display it without the least effort both in motion and at rest. And so do we, when our attention is directed beyond the mirror towards others' hearts.

MARK LYON

Die Eleganz ... entspringt nur dem Inneren. Den meisten Tieren ist sie eigen ohne jegliche Anstrengung, egal ob sie sich bewegen oder ruhen. Das gilt auch für uns, wenn wir unsere Aufmerksamkeit nicht auf unser Abbild, sondern auf die Herzen anderer Menschen richten.

MARK LYON

En réalité, l'élégance n'émane sans doute que de soi. La plupart des animaux la montre sans le moindre effort, en mouvement comme au repos. Et nous faisons de même, quand notre attention traverse le miroir, pour toucher le cœur d'autrui.

MARK LYON

To feel beauty is a better thing than to understand
how we come to feel it.

Die Schönheit zu spüren ist besser als zu verstehen,
was sie uns spüren lässt.

Ressentir la beauté est plus jouissif
que de savoir pourquoi nous l'avons ressentie.

GEORGE SANTAYANA

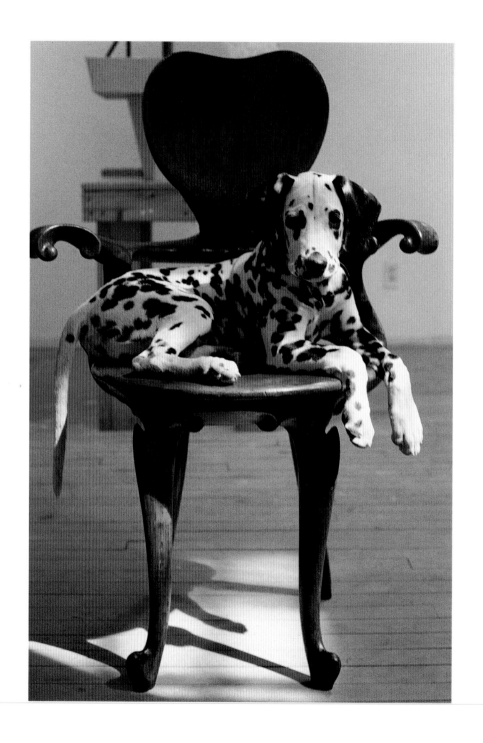

Bryan Hunt, 1985

Nature covers all her works
with a varnish of beauty.

Die Natur verleiht jedem einzelnen ihrer Werke
einen Hauch von Schönheit.

La nature recouvre toutes ses œuvres
d'un vernis de beauté.

ARTHUR SCHOPENHAUER

Eric Fischl, 1991

Tanya Braganti, 1999

Debbie Fleming Caffery, 1998

Francesco Scavullo, 1991

Peter Hujar, 1985

Beauty offers us for a moment the glimpse of an eternity
that we should like to stretch over the whole of time.

Schönheit erlaubt uns für einen Augenblick einen flüchtigen Blick auf die Ewigkeit,
von der wir wünschten, dass sie bis an das Ende der Zeiten andauert.

La beauté nous offre, l'espace d'un instant, une vision de l'éternité
que l'on aimerait prolonger jusqu'à la nuit des temps.

ALBERT CAMUS

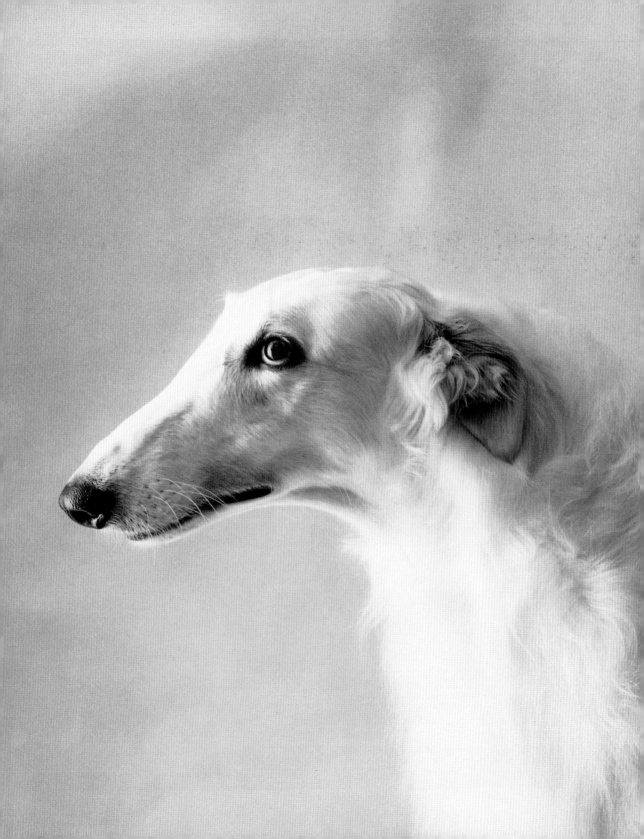

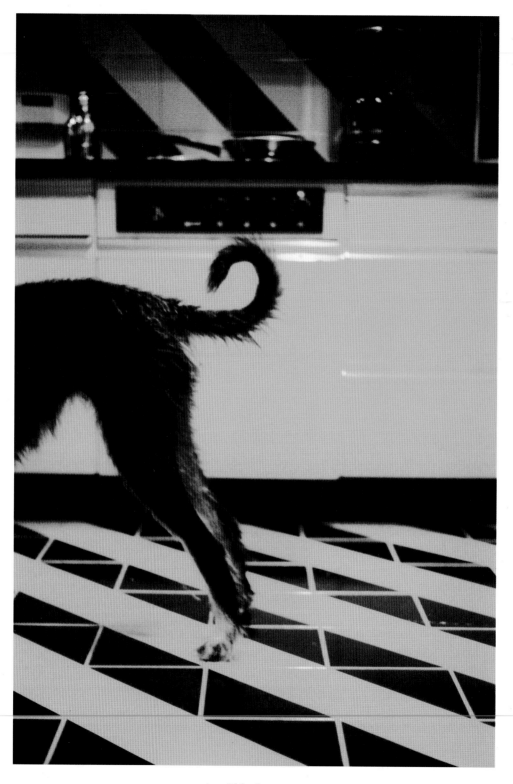

Anne Eickenberg, 1997

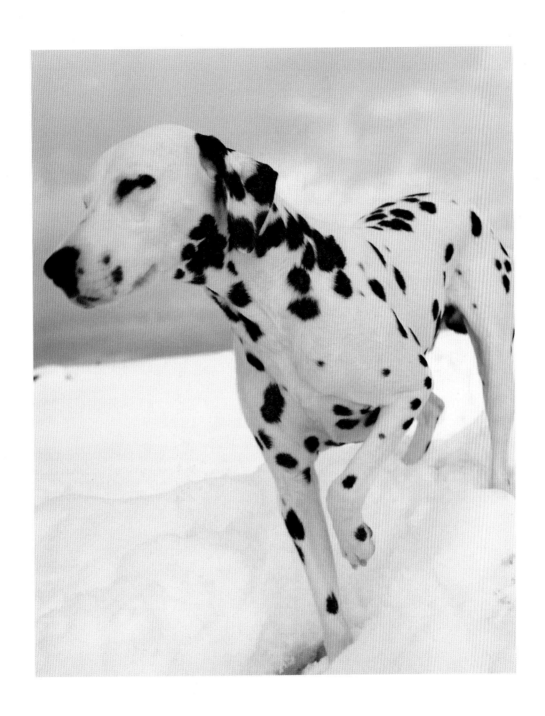

Ron Jude, 1994

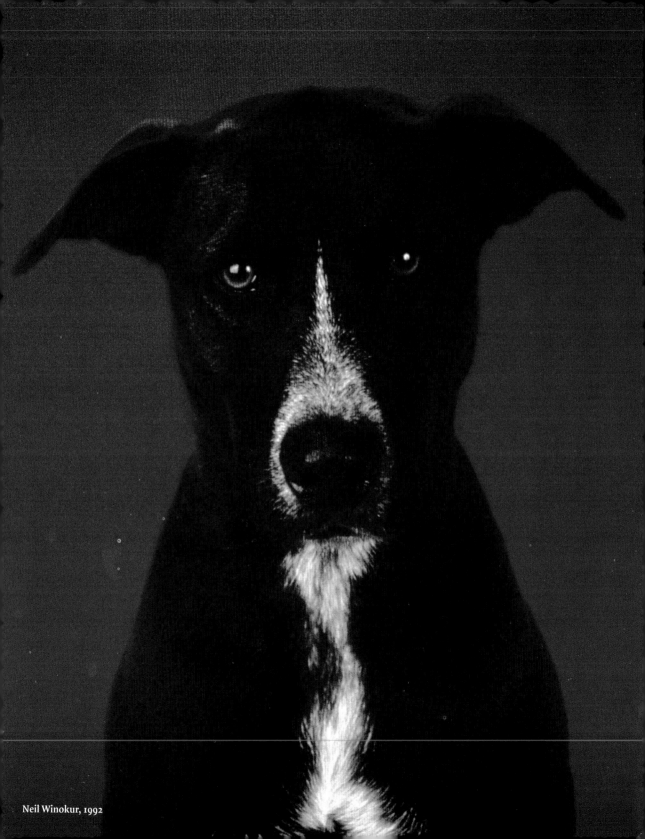

Neil Winokur, 1992

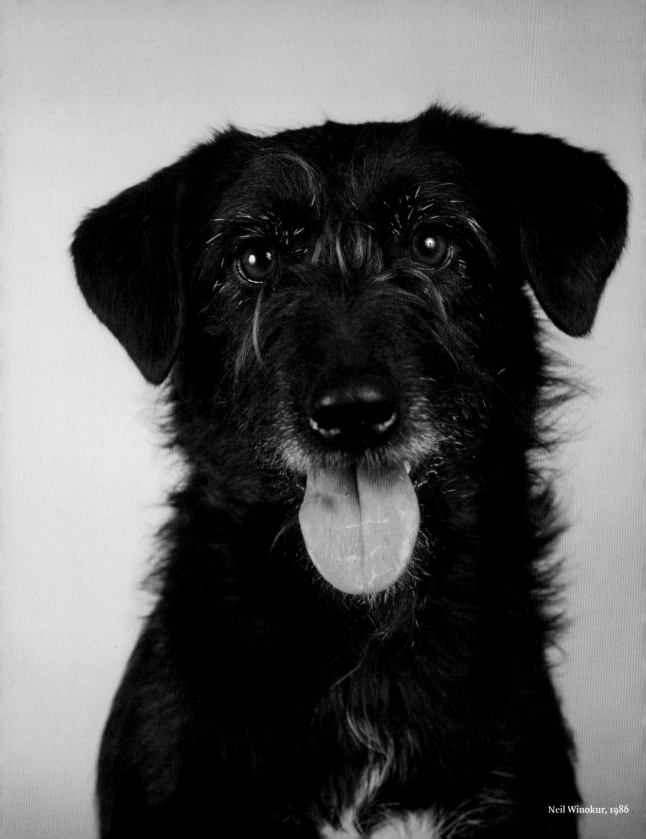

Neil Winokur, 1986

God sat down for a moment when the dog was finished to observe
what He had created. He knew that it was good, that nothing was
lacking and that He could not have done better.

Gott verweilte einen Moment, nachdem er den Hund erschaffen hatte, um seine
Schöpfung anzusehen. Er sah, dass sein Werk gut war und ihm nichts fehlte, und
er es nicht hätte besser machen können.

Dieu s'assit un instant, quand le chien fut fini, afin de l'observer
et de se rendre compte que c'était bien, que rien ne manquait,
qu'il n'aurait pu être mieux fait.

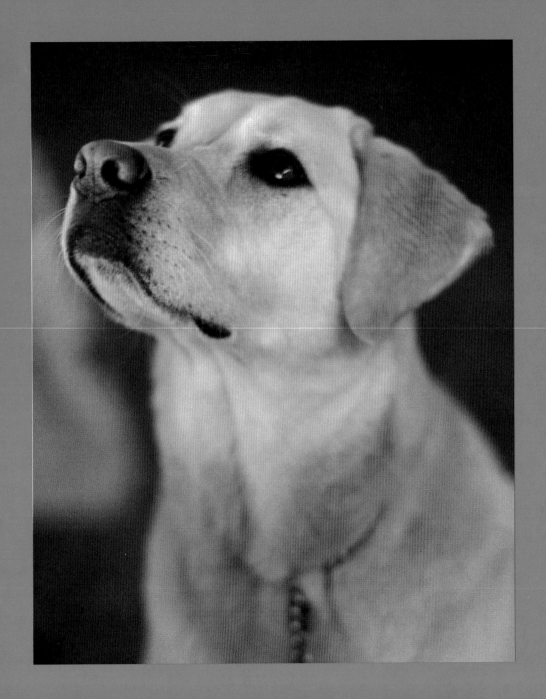

Ralph Gibson, 1999

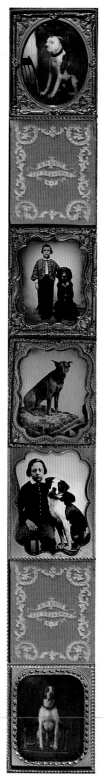

Acknowledgements · Danksagung · Remerciements

My co-editor Miles Barth and I wish to express our deep respect and thanks to the many professionals who helped make this project possible: to the artists and photographers, too many to enumerate, who graciously and freely provided the images that this book celebrates; to the participating galleries and dealers, Bonni Benrubi Gallery, N.Y. (particularly, Karen Marks), Mary Boone Gallery, N.Y., Janet Borden, Inc., N.Y., Marisa Cardinale, N.Y., Keith de Lellis, Eaton Fine Arts, West Palm Beach, FL, Kathleen Ewing Gallery, Washington, DC, Howard Greenberg Gallery, N.Y. (particularly, Tom Gitterman and Margit Erb), Michael Hoppen Photography, London, Edwynn Houk Gallery, N.Y., Jay Jopling, London, Hans P. Kraus, Jr., N.Y., Janet Lehr, N.Y., Lisson Gallery, London, Luhring Augustine Gallery, N.Y., Sarah Morthland Gallery, N.Y., Pace/MacGill Gallery, N.Y. (particularly, Peter MacGill and Michelle Ellwood), Candace Perich Gallery, Katonah, NY, P.P.O.W. Gallery, N.Y., Ricco/Maresca Gallery, N.Y. (particularly, William Hunt), Yancey Richardson Gallery, N.Y., Sag Harbor Picture Gallery, N.Y. (particularly, Jocelyn Benezakin), Julie Saul Gallery, N.Y., Charles Schwartz, N.Y., Monika Sprüth Galerie, Cologne, Staley-Wise Gallery, N.Y., and Galerie zur Stockeregg, Zurich; to the participating photo agencies, Archive Photos, N.Y., Contact Press Images, N.Y., Corbis Images (particularly, Jocelyn Clapp and Malorie Osgood), Endeavor Group, U.K., Hulton Getty Picture Library, London (particularly, Matthew Butson and his enthusiastic team), Time-Life Syndication, Inc., N.Y. (particularly, Bob Jackson), Michael Ochs Archives, Venice, CA, Magnum Photos, N.Y. (particularly, Eelco Wolf and Jessica Murray), Robert Montgomerie & Partners, Inc., London, Liaison Agency, Inc., N.Y. (particularly, Valerie Zars) and Shooting Star, Hollywood, CA; to the participating private collections and collectors, Hans Christian Adam, Germany, American Kennel Club, N.Y. (particularly, Barbara Kolk, Jeanne Sansolo, and Ann Sergi), Aperture Foundation, N.Y. (particularly, Michael Hoffman and Melissa Harris), Battersea Dog Home, London, Henry M. Buhl/The Buhl Collection, N.Y. (particularly, Marianne Courville and Blair Rainey), Pablo Butcher, Oxford, England, The Lisette Model Foundation, N.Y., The Bruce Cratsley Archives, N.Y., Pryor Dodge, N.Y., Harold & Esther Edgerton Foundation, Palm Press, Inc., Fraenkel Gallery, San Francisco, B. and H. Henisch, PA, The Estate of Peter Hujar, N.Y., The Estate of Leon Kuzmanoff, Berwyn, IL, Robert Mapplethorpe Foundation, N.Y. (particularly, Michael Stout), Carol Ann Merritt, N.Y., Uwe Scheid, Germany, Karen L. Schnitzspahn, NJ, Alan Siegel, N.Y., Transart Kunstberatung GmbH, Cologne, Baroness Jeane Wahl von Oppenheim, Cologne, and The Estate of David Wojnarowicz, N.Y.; to the participating public institutions, Addison Gallery of American Art, Andover, MA (particularly, Adam Weinberg, Bildarchiv Preussischer Kulturbesitz, Berlin, The J. Paul Getty Museum, Los Angeles (particularly, Weston Naef and Michael Hargraves), Imperial War Museum, London, International Center of Photography, N.Y. (particularly, John McIntyre), The Library of Congress, Washington, DC, The New-York Historical Society (particularly, Pam Dewey), The New York Public Library (particularly, Sharon Frost), The Metropolitan Museum of Art, N.Y.(particularly, Maria Morris Hambourg and Laura Muir), Ministère de la Culture, Paris, Mission de Patrimoine Photographic, Paris, The Museum of the City of New York, Museum für Kunst und Gewerbe, Hamburg, The Museum of Modern Art, N.Y. (particularly, Peter Galassi), Musée Picasso, Paris, Estate of Pablo Picasso/Artists Rights Society, N.Y./ADAGP, Paris, National Gallery of Art, Washington, DC (particularly, Sarah Greenough), Norton Museum of Art, West Palm Beach, FL (particularly, Neil Watson), The Royal Archives, London, Royal Geograph-ic Society Picture Library, London, Victoria and Albert Museum, London, and UNICEF, N.Y.; to the participating universities and study centers, Alice Austen Collection, Staten Island, N.Y., Center for Creative Photography, University of Arizona, Tucson (particularly, Dianne Nilsen, Marcia Tiede, and Denise Kramer), John F. Kennedy Library, Boston, Ohio Wesleyan University (particularly, Justin Kronewetter), University of Maryland, Baltimore (particularly, Tom Beck), North Carolina Collection, University of North Carolina Library at Chapel Hill, Harry Ransom Humanities Research Center at The University of Texas, Austin, Theodore Roosevelt Collection, Harvard College Library, Cambridge, MA, Scott Polar Research Institute, Cambridge, England, Staten Island Historical Society, N.Y., University of New Hampshire,

Unknown photographers, 1850–1880

Durham, The Andy Warhol Foundation, Inc., N.Y. (particularly, Timothy Hunt), and the University of Texas at El Paso.

And special thanks are due to our project staff, in particular, to Marie Lillis for her selfless dedication to the harrowing task of keeping order in the process; to Ruby Cherry and Maria Diaz for their assistance; to Kim Merritt and her research team led by Nils Hellpap for their painstaking efforts in obtaining, scanning, and cataloguing over four thousand images; to Abacus Solutions and Speer & Fulvio for generously providing space and equipment necessary for this project; to Nancy and Philippe Vermes, our Paris coordinators; to our proofreaders, Cathy McCandless and her willing team, particularly, Susan Manchester and Joan Cassidy; to Kristin Barnes for help with the initial layout; to Mary Elizabeth Thurston, our canine advisor, for her always sage counsel; to friends, Burt Wolf, Meryle Margolis, and Teddy Semlear for their constant encouragement; to Stuart Hart and Jeremy Miller for the patient and professional manner in which they helped shape and design this book; and finally to our colleague and contributor, Ralph Gibson, for lending his support, encouragement, and artistry to the process.

We wish to express our appreciation to TASCHEN, in particular to Benedikt and Angelika Taschen for their foresight in embracing a project of this scope and magnitude, to Simone Philippi and Horst Neuzner for their patience, support and professionalism, to Claudia Frey for her design, to Bettina Ruhrberg, and to Anja Lenze for her help and support.

Furthermore we wish to thank The Cygnet Foundation for its generosity support in making all of this possible. Through its involvement in the arts, The Cygnet Foundation is dedicated to helping those who cannot help themselves – children and animals in need. The net proceeds received by the editors from this project are being contributed to The Cygnet Foundation which, in turn, will make contributions to UNICEF and to animal rescue organizations throughout the world. We urge our readers to consider doing the same.

And finally, our thanks to the "hounds" – those creatures that made all this possible. It is man's almost Mesmerian attraction to them that in large degree propelled those who were part of this project. As our closest link to nature, their vibrancy and verve is in its own way the true art we celebrate here.

Raymond Merritt

To K.C.

Ralph Gibson, 1999

and those whose names she bears.

Picture Index · Abbildungsverzeichnis · Index des illustrations

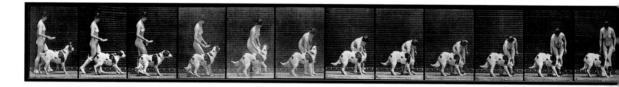

33(b) **Pascal Sébah** (Turkish, 1838–1890), c. 1870, albumen print on carte de visite mount. Courtesy, Hans P. Kraus, Jr., Inc., New York.

34 **Ottomar von Volkmann** (Austrian, 1839–1901), c. 1870, albumen print on carte de visite mount. Courtesy, Hans P. Kraus, Jr., New York.

36 **Jacob Byerly** (American, 1807–1883), 1848, daguerreotype. Courtesy, Uwe Scheid, Germany.

37 **Albert Sands Southworth** (American, 1811–1894) and **Josiah J. Hawes** (American, 1808–1901), 1852, daguerreotype. Courtesy, Uwe Scheid, Germany.

38 **Unknown photographer**, 1860, ambrotype. Courtesy, Uwe Scheid, Germany.

39 **Charles D. Frederick** (American, 1823–1894), 1860, ambrotype. Courtesy, Uwe Scheid, Germany.

40 **Lewis Carroll** (Charles Dodgson) (English, 1832–1898), *Edwin with Wilfred's Dog*, 1857, albumen print. Courtesy, Harry Ransom Humanities Research Center, University of Texas at Austin.

41 **Nadar** (Gaspard Félix Tournachon) (French, 1820–1910), *Paul and His Dog*, c. 1865, albumen print. Courtesy, The J. Paul Getty Museum, Los Angeles.

51 **Henry Tournier**, 1865, albumen print. Courtesy, Henry M. Buhl, New York.

52 **Clementina, Lady Hawarden**, (English, 1822–1865), *Florence Elizabeth Maude and Clementina Maude, Togge House, Dundru,* c. 1859, albumen print from wet collodion on glass negative. Courtesy, V & A Picture Library, London.

53 **David Octavius Hill** (Scottish, 1802–1870) and **Robert Adamson** (Scottish, 1821–1848), *The Three Sleepers: Sophia Finlay, Harriet Farnie and Brownie,* c. 1845, salted paper print from paper negative. Courtesy, Charles Schwartz, New York.

55 **Hills & Saunders** (English, active 1860s–1920s), *Queen Victoria and Boz,* c. 1870, albumen print on carte de visite mount. Courtesy, Charles Schwartz, New York.

56 **Blanford Caldesi & Co.** (English, active 1860–1870), *Boz with Lady Lawley,* 1867, albumen print on album page (three days before the Queen's favorite dog, Boz, died). Courtesy, Charles Schwartz, New York.

58 **Unknown photographer**, 1867, albumen print on cabinet card mount. Courtesy, Sarah Morthland Gallery, New York.

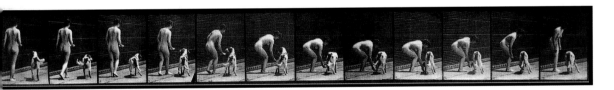

43 **Adolphe Braun** (French, 1811–1877), *Hunting Dog,* c. 1870, carbon print. Courtesy, The Museum of Modern Art, New York.

44 **Louis-Camille d'Olivier** (French, 1827–after 1870), 1857, salted paper print. Courtesy, Hans P. Kraus, Jr., Inc., New York.

45 **André-Adolphe-Eugène Disdéri** (French, 1819–1889), c. 1845, half of a hand-colored stereo daguerreotype. Courtesy, Uwe Scheid, Germany.

46 **Antoine Claudet** (English, b. France, 1797–1867), c. 1845, half of hand-colored stereo daguerreotype. Courtesy, Uwe Scheid, Germany.

47 **Unknown photographer**, c. 1860, albumen print. Courtesy, Uwe Scheid, Germany.

49 **Unknown photographer**, *Poijore,* 1870, albumen print mounted on a hand-colored album page. (A common 19th century photographer's trick to keep dogs still was to straddle them between two chairs.) Courtesy, Uwe Scheid, Germany.

50 **Henry Tournier** (French, active 1860–1870), 1863, albumen print. Courtesy, Michael Hoppen Photography, London.

59 **H. F. Ferguson** (American, 1850–1912), c. 1880, albumen print mounted on cabinet card. Courtesy, Charles Schwartz, New York.

61 **Unknown photographer**, 1871, hand-colored tintype. Courtesy, Charles Schwartz, New York.

62 **Gustave Le Gray** (French, 1820–1882), *Crimean War,* 1856, gold-toned albumen print from wax paper negative. Courtesy, Janet Lehr, New York.

63 **Roger Fenton** (English, 1819–1869), *Officers of the 71st Highlanders,* 1856, albumen print from wet collodion negative. Courtesy, Charles Schwartz, New York.

64/65 **Matthew Brady Studio,** *General Custer, Headquarters in the Field,* 1868, albumen print on stereo card mount. Courtesy, Janet Lehr, New York.

66/67 **Unknown photographer**, c. 1860, albumen print (with human figure erased). Courtesy, Sarah Morthland Gallery, New York.

69(t) **Unknown photographer**, 1852, hand-colored tintype. Courtesy, Charles Schwartz, New York.

69(b) **Unknown photographer**, c. 1867, tintype. Courtesy, Charles Schwartz, New York.

Eadweard J. Muybridge, c. 1872

70 **Léon Crémière** (French, 1831–undetermined), *Types de chiens de garde, Grand Danois*, c. 1880, Woodbury type. Courtesy, Julie Saul Gallery, New York.

71 **Léon Crémière**, *Tambette, Chienne Normande*, 1882, Woodbury type. Courtesy, Julie Saul Gallery, New York.

72 **André-Adolphe-Eugène Disdéri**, 1875, albumen print, uncut cartes de visite. Courtesy, Charles Schwartz, New York.

74 **H. S. Mendelsohn**, *In Remembrance of Sir Edwin Landseer*, 1873, albumen print on cabinet card. Courtesy, B. and H. Henisch, PA.

75 **J. U. Stead, Allen & Rowell, Witcomb & Son** (American, active late 1800s), c. 1875–1880, albumen prints on cartes de visite mounts. Courtesy, Janet Lehr, New York.

77 **Wilhelm Breiner** (German, active 1880s), c. 1880, albumen print. Courtesy, Hans Christian Adam, Germany.

78 **Eadweard J. Muybridge** (American, b. England, 1830–1904), *Animal Locomotion*, 1872–1885, calotype, plate No. 449 (detail). Courtesy, The Metropolitan Museum of Art, New York, Rogers Fund.

79 **Ottomar Anschütz** (German, 1846–1907), *Hundemeute, Lissa (Posen)*, 1887, albumen print. Courtesy, Hans Christian Adam, Germany.

80/81 **Unknown photographer**, c. 1870, albumen print. Courtesy of Carol Ann Merritt.

82 **Napoleon Sarony** (American, 1821–1896), *Alf Fisher with Dog*, 1890, gelatin silver chloride print on cabinet card mount. Courtesy, The New-York Historical Society.

83 **Richardson Brothers** (American, active 1870–1900), 1890, albumen print on cabinet card mount. Courtesy, Uwe Scheid, Germany.

84 **Studio Bengue & Kindermann** (Hamburg, active 1880–1910), c. 1890, silver chloride print on carte de visite mount. Courtesy, Hans Christian Adam, Germany.

85 **Jenks Studio** (American, active 1880–1910), *Newport, Vermont*, 1890, gelatin silver chloride print on cabinet card mount. Courtesy, Uwe Scheid, Germany.

87 **Unknown photographer**, *Dog with Child, Photo Album #86*, c. 1880, gelatin silver chloride print. Courtesy, The New-York Historical Society.

88 **Studio Tobias**, (American, active 1850–1890), 1885, gelatin silver chloride print on cabinet card mount. Courtesy, Sarah Morthland Gallery, New York.

89 **Wilhelm von Gloeden** (German, 1856–1931), *Child with Dog*, c. 1890, albumen print. Courtesy, The Metropolitan Museum of Art, New York, Gift of Milton Radutzky.

91 **Frederic Lewis** (American, active 1880s; attrib.), *President Franklin D. Roosevelt, Aged 6, and Budgy*, 1885, gelatin silver chloride print. (Roosevelt's mother dressed him as a girl and did not cut his hair until he was six. He was not permitted to socialize with other children during this period, and his principal non-parental friend was his dog "Budgy.") Courtesy, Archive Photos.

1890·1930
Embracing Uncertain Verities

92 **J. Eldee Hester** (English, active 1920–1940), *Pete*, c. 1927, gelatin silver print. Courtesy, Hulton Getty Picture Library.

94/95 **Unknown photographer**, *Buster Keaton and his Dog, Consentido*, c. 1928, gelatin silver print. Courtesy, Bettmann/CORBIS.

96 **Burr McIntosh** (American, 1862–1942), *Woman with Borzoi*, 1905, silver chloride print. Courtesy, The New-York Historical Society.

97 **Eugène Atget** (French, 1857–1927), *Cour Saint-Louis, 26 Rue de Lappe*, 1912, gelatin silver print. © Photothèque des Musées de la Ville de Paris. Courtesy, Musée Carnavalet.

98 **Detroit Publishing Co.**, *"Missis,"* c. 1905, gelatin silver print. Courtesy, The Library of Congress.

99(l) **Detroit Publishing Co.**, *Old Heidelberg*, c. 1905, gelatin silver print. Courtesy, The Library of Congress.

99(r) **Detroit Publishing Co.**, *An Old Sea Dog*, c. 1905, gelatin silver print. Courtesy, The Library of Congress.

100 **Unknown photographer**, c. 1915, gelatin silver print. Courtesy, Kathleen Ewing Gallery, Washington, DC.

101 **Unknown photographer**, c. 1920, orotone. Courtesy, Pablo Butcher, Oxford, England.

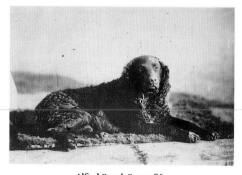

Alfred Capel-Cure, 1860

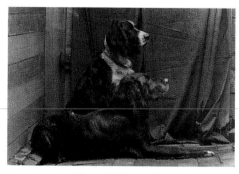

Thomas Eakins, c. 1890

149 **Frank Hurley**, (Australian, 1885–1962), 1915, *Lupoid*, gelatin silver print. Courtesy, Frank Hurley/Scott Polar Research Institute.

151 **Herbert G. Ponting** (English, 1871–1935), *Vida*, c. 1912, gelatin silver print. Courtesy, The J. Paul Getty Museum, Los Angeles.

152 **Unknown photographer**, *Sled Dog*, 1925, gelatin silver print. © Underwood & Underwood, CORBIS.

153 **Unknown photographer**, *Rags, Training for the Dog Show*, 1919, rotogravure. Courtesy, Private Collection, New York.

155 **Frank Hurley**, c. 1914, gelatin silver print. Courtesy, Frank Hurley/Scott Polar Research Institute.

156/ **Unknown photographer**, *Amundsen's Exploration of the*
157 *South Pole*, 1912, rotogravure. Courtesy, The Illustrated London News Picture Library.

158 **Austrian Archives**, *Richard Byrd, American Explorer*, 1930, gelatin silver print. Courtesy, CORBIS/Austrian Archives.

159 **Unknown photographer**, *German Explorer Schroder-Strantz at the North Pole*, 1912, gelatin silver print. Courtesy, Hulton Getty Picture Library.

160 **Frank Hurley**, *The End*, 1915, gelatin silver print. Courtesy, Frank Hurley/Scott Polar Research Institute.

162/ **Frank Hurley**, *Sue's Pups, the Ikeys*, 1915, gelatin silver print.
163 Courtesy, Frank Hurley/Scott Polar Research Institute.

164/ **Unknown photographer**, *Inspection of French Red Cross*
165 *Dogs*, Antwerp, 1914, gelatin silver print. Courtesy, Imperial War Museum, London.

166/ **Frank Hurley**, 1917, gelatin silver print. Courtesy, Royal
167 Geographical Society Picture Library, London.

168 **Unknown photographer**, *Battle of Polygon Woods*, 1917, gelatin silver print. Courtesy, Imperial War Museum, London, Crown Copyright.

169 **Unknown photographer**, *U.S. Soldiers*, 1917, gelatin silver print. Courtesy, Hulton Getty Picture Library.

170/ **Unknown photographer**, *Deutsche Hundekriegsschule hinter*
171 *der Westfront: Infanteriegefechtsübung mit Meldehund*, 1916, gelatin silver print. Courtesy, Bildarchiv Preussischer Kulturbesitz, Berlin.

173 **Unknown photographer**, *German Army Dog*, c. 1916, gelatin silver print. Courtesy, Hulton Getty Picture Library.

174/ **Unknown photographer**, *Russian Army, WWI*, c. 1919,
175 gelatin silver print. Courtesy, Endeavour Group, UK.

177 **Unknown photographer**, 1918, gelatin silver print. Courtesy, Mary Elizabeth Thurston.

178 **Unknown photographer**, c. 1900, albumen print. Courtesy, Sarah Morthland Gallery, New York.

180 **Edward Steichen** (American, b. Luxembourg, 1879–1973), toned gelatin silver print, 1915. Courtesy, Charles Schwartz, New York.

181 **Thomas Eakins** (American, 1844–1916), *Boyce, Portrait of Setter*, c. 1890, albumen silver print. Courtesy, The J. Paul Getty Museum, Los Angeles.

183 **George Seeley** (American, 1880–1955), *Blotches of Sunlight*, c. 1907, photogravure. Courtesy, Addison Gallery of American Art, Andover.

184 **Alfred Stieglitz** (American, 1864–1946), c. 1911, gelatin silver developed-out print. Courtesy, National Gallery of Art, Washington. DC, Alfred Stieglitz Collection.

185 **André Kertész** (American, b. Hungary, 1894–1985), *Le Gardier de Notre-Dame, Paris*, 1928, gelatin silver print. © Ministère de la Culture, France.

186 **Gertrude Käsebier** (American, 1852–1934), *Boy with Dog, Oceanside, L.I.*, 1904, platinum print. Courtesy, The Library of Congress.

187 **Jessie Tarbox Beals** (American, 1871–1942), 1908, platinum print. Courtesy, Howard Greenberg Gallery, New York.

189 **Peter Henry Emerson** (English, b. Cuba, 1856–1936), *The Poacher, a Hare in View*, 1887, photogravure. Courtesy, The Metropolitan Museum of Art, New York.

190 **Pablo Picasso** (Spanish, 1881–1973), c. 1908, *Scène de café*, gelatin silver print. Courtesy, Musée Picasso, Paris. © 2000 Estate of Pablo Picasso/Artists Rights Society, New York, Succession Picasso/VG Bild-Kunst, Bonn 2000.

192 **Berenice Abbott** (American, 1898–1991), *Woman Holding Dog*, n.d., gelatin silver print. Courtesy, Commerce Graphics, NJ/Norton Museum of Art, West Palm Beach.

193 **E. J. Bellocq** (American, 1873–1940), *Storyville Portrait*, c. 1912, printing-out paper print. Courtesy, Lee Friedlander and The Fraenkel Gallery, San Francisco.

195 **Jacques-Henri Lartigue**, *M.Folletete et Tuppy*, 1912, gelatin silver print. © Ministère de la Culture – France/ A.A.J.H.L. Courtesy, Mission de Patrimoine Photographique.

196 **Martin Munkacsi** (American, b. Hungary, 1896–1963), 1930, gelatin silver print. Courtesy, Howard Greenberg Gallery, New York.

197 **André Kertész**, *Marché Aux Animaux, Paris*, 1928, gelatin silver print. © Ministère de la Culture – France. Courtesy, Mission de Patrimoine Photographique.

Unknown photographer, 1925

Raymond C. Merritt, 1940

239 **Unknown photographer**, *"Shep,"* c. 1940, gelatin silver print. Courtesy, The New York Public Library, Astor, Lenox and Tilden Foundations.

240 **Paul Outerbridge** (American 1896–1958), *Rin Tin Tin,* c. 1940, carbro print. Courtesy, The J. Paul Getty Museum, Los Angeles.

241 **Unknown photographer**, *Shirley Temple and "Buck,"* 1935, gelatin silver print. Courtesy, Bettmann/CORBIS.

242/ **Unknown photographer**, *Dog License Amnesty, London,*
243 1933, gelatin silver print. Courtesy, Hulton Getty Picture Library.

245 **William Vanderson** (English, active 1930s), *Girl's Best Friend,* 1935, gelatin silver print. Courtesy, Hulton Getty Picture Library.

246/ **Unknown photographer**, *Our Gang,* c. 1935, gelatin silver
247 print. Courtesy, Hulton Getty Picture Library.

248 **Unknown photographer**, *Banbridge Show, Northern Ireland,* 1932, gelatin silver print. Courtesy, Hulton Getty Picture Library.

249 **Unknown photographer**, *Mary,* 1934, gelatin silver print. Courtesy, Hulton Getty Picture Library.

250/ **Ralph Bartholomew** (American, b. Germany,
251 1907–1985), 1938, gelatin silver print. Courtesy, Keith de Lellis Gallery, New York.

253 **Unknown photographer**, *Christmas Shoppers, Lisbon,* c. 1938, gelatin silver print. Courtesy, Hulton Getty Picture Library.

254 **Unknown photographer**, *Panso, Dog Show Champion,* 1941, gelatin silver print. Courtesy, UPI/Bettmann/ CORBIS.

255 **Unknown photographer**, *Jean Harlow in "Bombshell,"* c. 1930, gelatin silver print. Courtesy, Bettmann/CORBIS.

256(l) **Unknown photographer**, *Bob Hope,* 1945, gelatin silver print. Courtesy, Archive Photos.

256(r) **Lisa Sheridan/Studio Lisa**, *Princess Elizabeth,* 1936, gelatin silver print. Courtesy, Hulton Getty Picture Library.

257(l) **Unknown photographer**, *Doris Day,* 1949, gelatin silver print. Courtesy Michael Ochs Archives/Venice, CA.

257(r) **Phil Burchman**, *Bing Crosby,* 1933, gelatin silver print. Courtesy, Archive Photos.

258/ **Unknown photographer**, *Walking the Dogs,* 1934, gelatin
259 silver print. Courtesy, Hulton Getty Picture Library.

261 **Ian Tyas** (active 1930s), 1938, gelatin silver print. Courtesy, Hulton Getty Picture Library.

262 **Gambier Bolton** (English, active 1930s), *Corded Poodle,* 1930, gelatin silver print. Courtesy, Hulton Getty Picture Library.

263 **Ylla**, 1940, gelatin silver print. Courtesy, Pryor Dodge, New York.

264/ **Ylla**, c. 1944, gelatin silver print. Courtesy, Pryor Dodge,
265 New York.

266(t) **Unknown photographer**, *Helen Keller,* c. 1910, gelatin silver print. Courtesy, Bettmann/CORBIS.

266(b) **Bradley Smith** (American, 1910–1997), *Helen Keller,* 1960, gelatin silver print. © Bradley Smith/CORBIS.

267 **Byron Studio**, c. 1930, gelatin silver print. Courtesy, The Museum of the City of New York.

268 **Unknown photographer**, *Jacqueline Bouvier (Kennedy) with her Great Dane, "King Phar," Hewlett Harbor, NY,* 1935, gelatin silver print. Courtesy, Archive Photos.

269 **Unknown photographer**, *John F. Kennedy,* 1949, gelatin silver print. Courtesy, John F. Kennedy Library, MA.

271 **Carl Mydans** (American, b. 1907), *Gertrude Stein and Alice B. Toklas with Basket II,* 1944. Courtesy, LIFE Magazine. © Time Inc.

273 **Gordon Parks** (American, b. 1912), 1943, gelatin silver print. Courtesy, Bettmann/CORBIS.

275 **Charles Sheeler** (American, 1883–1965), c. 1945, gelatin silver print. Courtesy, The Addison Gallery of American Art, Andover, MA.

276 **Robert Doisneau** (French, b. 1912), *Juliette Greco in Paris,* 1947, gelatin silver print. Courtesy, Rapho/Liaison Agency.

278/ **Ansel Adams** (American, 1902–1984), *Sunrise, Laguna*
279 *Beach, NM,* 1937, gelatin silver print. Courtesy, Collection Center for Creative Photography, The University of Arizona. © Ansel Adams Publishing Rights Trust/CORBIS.

281 **Henri Cartier-Bresson** (French, b. 1908), *Dogs on the Sidewalk,* 1932, gelatin silver print. Courtesy, Magnum Photos.

Unknown photographer, c. 1943

Unknown photographer, c. 1934

282/ **Man Ray**, *Picasso sur la Plage de Golfe*, 1937, gelatin silver
283 print. © 2000 Man Ray Trust/Artists Rights Society,
ADAGP, Paris, VG Bild-Kunst, Bonn 2000.

284/ **Manuel Alvarez Bravo** (Mexican, b. 1902), *Can de Mar*,
285 1933, gelatin silver print. Courtesy, Collection Center for
Creative Photography, The University of Arizona.

286 **Erich Salomon** (German, 1886–1944), *Im Zug von Chicago
nach New York*, 1932, gelatin silver print. Courtesy, Bild-
archiv Preussischer Kulturbesitz, Berlin.

287 **Robert Capa** (American, b. Hungary, 1913–1954), *Spanish
Civil War, Barcelona, Spain*, 1936, gelatin silver print.
Courtesy, Magnum Photos.

289 **Harold Edgerton** (American, 1903–1990), *Jackie Wags his
Tail*, 1938, gelatin silver print. © Harold & Esther Edger-
ton Foundation, 1999. Courtesy, Palm Press, Inc.

290 **Weegee (Arthur Fellig)** (American, b. Poland,
1899–1968), *Arrested for Vagrancy*, 1940, gelatin silver
print. Courtesy, Weegee/ICP/Liaison Agency.

291 **Bill Brandt** (English, b. Germany, 1904–1983), *The
Magic Lantern of a Car's Lights*, 1945, gelatin silver print.
Courtesy, Hulton Getty Picture Library.

292 **Lola Alvarez Bravo** (Mex., 1907–1993), *Frida Kahlo,
Mexico City*, 1944, gelatin silver print. © 1995, Center for
Creative Photography, The University of Arizona
Foundation. Courtesy, Collection Center for Creative
Photography, The University of Arizona.

293 **Henri Cartier-Bresson**, *William Faulkner*, 1947, gelatin
silver print. Collection of Alan Siegel, New York,
Courtesy, Magnum Photos.

294 **Jacques-Henri Lartigue**, *Noisettes at Cannes*, 1940,
gelatin silver print. © Ministère de la Culture – France/
A.A.J.H.L.

295 **Herbert List** (German, 1903–1975), *Portofino*, 1936,
gelatin silver print. Courtesy, Magnum Photos.

297 **Johnny Florea** (American, b. 1930s), *K-Nine Corps., Los
Angeles*, 1942, gelatin silver print. Courtesy, LIFE Maga-
zine. © Time Inc.

298 **Joan Ludwig** (American, b. 1914), *British Soldier with
German Shepherd*, 1942, gelatin silver print. Courtesy of
the Artist.

300 **Unknown photographer**, *Peppy, Shot in Head by Japanese
Sniper in Guam*, 1944, gelatin silver print. Courtesy, The
National Archives and Mary Elizabeth Thurston.

301 **Unknown photographer**, *Iwo Jima*, 1945, gelatin silver
print. Courtesy, LIFE Magazine. © Time Inc.

303 **W. Eugene Smith** (American, 1918–1978), *Injection for War
Dog*, 1943, gelatin silver print. Courtesy, Collection Cen-
ter for Creative Photography, The University of Arizona.
© Estate of W. Eugene Smith/Black Star.

304/ **Unknown photographer**, *"Rip," London*, 1943, gelatin
305 silver print. Courtesy, Imperial War Museum, London.

306 **Johnny Florea**, *Poker-Face, Cologne*, 1944, gelatin silver
print. Courtesy, LIFE Magazine. © Time Inc.

1950·1980
Looking Within

308 **Unknown photographer**, *Old Bluey Eyes*, 1968, gelatin
silver print. Courtesy, London Daily Express/Archive
Photos.

310/ **Ted Streshinsky** (American, active 1950s), *Eugenia Van
311 Horn*, 1957, gelatin silver print. Courtesy, Bettman/
CORBIS.

313 **Eve Arnold** (American, b. 1913), *Brookhaven, Long Island*,
1957, gelatin silver print. Courtesy, Magnum Photos.

315 **Friedrich Seidenstücker** (German, active 1950s),
The Latest Model of Strollers, 1950, gelatin silver print.
Courtesy, Bildarchiv Preussicher Kulturbesitz, Berlin.

317 **Kurt Hutton** (English, b. Austria, 1893–1960), *Hoovering
the Dog*, c. 1950, gelatin silver print. Courtesy, Hulton
Getty Picture Library.

318/ **G. Thurston Hopkins** (English, b. 1913), *Walking the Dog*,
319 1954, gelatin silver print. Courtesy, Hulton Getty Picture
Library.

321 **Marc Riboud** (French, b. 1923), *Street Circus*, c. 1950.
Courtesy, Magnum Photos.

322 **Erika Stone** (American, b. Germany, 1924), *Women & Dog
in Window*, 1959, gelatin silver print. Courtesy of the
Artist.

323 **Todd Webb** (American, b. 1905), *79th Street, New York*,
1952, gelatin silver print. Courtesy, Yancey Richardson
Gallery, New York.

324 **Louis Stettner** (American, b. 1922), *1953*, gelatin silver
print. Courtesy, Bonni Benrubi Gallery, New York.

326 **Dennis Stock** (American, b. 1928), *James Dean, Fairmont,
IN*, 1955, gelatin silver print. Courtesy, Magnum
Photos.

327 **Unknown photographer**, *Lauren Bacall*, 1955, gelatin
silver print. Courtesy, UPI/Bettmann/CORBIS.

328(l) **Unknown photographer**, *Audrey Hepburn*, 1954 gelatin
silver print. Courtesy, Archive Photos.

328(c) **Unknown photographer**, *Elvis Presley*, c. 1955,
gelatin silver print. Courtesy, Michael Ochs Archives,
Venice, CA.

328(r) **Unknown photographer**, *Liz Taylor*, 1957, gelatin silver
print. Courtesy, Evening Standard Collection/Hulton
Getty Picture Library.

329(l) **Unknown photographer**, *Clark Gable*, 1950, gelatin silver
print. Courtesy, Archive Photos.

329(c) **Wayne Miller** (American, b. 1918), *Jayne Mansfield and
Mickey Haggerty*, 1958, gelatin silver print. Courtesy,
Magnum Photos.

329(r) **Unknown photographer**, *Grace Kelly*, c. 1950, gelatin
silver print. Courtesy, Archive Photos.

330/ **Slim Aarons** (English, b. 1916), *Joan Collins Relaxes with
331 her Pink Poodle*, c. 1955, chromogenic print. Courtesy,
Slim Aarons/Hulton Getty Picture Library.

393 **Lucien Clergue** (French, b. 1934), 1960, gelatin silver print. Courtesy of the Artist.

394/ **Danny Lyon** (American, b. 1942), *Knoxville, TN.*, 1967,
395 gelatin silver print. Courtesy, Magnum Photos and the Artist.

397 **William Wegman** (American, b. 1942), *On the Lake*, 1976, gelatin silver print. Courtesy of the Artist and Pace/MacGill Gallery, New York.

399 **Unknown photographer**, *Paul and Linda McCartney on their Scottish Farm*, 1971, gelatin silver print. Courtesy, Hulton Getty Picture Library.

401 **Unknown photographer**, *President Richard Nixon with his Dog, and Bebe Rebozo*, 1973, gelatin silver print. Courtesy, CORBIS/Bettmann/UPI.

403 **Sveva Vigeveno** (Italian, active, 1970s), *Brigitte Bardot*, c. 1975, gelatin silver print. Courtesy, Sveva Vigeveno/Gamma/Liaison Agency.

404 **Wolf von dem Bussche** (American, b. Germany, 1934), *Dog on Terrace*, 1970, gelatin silver print. Courtesy of the Artist and Eaton Fine Arts, West Palm Beach.

405 **Tio Cabrón** (American, b. c.1930), n.d., gelatin silver print. Courtesy of the Artist.

406 **Helmut Newton** (Austrian, b. Germany 1920), 1970, gelatin silver print. Courtesy of the Artist.

408 **Ferdinando Scianna** (Italian, b. 1943), *Benares, India*, 1972, gelatin silver print. Courtesy, Magnum Photos.

409 **Richard Kalvar** (American, b. 1944), *A restful dog in the Rue de L'Ouest*, 1974, gelatin silver print. Courtesy, Magnum Photos.

411 **Albert Kozák** (Hungarian, active 1970s) and **János Sarkady** (Hungarian, active 1970s), 1976, gelatin silver print. Courtesy, Interfoto MTI, Hulton Getty Picture Library.

412 **Garry Winogrand**, *Dog in Central Park*, c. 1970. © 1984, The Estate of Garry Winogrand. Courtesy, Fraenkel Gallery, San Francisco and The J. Paul Getty Museum, Los Angeles.

413 **William Wegman**, *Ray Cat*, 1978, ink on gelatin silver print. Courtesy of the Artist and Pace /MacGill Gallery, New York.

414 **Elliott Erwitt**, *New Jersey*, 1971, gelatin silver print. Courtesy, Elliott Erwitt and Magnum Photos.

416 **Andy Warhol** (American, 1928–1987), c. 1979, Polaroid. Courtesy, The Andy Warhol Foundation Inc./Art Resource, New York.

417 **Robert Mapplethorpe** (American, 1946–1989), *Boxer*, c. 1973, polaroid. © Estate of Robert Mapplethorpe. Used by permission. Courtesy, The Mapplethorpe Foundation, Inc., New York.

418/ **Jenny Lynn** (American, b. 1928), *Leo Castelli's Dalmatian,*
419 *Paddy Boy*, 1978, gelatin silver print. Courtesy of the Artist.

1980·2000
Closing the Circle

420 **Carole Baker** (English, b. 1960), *Stray Lenny*, 1998, digitally altered chromogenic print. Courtesy of the Artist.

422/ **Anne Turyn** (American, b. 1954), 1983, chromogenic
423 print. Courtesy, The Metropolitan Museum of Art, New York.

424 **Jacques-Henri Lartigue**, *Toby à Traiville*, 1923, gelatin silver print. © Ministère de la Culture – France/A.A.J.H.L.

425 **Elliott Erwitt**, 1998, gelatin silver print. Courtesy, Magnum Photos.

426 **William Wegman**, *Man Ray Contemplating Man Ray*, 1978, gelatin silver print. Courtesy of the Artist and Pace/MacGill Gallery, New York.

427 **Keith Carter** , *Bubba & Peggy*, 1993, toned gelatin silver print. Courtesy of the Artist and Howard Greenberg Gallery, New York.

428 **William Wegman**, *Letters, Numbers and Punctuation*, 1993, gelatin silver print. Courtesy of the Artist and Pace/MacGill Gallery, New York.

429 **Elliott Erwitt**, *Paris, France*, 1989, gelatin silver print. Courtesy, Magnum Photos.

431 **Jacques-Henri Lartigue**, *Cap d'Antibes*, 1968, gelatin silver print. © Ministère de la Culture – France/A.A.J.H.L.

432 **Keith Carter**, *Dog Beach*, 1995, toned gelatin silver print. Courtesy of the Artist and Howard Greenberg Gallery, New York.

433(t) **William Wegman**, *Modeling School*, 1974. Courtesy of the Artist and Pace/MacGill Gallery, New York.

433(b) **Jacques-Henri Lartigue**, *My Cousin, Simone Roussel, Villerville*, 1904, gelatin silver print. © Ministère de la Culture – France/A.A.J.H.L.

435 **Elliott Erwitt**, 1979, gelatin silver print. Courtesy, Magnum Photos.

437 **Maseo Yamamoto** (Japanese, b. 1957), *#332 from A Box of Ku*, 1995, chromogenic print. Courtesy, Yancey Richardson Gallery, New York.

Josef Koudelka, 1976

439 **Martha Casanave** (American, b. 1946), 1996, gelatin silver print. Courtesy of the Artist.

440 **Nina Schmitz** (German, b. 1968) and **Bernd Schaller** (German, b. 1963), 1996, Baryth-print. © Nina Schmitz and Bernd Schaller. Courtesy of the Artists.

441 **Tamara Leuty** (American, b. 1966), *Willow*, 1998, gelatin silver print. Courtesy of the Artist.

442 **Dario Mitidieri** (Italian, b. 1959), *See the Boy, See the Bomb*, 1991, gelatin silver print. Courtesy, UNICEF and the Artist.

443 **Sally Mann** (American, b. 1951), *The Hotdog*, 1989, gelatin silver print. © Sally Mann. Courtesy, Edwynn Houk Gallery, New York.

444 **Tina Barney** (American, b. 1945), *The Twins*, 1994, chromogenic print. Courtesy of Janet Borden, Inc., New York.

445 **David Bailey** (English, b. 1938), 1986, gelatin silver print. Courtesy, Robert Montgomerie & Partners, Inc., London.

446 **Wolfgang Tillmans** (German, b. 1968), 1997, gelatin silver print. Courtesy of the Artist.

447 **Christophe Agou** (French, b. 1969), 1999, gelatin silver print. Courtesy of the Artist.

448 **Robert Adams** (American, b. 1937), 1989, gelatin silver print. Courtesy of the Artist.

450 **Donna Ferrato** (American, b. 1949), 1987, chromogenic print. Courtesy of the Artist.

451 **Shelby Lee Adams** (American, b. 1950), *Napier Brothers with Puppies*, 1993, toned gelatin silver print. Courtesy of the Artist.

452 **Nina Schmitz**, 1999, color print. © Nina Schmitz. Courtesy of the Artist.

453 **David Hockney** (English, b. 1937), *Jeff Burkhart, # 1, September 9*, 1990, still video composite. © David Hockney. Courtesy of the Artist.

454 **Shelby Lee Adams**, *Chester and his Hounds, Delphia*, 1992, toned gelatin silver print. Courtesy of the Artist.

455 **Mary Ellen Mark** (American, b. 1941), *Maya Miller*, 1990, gelatin silver print. Courtesy of the Artist.

456 **Suzanne Shaker** (American, b. 1951), *Athena*, 1998, gelatin silver print. Courtesy of the Artist.

457 **Suzanne Shaker**, *Athena*, 1998, gelatin silver print. Courtesy of the Artist.

458/ **Sebastiao Salgado** (Brazilian, b. 1944), *Mexico*, 1980,
459 gelatin silver print. © 1996, Sabastiao Salgado/Contact Press Images.

461 **John Sann** (American, b. 1963), 1989, gelatin silver print. Courtesy of the Artist.

462/ **Michael Smith** (American, b. 1951), *Unicoi County, TN.*,
463 1999, chromogenic print. Courtesy, Yancey Richardson Gallery, New York.

464/ **Martin Parr** (English, b. 1952), from the series *Common*
465 *Sense*, 1986, chromogenic print. Courtesy, Janet Borden, Inc., New York.

466 **Bruce Gilden** (American, b. 1946), *Port-au-Prince, Haiti*, 1990, gelatin silver print. Courtesy of the Artist and Magnum Photos.

467 **Leon Kuzmanoff** (American, 1921–1998), *Nome, Alaska*, 1985, gelatin silver print. © The Estate of Leon Kuzmanoff. Courtesy, Carol Ann Merritt.

468 **Freddie Reed** (English, active 1980s), *In Jail*, 1980, gelatin silver print. Courtesy, Battersea Dog Home, London.

469 **Marianne Courville** (American, b. 1965), *Dog, 1968/1997*, 1997, chromogenic print. Courtesy of the Artist.

470 **James Balog** (American, b. 1952), *Yellow Lab*, 1993, chromogenic print. Courtesy of the Artist.

471 **Keith Carter**, *Lost Dog*, 1992, gelatin silver print. Courtesy of the Artist and Howard Greenberg Gallery, New York.

472 **Carole Baker,** *Stray Sally*, 1998, digitally altered chromogenic print. Courtesy of the Artist.

473(t) **Carole Baker**, *Stray Blue*, 1998, digitally altered chromogenic print. Courtesy of the Artist.

473(c) **Carole Baker**, *Stray Rufus*, 1998, digitally altered chromogenic print. Courtesy of the Artist.

473(b) **Carole Baker**, *Stray Sparky*, 1998, digitally altered chromogenic print. Courtesy of the Artist.

475 **David Salle** (American, b. 1952) and **David Pandiscio**, *Dog Details* from *Jar of Spirits*, 1987, Candle Detail from *Coming and Going*, 1987. © David Salle/Licensed by VAGA, New York. Photograph courtesy, UPI/Bettmann. Courtesy of the Artist.

Robin Schwartz, 1987

Donna Ruskin, 1995

476 **Max Aguilera-Hellweg** (American, b. 1955), *Dog Having CT Scan, New York*, 1999, chromogenic print. Courtesy of the Artist.

477 **Gilles Peress** (French, b. 1946), *Kosovo*, 1999, gelatin silver print. Courtesy of the Artist.

478 **Francis Alÿs** (Belgian, 1959), *"Sleepers," Mexico City, Mexico*, 1999, slide-projection transparency. Courtesy of the Artist and Lisson Gallery, London.

479 **Camilo José Vergara** (American, b. Chile, 1944), *S. Central*, 1997, chromogenic print. Courtesy of the Artist.

480/ 481 **Robert Adams**, 1989, gelatin silver print. Courtesy of the Artist.

483 **Lorna Bieber** (American, b. 1949), *Two White Dogs*, 1999, gelatin silver print. Courtesy of the Artist.

484/ 485 **Harry Giglio** (American, b. 1950), *Pray for Peace*, 1996, gelatin silver print. Courtesy of the Artist.

487 **Ulrich Tillmann**, *Zwei Guedras mit Hütehund*, 1986, gelatin silver print. Courtesy of the Artist, from the collection of Baroness Jeane Wahl von Oppenheim.

488 **Robert Frank** (American, b. Switzerland, 1924), *Mabou (Electric Dog)*, 1980, gelatin silver print. © Robert Frank. Used by permission. Courtesy of the Artist and Pace/MacGill Gallery, New York.

490 **David Seltzer** (American, b. 1947), *The Parisian*, 1988, toned gelatin silver print. Courtesy of the Artist.

491 **Jill Mathis** (American, b. 1964), *A Cynic*, 1999, gelatin silver print. Courtesy of the Artist.

493 **Graciela Iturbide** (Mexican, b. 1942), *Francisco Toledo, Oaxaca, Mexico*, 1995, gelatin silver print. Courtesy of the Artist.

494 **David Hiscock** (English, b. 1956), *Oscar*, 1982, gelatin silver print. Courtesy of the Artist and Robert Montgomerie & Partners, London.

495 **Susan Paulsen** (American, b. 1957), 1998, gelatin silver print. Courtesy of the Artist.

497 **Michal Rovner** (Israeli, b. 1957), *Rising Dog*, 1987, chromogenic print. Courtesy of the Artist.

498/ 499 **Blair Rainey** (American, b. 1962), *Key Dog, New York*, 1980, gelatin silver print. Courtesy of the Artist.

500 **Robert Stivers** (American, b. 1953), *Series #5 (Dog #12)*, 1996, gelatin silver print. Courtesy of Yancey Richardson Gallery, New York.

501 **Felicia Murray** (American, b. 1954), *Ghost Dog, Arles*, 1995, gelatin silver print. Courtesy of the Artist.

502/ 503 **Steve Vaccariello** (American, b. 1965), *Nuclear Dogs, Chicago*, 1991, gelatin silver print. Courtesy of the Artist.

504 **Christopher Wool** (American, b. 1955), 1991, gelatin silver offset print. Courtesy of the Artist.

505 **Christopher Wool**, 1992, gelatin silver print. Courtesy of the Artist.

506 **David Wojnarowicz** (American, 1954–1992), 1988, gelatin silver print. Courtesy, P.P.O.W., New York and the Estate of David Wojnarowicz.

508 **Gregory Crewdsen** (American, b. 1962), from *The Twilight Series*, 1998, gelatin silver print. Courtesy, Luhring Augustine Gallery, New York.

509 **Sam Taylor-Wood** (English, b. 1967), *Soliloquy II*, 1998, chromogenic print. Courtesy, Jay Jopling, London.

510 **William Wegman**, *To Sleep*, 1995, Polaroid. Courtesy of the Artist and Pace/MacGill Gallery, New York.

511 **Jan Saudek** (Czechoslovakian, b. 1935), *Marie's Pet*, 1994, hand-colored gelatin silver print. Courtesy of the Artist.

512/ 513 **Pentti Sammallahti** (Finnish, b. 1950), *Solovki, White Sea*, 1992, gelatin silver print. Courtesy of the Artist and Candace Perich Gallery, Katonah, NY.

515 **Donna Ferrato**, *Fanny*, 1997, gelatin silver print. Courtesy of the Artist.

516 **Wayne Maser** (American, b. 1957), 1980, gelatin silver print. Courtesy, Staley-Wise Gallery, New York.

517 **David Jensen** (American, b. 1963), *Winston Wilde and Buddy Cross-Dressed*, 1996, gelatin silver print. Courtesy of the Artist and Winston Wilde.

518/ 519 **Tariq Alvi** (English, b. 1965), 1998, chromogenic print assemblage. Courtesy of the Artist.

521 **Bruce Weber** (American, b. 1946), *Rob and Little Bear at the Entrance of Bear Pond, Adirondack Park*, 1989, gelatin silver print. Courtesy, Marisa Cardinale. © Bruce Weber. Used by permission.

522 **Marilyn Bridges** (American, b. 1948) and **Will Peterson** (American, b. 1948), *Self-Portrait, Sitting with Ali*, 1981, gelatin silver print. Courtesy of the Artists.

524/ 525 **Sage Sohier** (American, b. 1954), *Vincenzo, Paris & Peter, Cambridge, MA.*, 1992, gelatin silver print. Courtesy of the Artist.

527 **Julie McConnell** (American, b. 1963), 1999, digital print. Courtesy of the Artist and the Sag Harbor Picture Gallery.

528 **Linda McCartney** (American, 1941–1999), *Merdock*, 1985, cyanotype. © The Estate of Linda McCartney. Courtesy, Robert Montgomerie & Partners, London.

529 **Andy Hervey** (American, active 1990s), *New Orleans*, 1991, chromogenic print. Courtesy of the Artist.

530 **Bruce Cratsley** (American, 1945–1998), *Adorable Dog Chez Flea Market*, 1990, gelatin silver print. Courtesy, The Bruce Cratsley Archives and Sarah Morthland Gallery, New York.

531 **David Levinthal** (American, b. 1949), from the series *Mein Kampf*, 1994, Polaroid. Courtesy of the Artist.

532/ 533 **Nic Nicosia** (American, b. 1951), *Near (Modern) Disaster #1*, 1983, Cibachrome print. Courtesy of the Artist.

534 **Max Below Toledo-Paris** (American, b. 1948) and **Kim Irwin** (American, b. 1947), *Dog and Lipstick*, 1998, Polaroid. Courtesy of the Artists.

535 **William Eggleston** (American, b. 1939), c. 1980, chromogenic print. © William Eggleston/Art + Commerce Anthology Inc.

536/ **Sandy Skoglund** (American, b. 1946), *The Green House*, 537 1990, Cibachrome print. Courtesy of the Artist.

539 **Michael Kenna** (English, b. 1953), *Paolo's Beeswax Dog, Monique's Kindergarten*, 1995, toned gelatin silver print. Courtesy of the Artist and Bonni Benrubi Gallery, New York.

540 **Paul McCarthy** (American, b. 1945), *Dog Cowboy* from his sculpture *Bunkhouse*, 1996, chromogenic print. Courtesy of the Artist and the Luhring Augustine Gallery, New York.

541(t) **Larry Gianettino** (American, b. 1956), *Black Dog*, 1995, Cibachrome print. Courtesy, Ricco/Maresca Gallery, New York.

541(c) **Larry Gianettino**, *Cross-Eyed Dog*, 1999, Cibachrome print. Courtesy, Ricco/Maresca Gallery, New York.

541(b) **Larry Gianettino**, *Brown Pup*, 1999, Cibachrome print. Courtesy, Ricco/Maresca Gallery, New York.

542 **Arthur Tress** (American, b. 1940), *Call of the Wild, New York*, 1988, chromogenic print. Courtesy of the Artist and the Collection Center for Creative Photography, University of Arizona.

543 **Chris Schiavo** (American, b. 1965), *Harley & Friends*, 1992, chromogenic print. Courtesy of the Artist.

544 **Stuart Hart** (American, b. 1973), 1999, chromogenic print. Courtesy of the Artist.

545 **Vik Muniz** (Brazilian, b. 1961), *Coyote*, 1994, from the series *Shadow Grams (X-rays)*, blue-toned gelatin silver print. Courtesy, The Buhl Collection, New York.

547 **Tony Mendoza** (American, b. 1941), 1990, hand-toned gelatin silver print. Courtesy of the Artist.

548 **Jed Devine** (American, b. 1944), 1991, platinum print. Courtesy, Bonni Benrubi Gallery, New York.

549 **Ulrich Tillmann**, *Kleiner Ekel*, 1989, gelatin silver print. Courtesy of the Artist, from the Collection of Baroness Jeane Wahl von Oppenheim.

550 **Abelardo Morrell** (American, b. Cuba, 1948), *Poor Little Thing*, 1998, gelatin silver print. Courtesy of the Artist and Bonni Benrubi Gallery, New York.

552/ **Donald Lokuta** (American, b. 1946), *Dog at the 26th Street* 553 *Flea Market, New York*, 1997, gelatin silver print. Courtesy of the Artist and Sarah Morthland Gallery, New York.

554 **Unknown photographer**, *Officer John Martin*, 1988, gelatin silver print. Courtesy, LIFE Magazine. © Time Inc.

555 **Roger F. Ballen** (American, b. 1950), *Security Guard and Puppy on Staircase, Gauteng, South Africa*, 1996, gelatin silver print. Courtesy of the Artist and Michael Hoppen Photography, London.

556/ **Roger F. Ballen**, *Puppy Between Feet*, 1999, gelatin silver 557 print. Courtesy of the Artist and Michael Hoppen Photography, London.

559 **Barry Haynes** (American, b. 1953), 1996, digital dye-sublimation print. Courtesy, Floyd Segal and the Norton Museum of Art, West Palm Beach.

560/ **William Wegman**, *Deposition*, 1997, five Polaroid panels. 561 Courtesy of the Artist and Pace/MacGill Gallery, New York.

562(ul) **Rosemarie Trockel** (German, b. 1952), *Elena*, 1993, mixed media. Courtesy, Monika Sprüth Galerie, Cologne.

562(ur) **Rosemarie Trockel**, *Mela*, 1993, mixed media. Courtesy, Monika Sprüth Galerie, Cologne.

562(ll) **Rosemarie Trockel**, *Mela*, 1993, mixed media. Courtesy, Monika Sprüth Galerie, Cologne.

562(lr) **Rosemarie Trockel**, *Elena*, 1993, mixed media. Courtesy, Monika Sprüth Galerie, Cologne.

564 **Bryan Hunt** (American, b. 1947), *Chester in Studio on Gaudí Chair*, 1985, chromogenic print. Courtesy of the Artist.

565 **Alen MacWeeney** (Ireland, b. 1939), 1994, chromogenic print. Courtesy of the Artist.

566 **Jörg Brockmann** (American, b. 1967), *Shepherd Dog, Mongolia*, 1996, gelatin silver print. Courtesy of the Artist.

568/ **Eric Fischl** (American, b. 1948), 1991, gelatin silver print. 569 Courtesy of the Artist.

570 **Tanya Braganti** (American, b. 1971), 1999, gelatin silver print. Courtesy of the Artist.

571 **Debbie Fleming Caffery** (American, b. 1948), *Versailles*, 1998, gelatin silver print. Courtesy of the Artist and Ricco/Maresca Gallery, New York.

572 **Francesco Scavullo** (American, b. 1924), *Dracula*, 1991, gelatin silver print. Courtesy of the Artist.

573 **Peter Hujar** (American, 1934–1987), *Will: Char-Pei*, 1985, gelatin silver print. © The Estate of Peter Hujar. Courtesy, Stephen Koch.

575 **Alen MacWeeney**, 1998, chromogenic print. Courtesy of the Artist.

576 **Anne Eickenberg** (German, b. 1969), 1997, chromogenic print. Courtesy of the Artist.

Yves Guillot, 1994

Appendix

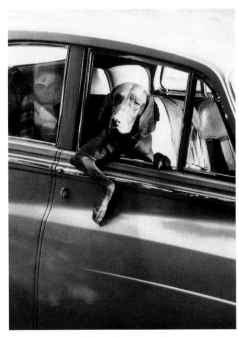

Philippe Vermes, 1976

Index of Photographers · Index der Fotografen · Index des photographes

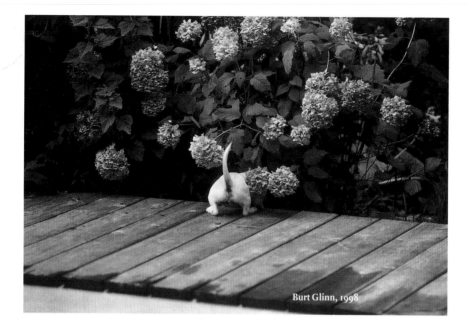

Burt Glinn, 1998

© 2000 TASCHEN GmbH
Hohenzollernring 53, D–50672 Köln
www.taschen.com

Editors
Raymond Merritt, Miles Barth, New York

Layout
Raymond Merritt, Miles Barth, New York

Editorial coordination
Simone Philippi, Cologne
Anja Lenze, Cologne

Design
Claudia Frey, Cologne

Cover Design
Angelika Taschen, Cologne

German translation
Ursula Höfker, Remchingen
Peter Torberg, Munich (The Power of the Dog
by Rudyard Kipling)

French translation
Simone Manceau, Paris

Production
Horst Neuzner, Cologne

© 2000 for the illustrations by VG Bild-Kunst,
Bonn; the photographers, their agencies and
estates

© for the essay A Path to a New Ethic by
Mary Elizabeth Thurston

© for the text and unattributed quotations by
Raymond Merritt

© for "Canis Major" from Collected Poems, by
Robert Frost. Reprinted by permission of Henry
Holt and Company Inc.

© for "The Power of the Dog" from Actions and
Reactions, by Rudyard Kipling. Reprinted by
permission of Mrs. George Bambridge, Thomas
A. Watt & Son and Doubleday & Co.

© for Arthur Guiterman, "Motto for a Dog
House" from Lyric Laughter by E. P. Dutton & Co.

Printed in Italy
ISBN 3–8228–6223–1 [ENGLISH EDITION]
ISBN 3–8228–6024–7 [GERMAN EDITION]
ISBN 3–8228–5964–8 [FRENCH EDITION]

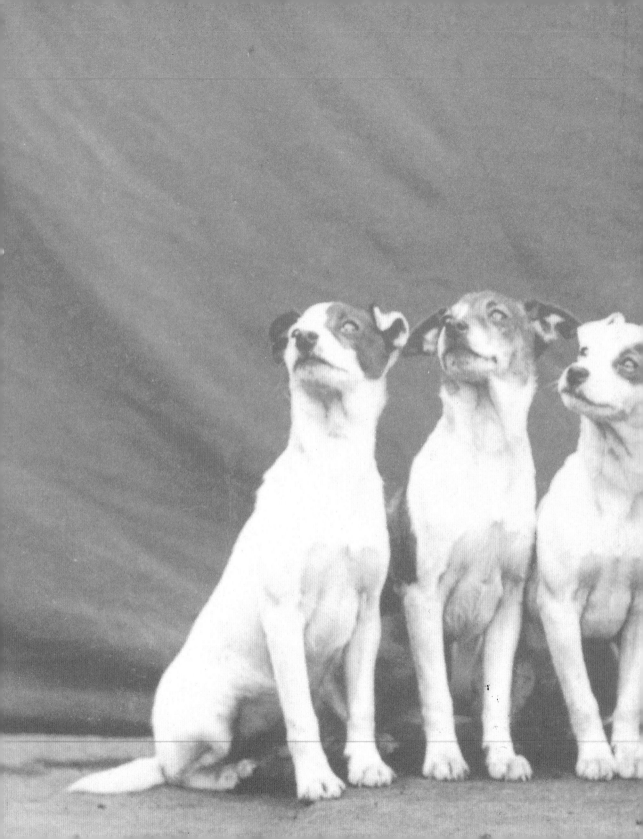